MERCHANDISING MATHEMATICS: HIGH MARGIN RETURNS FOR RETAILERS AND VENDORS

The Delmar Fashion Series

Fashion Retailing by Ellen Diamond

Retail Buying by Richard Clodfelter

Exporting and Importing Fashion: A Global Perspective by Elaine Stone

Introduction to Fashion Merchandising by Patricia Rath,
 Jacqueline Peterson, Phyllis Greensley and Penny Gill

AutoCAD for the Apparel Industry by Phyllis Bell Miller

Merchandising Mathematics by Meridith Paidar

Fashion Apparel and Accessories by Jay and Ellen Diamond

Wardrobe Strategies for Women by Judith Rasband

Fashion History Videos by Vidcat
 Fabulous Fifties: 1950s
 Vintage Chic: 1950s and 1960s
 Mostly Mod: 1960s

The Fashion Retailing Video Series by Diamond/Vidcat
 Vol. 1 *Classifying the Retailers*
 Vol. 2 *The Fashion Retailer's Environment*
 Vol. 3 *Buying and Merchandising Fashion*
 Vol. 4 *Retail Advertising and Promotion*
 Vol. 5 *Selling and Servicing the Retail Customer*

Wardrobe Strategies for Women Videos by Rasband
 Vol. 1 *Clothing: A Powerful Resource*
 Vol. 2 *Style Lines and Shapes*
 Vol. 3 *Color and Fabrics*
 Vol. 4 *Pattern and Personal Style*
 Vol. 5 *Wardrobe Cluster Concept*
 Vol. 6 *Clothing Care and Shopping for Value*

MERCHANDISING MATHEMATICS: HIGH MARGIN RETURNS FOR RETAILERS AND VENDORS

Meridith Paidar
The Meridith Group

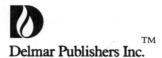
Delmar Publishers Inc.™

I(T)P™

NOTICE TO THE READER

Publisher does not warrant or guarantee any of the products described herein or perform any independent analysis in connection with any of the product information contained herein. Publisher does not assume, and expressly disclaims, any obligation to obtain and include information other than that provided to it by the manufacturer.

The reader is expressly warned to consider and adopt all safety precautions that might be indicated by the activities described herein and to avoid all potential hazards. By following the instructions contained herein, the reader willingly assumes all risks in connection with such instructions.

The publisher makes no representations or warranties of any kind, including but not limited to, the warranties of fitness for particular purpose or merchantability, nor are any such representations implied with respect to the material set forth herein, and the publisher takes no responsibility with respect to such material. The publisher shall not be liable for any special, consequential or exemplary damages resulting, in whole or in part, from the readers' use of, or reliance upon, this material.

Cover design by Spiral Design Studio

Delmar staff:
Senior Acquisitions Editor: Mary McGarry
Project Editor: Theresa M. Bobear
Production Coordinator: James Zayicek
Art & Design Coordinator: Karen Kunz Kemp

For information, address Delmar Publishers Inc.
3 Columbia Circle, Box 15-015
Albany, NY 12212-9985

Printed in the United States of America
Published simultaneously in Canada
by Nelson Canada,
a division of The Thomson Corporation

1 2 3 4 5 6 7 8 9 10 XXX 00 99 98 97 96 95 94

Paidar, Meridith.
 Merchandising mathematics : high margin returns for retailers and vendors
 / Meridith Paidar.
 p. cm.
 Includes index.
 ISBN 0-8273-5703-6
 1. Merchandising. 2. Business mathematics. I. Title.
 HF5429.P315 1994
 381′.1′0151—dc20 93-25984
 CIP

Brief Contents

Table of Contents

Preface

Merchandising Math: High Margin Returns for Retailers and Vendors evolved from my professional experience as both a retailer and a vendor. When I searched for a reference book that would provide me with *just* the basics of profitable merchandising, I discovered that one did not exist. The merchandising books which were available included unnecessary information, lacked "real world" examples, and did not provide clearcut procedures in preparing stock/sales plans, calculating open-to-buys, evaluating vendors, etc., or include forms and worksheets for immediate application in retail and wholesale careers. To meet my needs for information, as well as those of students, retailers, and vendors throughout the country, I wrote my own book.

This book will provide students, retailers, and vendors with the following benefits:

Students (having completed a preliminary retail merchandising course) should:

1. Learn the basic merchandising fundamentals for careers in retailing

2. Possess a valuable reference book for use throughout their retail/wholesale careers

Retailers (beginning entrepreneurs, executive trainees, or established retailers of small, medium, or large operations) should be able to:

1. Facilitate more effectively the planning, acceptance, and profitability of merchandise lines

2. Improve vendor negotiating skills

Vendors (entering or established in the wholesale market) should be able to:

1. Increase their understanding of the retailers' point-of-view

2. Improve their sales presentation skills and ability to achieve the retailer's and their sales goals

CONTENTS

The format of *Merchandising Math* logically builds upon the necessary understanding, knowledge, and working applications of the basics for profitable merchandising so that the reader will understand how merchandising components interface with each other.

Part One, "Vendor/Retailer Negotiations," pertains to retailers and vendors building mutually profitable partnerships because the pipeline of incoming merchandise is dependent upon the relationship developed between them. Chapter One, "WIN/WIN Partnerships," examines the ingredients of, and negotiating guidelines for, successful partnerships. For both the retailer and the vendor to achieve their sales and profit goals, they must work together to anticipate and meet the consumer's needs and wants. Chapter Two, "Terms of Sale," focuses on understanding shipping terms, payment arrangements, and discounts, and illustrates negotiating opportunities to increase gross margins. Chapter Three, "Components

for Profit," defines and illustrates the interaction of five basic profit factors which contribute to the profit produced within any retail operation. The five income statement analyses demonstrate the impact the retailer's decisions have on profits.

Three chapters are contained in Part Two, "Pricing Strategies," which develop the retailer's profit goals and pricing strategy. Chapter Four, "Pricing Considerations," emphasizes the importance of creating a consistent pricing policy to reinforce the store's image and details the components that comprise setting prices to achieve profit goals. Chapter Five, "Item Pricing," includes detailed descriptions of and follow-up exercises regarding the three item pricing methods used to prevent the purchase of goods under incorrect profit assumptions. The Markup Percent Pricing Table and Markup Tracking Log provide guides for profitable purchasing and the monitoring of progress toward achieving profit goals, respectively. Chapter Six, "Price Adjustments," focuses on markdowns, the inherent part of retailing. The Markdown Planning Worksheet, Price Change Report, and Employee Purchase Log provide useful tools for "real world" applications, but the emphasis is on the methods available to minimize markdowns.

Part Three, "Merchandising Planning," develops the skills necessary to profitably plan, select, and maintain the proper balance of stock to sales. The steps involved in blending the "ideal" merchandise mix are detailed in Chapter Seven, "Assortment Planning," with emphasis on ensuring that all decisions are based upon the targeted customer group's needs and wants. Chapter Eight, "Stock/Sales Budgeting," pulls the merchandise assortment, profit plans, and pricing strategies together into the development of the stock/sales plan. This is a working chapter where the reader formulates a merchandise budget to profitably balance the retailer's major dollar investment, stock, to sales. Chapter Nine, "Open-to-Buy," illustrates how the "checkbook" for writing orders works in tandem with the stock/sales plan to protect the retailer from making excess purchases, to maintain the proper balance of stock to sales, and to achieve profit goals. Open-to-Buy forms are used to provide the hands-on learning approach.

Part Four, "Inventory Management," focuses upon the control systems of inventory management which work in tandem with the merchandise plan and open-to-buy for effective dollar control, budgeted buying, and achievement of profit plans. Chapter Ten, "Ordering Systems," illustrates how initial orders and reorders are computed and details which ordering method works best for basic, seasonal, promotional, and fashion merchandise. Chapter Eleven, "Purchase Order Management," pertains to the execution, control, and management of the ordering and receiving of merchandise. Chapter Twelve, "Inventory Valuation," demonstrates the cost and retail inventory valuation methods used to determine the total value of stock on hand.

Part Five, "Sales Promotion," emphasizes the importance of preplanning to shrewdly negotiate prices while protecting gross margins. The steps of promotional planning are detailed from the six month sales and promotional plan created when planning the stock/sales plan to the actual use of the monthly promotional calendar to ensure the successful execution of the planned sales promotions and to provide records for the future planning of events.

Part Six, "Keys to Profit," presents benefits for both the retailer and vendor. Chapter Fourteen, "Retailer Options," provides the retailer with three negotiating tools—first, the vendor log, which provides a checklist for meetings with current and prospective vendors, negotiating opportunities, merchandise assortment overviews, and profit potentials; second, the receipts, sales and markdown summary, which recaps the vendor's results; and third, the vendor performance evaluation form, which calculates each resources' profit contribution. Chapter Fifteen, "Vendor Opportunities," provides meeting preparation and presentation guidelines and supplies additional selling tools to aid in the achievement of the retailer's and vendor's sales goals.

Also included in this text are six appendices. The first four appendices review mathematical computations and include handy reference tables to make calcula-

tions easier. The remaining two appendices cover necessary information to make sound business decisions.

Appendix 1, "Calculator Review," provides a refresher of calculator operations to speed the accuracy of simple and complex calculations. Appendix 2, "Fractions, Decimals, and Percents," defines each equivalent value and illustrates their conversion to make mathematical calculations easier. An easy, at-a-glance conversion table includes the most common values used by retailers and vendors alike to allow the reader to quickly convert fractions, decimals, and percent values. Appendix 3, "Rounding Numbers and Financial Notation," details the steps of abbreviating numbers to easily perform calculations. The reference chart clarifies the process in which one rounds numbers and uses financial notation for the simplification of presenting numbers when exact numbers are not necessary. A quick reference guide, Appendix 4, "Key Merchandising Math Formulas," compiles the most frequently used formulas for ease in selecting and performing calculations.

As successful retailers must first have a thorough understanding and working application of merchandising principles and formulas before considering converting manual inventory management systems to computerized systems, Appendix 5, "Computerization Decisions," is included in this text. Retailers must also be aware of the major laws which regulate free competition to ensure compliance in day-to-day business activities. Appendix 6, "The Impact of Federal Laws and Regulations on the Retailer," summarizes the major laws designed to allow "fair" competition and to protect the consumer from unfair trade practices.

FEATURES

The practical nature of *Merchandising Math* makes this text an ideal reference to keep and use throughout your professional career. Because of its many forms, formulas, tables, and illustrations, it can easily serve as a knowledge refresher for years to come. Nonetheless, the primary purpose of this text is as a basic guide to profitable merchandising. As a result, you will find many important features which enhance this objective and make this book the most effective instrument of its kind.

Terminology is the basis for learning any subject, and consequently this text emphasizes the understanding of the basic terms of the trade. To begin, each new term is boldfaced and defined at first use. In addition, a marginal glossary within each chapter highlights these key terms and their definitions for ease of review and understanding. Finally, an end-of-text Glossary contains an alphabetical listing and definition of each boldfaced term in this text.

Because we learn best by example, this text provides numerous examples of merchandising calculations and situations, as well as numerous figures illustrating basic forms necessary to profitable merchandising.

A key feature of this text is the Self Quizzes, which are integrated throughout most chapters. The purpose of these quizzes is to function as a periodic review of key concepts and computations. Think of these quizzes as self-help section summaries. Respond to the questions and problems posed and you'll find it easier to retain your knowledge of chapter material.

An occasional chapter feature is the "Something to Consider" box, which provides additional information to that which is supplied in the chapter narrative. First, for those who thoroughly understand the steps of a mathematical formula, the "short-cut," or simplified formula version, is provided to speed the computation process. Second, to clarify the introduction of a new mathematical concept, computational reminders are positioned to the side to further understanding. Finally, additional industry concepts are presented as asides to be absorbed as the process of building the necessary understanding, knowledge, and working applications of the basics for profitable merchandising progresses.

Because learning basic merchandising math and the principles of profitable merchandising involves understanding concepts as well as performing calculations,

two sets of activities have been provided at the end of each chapter to assist you in reviewing and retaining the materials you've read. First, the "Chapter Review" presents questions which ask you to recall information learned and, in many cases, use chapter concepts to respond to hypothetical business situations which occur in the "real world." Second, the "Chapter Test" presents problems which offer you the opportunity to test your grasp of the mathematical concepts studied in that chapter. Having successfully completed the review and test in each chapter, you will be well on your way to effectively learning how merchandising components interface with each other for profitable merchandising.

INSTRUCTOR'S GUIDE

As a supplement to this text, an Instructor's Guide has been developed to assist the instructor in teaching this course. This guide includes an overview of each chapter in the text and answer keys to all chapter quizzes, reviews, and tests.

Acknowledgments

Feedback from participants in my training seminars and clients are responsible for this book, but my first acknowledgments must go to the two people who helped me develop my company, The Meridith Group, a retail consultancy firm specializing in meeting the merchandising needs of retailers and vendors. They are John W. Lee II, president and CEO of Learning Curve Toys, and Adrienne Kostreva, president and founder of The Retail Leadership Source.

Secondly, Mary McGarry, the senior acquisitions editor, who selected my book for publication and Bob Nirkind, who provided editorial guidance throughout the manuscript development process, must be recognized.

Third, I wish to thank the following reviewers, without whose insight, comments, criticisms, and suggestions for improvement this text would not be the one you are reading at this moment:

Susan Alonzo
Phoenix College, Phoenix, AZ

Lori Battistone
ICM School of Business, Pittsburgh, PA

Gary Gran
International Academy of Merchandising and Design, Grays Lake, IL

Edith Jerd
Montgomery County Joint Vocational School, Clayton, OH

Kay King
Houston Community College, Houston, TX

Jerry Lancio
Daytona Beach Community College, Daytona Beach, FL

Kay Moorman
Chappewa Valley Technical College, Eau Claire, WI

Teresa Yohon
Hutchinson Community College, Hutchinson, KS

Fourth, my special thanks go to those who contributed their time to bring this book to publication. They include Michael LaVieri, Kathy Price, Valerie Roebke, and Betsy Stojanoff.

Fifth, a thank you to friends and colleagues who provided their "real world" expertise and forms: Marsha Anderle, Annette Atovsky, Cindi Berns, Michelle Brenner, Pam Clark-Ionnotta, Carl Jerls, Renee Slas, Debi Tobowlski, Lisa Weaver, and to all the vendors and retailers with whom I've worked with and learned from throughout my career.

Finally, I must recognize George Usleber, my motivator in life.

About the Author

Meridith Paidar is the president and founder of the consulting firm, The Meridith Group. Established in 1988, The Meridith Group provides strategic merchandising services to retail marketers and works directly with vendors to advance their knowledge of the retailers' point of view.

Meridith Paidar's ability to maximize sales and profits developed from over 20 years of experience in the areas of merchandising, management, and wholesale marketing. Ms. Paidar received her retail credentials from Bloomingdale's, Chas. A. Stevens, and World Bazaar Imports where she held executive merchandising positions. Her wholesale expertise was derived from executive positions with the Bali Company, Ben Rickert, Inc., and Philip Morris USA.

Meridith Paidar is the author and creator of the TIPPS Merchandising Training System, has produced training manuals for vendors and retailers, and has designed and conducted national training seminars. She continues to promote the education and development of retailers and vendors as a board member of The Fashion Group, an international professional association which serves as a network to exchange information on every phase of fashion design, manufacturing, retailing, and education.

PART

I

VENDOR/RETAILER NEGOTIATIONS

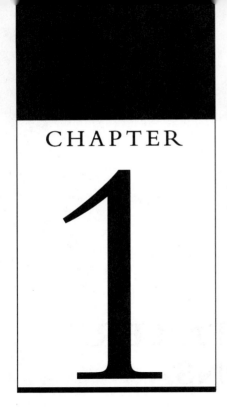

WIN/WIN Partnerships

The essence of **merchandising** depends on the relationship developed between the **retailer**, the party who resells the goods obtained from a vendor, and the **vendor**, the source from whom goods are obtained. (A vendor may also be referred to as a *manufacturer, supplier, wholesaler* or *resource*.) By developing and maintaining WIN/WIN relationships with vendors, the retailer may better achieve the **five golden rules of merchandising**:

1. Having the *right* merchandise

2. At the *right* time

3. At the *right* price

4. In the *right* quantity

5. In the *right* place

THE COMMON GOALS OF RETAILER AND VENDOR

merchandising—all activities involved in the buying and selling of merchandise

retailer—the party who resells the goods obtained from a vendor

THE INGREDIENTS OF WIN/WIN PARTNERSHIPS

vendor—the source from whom goods are obtained; also known as *manufacturer, supplier, wholesaler,* and *resource*

RETAILER/VENDOR NEGOTIATIONS

five golden rules of merchandising—having the *right* merchandise, at the *right* time, at the *right* price, in the *right* quantity, in the *right* place

Today, in the increasingly competitive marketplace, both retail outlets and vendor facilities have been dramatically reduced. What remains are fewer resources to select merchandise from and fewer retailers to "sell" goods to. The retailer needs merchandise to generate sales and produce a profit. The vendor needs retailers to "sell" to in order to meet sales quotas and profit goals.

To accomplish their common goals, the retailer and vendor must work together, as partners, to anticipate and meet the consumer's needs and wants. This requires close communication and the understanding of each other's respective needs.

WIN/WIN partnerships occur when the retailer and vendor work together to mutually arrive at satisfactory solutions for each party, while anticipating and meeting the consumer's needs and wants.

Let us examine the necessary ingredients of successful partnerships listed in Table 1.1 on page 3.

The needs of both the retailer and vendor are reasonable. To build winning alliances the retailer and the vendor must recognize each other's needs; be courteous, honest, and loyal; and play fair. These ingredients are the foundation for building WIN/WIN partnerships.

Negotiations are mutual discussions and arrangements of the terms of an agreement with satisfactory solutions arrived at for each party. Negotiations require a working knowledge and application of industry terms and mathematical formulas, a thorough understanding of each respective business, and adequate preparation so that objectives may be profitably achieved.

Successful vendors and retailers are prepared for their meetings. In advance, they analyze:

1. Their own personality and that of the persons they will be meeting and their respective needs and motivations.

Table 1.1 Ingredients of WIN/WIN Partnerships

Retailer Needs	*Vendor Needs*
1. Merchandise that produces a profit	1. On-time payment of invoices
2. Increased stock turn/sales	2. Increased orders/sales
3. Timely flow of quality merchandise	3. Reasonable and clear ship and cancel dates
4. Return goods privileges	4. Prior return authorization
5. Prompt response to calls	5. Returned phone calls
6. Advertising allowances	6. Advertising impact and display
7. Product knowledge and training	7. Target customer profile
8. Service comparable to volume	8. Respect of time allocated by volume
9. Industry trends	9. Industry updates
10. Confirmed appointments	10. Scheduled and kept calls

WIN/WIN partnerships—situation whereby the retailer and the vendor work together to mutually arrive at the satisfactory solutions for each party, while anticipating and meeting the consumer's needs and wants

negotiations—mutual discussions and arrangements of terms of an agreement with satisfactory solutions arrived at for each party

 a. Personality: What is the best way to establish initial rapport? Is small talk important or is a direct business approach more appropriate?

 b. Needs: What personal needs potentially must be met? To develop a reputation as that of being fair? To be acknowledged as an expert in their field?

 c. Motivations: What underlying motivations exist? To perform effectively so as to be promoted to the next level?

2. The business aspects important for both parties are:

 a. To improve profitability

 b. To increase sales

 c. To overcome competition's dominance

3. The objectives for each meeting. These objectives should be specific. For example:

markdown dollars—the dollar difference between the original retail price and the new retail price of an item

 a. Retailer: To obtain $1,500 in **markdown dollars** based on the weak sales results of the vendor's product line

 b. Vendor: To introduce two new styles, each in the retailer's three best selling colors

4. Possible concessions that could be made, if necessary. For example:

 a. Retailer: If necessary, will contribute 50% of the markdown dollar request to jointly clear out the vendor's product line's slow sellers

 b. Vendor: Possibly exchange one slow style to introduce the two new styles

 The vendor approaches each retailer meeting prepared with a list of goals. These goals may include obtaining a basic stock reorder, introducing a new product line, and selling an upcoming item promotion. The vendor, the provider of merchandise, establishes the limits at which he or she is willing to compromise to achieve company and personal goals. An example may be contributing a product for an in-store event or providing a return authorization. These are referred to as **"bottom-line" limits**.

"bottom-line" limits—the minimum and maximum concessions that a party is willing to compromise on to continue building a mutually profitable relationship

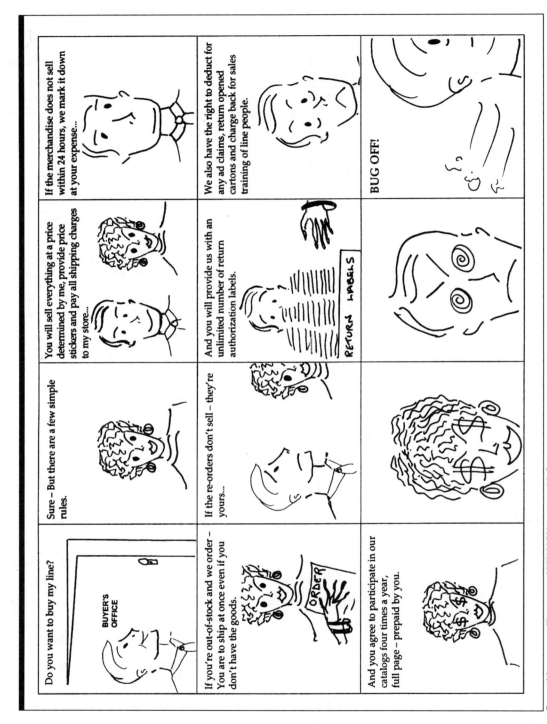

Does this cartoon illustrate a WIN/WIN partnership?

The retailer is also prepared for each meeting to achieve goals that may include securing a better price for a basic stock item, obtaining markdown dollars for slow moving merchandise, and gaining vendor participation for an in-store event. The retailer has established bottom-line limits for the effective achievement of goals, perhaps the lowest cost price acceptable or the allocation of additional display space.

NEGOTIATING GUIDELINES

Negotiations where both parties come to satisfactory agreements are games of give-and-take. Each party has preset bottom-line limits that are tested during each negotiation. Guidelines to follow when negotiating include:

1. *Create a two-way dialogue.* Present "what if" scenarios to get a sense of where the other party is positioned and the parameters within which they must work. The retailer may state, for example: "We support your product line and foresee continued growth; therefore, we are considering expanding your assortment. If we were to do this, what merchandise items would you recommend adding to the existing assortment? How will the pricing structure be adjusted if we decide to expand your line? Explain what additional support we may expect from you in terms of in-store events, advertising support, additional markdown dollars, etc."

2. *Actively listen* without interrupting, offering advice, comments, or suggestions when the other is speaking. Resist the temptation to immediately say no by accepting what you are hearing and then considering how this request could work and then. . .

3. *Paraphrase and restate* what you are hearing to ensure that you are correctly understanding what the other is saying. For example: "If I understand you correctly, what you're saying is that I will expect to receive delivery in 2 weeks instead of the usual 4-week delivery period."

4. *Justify requests* with facts, benefits, and features. For example: "If you will extend my payment terms an additional 30 days, I will sell through your merchandise and therefore, place more frequent reorders based on an improved cash flow position."

5. *Ask for opinions and ideas.* Follow the "who, what, where, and when" scenario and include "explain, describe, how," and perhaps, "what if." Force the other party to look at a situation from your viewpoint. For example: "Your sales have dropped 20% for the past 2 months, so we're overstocked. What are your recommendations to correct this situation?"

6. *Ask questions and wait,* no matter how long, for the other to respond. Often the one who speaks first loses negotiating position. For example, if the vendor responds to the retailer's question in number 5 by stating "We don't accept returns nor do we contribute markdown dollars," the retailer should then ask "Why? What alternatives can you suggest?" and wait for the vendor to respond. The effective, sometimes lengthy, pause works because silence is a powerful negotiating tool. Alternatives will be suggested by the vendor unless the retailer breaks the silence first.

7. *Recap and summarize* each point to gain agreement and then move forward to the next issue. For instance: "Great! I'm pleased you've agreed to hold a sales training workshop. I'll schedule the training seminar for the first Tuesday of next month." Be clear about what you understand, what will be done, and by whom.

8. *Avoid the outright use of irritator words* such as "unfair" and "unreasonable." Replace these words with statements like "You're surprised that I want you

to take the merchandise back." Acknowledge the feeling you are receiving from the vendor, wait for the person's response, and actively listen.

9. In at least one meeting, the two parties will clash because of their individual personality styles. *Consider your body language and adjust it by* internally repeating "I really like you and we have a common interest." Repeat this over and over. It works, perhaps not the first time, but it does succeed. The "correct" body language will follow naturally.

10. *Do not get emotional and do not allow the other person to get emotional.* It is a business relationship, not a personal one. When confronted with the "intimidator" who makes uncomplimentary remarks about your company, your merchandise, your policies, and so forth, remember that this is a display of insecurity. Focus on the objectives and have preset "bottom-line" limits. Be prepared to walk away if your limits are not compatible with the other party's ultimatums.

NEGOTIATING MANEUVERS

At some point, whether professionally or personally, everyone will encounter the following negotiating tactics. Therefore, it is necessary to be knowledgeable of these negotiating maneuvers, the methods in which to turn them into potential WIN/WIN situations, and the possible repercussions if these negotiating approaches are regularly used.

Negative Attack. The negative attack maneuver begins with one party, commonly referred to as the bully, immediately attempting to intimidate the other by recounting his or her mistakes. For example, on the vendor's arrival, the retailer dispenses with establishing any rapport and states "You really blew it this time! Your merchandise arrived 2 days after we advertised it so we had irate customers. On top of that, my boss was extremely upset. I don't know how much longer I can put up with this treatment!"

The novice negotiator (in this example, the vendor) will be intimidated and perhaps not attempt to ask for a basic reorder or present a new promotion. Instead, the vendor will either attempt to make excuses that will not diffuse the situation or be thrown so totally off guard that he or she consents to unreasonable and unnecessary demands.

Solution: The vendor actively listens and responds not only to the content of what is being said, but to the feelings that are being expressed to reduce the frustration of the other party (the retailer, in this case). For example, the vendor responds by stating, "You're absolutely right to be upset. Our company really dropped the ball and I should have personally made sure your goods were shipped at least a week in advance of your ad date. I really blew it and I'm sorry. I'll make every effort to ensure it doesn't happen again." By actively listening and acknowledging the other's feelings, the retailer no longer can continue ranting about this problem. Ideally, the vendor would have been aware of this situation before the meeting and would have brought up the error first, thus eliminating the retailer's weapon of the negative attack maneuver.

"Good Cop/Bad Cop." Any meeting with two-against-one is already lopsided and potentially intimidating. This negotiating maneuver relies on creating the two-against-one scenario in which one plays the obnoxious, outrageous role and the other acts as the nice, fair, reasonable partner. Typically, the superior will play the "bad cop" role, because this person is rarely involved with regular negotiations between the two parties. For example, the vendor arrives with his boss. The boss states her dissatisfaction with their products' performance and positioning in the store and implies the line will be withdrawn if the retailer does not increase sales and reallocate display space immediately. As the retailer begins

to respond, the vendor's superior constantly challenges the retailer while the vendor appears to offer positive, reinforcing support for the retailer's actions. The "bad cop" will work to emotionally manipulate responses and may include techniques such as misstating your name or your position, or making disparaging remarks to diminish your self-esteem. It is important to be aware that the "good cop/bad cop" roles have been predetermined and previously role played.

Solution: In this example, the retailer prepares thoroughly for each meeting because he or she may not be informed that two persons instead of one will attend. With thorough advance preparation the retailer knows the sales performance and the line's ranking within the store to determine if these are justifiable requests or intimidating bluffs. Being knowledgeable about their business, the retailer can confidently apply the rules of successful negotiating and focus on tuning out the "good cop" to concentrate on turning around the "bad cop" to their viewpoint. Naturally, the manipulated party (the retailer) will gravitate toward the "good cop," so a concentrated effort must be made in blocking out the "good cop" so that rational decisions are made that are mutually beneficial for both parties.

Ultimatum. Ultimatums are final propositions stated as, "You have to do better than that" or "That's the best price I can offer" to threaten inexperienced negotiators into conceding. In reality, this negotiating tactic is used to test the "bottom-line" limits established by the other party and should be acknowledged as the beginning, not the end, of negotiations.

Solution: When presented with ultimatums, active listening, paraphrasing, and asking questions play primary roles. In addition, **mirroring**, the act of adopting another's behavior, becomes another important negotiating tool. Not only is the body language subtly mimicked, (i.e., leaning forward when they lean forward, aligning papers as they do), but oral responses are tailored toward one of three types of nonverbal personality behaviors.

The three types of nonverbal personality behaviors are *visual, auditory,* and *kinesthetic.* The visual personality type will look up when considering thoughts to get a new focus, a better view, so terms such as "I see," and "It looks like" mirrors their personality and establishes greater rapport. The auditory personality is identified by a tilt of the head, looking over one's shoulder, and darting eyes, as this personality type speaks to himself before responding. The appropriate phrases include "It sounds like," and "I hear you," used right after the party has been talking. Finally, the kinesthetic personality type reacts intuitively and is identified by sighing and responding with emotion. "So you feel," and "You're inclined to" are the phrases used.

mirroring—the act of adopting another's behavior for the purposes of negotiations

NEGOTIATING REPERCUSSIONS

When one frequently uses the negative attack, the "good cop/bad cop" routine, or the ultimatum negotiating maneuver, the following repercussions may occur.

Retailers may subtly punish the vendors who use these techniques by:

• Reporting the difficulties of developing the vendor's line to the vendor's superior, which may thwart the vendor's future promotions in the company

• Allocating poor display space on the selling floor

• Letting the vendor wait unreasonably after the scheduled meeting time due to "unforeseen store business"

• Actively pursuing replacement merchandise to eliminate the vendor's line from their merchandise assortment

In turn, vendors may undermine the retailer by:

- Going over the retailer's head to discuss the success of the line yet the lack of support and cooperation being received, which is hurting its sales and profit potential

- Suddenly being out of stock and unable to ship the items ordered

- Developing business with other retailers and minimizing or eliminating its line

- Reducing promotional support such as in-store sales support, providing employee sales incentives, and so forth

Obviously, both the vendor and retailer are hurting their potential for increased sales and profits with these actions, but dealing with difficult and unpleasant negotiators creates situations in which people are not willing to work as hard toward helping someone build business. Business energies become concentrated on partners with whom it is more pleasant to do business and who genuinely want to develop WIN/WIN partnerships. It is more enjoyable to gain a reputation as fair and reasonable so that both "reward" themselves in increased sales, profits, promotability, and industry respect.

Everyone has a personal style of negotiating. Remember that successful negotiating is a professional game of give-and-take. Know your limits and never expect total victory.

WIN/WIN PARTNERSHIPS

Remember that a WIN/WIN partnership means profitable negotiations for the retailer and for the vendor. Successful partnerships share in each other's problems and successes.

Reliable vendors can and will work for you; however, they will do so only as long as it is profitable. So, if you expect to work together, do not make unreasonable demands, unjustifiably cancel orders, deliberately deduct unauthorized discounts, and so on. Reputations stick and are difficult to change. Vendors may knowingly quote higher prices to retailers who have a long "shopping list" of demands.

Expect from vendors what your customers expect from you—WIN/WIN partnerships.

CHAPTER REVIEW

1. List the other four terms by which a vendor may be referred.

2. Fill in the blanks. The retailer may better achieve the five _____ of _____ —having the right _____, at the right _____ , at the right _____, in the right _____, and in the right _____ —by developing and maintaining _____ with vendors.

3. Explain in detail the importance and benefits of the retailer and the vendor working together to mutually anticipate and meet the consumer's needs and wants.

4. Define WIN/WIN partnerships and explain the needs of the retailer and the vendor.

5. What are the three requirements for successful negotiations?

6. Name the four components that comprise meeting preparation.

7. Define and explain the purposes of "bottom-line" limits.

8. List the three negotiating maneuvers, the purposes of each tactic, and the methods to turn them into potential WIN/WIN situations.

9. The act of adopting another's behavior is called _____. Name and describe the three types of nonverbal personality behaviors and the best method for responding to each.

10. Successful negotiating is a professional game of give-and-take. Describe the potential repercussions when one party constantly wins in every negotiation.

CHAPTER TEST

1. What is your opinion of this communication to a vendor?

This letter was sent to vendors by a retailer! Although the content of this communication is valid and establishes the working rules of fairness between the retailer and the vendor, the tone of the message is abrasive and negative and may affect all future retailer/vendor communications. The vendor may well respond to this as an entree to reduce service levels currently provided.

To build a WIN/WIN partnership, rewrite this memo to establish the working rules of fairness.

To: All Vendors

From: A Retailer

1. From this day forth, and until further notice. . .the following policy will be adhered to by *all* vendors. . .*without exception!*

2. *Deviation* will result in dealing with *another resource*. . .

3. We *will not* accept "back orders" or "substitute items". . .they will by *refused* and *returned* "freight collect."

4. There *will not* be exceptions if you expect to maintain an account with this company.

To:

From:

2. Read each statement and then describe the way in which initial rapport is being established.

 a. The vendor begins the meeting by asking the retailer how her vacation was.

 b. The retailer's desk is neat and orderly. The vendor immediately states, "We've had a very good month. Sales increased 15% over sales plan."

 c. The retailer storms into the vendor's showroom and begins recounting the vendor's mistakes.

 d. The vendor is presenting a basic stock fill-in order and his superior interrupts with "Miss, whatever your name is, you don't have a clue about ordering. You're stifling our business!"

3. Describe your initial feelings if you encountered the approaches in problem 2, parts c and d, and how you would respond to each to create potential WIN/WIN situations.

 c. Feelings:

 Response:

 d. Feelings:

 Response:

4. Place an *S* next to each meeting objective that is specific.

_____To gain the vendor's commitment to count the stock the last week of each month

_____To ask for advertising dollars

_____To obtain the vendor's return authorization label for damaged merchandise before approving the vendor's reorder

_____To secure markdown dollars

_____To purchase the vendor's best selling styles at reduced prices for an upcoming promotion

_____To change the ship and cancel dates of purchase order #14254

5. To actively listen to another requires attention and acknowledgment of not only the content but the feelings being stated. Write responses to each of the following statements to demonstrate that you actively listened.

Statement: The vendor says, "That's ridiculous! There is no way I can authorize another return for you!"

Response: "You're feeling frustrated with my request for another return."

a. Statement: "I must have this order canceled. Sales have fallen off and I'm overstocked and must remedy the situation before this week's meeting with my boss."

Response:

b. Statement: "My company was impressed with your newspaper ad and the in-store displays of our products."

Response:

c. Statement: "What? Another change in your order?"

Response:

 d. Statement: "We agreed to monthly reorder dollar amounts as long as my line performed as we planned, yet you want me to cut my reorder by 18% because another line is not performing?"

 Response:

6. Paraphrase and restate the objections listed below. Then determine the appropriate questions that might follow these objections to gain more information.

 a. "This order is too small to justify our supporting a full catalog page."

 b. "You don't have the right customer image for my line."

 c. "We can't guarantee you'll receive these goods in time for this promotion."

 d. "The quantity you expect me to order is too high."

7. For All Seasons is known for its quality European-styled sports apparel and its specialized sports equipment. As the buyer of men's sports apparel, you have just received 144 nylon warm-up suits from the vendor, Hart. Twelve suits have snags in them, four zippers are broken, and all the size medium warm-up suits have a dye-lot problem (the coordinate jacket and pant colors do not match). Hart has been a profitable vendor for the past 6 years, but their quality seems to be slipping. As the buyer of men's sports apparel, prepare for the upcoming meeting with Hart by defining the main objectives

for this meeting, formulating an approach to create a two-way dialogue, determining ways to justify your request with facts, benefits, and features, and preparing questions that will ask for Hart's opinions and ideas to arrive at a WIN/WIN solution.

8. A For All Seasons vendor of athletic shoes, Jumping Jax, has analyzed the sales of each shoe style. It is apparent that the buyer is not ordering properly because every month too many size 7 shoes are on hand and sizes 8 and 9 are constantly out-of-stock. The Jumping Jax vendor prepares for the upcoming meeting with the For All Seasons shoe buyer by outlining the sales call:

Meeting objectives:

Possible concessions:

Two-way dialogue approaches:

Ways to justify request(s):

Potential questions to ask:

9. The accessories buyer authorized Avia, a sports glasses vendor, to write and ship a $1,000 order at cost. The order is received and it totals $1,625 at cost! It is determined that a mathematical error was made by Avia and no one in the accessories buying office double-checked the order when it was internally processed. This order also created an overstock situation in accessories. Create three negotiating scenarios as follows:

a. The buyer is known as a bully.

b. The vendor receives the invoice copy in advance of the meeting and realizes the error.

c. The buyer has a reputation for developing WIN/WIN partnerships.

10. Given the following information, prepare on paper a negotiating role-play scenario between the For All Seasons accessories buyer and Star Pack, the accessories travel pack vendor, to create a WIN/WIN partnership. Determine the best way to establish initial rapport, set the meeting objectives, possible concessions, and then thoroughly outline a dialogue between the buyer and vendor.

<u>For All Seasons Accessories Buyer</u>

Very detail-oriented, likes to get to the point quickly, knows the business.

Is planning a travel pack promotion and needs to purchase four travel bags from the vendor, Star Pack, at, ideally, the purchase prices listed below:

Convertible Day Pack	$42.00
Expedition Pack	$54.00
Camp Trail Pack	$48.00
Mountaineer Pack	$56.00

The retailer is willing to place the order with Star Pack if the costs do not exceed $5.00 more per style than planned.

Star Pack normally takes 4 weeks from receipt of an order to deliver merchandise and the retailer needs delivery within 3 weeks.

Star Pack has allocated $1,500 for advertising support for the season. To date, the retailer has used $500 and for this promotion needs $1,500 to include the travel packs in the store catalog. For All Seasons has increased its mailing quantity for this catalog.

The vendor needs a basic stock reorder passed in the amount of $5,000 cost/$10,500 retail to maintain a steady flow of merchandise and to achieve this month's sales quota. Star Pack is pleased with the sales growth and is rapidly gaining market exposure and dominance over the competition. They have created a national ad campaign and would like to include For All Seasons' name in their ads because of their reputation for quality.

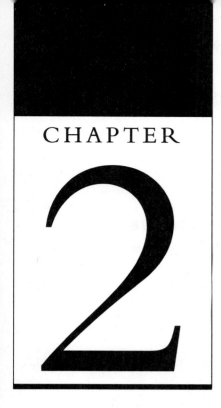

Terms of Sale

It is important to have a thorough knowledge and understanding of terms of sale when:

- Selecting vendors

- Purchasing from vendors

- Evaluating existing vendors

- Establishing retail prices

Terms of sale specify the agreements negotiated between suppliers and purchasers regarding transportation arrangements and shipping charges, payment terms and dating agreements, and merchandise discounts. These terms can contribute to lowering the cost of goods being purchased. Therefore, terms of sale should be negotiated in advance of committing to any purchasing contract to provide the retailer with yet another opportunity to enhance profit margins.

Terms may vary from industry to industry, but the mathematical fundamentals and definitions are applicable to all businesses. This chapter covers the most commonly used terms of sale.

terms of sale–terms specifying agreements negotiated between suppliers and purchasers

SHIPPING TERMS

F.O.B.–Free on Board or Freight on Board; the abbreviated transportation term that is always followed by a point of destination and specifies who pays transportation charges and assumes risk of loss while goods are in transit

F.O.B. Store/Destination–agreement whereby vendor assumes all risk of loss and pays all transportation charges until goods arrive at store or designated location

F.O.B. Store/Destination, Freight Collect and Allowed–agreement whereby vendor assumes risk of loss until goods arrive at store or specified location, and purchaser, on receipt of goods, pays shipping charges, which are deducted from the vendor's invoice when payment is made

F.O.B. Origin/Factory–agreement whereby purchaser assumes risk of loss and pays all shipping charges from the time the goods leave the designated origin

Shipping terms, which must be factored into the cost of goods, include two key elements that can immediately affect profit potential:

1. Who assumes the risk of loss while goods are in transit?

2. Who pays the transportation charges?

Shipping terms are expressed as **F.O.B.** (Free on Board or Freight on Board) followed by a point of destination (store/destination, origin/factory). The place that is designated specifies who pays transportation charges and assumes risk of loss of the merchandise being shipped to the purchaser. The most frequently used shipping terms are listed as follows in descending order of benefit for the retailer.

- **F.O.B. Store/Destination** Until the goods arrive at the store or designated location, the vendor assumes all risk of loss and pays all transportation charges.

- **F.O.B. Store/Destination, Freight Collect and Allowed** The vendor assumes risk of loss until the goods arrive at the store or specified location. The purchaser, on receipt, pays the shipping charges and then deducts them from the invoice, when payment is made.

- **F.O.B. Origin/Factory** The purchaser assumes risk of loss and pays all shipping charges from the time the goods leave the designated origin/factory.

PAYMENT ARRANGEMENTS

cash discount–stated discount percentage deductible from the billed cost on invoice if payment is made on or before a designated payment period

dating agreement–agreement specifying time period for payment of an invoice to increase selling period before payment is due

Retailers can further affect the "bottom line" when terms are extended by vendors in two ways:

1. Securing **cash discounts** for early payment to decrease the total cost of goods.

2. Obtaining **dating agreements** to increase the selling period before payment is due.

The retailer will therefore ask the suppliers: "What are your payment terms and dating arrangements?"

PAYMENT ARRANGEMENT COMPONENTS

The terms involved in the majority of payment arrangements offered by vendors include three components:

1. A stated cash discount percentage if payment is made on or before a designated payment period

2. The number of days allowed, from the date of an invoice, to pay the invoice with the offered cash discount

3. The total number of days, from the date of an invoice, to pay the invoice in full

Note: Unless otherwise agreed on, all payment terms begin from the date of an invoice.

CASH DISCOUNTS

It is important to explain cash discounts within the payment arrangements segment because they are an integral part of payment formulas. Other discounts will be detailed later in this chapter. Cash discounts are rewards for immediate payment or for payment in advance of a specified time period, thus enabling vendors to receive their money more quickly. This is particularly important to the under-capitalized vendor.

ORDINARY TERMS AND DATING

Payment arrangements are referred to as "ordinary" when they are commonly used. An example of an ordinary term and dating arrangement is 2/10/N30, frequently used in the home furnishings industry.

The term, written as 2/10/N30, represents:

2 This number states the offered cash discount percentage that may be deducted from the billed cost on an invoice.

10 The second number states the number of days, from the date of an invoice, the purchaser has to take advantage of the offered cash discount.

N30 *N* stands for Net. The number following the *N* indicates the number of days, from the date of an invoice, the purchaser has to pay an invoice in full. The purchaser is not eligible to deduct the cash discount after the specified cash discount period.

EXAMPLE:

The term *3/10/N30* represents:

3% offered cash discount percentage.

10 days from the date of an invoice to pay and deduct the offered 3% cash discount.

30 days from the date of an invoice final payment must be made. If an invoice is not paid within the 10-day discount period, the **billed cost** is payable within the 20-day period following the discount deadline (10 days + 20 days = Net 30 days).

PAYMENT FORMULAS

It is important to stop at this point and review the easiest methods in calculating payment arrangements.

EXAMPLE:

Terms 2/10/N30 Invoice Date March 1

WRITE the Date of Invoice	March 1
ADD the number of Discount Days	+ 10 days
EQUALS Discount Payment Deadline	= March 11

| ADD the remaining Net Payment Days | + 20 days |
| EQUALS Final Net Payment Date | = March 31 |

EXAMPLE:

Terms 3/10/N30 Invoice Date March 5

WRITE the Date of Invoice	March 5
ADD the number of Discount Days	+ 10 days
EQUALS Discount Payment Deadline	= March 15

| ADD the remaining Net Payment Days | + 20 days |
| EQUALS Final Net Payment Date | = March 35!! |

March does not have 35 days so:	
DEDUCT the number of days in March	– 31 days
EQUALS Final Net Payment Date	= April 4

EXAMPLE:

This "real world" example illustrates the steps the retailer takes when purchasing 100 golf tee sets, @ $5.00 each.

Terms 2/10/N30 Invoice Date May 1

1. What is the billed cost of this order? $500.00

 100 pieces × $5.00 = $500.00

2. Calculate the amount paid on May 8 $490.00

 a. May 1 (date of invoice)

 + 10 days (discount period)

 = May 11 (2% deadline)

 b. $500.00 × .02 (Cash discount) = $10.00

 c. $500.00 − $10.00 = $490.00

3. Compute the amount paid on May 25. $500.00

 a. The 2% cash discount deadline was May 11.

 b. May 11 (discount deadline)

 + 20 days (remaining net payment days)

 = May 31 (final net payment date)

 c. May 12–May 31 the billed cost must be paid.

SELF QUIZ

1. Explain in detail what the term 3/10/N30 represents.

2. The For All Seasons accessory buyer commits to a $200.00 order. The negotiated payment term is 2/10/N30. October 2 is the invoice date.

 a. What is the offered cash discount percentage?

 b. On what date does the cash discount period end?

 c. What is the amount paid on October 10?

 d. What is the final date of this invoice?

 e. How many days does the buyer have to pay the invoice without the cash discount?

f. What is the amount paid on October 31?

3. A For All Seasons sports equipment vendor has been authorized by the store's management to ship an order consisting of tennis racquets, tennis balls, volley balls, and sports bags in preparation for the store's Summer Sports Extravaganza Sale scheduled for June 1. The cost of the order totals $25,000.00, the invoice date is May 10, and the negotiated payment term is 3/10/N30.

 a. What is the offered cash discount percentage?

 b. When is the discount payment deadline?

 c. What is the final payment date of this invoice?

 d. If the invoice is paid on May 21, what would be the total amount sent to the vendor?

 e. If the invoice is paid on June 10, what would be the total amount sent to the vendor?

E.O.M. (END-OF-MONTH) TERMS AND DATING

E.O.M. payment terms—the abbreviation E.O.M. stands for end-of-month, in which an invoice is dated, when the cash discount period and credit terms begin

E.O.M. payment terms are a convenience and benefit for the retailer. Payments are made at one time, to each vendor, each month, thereby reducing accounting difficulties and costs. If the merchandise delivery dates are carefully planned, the retailer will also gain additional selling time before payment is due. We will use

8/10 E.O.M. terms to demonstrate the convenience and benefit of these terms, which are common to the ready-to-wear apparel industry:

8 This number states the offered cash discount percentage that may be deducted from the billed cost of an invoice.

10 The second number states the number of days, from the start of the payment terms, to take advantage of the cash discount.

E.O.M. The abbreviation E.O.M. stands for end-of-month, in which an invoice is dated, when the cash discount period and credit terms begin.

EXAMPLE:

8/10/E.O.M. terms, with a May 15 invoice date, represent:

8% offered cash discount

10 days from the end of May to take the discount

E.O.M. from the end-of-month of the invoice date, May 15, the cash discount and net credit terms begin. This invoice must be paid by June 10 to take the 8% cash discount (10 days after the end of the month of the invoice date). Although the number 30 does not follow the E.O.M. notation, it is commonly understood that the net credit terms remain 30 days, unless otherwise stated. The net amount of this invoice is payable from June 11–June 30 (June 10 + 20 days = June 30).

bonus E.O.M. 26th-31st rule—for all invoices dated the 26th-31st of month, payment terms begin the end of the following month

The Bonus E.O.M. 26th–31st Rule. The **bonus E.O.M. 26th–31st rule** states that, with all invoices dated the 26th– 31st of any month, terms begin the end of the *following month*. This rule was established to allow a reasonable selling period before payment is due. When retailers time deliveries between these dates, they gain additional selling days before payment is due. For example, goods are received and invoiced on October 26 with 8/10 E.O.M. terms:

October	26 – 31	+ 6 days	(before terms begin)
November	1 – 30	+ 30 days	(in the month of November)
December	10	+ 10 days	(discount deadline, 10 days after end of the following month)
30 Extra Selling Days		= 46 days	(30 days without the cash discount! Bonus rule: 46 less 16 days)

If payment is made without the cash discount, the retailer gains 50 days. (Final net payment date is December 30.) (46 days + 20 net days = 66 days); 50 days without Bonus Rule (66 days − 16 days).

Without the Bonus E.O.M. Rule, payment would be due within 16 days:

October	26 – 31	+ 6 days	(before terms begin)
November	10	+ 10 days	(10 days from the end of October)
		= 16 days	

EXAMPLE:

8/10/E.O.M. terms, with a January 27 invoice date, represent:

8% offered cash discount

10 days from the end of the *following month*, February, to take the 8% cash discount. This invoice must be paid by March 10 to deduct the cash discount.

E.O.M. terms from the end of the following month, February, the cash discount and net credit terms begin. The 8% cash discount may be taken if the invoice is paid by March 10. The billed cost is due from March 11–March 30.

SELF QUIZ

1. Explain the difference between E.O.M. terms and the bonus E.O.M. 26th–31st rule.

2. A ski apparel order was received by For All Seasons with payment terms of 8/10 E.O.M. The billed cost of the invoice is $600.00. Indicate in the spaces below for each invoice date:

 a. The final date the cash discount may be taken.

 b. The number of days to pay the invoice with the discount.

 c. The last date to pay the invoice without the discount.

 d. The number of selling days before final payment is due without the discount.

Invoice Date:	January 18	January 26
Answers:	a.	a.
	b.	b.
	c.	c.
	d.	d.

3. The For All Seasons sports apparel buyer places a reorder of down ski jackets. The negotiated payment terms are 8/10 E.O.M., the billed cost of the invoice is $5,000.00, and the invoice date is January 17.

 a. The invoice is scheduled to be paid on February 10. What amount will be sent to the vendor?

b. For All Seasons misses the originally scheduled February 10 payment date and issues a check dated February 20. What amount was the check for this invoice?

4. The down ski jacket order was delayed and finally shipped and invoiced on January 28. When must the invoice be paid to take advantage of the discount deadline?

EXTRA TERMS AND DATING

Occasionally, retailers are able to secure additional time to pay for purchases, without losing the offered cash discounts. Many suppliers will agree to these terms with their high volume accounts or long-term customers who have built strong working partnerships.

If the standard terms are 2/10/N30 and the supplier agrees to extend the cash discount terms by 60 days, the term is changed to 2/10–60X. The *X* represents extra...extra days to pay. With these terms, the retailer can, from the date of the invoice:

- Deduct 2% off the billed cost of an invoice within a 70-day period. 10 days + 60 extra days = 70 days to sell the goods, with the cash discount, before payment is due!

Or

- Pay the billed cost of an invoice, 20 days after the 70-day cash discount period ends. 70 days + 20 days = 90 days before the final net invoice amount is due. The standard 20-day net payment period follows, although it is not stated.

"SEASONAL," "ADVANCED," OR "POST" TERMS AND DATING

"Seasonal," "Advanced," or "Post" terms and dating—payment made some time after receipt of shipment

"Seasonal," "advanced," or "post" terms and dating means that payment terms will become effective some time after a shipment is received. These terms are to entice buyers to order in advance of a selling season to enable the manufacturers to preplan their production schedules.

In other instances, suppliers extend these terms only if the buyer will accept early delivery, in advance of the selling season, to release their warehouse space for incoming merchandise.

EXAMPLE:

Order Dates:	4/1 to 8/23
Ship Dates:	5/24 to 8/30
Terms:	2% September 10

Note: Retailers will receive 2%/120 dating on orders that ship between 4/1 and 6/10. Any other orders placed during this period to ship within the specified dates will receive 2%/60.

Whether merchandise is accepted early or during the selling season, the benefit is that payment is postponed, providing the opportunity to **"sell-through"** the merchandise before the invoice is payable. In other words, the merchandise received is sold, which in turn generates the monies for payment of the invoice.

sell-through—act of selling invoiced merchandise to produce the necessary monies for invoice payment prior or equal to final payment date

The notation added to the standard quoted payment and dating term is "as of _____." An example is: Invoice dated and merchandise is received January 1, with terms quoted as 2/10/N30, "as of March 1."

The retailer has 70 days to pay and deduct the offered 2% cash discount with the terms quoted above!

January	+ 31 days
February	+ 28 days
March (March 1 + 10 days)	+ 11 days (to deduct 2%)
70 days with the Cash Discount!	= 70 days

Or

The retailer makes final payment on March 31 and has 90 selling days!

March	11	(final payment date)
	+ 20	(net payment days)
March	31	(last payment date)

NET TERMS AND DATING

net terms and dating—payment in full is due within the specified net period, from the date of invoice, which is understood to be 30 days unless otherwise stated

With **net terms and dating** no cash discounts are available. Payment in full is due within the specified net period, from the date of invoice, which is understood to be 30 days, unless otherwise stated. Occasionally the retailer can negotiate additional dating terms such as net 60 days, gaining 30 extra selling days before final payment is due.

C.O.D. (CASH ON DELIVERY) TERMS AND DATING

C.O.D. terms and dating—cash on delivery; payment due at time of delivery or shipment is immediately returned to supplier

C.O.D. terms and dating are commonly used for retailers lacking credit histories or with established poor credit histories. In certain cases, wholesalers will work exclusively on a cash basis, maintaining that their low prices do not permit any discounts.

R.O.G. (RECEIPT OF GOODS) TERMS AND DATING

R.O.G. terms and dating—receipt of goods; payment begins on date retailer receives shipment from vendor, rather than the date on invoice

R.O.G. terms and dating are negotiated when suppliers are unable to state, in advance, when delivery will be made. For example, a shipment originates in California with a final destination of New York. Frequently, the shipment will arrive just before or after the stated cash discount period expires. Because the retailer does not want the payment terms to begin before the merchandise is received, the term R.O.G. is added to the original terms. Terms may be noted as: 2/10/N30 R.O.G. with the payment cycle beginning on the date of receipt, not on the date of an invoice.

CONSIGNMENT OR MEMO (MEMORANDUM) TERMS

consignment terms—allows retailer to test new products or resources without paying for the merchandise until it sells; vendor retains ownership of the merchandise until it is sold or returned by the purchaser

Some retailers often "borrow" merchandise from suppliers. Securing **consignment terms** or **memorandum terms** enables the retailer to "test" new products and new resources without paying for the merchandise until it sells. Consignment terms are the most advantageous because the supplier retains title and assumes all risk of loss. With memorandum terms, the retailer takes title at the point of origin and assumes all risk of loss.

Retailers should negotiate the following when agreeing to these terms:

1. The vendor will pay all transportation charges.

2. The vendor will accept all remaining unsold merchandise.

3. The retailer will pay the vendor only for the goods sold.

4. The billed cost, payment terms, and dating arrangements will coincide with the current market.

THE PAYMENT ARRANGEMENT FORMULAS CHART AND PAYMENT TERMS AND DATING SCHEDULE

To make the retailer's job of calculating payment arrangements easier, the various formulas necessary to the task are illustrated in Figures 2.1 and 2.2. The Payment Arrangement Formulas Chart, Figure 2.1, provides a step-by-step format of each payment arrangement. This allows the retailer to select the applicable term, insert an invoice date, and follow the outlined format to compute the final discount date and the last payment date. The Payment Terms and Dating Schedule illustrated in Figure 2.2 (page 28) aids retailers in managing and facilitating payment of numerous invoices with varied terms and dating.

SELF QUIZ

Use the provided information to answer the following questions.

Invoice Date:	*August 14*
Billed Invoice Cost:	*$287.50*

1. Terms are 2/10/N30.

 a. What is the offered cash discount percentage?

 b. What is the dollar amount paid to the supplier on August 23?

 c. What is the last payment date without the cash discount?

2. Terms are 8/10 E.O.M.

 a. What is the last date to pay and deduct the cash discount?

b. What is the dollar amount of the cash discount?

Terms: Net 30			Invoice Date: March 25
	March	25	Invoice date
		+ 30 days	Number days to pay
		= 55 days	Subtotal
		− 31 days	Number days in March
	April	24	Last Payment Date
Terms: 2/10/N30			Invoice Date: April 10
	April	10	Invoice Date
		+ 10 days	Number discount days
	April	20	Final Discount Date
		+ 20 days	Net payment days
		= 40 days	Subtotal
		− 30 days	Number days in April
	May	10	Last Payment Date
Terms: 8/10 E.O.M.			Invoice Date: July 6
	July	31	Last date of invoice month
		+ 10 days	Number discount days
	August	10	Final Discount Date
		+ 20 days	Net payment days
	August	30	Last Payment Date
Terms: 2/10−60X			Invoice Date: June 10
	June	10	Invoice date
		+ 70 days	Number discount days
		= 80 days	Subtotal
		− 30 days	Number days in June
		= 50 days	Subtotal
		− 31 days	Number days in July
	August	19	Final Discount Date
		+ 20 days	Net Payment Days
		= 39 days	
		− 31 days	Number days in August
	Sept.	8	Last Payment Date
Terms: 2/10/N30 R.O.G.			Invoice Date: April 1 / Receipt Date: April 8
	April	8	Receipt date
		+ 10 days	Number discount days
	April	18	Final Discount Date
		+ 20 days	Net payment days
		= 38 days	Subtotal
		− 30 days	Number days in April
	May	8	Final Payment Date
Terms: 2/10/N30 "as of May 1st"			Invoice Date: March 1
	May	1	"As of" date, terms begin
		+ 10 days	Number discount days
	May	11	Final Discount Date
		+ 20 days	Net payment days
	May	31	Final Payment Date

Figure 2.1. Payment Arrangement Formulas Chart

Terms & Dating	Invoice Date	Last Disc. Date	Net Amount Due If Paid After Disc. Deadline	Past Due Date & . . .
NET 30 (Regular dating)	3/25	N/A	3/25–4/24	4/25
2/10/N30 (Cash Discount dating)	4/10	4/20	4/21–5/10	5/11
8/10 E.O.M. (End–of–Month dating)	7/6	8/10	8/11–8/30	8/31
2/10 – 60X (Extra dating)	6/10	8/19	8/20–9/8	9/9
2/10/N30 R.O.G. (Receipt of Goods dating)	4/1 Rec'd 4/8	4/18	4/19–5/8	5/9
2/10/N30 as of 1st (Seasonal, Advanced, Post dating)	3/1	5/11	5/12–5/31	6/1

The above schedule has been calculated on the number of days in a calendar month.

Figure 2.2. Payment Terms and Dating Schedule

 c. What is the dollar amount that was paid on September 12?

3. Terms are Net 60.

 a. What is the offered cash discount?

 b. What is the final payment date?

 c. What is the dollar amount to be realized?

4. Terms are 2/10/N30 "As of November 1."

 a. What is the last date to pay and deduct the cash discount?

 b. What is the last payment date without the cash discount?

 c. What is the dollar amount paid to the supplier on November 8?

5. Terms are 2/10–60X.

 a. What is the final date on which the cash discount may be taken?

 b. What is the last payment date without the cash discount?

 c. What is the number of available selling days before final payment is due?

DISCOUNTS

discount–reduction from original price of goods

Discounts are reductions from the initial price of goods that are deducted before cash discounts are calculated. Retailers who can take advantage of the different discount opportunities in their negotiations with vendors increase their opportunities for improved profit performance. The principle discounts that have importance are:

- Cash (previously discussed)
- Trade
- Quantity
- Seasonal
- Promotional

TRADE DISCOUNTS

Most suppliers quote their **gross wholesale prices** before negotiating cash, quantity, seasonal, or promotional discounts, but some suppliers do not quote gross wholesale prices. Instead, they quote their **list prices**, those prices "listed" in their catalogues or on their product offering sheets. Then a percentage or a series of percentage discounts are offered to arrive at the billed cost price. This is the procedure for **trade discounts**.

Trade discounts are commonly used by suppliers who purchase raw materials, such as silk, cotton, and wool, used in the production of their products. The price of their raw materials may fluctuate, so list prices are established as the base for deductions to arrive at billed cost prices.

It is important to first determine if the supplier is quoting list prices at cost or retail. Although the quoted list price for soft lines industries (ready-to-wear and accessories) is usually the suggested retail price, the hard lines industries (consumables, furniture, hardware), usually quote list prices at cost. For example, many full service health and beauty aid suppliers work with list prices at cost, whereas most sunglasses suppliers work with list prices at retail. This is *essential* knowledge when purchasing goods and setting their retail prices!

As illustrated in Figure 2.3, some suppliers are straightforward in communicating the basis of their pricing structure.

The format in calculating trade discounts is as follows:

1. The list prices are established by the supplier.

2. A single percentage discount is offered, or more frequently, a series of percentage discounts are offered, to arrive at the billed cost price.

3. Each discount is deducted separately.

YOUR
TRADE DISCOUNT
FROM CATALOGUE LIST PRICES

50%

The list prices are intended to act as a pricing guide only.
Due to constant fluctuation of prices, we cannot guarantee catalogue pricing. For the latest price please call.
Prices are subject to change without notice. We cannot be responsible for printing errors.

QUANTITY DISCOUNT PRICING IS AVAILABLE.
PLEASE CALL FOR INFORMATION.
To conceal your costing, remove this page.

MID*LAKES, INC.
Distributors of Sports Equipment

Figure 2.3. Trade Discount Sheet

EXAMPLE:

Quoted List Price	less	First Trade Discount	less	Second Trade Discount
$100.00		35% (.35)		10% (.10)

	Quoted List Price:		$100.00	
−	First Trade Discount:	−	35.00	($100.00 x .35)
	Subtotal:	=	$ 65.00	
−	Second Trade Discount:	−	6.50	($65.00 x .10)
	BILLED COST:		$ 58.50	

on-percentage—short-cut method of calculating successive or chain discounts, such as trade discounts, through the use if the product of complements

Something to Consider: On-Percentage Short-Cut Method for Calculating Trade Discounts

Trade discounts may be calculated using a "short-cut" method known as **on-percentage.** When vendors offer trade discounts that are a series of percentage discounts, they cannot be added together for one percentage calculation. Using the on-percentage method facilitates the calculation of offered successive discounts.

Note: Refer to Appendix 2, "Fractions, Decimals, and Percents," for further information about on-percentage.

EXAMPLE:

A vendor offers a retailer a trade discount of 25, 15 on an $8,000 order. Find the billed cost of the order.

First, find the complement of each offered discount percentage by subtracting the percent from 100.

100%		100%
− 25%		− 15%
75%		85%

Second, multiply the complements to find the product of complements.

$$.75 \times .85 = .6375 = .64$$

Third and finally, multiply the order amount by the product of complements or on-percentage.

$$\$8,000.00 \times .64 = \$5,120.00$$

The billed cost of this order is $5,120.00.

EXAMPLE:

The quoted list price of downhill skis is $200.00, less 30%, less 10%. Find the billed cost price.

Quoted List Price:	$ 200.00	
less:	− 60.00	($200.00 x .30)
Subtotal:	= $ 140.00	
less:	− 14.00	($140.00 x .10)
BILLED COST:	= $ 126.00	

Rule: Discounts cannot be added together and deducted at once, resulting in a lower cost for the retailer but not the supplier. For example, you are offered a trade discount of 35% and 10%, a supposed total discount of 45%. Using that percentage discount, then the discount in dollars would be $45.00 ($100.00 x .45), leaving a billed cost of $55.00 versus $58.50. This is not allowed by vendors!

SELF QUIZ

1. Place an X under either the True or False column for each of the following statements.

	True	**False**

a. Trade discounts are commonly used by suppliers who purchase raw materials used in the production of their products.

b. When discussing prices with a supplier, one may assume that he is quoting gross wholesale prices.

c. When a series of trade discounts are offered, they are added together and deducted at one time.

d. The formula for calculating trade discounts is:

	Quoted List Price
Less:	First Trade Discount
	Subtotal
	Subtotal
Less:	Second Trade Discount
	BILLED COST

2. A vendor quotes the For All Seasons' accessories buyer a list price of $5.00, less 10%, less 4%.

a. What is the first question the accessories buyer would ask the vendor when quoted a list price and why?

b. Calculate the first discount, showing your computations.

c. Compute the second discount.

d. What is the billed cost price?

e. Explain why the billed cost price is not $4.30.

3. A vendor's tennis racquet's list price is $69.99, less 35%, less 10%. Find the billed cost.

QUANTITY DISCOUNTS

quantity discount—discount to retailer based on size of individual order or total sum of purchases over a specific period

Quantity discounts encourage retailers to purchase larger quantities than they normally would. The two primary types of quantity discounts are:

1. Based on the size of an individual order. The more one purchases, the lower the cost.

2. Based on the total sum of purchases over a specific time period, such as a month, a season, or a year. This is referred to as a "customer reward" discount.

EXAMPLE:

The following chart illustrates that a 2.5% quantity discount is available on orders of 50 dozen or more.

0%		2.5% Qty. Discount* 50 Dozen Minimum	
Dozen	Unit	Dozen	Unit
$29.07	$2.42	$28.35	$2.36

*Quantity discount is available only on full case orders (6 dozen per case).

Many suppliers use quantity discounts for:

- Promotional tools

- Bargaining devices to secure new business

- Clearing out their slow sellers in the warehouse

- Increasing end-of-month shipments to meet sales quotas

EXAMPLE:

The gross wholesale price for swimming caps is $1.00. This supplier also offers quantity discounts as follows:

1−499	pieces	@ $1.00
500−999	pieces	@ $.90
1000+	pieces	@ $.70

The retailer purchases 515 swimming caps.

1. What is the cost per cap? @ $.90
 (500−999 pieces @ $.90)

2. What is the total quantity price? $463.50
 (515 pieces x $.90 = $463.50)

EXAMPLE:

A vendor offers a 2% quantity discount percentage if the retailer places a minimum order of 12 dozen note card boxes.

The retailer orders 12 dozen and the total billed cost is $720.00.

1. What is the quantity discount amount? $ 14.40
 ($720.00 x .02 = $14.40)

2. What is the net wholesale cost of this order? $705.60
 ($720.00 - $14.40 = $705.60)

SELF QUIZ

1. A supplier's wholesale price list for sunblock SPF 8 reads:

1−49	pieces	@ $2.00
50−99	pieces	@ $1.50
100−249	pieces	@ $1.00

The retailer purchases 6 dozen. Find:

a. The cost price per piece.

b. The total quantity price.

2. For All Seasons decides to order 60 pairs of Carolina sunglasses and 120 pairs of Tasha sunglasses. The vendor's price list reads:

Carolina	Tasha
1–48 pairs @ $24.00	1–48 pairs @ $32.00
49–100 pairs @ $18.00	49–100 pairs @ $26.00

a. What is the cost per pair of Carolina sunglasses and Tasha sunglasses?

b. What is the total quantity price for each sunglasses style?

c. What is the total cost of sunglasses?

3. A tennis equipment vendor will discount each order as follows:

$ 500–$1,500 1.0% discount

$1,501–$3,000 1.5% discount

$3,001–$5,000 2.0% discount

For All Seasons places an order totaling $2,852.50.

a. Calculate the discount dollar amount.

b. Compute the cost of the tennis equipment order.

Rule: Quantity discounts are calculated before trade discounts.

EXAMPLE:

A supplier's price list reads:

$$1-49 \text{ pieces} \quad @ \$6.25$$
$$50-99 \text{ pieces} \quad @ \$5.75$$
$$100-249 \text{ pieces} \quad @ \$5.00$$

with trade discounts of 25, 15. The retailer purchases 14 pieces.

1. The initial total quantity price: (14 pieces x $6.25 = $87.50)	$87.50
2. The total billed cost after trade discounts are deducted:	$55.78

Total Quantity Price:	$87.50
Less First Trade Discount:	− 21.88
($87.50 x .25 = $21.875, rounded up)	
Subtotal:	$65.62
Less Second Trade Discount:	− 9.84
($65.62 x .15 = $9.843, rounded down)	
TOTAL BILLED COST:	$55.78

SELF QUIZ

1. The health and beauty aids supplier offers a 2% quantity discount for orders totaling $2,500.00 or more and trade discounts of 5, 3. An order for $3,215.00 is placed.

 a. Calculate the quantity discount dollar amount.

 b. Compute the billed cost of this order.

2. Mountain snack packs pricing is as follows:

 1–4 dozen @ $1.65 each

 5–12 dozen @ $1.00 each

 Trade discounts 6, 2

An order is placed for 6 dozen snack packs. Calculate the billed cost of this order and show your computations.

SEASONAL DISCOUNTS

seasonal discount– discount offered to retailer who places orders prior to normal buying season, allowing manufacturer to preplan production schedules

Seasonal discounts are often offered to retailers who place orders before the normal buying season. These "early bird" discounts are beneficial to the retailer if early delivery is not required or if seasonal terms and dating agreements are secured, as discussed earlier in this chapter. The retailer gains a higher profit potential; the supplier gains in production scheduling planning.

PROMOTIONAL DISCOUNTS

promotional discount– discount offered to retailer to help promote merchandise

Promotional discounts help promote merchandise and are used for:

- Advertising and sales promotion

- Selling incentives

P.O.P. display– point of purchase; display used for new product introduction and as impulse sale generator

- Positioning of **P.O.P. (point of purchase) displays** for increased visibility

- Securing designated display space

Although promotional discount policies may vary from industry to industry, 3% of net cost purchases is standard. It is important to ask each supplier what monies are available to help promote their merchandise because some publish their policies, whereas others keep it to themselves, unless asked!

Specific examples of promotional discount uses include:

- *Print advertising:* newspaper ads, flyers, bill inserts, coupon books, catalogues

- *Sales promotion:* raffles, sweepstakes, premium offerings (gift with purchase or purchase with purchase)

- *Selling incentives:* sales quotas contests, "push" (incentive) monies, award banquets

- *Visual materials:* temporary or permanent signage and/or display fixtures, clocks, logos

Quantity, seasonal, and promotional discounts can improve the retailer's profit performance if the additional stock that must be purchased will perform profitably and not build unnecessary stock levels. Listed below are important considerations a buyer should evaluate when deciding to take advantage of these discounts:

1. Cash flow

2. Past sales history

3. Markdown records

4. Potential sales volume

5. Strength of the offering

6. Availability of space

SEQUENCE OF TERMS OF SALE

It is important to include the sequence of negotiating terms of sale to ensure the retailer purchases with the most advantageous terms.

First, the retailer must determine if the vendor is quoting prices in cost or retail dollars so that purchasing and pricing errors are avoided.

Second, the retailer asks what quantity, trade, and seasonal discounts are available and determines if they are advantageous or inventory builders.

Third, the retailer calculates the billed cost of the order, the invoice amount after trade, quantity, and seasonal discounts have been deducted, but before cash discounts are subtracted.

Fourth, the retailer secures the best possible transportation terms. If the retailer must pay the shipping charges, the retailer specifies the freight carrier and details the transportation route. If possible, the transportation charges are added to the billed cost of the invoice before shipment. Regardless, the retailer is aware that transportation charges must be included in the cost of merchandise when pricing goods.

Fifth and finally, the best possible payment terms and dating arrangements are negotiated. If the retailer takes advantage of cash discounts, the retailer understands that they are computed on the billed cost of the invoice before transportation charges. If the retailer decides to pay the invoice on the final payment date, thus allowing the maximum sell-through period, the net cost of the invoice is remitted to the supplier, without the cash discount percentage deduction.

CHAPTER REVIEW

1. What is the most advantageous shipping term for retailers to secure? Explain your answer.

2. What negotiating opportunities are available for retailers when purchasing from vendors and why?

3. Cash discounts should be used all the time. Explain why this statement is or is not true.

4. List and describe the three components that comprise ordinary terms and dating.

5. What are the advantages of paying per date of receipt of a shipment versus date of an invoice?

6. Explain the importance of timing deliveries of merchandise.

7. Why is it important to forward all invoices to accounting as soon as possible?

8. What benefits do retailers and vendors gain from increasing their knowledge and understanding of terms of sale?

9. How may general economic trends influence the negotiation of terms?

10. If a retailer does not appear knowledgeable about terms of sale, what might occur when purchasing goods from a supplier?

11. Explain the importance of determining whether a vendor is quoting cost or retail list prices. What impact might this have if the retailer is unsure which price has been quoted?

12. What are the advantages of specifying freight carriers and detailing transportation routes when the retailer is responsible for transportation charges?

13. Plain white cuffed crew socks are a proven best seller. The retailer regularly orders 144 pairs each week. If the retailer purchases 576 pairs, the item cost will be reduced by $.25. Under what circumstances would the retailer take this offered quantity discount?

14. You have been hired by For All Seasons, located in the northwest, as its workout wear buyer. The general merchandise manager has approved your request to add another workout wear line to your merchandise assortment. After thoroughly shopping the workout wear market, you have narrowed your choice to two vendors. Listed below are the terms of sale for each vendor. Which vendor would you select to work with and why?

Terms of Sale	Vendor #1	Vendor #2
Shipping Terms	F.O.B. Factory	F.O.B. Factory
Point of Origin	New York City	Los Angeles
Payment Terms	8/10/E.O.M.	Net 30 R.O.G.
Wholesale Cost	@ $15.75	@ $15.70
Discounts	Quantity	Promotional
	•"Customer reward"	•Advertising
		•Training
		•Incentives

1. The billed cost of an invoice is $8,755.50. The invoice date is July 13 with payment terms of 2/10 E.O.M. The invoice is paid on July 26. What amount was remitted to the vendor?

2. An invoice is dated on April 6 with 2/10/N30 terms. It is paid on April 16. What is the discount taken with these terms?

3. Given the following information, answer the questions below.

 Invoice Date April 8

 Payment Terms 3/10/N30

 Billed Cost $6,722.25

 a. What is the offered discount percentage?

 b. On what date does the cash discount period end?

 c. How many selling days does the retailer have before final payment is due without the cash discount?

 d. What is the dollar discount amount?

4. Indicate in the spaces below the final dates on which a cash discount may be taken for invoices dated May 15.

Terms are:

2/10/N30 _____

8/10 E.O.M. _____

Net 30 _____

2/10–60X _____

2/10/N30 R.O.G. _____

5. Complete the Payment Terms and Dating Schedule

Terms & Dating	Invoice Date	Last Disc. Date	Net Amount Due	Past Due Date
N30	4/18			
2/10/N30	8/16			
8/10 E.O.M.	2/28			
2/10–50X	5/1			
2/10 E.O.M.	3/1			

6. Vendors at the national July gift show are offering 5% discounts on all Christmas orders placed by August 1. Retailers must also commit to accepting delivery in October. The offered payment terms are N30, "as of December 1." For All Seasons places a $3,000.00 order on July 15 with a specified start ship date of October 25 and a cancellation date of November 25.

a. Identify and explain this form of terms and dating.

b. Calculate the savings that For All Seasons realized by placing this order on July 15.

c. What is the final payment date of this invoice?

d. For All Seasons followed the vendor's guidelines to secure the 5% discount. Explain the step For All Seasons took to meet the vendor's guideline that most retailers would not think to do.

e. What factors did For All Seasons consider before placing this holiday order?

7. The For All Seasons accessories buyer reviewed past sales records and determined that 60 waterproof flashlights must be ordered. The vendor's price list is as follows:

 1–49 @ $9.00

 49–99 @ $8.25

 Payment terms are 1/10 E.O.M. The flashlights were shipped on May 10.

 a. Calculate the billed cost of this order.

 b. What amount is to be remitted within the cash discount time period?

 c. Compute the number of days available to sell-through the flashlights before final payment is due.

d. What is the final cash discount date and the amount to be remitted to the vendor?

e. Determine the final payment date without the cash discount deduction and compute the net cost of this invoice. (Transportation charges totaled $35.00.)

8. Biking helmets have a list price of $29.00, less 25, less 15. Calculate the billed cost per biking helmet.

9. For All Seasons sports equipment buyer purchased 35 soccer balls. Refer to the supplier's list below and calculate the following:

 1–50 @ $17.50
 51–125 @ $15.00

 a. Determine the cost per soccer ball.

 b. Compute the total quantity price.

 c. Find the billed cost of this order.

d. Payment terms are 1/10/N30. What is the final payment due date?

e. Transportation charges totaled $62.00. Compute the net cost of this order and show your computations.

10. Given the following information, complete the following exercises.

Payment Terms	2/10 E.O.M.
Invoice Date	May 3
Transportation Charges	$210.00

100 bike locks, @ $5.25, were ordered, qualifying for a total order discount of 5%. The retailer also received a 5% trade discount.

a. Determine the total quantity price.

b. What is the billed cost of this order?

c. Compute the cash discount dollar amount.

d. What is the last date payment may be made to take the cash discount deduction?

e. Compute the net cost of this invoice assuming payment is made within the cash discount time frame.

f. Determine the final payment date of this invoice and the amount to be remitted to the vendor.

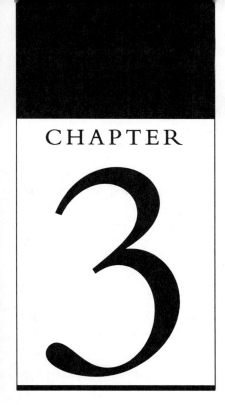

CHAPTER 3

Components for Profit

Both retailers and vendors are expected to contribute to the profitability of the companies they represent. To contribute profits to their respective organizations while working together effectively, a thorough knowledge and working application of the components for profitable merchandising are necessary. Business judgments depend on the computation and interpretation of figure facts.

The means to improve profits for retailers and vendors alike are accomplished by following the ideas presented throughout this text while keeping in mind the interaction of the basic profit components and the effect decisions will have on generating profits.

BASIC PROFIT COMPONENTS

Five basic profit components interact to contribute to the profit produced within any retail operation. These five factors are brought together by the retailer's pricing decisions with the results reflected on the income statement.

NET SALES VOLUME

Net sales volume is the total amount of dollars received from the sale of merchandise, less customer returns and allowances, sales taxes, and the retailer's excise taxes collected directly from customers for a specific period of time.

COST OF GOODS SOLD

Cost of goods sold is the total merchandise costs for a specific period of time, including the billed invoice amounts of merchandise purchased, transportation charges incurred, and the costs of preparing merchandise for sale.

GROSS MARGIN OF PROFIT

Gross margin of profit (GM/GP) is the dollar amount remaining after the cost of goods sold is subtracted from the net sales volume. This amount must be high enough to cover the costs of doing business to produce the desired profit.

TOTAL OPERATING EXPENSES

Total operating expenses are the costs incurred in operating the store, not including merchandise expense.

NET OPERATING PROFIT

Net operating profit is profit before other income, other expenses, and income taxes are considered. This is the difference between income and total operating expenses realized from the buying and selling of merchandise. If income exceeds

expenses, net operating profit results (otherwise referred to as being "in the black"). Conversely, if total operating expenses are greater than income, the result is net operating loss (also known as being "in the red").

These five basic profit components are formatted on the income statement so that the results are easily comparable to planned sales and expense goals, last year's results, and comparable retail operations for analysis.

These components are represented not only as dollar figures but also as percentages of net sales. Since net sales is valued at 100%, each component is a percent of that and provides the basis for calculating profit contribution in financial accounting. These ratios (quantitative relationships) are used to analyze the financial condition of a company, past to the present. Such ratios are published for most industries to offer comparisons to others in specific business fields. Dun & Bradstreet's *Key Business Ratios* report, the National Retail Merchants Association *Merchandising and Operating Results* publication, and industry trade associations provide this information annually.

THE INCOME STATEMENT

income statement—reveals net sales volume, cost of goods sold, gross margin of profit, all related expenses, and resulting net profit or loss; also known as profit and loss statement (P&L) and operating statement

The financial guide to the success of any retail operation is the **income statement**, also referred to as the **profit and loss statement (P&L)** or **operating statement**. The income statement serves two purposes:

1. It provides financial data for income tax reporting and other required legal reports.

2. It reports the recent results of merchandising and operating decisions.

Usually prepared monthly, with quarterly and annual recaps, the income statement reveals net sales volume, cost of goods sold, gross margin of profit, all related operating expenses (fixed and variable), net operating profit or loss, and net profit or loss after other income, other expenses, and income taxes.

Every merchant is accountable for the performance of his or her department or store, so it is vital to be able to understand and interpret the income statement. Analysis of the overall income statement reveals where strengths and weaknesses exist or may be developing. Sales goals, gross margin of profit objectives, expense budgets, and profit targets enable each income statement to be analyzed in detail.

Analysis of the components in the statement provide a yardstick of measurement of the retailer's merchandising and operation capabilities. A hypothetical income statement is shown in Figure 3.1. All of the income statement calculations are based on the hypothetical For All Seasons Sports Equipment department income statement presented in this figure.

SELF QUIZ

1. What are the five basic profit components and their definitions?

2. Explain the two purposes of the income statement.

FOR ALL SEASONS

For All Seasons November Sports Equipment Income Statement

	Dollar Amount	Percent of Sales
Net Sales Volume	$100,000	100.0%
Cost of Goods Sold	– 60,000	60.0%
GROSS MARGIN of PROFIT (Gross Margin)	$ 40,000	40.0%
Operating Expenses:		
Fixed $ 7,000		
Variable +22,500		
$29,500		
Total Operating Expenses	– 29,500	29.5%
NET OPERATING PROFIT	$ 10,500	10.5%
Other Income	+ 2,500	2.5%
Other Expense	– 500	.5%
NET PROFIT before Income Tax	$ 12,500	12.5%
Income Taxes	– 2,500	2.5%
NET PROFIT	$ 10,000	10.0%

Figure 3.1.

3. Why is it important for the retailer to understand how to analyze the components of the income statement?

NET SALES VOLUME

Net sales volume is the major income-producing component from which all other income statement results are expressed as a percentage for comparison to other operations as a check on progress toward achieving profit goals. We will now explain the concept of net sales volume and illustrate the steps by which net sales volume results.

net sales volume– gross sales less discounts, customer returns, and allowances

Net sales volume, often referred to as **sales volume** or **operating income**, is the total amount of dollars received from the sale of merchandise, less customer returns and allowances, sales taxes, and the retailer's excise taxes collected directly from customers (e.g., gasoline) for a specific period of time. Net sales volume represents what the customer is willing to pay.

Note: Although the majority of operations have cash registers/terminals which automatically deduct sales taxes, it is important to specify all reductions which comprise the net sales volume calculation.

Gross sales is the total amount of dollars received from the sale of merchandise for a specific period of time.

For All Seasons' sports equipment gross sales are $108,000.

Formula for Calculating Net Sales Volume

	Gross Sales	$108,000
Less:	Customer Returns & Allowances	1,520
Less:	Sales Taxes (6%)	6,480
Less:	Excise Taxes	–0–
	Net Sales Volume	**$100,000**

customer returns and allowances—100% refunds to comply with retailer's customer service policy; partial refunds to comply with retailer's customer service policy

Customer returns, 100% refunds, and **customer allowances**, partial refunds, are provided to satisfy the retailer's customer service policy. They may be given for unsatisfactory merchandise, to meet a competitor's price, or for donations to local charities.

SELF QUIZ

1. Explain the difference between gross sales and net sales.

2. The competition advertises an identical item that For All Seasons stocks. A customer requests a price adjustment from For All Seasons to meet the competition's price. For All Seasons issues a refund to the customer. This is called a customer refund.

 True **False**

3. Net sales volume totaled $60,000 after $5,000 in customer returns and allowances were accounted for. Compute the gross sales figure.

4. Gross sales totaled $625,000. Customer returns amounted to $10,500; customer allowances were $10,500.

 a. Compute the net sales volume.

 b. What percentage of goods sold were returned?

5. Answer the following questions using the information given from the For All Seasons store. On January 4, sales from the Accessories Department were:

50 pairs of gloves	@ $15.99 each
75 hats	@ $12.99 each
25 scarves	@ $12.99 each

Two scarves received as Christmas presents were returned and cash refunds were given.

a. What is the gross sales figure for January 4?

b. What is the total dollar amount of customer returns?

c. The sales tax rate is 6% (.06). What dollar amount is to be deducted for taxes?

d. Calculate the net sales volume for January 4.

COST OF GOODS SOLD

Another vital figure in the income statement is **cost of goods sold**, which is defined as the total merchandise costs for a specific time period. The total merchandise costs include the billed invoice amounts of merchandise purchased, transportation charges incurred, and the costs of preparing the merchandise for sale. The formula used in computing cost of goods sold has several components; each will be fully explained following the formula on page 52.

For All Season's sports equipment cost of goods sold is $60,000.

Formula for Calculating Cost of Goods Sold

	Beginning Cost Inventory	$120,000
Plus:	Cost of All Goods Purchased	60,000
Plus:	Transportation Charges Incurred	3,000
	Total Merchandise Handled	$183,000
Less:	Vendor Returns	14,000
Plus:	Vendor Allowances	4,000
Less:	Ending Cost Inventory	115,000
	Gross Cost of Goods Sold	$ 58,000
Plus:	Alteration and Workroom Costs	2,000
	Cost of Goods Sold	**$ 60,000***

*(Before Cash Discounts)

cost of goods sold—the total merchandise costs for a specific period of time, which include billed invoice amounts of merchandise purchased, transportation charges incurred, and costs of preparing merchandise for sale

BEGINNING COST INVENTORY

beginning cost inventory—dollar amount of all merchandise in stock at cost value

Beginning cost inventory is the dollar amount of all merchandise in stock at cost value. The beginning cost inventory equals the previous ending cost inventory figure.

COST OF ALL GOODS PURCHASED

cost of all goods purchased—all new merchandise received after beginning cost inventory figure is totaled

Cost of all goods purchased represents all new merchandise received after the beginning cost inventory figure is totaled. This figure represents all merchandise received during a specific time period. It is the total of billed invoices less trade and quantity discounts.

TRANSPORTATION CHARGES INCURRED

transportation costs incurred—all shipping costs paid by retailer and not chargeable to vendor

Transportation charges incurred are all shipping costs paid by the retailer and not chargeable to vendors.

TOTAL MERCHANDISE HANDLED

total merchandise handled—beginning cost inventory plus cost of goods purchased and transportation charges incurred

Total merchandise handled is the beginning cost inventory plus the cost of goods purchased and transportation charges incurred.

VENDOR RETURNS

vendor returns—shipments of merchandise returned due to errors in filling store's purchase order(s) or due to late delivery, defective materials or workmanship, or other breaches of contract

Vendor returns are shipments of merchandise returned due to errors in filling the store's purchase order(s), or because of late delivery, defective materials or workmanship, or other breaches of contract. These returns to vendor are abbreviated as **RTV**.

VENDOR ALLOWANCES

vendor allowances—partial or complete reimbursements for damaged merchandise, price competition, or in lieu of returning unsatisfactory goods

Vendor allowances are partial or complete adjustments for damaged merchandise, price competition, or in lieu of returning unsatisfactory merchandise. They are reimbursements to the retailer.

ENDING COST INVENTORY

ending cost inventory—total dollar cost value of merchandise in stock at end of specified period of time

Ending cost inventory is the total dollar cost value of merchandise in stock at the end of a specified period of time.

GROSS COST OF GOODS SOLD

gross cost of goods sold—inventory value before alteration and workroom costs

Gross cost of goods sold is the inventory value before alteration and workroom costs.

ALTERATION AND WORKROOM COSTS

alteration and workroom costs—total costs incurred in preparing merchandise for sale

Alteration and workroom costs are the total costs incurred in preparing merchandise for sale excluding receiving and pricing costs. Examples of workroom costs include engraving, monogramming, drapery fabrication, and millinery.

Cash discounts, as discussed in Chapter 2, are stated discount percentages deductible from the billed cost on an invoice. They are rewards for immediate payment or for payment in advance of a specified period. Retailers treat them in two ways on the income statement:

1. Some retailers deduct cash discounts from the cost of all goods purchased to provide a cushion to cover transportation, alteration, and workroom costs. This method benefits the gross margin of profit figure (the difference between net sales volume and cost of goods sold). So if we subtract $2,500.00 in cash discounts from the For All Seasons cost of goods sold figure of $60,000, total cost of goods sold is now $57,500. As a buyer accountable for meeting gross margin of profit goals, deducting cash discounts from the cost of all goods purchased is a definite advantage.

2. The majority of large retailers add cash discounts to an account named Other Income for income—received from nonoperating sources to benefit the overall company profit picture—and do not allow it to affect the gross margin of profit. Many make these decisions based on their cash flow situation, their ability to pay within the specified period to take advantage of the offered discounts.

SELF QUIZ

1. The previous ending cost inventory figure was $135,000. What is the beginning cost inventory figure?

2. Explain in detail each of the components that comprise the cost of goods sold formula.

3. Write the cost of goods sold formula below.

4. Cash discounts are stated discount percentages that are deductible from the billed cost on an invoice. They are rewards for immediate payment or for payment in advance of a specified period.

True **False**

5. Briefly explain the two ways in which retailers treat cash discounts with regard to the income statement.

6. The active wear buyer purchased 60 pairs of leotards. The cost per leotard was $12.00. Transportation charges incurred totaled $65.00. Calculate the total cost of goods.

7. The shoe buyer ordered 48 pairs of shoes @ $25.75, 72 pairs @ $32.10, and 36 pairs @ $45.45. Transportation charges represented 5% of the cost of merchandise ordered.

 a. Calculate the total amount of this order.

 b. Compute the transportation dollar charge.

8. The beginning cost inventory on February 1 was $125,000. The total of billed invoices for new merchandise received in February was $65,000. Vendor returns totaled $5,000 at cost. The cost inventory result on February 28 was $120,000.

 a. What is the cost of goods sold for the month of February? Show your calculations.

 b. Transportation charges of $5,000 were omitted in error. Recalculate the cost of goods sold.

c. Vendor allowances totaled $4,000. Include this figure in the cost of goods calculation.

GROSS MARGIN OF PROFIT

gross margin of profit–difference between net sales volume and cost of goods sold; also known as gross profit or gross margin

This profit component plays an integral role within the income statement. **Gross margin of profit**, also known as **gross profit** or **gross margin**, is the difference between net sales volume and the cost of goods sold. It reflects the retailer's success in negotiating with vendors to achieve the five golden rules of merchandising (having the right merchandise, at the right time, at the right price, in the right quantity, in the right place). It is the major component that contributes to the profit produced within any retail operation. The gross margin must be high enough to cover the total operating expenses, both fixed and variable, and to produce the desired net operating profit and the resultant net profit after other income, other expenses, and income taxes have been factored in.

For All Seasons sports equipment gross margin is $40,000.

Formula for Calculating Gross Margin Dollars

	Net Sales Volume	$100,000
Less:	Cost of Goods Sold	60,000
	Gross Margin Dollars	**$ 40,000**

gross margin percent–percent of net sales volume dollars remaining after costs related to purchasing and preparing merchandise for sale are subtracted; calculated by dividing gross margin dollars by net sales volume dollars

Gross margin percent, or **GM%**, represents the percent of net sales volume dollars remaining after costs related to purchasing and preparing merchandise for sale are subtracted.

Formula for Calculating Gross Margin Percent

$$\frac{\text{Gross Margin Dollars}}{\text{Net Sales Volume Dollars}} = \textbf{GM\%}$$

For All Season's sports equipment GM% is 40.0%. The 40.0% means that 40% of net sales volume, which represents 100%, remains to cover the costs of doing business and to produce the desired profit. Another way of expressing this is to say that 40 cents ($.40) on each sales dollar remains to cover total operating

Something to Consider: Calculating Percentage of Net Sales Volume

Each component of the statement is expressed as a percentage of net sales volume, the base of calculating profit contribution in income statement accounting, for comparison to plan, last year, and comparable stores.

Formula for Calculating Percent of Net Sales Volume

$$\frac{\$ \text{ Component}}{\$ \text{ Net Sales Volume}} = \textbf{\% of Net Sales Volume}$$

expenses and to produce the desired net operating profit and the resultant net profit after other income, other expense, and income taxes have been factored in.

This GM% was arrived at by:

$$\frac{\$\ 40{,}000}{\$100{,}000} = .40$$

.40 equals forty one-hundredths (40/100), or 40.0%. To convert a decimal to a percent, move the decimal point two places to the right and add the percent sign or multiply by 100 and add the percent sign (%).

SELF QUIZ

1. Gross margin is the sum of net sales volume and cost of goods sold.

 True **False**

2. Gross margin must be high enough to cover the costs of doing business and to produce the desired net operating profit.

 True **False**

3. Write the formula below for calculating gross margin dollars and gross margin percent.

4. Calculate the gross margin percent for each example.

 a. Gross Margin $ 15,000
 Net Sales Volume 60,000 _____ %

 b. Gross Margin $ 188,000
 Net Sales Volume 320,000 _____ %

 c. Gross Margin $ 25,250
 Net Sales Volume 81,750 _____ %

 d. Gross Margin $ 592,752
 Net Sales Volume 1,578,500 _____ %

5. Net sales volume for March was $75,000. The cost of goods sold totaled $33,750.

 a. What are the gross margin dollars for March?

 b. Calculate March's gross margin percent.

> **c.** How many cents on each sales dollar ($1.00) remain to cover total operating expenses and produce the desired net operating profit?

6. Calculate gross margin dollars and percent using the information provided.

Gross Sales	$242,000
Customer Allowances	500
Cost of Goods Purchased	130,000
Vendor Allowances	5,000
Alteration Costs	2,000

TOTAL OPERATING EXPENSES

total operating expense–fixed and variable costs incurred in operating the store, not including merchandise expense

We will now focus on the calculation of the total operating expenses formula and its importance to the retailer's "bottom line." **Total operating expense** is the total of fixed and variable expenses and represents the cost of doing business. This component of the income statement is essential in the analysis of the profitability of any business. When total operating expenses increase out of proportion to net sales volume and the cost of goods sold, and therefore the gross margin, the desired profit can be affected adversely and little or no profits will be generated.

For All Seasons sports equipment total operating expenses are $29,500.

Formula for Calculating Total Operating Expenses

	Fixed Expenses	$ 7,000
Plus:	Variable Expenses	22,500
	Total Operating Expenses	**$29,500**

overhead–expenses of operating a business, which are not specifically chargeable to a selling, workroom, or manufacturing department

fixed expenses–costs incurred regardless of sales volume

variable expenses–costs that fluctuate monthly as net sales volume increases and decreases

It is vital to determine the "**overhead**," the expenses of operating any business, before pricing merchandise. Remember, the gross margin must be large enough to cover expenses to produce the desired net profit.

The two categories of operating expenses are fixed and variable. **Fixed expenses** are costs incurred regardless of the sales volume. They remain fairly constant and are expenses such as rent (unless the lease is determined as a percentage of net sales), utilities, equipment rental (e.g., bank card machines), and salaried employees.

Variable expenses are costs that fluctuate each month, as net sales volume increases and decreases. Examples are sales commissions, payroll taxes, supplies, credit card fees, and advertising expenditures. Variable expenses are controllable.

Fixed and variable expenses are related to "the cost of operating the store" and do not include merchandise expense. In some operations, the cost of shortage is included in the calculation of cost of goods sold as a merchandise cost. However,

shortage is more appropriately classified as a variable expense and actually reveals poor operating controls.

In some large organizations, direct expenses not related to running the store may be allocated to each branch. Examples include corporate expenses and accounting operations expenses. These "cost center" expenses are not planned to generate revenue, but instead are support and service generators to other parts of the business. In a large company, the Human Resources division is not a revenue center; it is a cost center because in the course of providing services, it expends monies but does not generate any.

SELF QUIZ

1. Fixed expenses total $27,400.

 Variable expenses are $189,000.

 Net sales volume is $952,000.

 a. What is the total operating expense?

 b. Calculate the percent that total operating expenses represent to net sales volume.

2. F represents fixed expenses.

 V represents variable expenses.

 Write in F or V next to the following operating expenses.

Manager's salary	_____
Building maintenance	_____
Shortage	_____
Sales salaries	_____
Accounting fees	_____
Dues and subscriptions	_____
Licenses, permits	_____
Payroll taxes	_____
Advertising	_____
Computer rental	_____

3. Last year's November sales totaled $29,500. This year's results show $27,500. What was the percent change?

4. For All Seasons sales have dropped 15% for the last 3 months. Vendors are working with you and your sales staff is excellent. On reviewing your operating expenses, what steps would you take to better control or reduce them? Why? How?

Operating Expenses

Rent	Payroll
Utilities	Payroll taxes
Telephone	Insurance
Maintenance	Supplies
Travel	Dues and subscriptions

NET OPERATING PROFIT

net operating profit—difference between gross margin and total operating expenses

The net profit realized from the buying and selling of merchandise is the **net operating profit**. It is the difference between gross margin and total operating expenses. In most retail operations and merchandise firms, buyers and sales representatives will be held accountable for the results up to this point on the income statement and will receive reports that only reflect these components. Other income (i.e., interest on investments), other expenses (i.e., interest paid on loans), and income tax amounts generally remain as confidential information for the owners' and accountants' "eyes" only.

For All Seasons sports equipment net operating profit is $10,500.

Formula for Calculating Net Operating Profit

	Gross Margin Dollars	$40,000
Less:	Total Operating Expenses	29,500
	Net Operating Profit	**$10,500**

NET PROFIT

net profit—total of net operating profit and other income, less other expense and income taxes

From the interaction of the five basic profit components comes **net profit**. Perhaps the most critical income statement figure, it is the end result of all previous components explained thus far. Net profit is defined as the total of net operating profit and other income, less other expense, less income taxes. This "bottom-line" figure provides the retailer with insight as to the "health" of the business at a glance.

Our goal at this point in the chapter is to introduce the concept of net profit and its formulas before explaining how to analyze and control the income statement results.

Other income represents monies received from nonoperating sources. Examples are cash discounts, advertising allowances, and interest income from investments. For All Seasons earned $2,500 in cash discounts for November.

Other expenses are costs not directly related to merchandising operations...the buying and selling of merchandise. Bad debt losses and interest expense would be posted to this account. For All Seasons "wrote off" $500 in uncollectable customer debt and paid a $2,000 interest payment to the bank for monies borrowed.

other income—monies received from nonoperating sources, i.e., interest on investments

other expenses—costs not directly related to merchandising operations, i.e., interest paid on loans

Formula for Calculating Net Profit Before Income Taxes

$$
\begin{array}{ll}
& \text{Net Operating Profit} \\
+ & \text{Other Income} \\
- & \text{Other Expense} \\
\hline
= & \textbf{Net Profit Before Income Taxes}
\end{array}
$$

EXAMPLE:

$$
\begin{array}{lll}
& \$10,500 & \text{Net Operating Profit} \\
+ & 2,500 & \text{Other Income} \\
- & 500 & \text{Other Expense} \\
\hline
= & \$12,500 & \textbf{Net Profit Before Income Taxes}
\end{array}
$$

This is the net profit earned and is the basis for computing income taxes.

Formula for Calculating Net Profit

$$
\begin{array}{l}
\text{Net Profit Before Income Taxes} \\
- \text{Income Taxes} \\
\hline
= \textbf{Net Profit}
\end{array}
$$

EXAMPLE:

$$
\begin{array}{lll}
& \$12,500 & \text{Net Profit Before Income Taxes} \\
- & 2,500 & \text{Income Taxes} \\
\hline
= & \$10,000 & \textbf{Net Profit}
\end{array}
$$

net profit percent—calculated by dividing net profit dollars by net sales volume dollars

For All Seasons sports equipment net profit earned was $10,000. The **net profit percent** is 10.0%. Ten cents ($.10) received per sales dollar is net profit. This is calculated as follows:

Formula for Calculating Net Profit Percent

$$
\frac{\$ \text{ Net Profit}}{\$ \text{ Net Sales Volume}} = \frac{\$10,000}{\$100,000} = .100 = \textbf{10.0\%}
$$

SELF QUIZ

1. Define total operating expenses and write the formula below.

2. Gross margin dollars for the first quarter of last year were $725,000. Total operating expenses were $550,000. What was the net operating profit realized for the first quarter of last year by For All Seasons?

3. The formula for computing net profit is:

$$
\begin{array}{rl}
 & \text{Net Operating Profit} \\
+ & \text{Other Income} \\
- & \text{Other Expense} \\
\hline
= & \text{Net Profit}
\end{array}
$$

True **False**

4. Net operating profit totaled $12,000. Other income generated was $3,250 and other expense paid was $700.

 a. Calculate the store's net profit before income taxes.

 b. The net sales volume was $125,000. Compute the net profit percent before income taxes.

INCOME STATEMENT ANALYSIS

The understanding of the components and the work applications of the mathematical formulas involved in the income statement provide retailers with the ability to analyze and control their businesses.

We will now demonstrate the interaction of the five basic profit components and show how changes of net sales volume, cost of goods sold, gross margin, and operating expenses have an impact the net operating profit result before other income, other expenses, and income taxes. Figure 3.2 illustrates the effect decisions have on the resulting net operating profit.

NET SALES VOLUME

Our first example, Figure 3.2, illustrates the result of increasing net sales volume while all costs remain the same, resulting in higher net operating profit.

Net sales volume increased $10,000 or $10.0, using financial notation format (see Appendix 3, "Rounding Numbers and Financial Notation").

Something to Consider: Financial Notation Format	
100.0 = $100,000	TY = This Year
29.5 = $ 29,500	LY = Last Year
.5 = $ 500	

FOR ALL SEASONS

For All Seasons Skeletal November Sports Equipment Income Statement
(Expenses remain constant while sales volume increases.)

	Dollar Amount		Percent of Sales		Impacting Change Factors
	TY	LY	TY	LY	
Net Sales Volume	$110.0	$100.0	100.0%	100.0%	**$10.0** SALES INCREASE
Cost of Goods Sold	– 60.0	60.0	54.5	60.0%	**5 1/2 CENTS** PER SALES **$1.00** REDUCTION
Gross Margin of Profit	$ 50.0	$ 40.0	45.5% (45.45%)	40.0%	**46 CENTS** EARNED PER **$1.00** RECEIVED BEFORE EXPENSES
Operating Expenses:					
Fixed $22,500					**REMAINED THE SAME**
Variable + 7,000					
$29,000					
Total Operating Expenses	– 29.5	$ 29.5	26.8 % (26.82%)	29.5%	**DECREASE IN EXPENSES PER SALES DOLLAR**
NET OPERATING PROFIT	$ 20.5	$ 10.5	18.6 % (18.63%)	10.5%	**18.6 CENTS** PER DOLLAR SALE, INCREASE OF **8.1 CENTS**

Figure 3.2.

This was achieved by making the following decisions:

1. Competitive shopping revealed that a nationally recognized brand of skis that For All Seasons stocked, which is a major sales producer, were priced $50.00 more at all surrounding stores. For All Seasons increased their retail price on this brand of skis by $20.00...just enough to increase the gross margin and remain lower in their market.

2. The buying staff began to spend one day a week on the selling floor. The sales staff's product knowledge and sales skills increased and the merchandise offerings were fine-tuned to better serve their customers.

NET SALES VOLUME AND TOTAL OPERATING EXPENSES

Our first example represents an "ideal" situation—total operating expenses remained constant while net sales volume increased.

Our second example, Figure 3.3, shows the effect of increasing sales volume on total operating expenses. As sales rose, so did sales commissions, part-time staffing, and supplies (e.g., register tape, shopping bags).

Fixed expenses, which regularly remain consistent, were unchanged. Variable expenses, those operating expenses that fluctuate with sales volume, increased 24.4% over last year.

The percentage change is the measure of increase or decrease in sales, expenses, and so forth between two time periods, usually this year and last year.

$$\frac{\text{TY Variable Expenses} - \text{LY Variable Expenses}}{\text{LY Variable Expenses}} = \% \textbf{ Change}$$

FOR ALL SEASONS

For All Seasons Skeletal November Sports Equipment Income Statement
(As sales volume increases, total operating expenses increase.)

	Dollar Amount		Percent of Sales		Impacting Change Factors
	TY	LY	TY	LY	
Net Sales Volume	$110.0	$100.0	100.0%	100.0%	
Cost of Goods Sold	- 60.0	60.0	54.5%	60.0%	
Gross Margin of Profit	$ 50.0	$ 40.0	45.5%	40.0%	
Operating Expenses:					
Fixed $ 7,000	7.0	7.0	6.4%	7.0%	VARIABLE EXPENSES
Variable +28,000	- 28.0	22.5	25.5%	22.5%	INCREASED BY 24.4%.
$35,000					VARIABLE NOW COST
					25 1/2 CENTS PER
					SALES DOLLAR.
Total Operating Expenses	$ 35.0	$ 29.5	31.9%	29.5%	
NET OPERATING PROFIT	$ 15.0	$ 10.5	13.6%	10.5%	13.6 CENTS PER $1.00 REMAINS

Figure 3.3.

$$\frac{\$28,000 - \$22,500}{\$22,500} \qquad \frac{\$ 5,500}{\$22,500} = .244 = 24.4\%$$

Reminder: Dividing one number by another yields a decimal. To get the percent, move the decimal two places to the right and add the percent sign (%), or multiply times 100.

COST OF GOODS SOLD

In our third example, Figure 3.4, management expects net operating profit to increase to 14.5%, 14 1/2 cents per sales dollar received. New competition and a stagnant economy are making it almost impossible to generate sales volume equal to last year.

This income statement shows the results of reducing the cost of goods sold. This was accomplished by:

1. Increasing the turnaround time of defective merchandise returns

2. Analyzing resource performance and securing vendor allowances

3. Specifying shipping instructions instead of allowing suppliers to ship "best way"

4. Adjusting merchandise assortments to better meet the customers' needs and wants

OPERATING EXPENSES

In our fourth example, Figure 3.5, last year's total operating expenses represented 29.5% of the net sales volume. This year total operating expenses are to be held at 27.5% of the net sales volume. This income statement shows the results of reducing total operating expenses while net sales volume and the cost of goods sold remain the same.

FOR ALL SEASONS

For All Seasons Skeletal November Sports Equipment Income Statement
(When cost of goods is reduces and net sales volume and total operating expenses remain the same.)

	Dollar Amount		Percent of Sales		Impacting Change Factors
	TY	LY	TY	LY	
Net Sales Volume	$100.0	$100.0	100.0%	100.0%	
Cost of Goods Sold	− 56.0	60.0	56.0%	60.0%	**REDUCED BY 4 CENTS PER $1.00**
Gross Margin of Profit	$ 44.0	$ 40.0	44.0%	40.0%	
Operating Expenses :					
Fixed $ 7,000					
Variable +22,500					
$29,500					
Total Operating Expenses	− 29.5	$ 29.5	29.5%	29.5%	**NO CHANGE**
NET OPERATING PROFIT	$ 14.5	$ 10.5	14.5%	10.5%	**INCREASED NET PROFIT PER SALES DOLLAR BY 4 CENTS**

Figure 3.4.

FOR ALL SEASONS

For All Seasons Skeletal November Sports Equipment Income Statement
(When total operating expenses are reduced and net sales volume and cost of goods sold remain constant.)

	Dollar Amount		Percent of Sales		Impacting Change Factors
	TY	LY	TY	LY	
Net Sales Volume	$100.0	$100.0	100.0%	100.0%	
Cost of Goods Sold	− 60.0	60.0	60.0%	60.0%	**NO CHANGE**
Gross Margin of Profit	$ 40.0	$ 40.0	40.0%	40.0%	
Operating Expenses :					
Fixed $ 7,000	$ 7.0	$ 7.0	7.0%	7.0%	
Variable +20,500	$ 20.5	$ 22.5	20.5%	22.5%	**REDUCED VARIABLE EXPENSES BY 8.9.%**
$27,500					
Total Operating Expenses	− 27.5	$ 29.5	27.5%	29.5%	**DECREASE 2 CENTS PER SALES DOLLAR RECEIVED.**
					INCREASE 2 CENTS PER $1.00 19% INCREASE IN NET PROFIT $'s
NET OPERATING PROFIT	$ 12.5	$ 10.5	12.5%	10.5%	

Figure 3.5.

Variable expenses, the controllable operating expenses, were reduced by:

1. Improved scheduling of the sales staff—according to the store's sales curve based on analyzing the transaction per hour data

2. Restricting employee phone usage and calling vendors' 800 numbers or collect as much as possible

3. Negotiating lower prices for shopping bags, tissue, and other supplies after shopping other comparable resources

4. Reducing the length and frequency of buying trips

INCOME STATEMENT ANALYSES RECAP

The four income statement examples clearly illustrate the effect a retailer's decisions have on profits. Increased net operating profits resulted from:

1. Generating more sales while holding all expense factors constant

2. Increasing net sales volume while controlling variable expenses increases

3. Decreasing the cost of goods sold as sales and total operating expenses remained the same

4. Reducing total operating expenses with sales and cost of goods sold equal to last year's percent to net sales volume figures

The cumulative results of changes of the five basic profit components are shown in Figure 3.6.

FOR ALL SEASONS

For All Seasons Skeletal November Sports Equipment Income Statement
(When sales increase and cost of goods sold and total expenses decrease)

	Dollar Amount		Percent of Sales		Impacting Change Factors
	TY	LY	TY	LY	
Net Sales Volume	$110.0	$100.0	100.0%	100.0%	**10%** SALES INCREASE.
Cost of Goods Sold	− 56.0	60.0	50.9%	60.0%	**9 CENTS** REDUCTION PER **$1.00** RECEIVED.
Gross Margin of Profit	$ 54.0	$ 40.0	49.1%	40.0%	**9 CENT INCREASE BEFORE EXPENSES**
Operating Expenses:					
Fixed $ 7,000	7.0	7.0	6.4%	7.0%	**8.9%** VARIABLE REDUCTION
Variable +20,500	20.5	22.5	18.6%	22.5%	
$27,500					
Total Operating Expenses	$ 27.5	$ 29.5	25.0%	29.5%	**4 1/2 CENT REDUCTION PER $1.00.**
NET OPERATING PROFIT	$ 26.5	$ 10.5	24.1%	10.5%	**24 CENTS REMAIN BEFORE TAXES**

Figure 3.6.

1. Explain why it is important that the retailer and vendor both understand how to analyze an income statement.

2. Changes in net sales volume, cost of goods sold, gross margin, and total operating expenses have an impact on the net operating profit result before income taxes.

 True **False**

3. Using the last year's figures illustrated in Figure 3.7 complete the November income statement as follows:

 a. Compute LY's net operating profit.

 b. Calculate and write in the percent each component on the income statement represents.

FOR ALL SEASONS

For All Seasons Skeletal November Sports Equipment Income Statement
(The results from planning a 10% net sales volume increase)

	Dollar Amount		Percent of Sales		Impacting Change Factors
	TY	LY	TY	LY	
Net Sales Volume	$	$100.0	100.0%	%	_____
Cost of Goods Sold	–		%	%	_____
Gross Margin of Profit	$	$ 40.0	%	%	
Operating Expenses:					
Fixed $	$	$ 7.0	%	%	
Variable +	$	$ 22.5	%	%	_____
$					
Total Operating Expenses	–	$ 29.5	%	%	
NET OPERATING PROFIT	%	$	%	%	_____

Figure 3.7.

c. Set up this year's (TY) November income statement that reflects a 10% increase in net sales volume. All other components remain the same. Show all dollar amounts and percentages.

d. Compare the results to last year's and fill in the impacting change factors column where applicable.

4. Management decides that gross margin for your department must increase by 2% over last year. You plan to achieve this goal by reducing the cost of goods sold. Net sales volume and total operating expenses will be planned equal to last year's results. Use the information provided in Figure 3.8 to complete the income statement as follows:

a. Calculate LY's net operating profit.

FOR ALL SEASONS

For All Seasons Skeletal November Sports Equipment Income Statement
(The results from planning a 2% gross margin increase)

	Dollar Amount		Percent of Sales		Impacting Change Factors
	TY	LY	TY	LY	
Net Sales Volume	$	$100.0	100.0%	100.0%	
Cost of Goods Sold	–		%	%	
Gross Margin of Profit	$	$ 40.0	%	40.0%	
Operating Expenses:					
Fixed $	$	$ 7.0	%	%	
Variable +	$	$ 22.5	%	%	
$					
Total Operatings Expenses	–	$ 29.5	%	29.5%	
NET OPERATING PROFIT	%	$	%	%	

Figure 3.8.

b. Compute the missing LY percentage figures for each component.

c. Complete the income statement to reflect the 2% reduction in the cost of goods sold.

d. Describe the results of increasing the gross margin in the impacting change factors column.

5. Create an income statement that reflects all the changes made in the previous two problems. Include LY and TY dollar figures and percentages. Thoroughly analyze the impact these decisions had on net operating profit.

CHAPTER REVIEW

Circle true or false for each of the following statements.

1. Net sales volume is the total amount of dollars received from the sale of merchandise for a specific time period.

 True **False**

2. A customer returns a set of silk underwear because it has a small run in the sleeve. The store grants the customer a refund of $5.00 and the customer accepts it. This is a customer return.

 True **False**

3. The beginning cost inventory figure equals the previous ending cost inventory figure.

 True **False**

4. Transportation charges incurred are all vendor paid shipping costs.

 True **False**

5. Gross cost of goods sold and cost of goods sold are the same figure if alteration services are not provided by the retailer.

 True **False**

6. Gross margin is the difference between net sales volume and the gross cost of goods sold.

 True **False**

7. If net sales volume is equal to the previous month's net sales volume, variable expenses will remain the same.

<div align="center">

True **False**

</div>

8. Higher net profit will be achieved when net sales volume increases and all costs remain the same.

<div align="center">

True **False**

</div>

9. Both variable and fixed expenses are controllable.

<div align="center">

True **False**

</div>

Fill in the blanks for each of the following statements.

10. The difference between net sales volume and _____ _____ _____ _____ is gross margin.

11. The gross margin equals _____ _____ _____ less the _____ _____ _____ _____ .

12. The amount remaining after all operating expenses have been recognized is _____ _____ _____ .

Answer the following questions in detail.

13. What steps would a retailer take to reduce the cost of goods sold figure?

14. What benefits will both the retailer and vendor gain from having a thorough understanding and working application of the components for profit?

15. Why is net sales volume represented as 100% on the income statement?

16. Under what circumstances would the retailer return merchandise to a vendor?

17. When a retailer cannot pay a vendor's invoice in time to take advantage of the offered cash discount, which method of accounting for cash discounts is best?

18. In analyzing gross margin results, is the dollar amount or the percentage figure more meaningful? Why?

19. Name and describe three methods by which to increase profits.

20. What steps would a retailer take to reduce operating expenses?

CHAPTER TEST

1. The reported net operating profit on the income statement was $12,000 and 8%. Compute the net sales volume figure.

2. Fill in the blanks on the hypothetical income statement.

DECEMBER
INCOME STATEMENT

	$	% of Sales
NET SALES	160.5	_____
Cost of Goods Sold	93.0	_____
GROSS MARGIN	_____	_____
Operating Expenses:	_____	_____
Fixed	7.0	_____
Variable	39.0	_____
TOTAL OPERATING EXPENSES	_____	_____
NET OPERATING PROFIT	_____	_____

3. Use the 6-month result figures to answer each question and show your computations.

6-Month Results

Net Sales Volume	$250,000
Cost of Goods Sold	100,000
Total Operating Expenses	130,000
Other Income	2,500
Taxes	3,000

a. What is the gross margin in dollars and percent?

b. Compute the net operating profit.

c. Calculate the net profit before income taxes.

d. Calculate the net profit in dollars and percent.

e. Explain what the net profit figure represents per dollar received.

4. Set up a skeletal income statement, showing dollar figures and percentages based on the information provided below.

	$	%
Gross Sales	$225,000	
Cost of Goods Sold		54%
Customer Returns	4,500	
Total Operating Expenses		42%

5. Calculate and write in the missing figures on Figure 3.9.

 a. GM% for LY (last year).

 b. TY's cost of goods sold dollars.

 c. LY's total operating expenses percent to sales.

 d. Last year's net operating profit dollars.

 e. This year's net operating profit percent.

FOR ALL SEASONS

For All Seasons Skeletal November Accessories Income Statement

	Dollar Amount		Percent of Sales	
	TY	LY	TY	LY
Net Sales Volume	$38.5	$35.0	100.0%	100.0%
Cost of Goods Sold	–	19.2	54.5%	54.9%
Gross Margin of Profit	$17.5	$15.8	45.5%	%
Operating Expenses:				
Fixed $				
Variable +				
$10,000				
Total Operating Expenses	–10.0	$9.8	26.0%	%
NET OPERATING PROFIT	$ 7.5	$	%	17.1%

Figure 3.9.

6. Using the income statement in problem 5, calculate the net sales increase and the net operating profit dollar increase over last year. Show your calculations below.

7. Per sales dollars received on your completed income statement (Figure 3.9), write the answers below for this year's:

 a. Gross Margin _____

 b. Total Operating Expenses _____

 c. Net Operating Profit _____

8. Sales have dropped 15% for the last 3 months. What steps would you take to maintain your desired net profit goal?

9. The For All Season's Workout Wear buyer created two pro forma (projected) income statements to analyze upcoming business. Complete each statement by filling in the blanks and then answer the questions.

	#1		#2	
	$	%	$	%
NET SALES	$125,000	100.0	$135,000	_____
Cost of Goods Sold	_____	_____	$ 78,000	_____
GROSS MARGIN	50,000	_____	_____	42.2
Operating Expenses	37,500	_____	37,500	_____
NET OPERATING PROFIT	$_____	_____	$_____	_____

 a. Analyze each statement thoroughly describing the interaction of the five basic profit components.

 b. Select the pro forma income statement that the buyer should strive to achieve. Explain the reasons for your decision.

FOR ALL SEASONS

For All Seasons Skeletal Quarterly Sports Apparel Income Statement

	Dollar Amount		Percent of Sales	
	TY	LY	TY	LY
Net Sales Volume	$368.5	$335.0	100.0%	100.0%
Cost of Goods Sold	−186.1	175.0	50.5%	52.5%
Gross Margin of Profit	$182.4	$160.0	49.5%	47.8%
Operating Expenses:				
Fixed $ 33,500	$ 72.0	$ 63.7	19.5%	19.0%
Variable + 72,000	$ 33.5	$ 33.5	9.1%	10.0%
$105,500				
Total Operating Expenses	−105.5	97.2	28.6%	29.0%
NET OPERATING PROFIT	$ 76.9	$ 62.8	20.9%	18.8%

Figure 3.10.

10. You are hired as a consultant to help For All Seasons increase their profitability. Your first project is to review the last quarterly sports apparel income statement, as outlined in Figure 3.10, and make recommendations to increase net operating profit. Note that cash discounts will now be accounted for in the cost of goods sold calculation. Detail your recommendations below.

PART

II

PRICING STRATEGIES

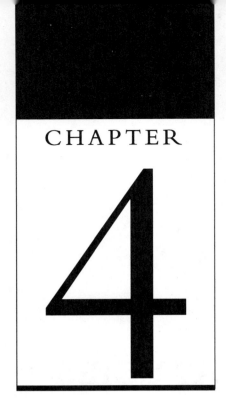

PRICING CONSIDERATIONS

When pricing merchandise, the retailer considers the following **five key pricing considerations** that determine a retail price:

1. What the customer would be willing to pay

2. Pricing strategy

3. Pricing terms

4. Gross margin percent plan

5. Initial markup/markon

WHAT THE CUSTOMER WOULD BE WILLING TO PAY

five key pricing considerations—determination of retail price based on what customer would be willing to pay, pricing strategy, pricing terms, gross margin percent plan, and initial markup/markon

The retailer works toward satisfying the targeted customer group by realistically pricing the goods to produce sales and profit. Uppermost in the retailer's mind is the initial selling price. Will the customer respond to it? Or, will price reductions be necessary, therefore reducing the initial profit and potentially losing customers who did not respond at first because of price?

The successful retailer focuses on what the customer would be willing to pay by:

1. Regularly spending time on the selling floor working with and listening to customers. What did the customer come in to buy? Did the customer buy it? Why? Why not?

2. Shopping the competition within the local trading area every month to stay well-informed regarding all of the competitors' activities in merchandise, price, and service offerings. What is selling? At what price? What is not?

3. Reviewing the targeted customer group regularly to identify possible changes occurring among customers, which could affect business. Is a major employer planning to "streamline" its operation? Are economic changes taking place?

4. Continually listening to employees and vendors, attending trade shows and local events, and reading trade and business publications.

5. Identifying the "ideal" retails the customer responds to without price reductions from the analysis of sales and markdown (price reduction) records.

PRICING STRATEGY

pricing strategy—plan outlining a store's pricing policy based on the consideration of pricing above, equal to, or below competition; leader pricing; price lining; and odd and/or even pricing

A store's **pricing strategy**, which contributes to the image of the store, must be evaluated before setting retail prices. There are four key pricing strategies to be considered:

1. Pricing above, equal to, or below the competition

2. Leader pricing

3. Price lining

4. Odd and/or even pricing

PRICING ABOVE, EQUAL TO, OR BELOW THE COMPETITION

When pricing merchandise, the retailer must determine if an item should be priced above, equal to, or below the competition. Listed below are each of the three pricing levels and the reasons why an item would be priced in one of them.

1. Pricing *above* the competition

 a. Suggests exclusive merchandise and reinforces the store image

 b. Store provides exceptional customer services

 c. Store has a captive market (i.e., open 24 hours a day)

2. Pricing *equal* to the competition

 a. Recognizes customers' price awareness on widely distributed merchandise

 b. Acknowledges that customers shop for the best price especially on big ticket items

 c. Prices guided by manufacturer's suggested retail prices and standard trade gross margin goals

3. Pricing *below* the competition

 a. Promotes values to increase traffic

 b. Selectively prices basic stock items to capture market share

 c. Offers multiple purchase opportunities on frequent replacement merchandise

LEADER PRICING

leader pricing—when one or more items are selected and priced below normal gross margin potential with goal of increasing traffic and conveying idea that merchandise is priced low

Leader pricing occurs when one or more items are selected and priced below the normal gross margin potential hopefully with the goal of increasing traffic and conveying the idea that all merchandise is priced low.

Merchandise selected for leader pricing must have the following characteristics:

1. Universal appeal to the targeted customer group

2. Requires frequent replacement

3. Widely known price

For All Seasons' merchandise for leader pricing might include tennis balls and white 100% cotton sports socks.

loss leader—item that is knowingly priced below cost

Leader pricing is not to be confused with loss leaders. A **loss leader** is an item that is knowingly priced below cost. The merchandise is priced to sell at a loss with the expectation that customer traffic will increase and that customers will purchase other merchandise that is priced with higher profit potential.

PRICE LINING

price lining—sets forth specific pricing guidelines for merchandise within a category, department, or total store

Price Lining sets forth specific pricing guidelines for merchandise within a category, department, or total store. These guidelines are based on the belief that potential customers have an idea of the quality they want and the price they are willing to pay. **Price lines**, specific price points, are created and regularly updated

price lines— specific price points

shopping goods—merchandise that customers want to inspect and compare in relatively broad assortments of different styles, colors, and sizes before selection

price zone—a series of price lines that produce the strongest sale of units within an assortment of merchandise; where purchases are concentrated to maximize sales and profits

based on sales records that enable the retailer to pinpoint the prices at which the targeted customer group best responds. Price lines are suited for **shopping goods**, merchandise that customers want to inspect and compare in relatively broad assortments of different styles, colors, and sizes before selection. Sweaters and pants are examples of shopping goods.

Price lines are classified within price zones. A **price zone** is a series of price lines that produce the strongest sale of units within an assortment of merchandise targeted for a specific customer group. Price lines are typically grouped into three price zones:

1. The *lowest zone* establishes the lowest prices for which merchandise may be offered for sale.

2. The *median zone* specifies the average pricing structure that produces the highest sales volume and where the majority of purchases are concentrated.

3. The *highest zone* sets the highest prices for the "prestige layer" of merchandise.

A sunglasses price line structure may be as follows:

Lowest Price Zone	$19.00–$25.00
Median Price Zone	$29.00–$40.00
Highest Price Zone	$45.00–$65.00

Another example of a price line structure is illustrated in Figure 4.1.

Promotional and clearance price lines within each price zone may also be created. It is important to note the price "gap" between each zone. This gap distinguishes each targeted customer group. An easy way to test the success of each price line within each price zone is to remove the price tickets and select the merchandise that belongs to each price zone. If it is too difficult to determine based on the quality or style or other characteristics of the merchandise, then the price lines and price zones are too closely set.

The advantages of price lining are as follows:

1. *Increases sales*

 a. Wide assortment offered at targeted customer prices

 b. Display emphasis on price and "perceived values"

 c. Prompts customers to buy now, not later, with concentrated price assortment

2. *Reduces costs*

 a. Shortens merchandise receiving and processing time

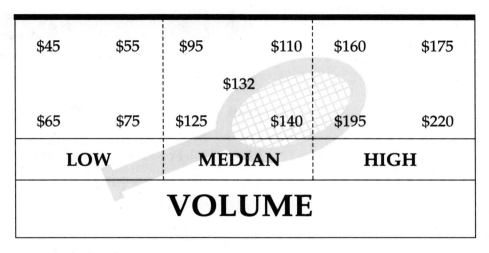

$45	$55	$95	$110	$160	$175
			$132		
$65	$75	$125	$140	$195	$220

LOW	MEDIAN	HIGH

VOLUME

Figure 4.1. Price Line Structure

 b. Speeds up internal paperwork flow

 c. Decreases accounting time

3. *Improves profits*

 a. Reduces buying costs by concentrating purchases with fewer resources

 b. Increases the opportunity for quantity discounts, advertising allowances, and improved payment terms

 c. Decreases markdowns and increases stock turnover

ODD AND/OR EVEN PRICING

odd and/or even pricing—specifies use of odd and/or even pricing digits as price point endings

Odd and/or even pricing specifies the use of odd and/or even price endings (i.e., $.99, $.40, $.00); these are commonly referred to as price point endings. Establishing price point endings facilitates the setting of prices and provides for pricing consistency throughout the retail operation.

 Retailers must consider their store image when predetermining odd and/or price point endings. Some points to consider when establishing or evaluating the store's pricing policy are:

1. The use of odd price point endings, such as $2.99, is said to give the impression of lower prices.

2. Even price point endings, such as $25.00, imply "better" merchandise.

3. Many stores use a combination of odd and even price point endings—even for regularly priced merchandise; odd for sale merchandise.

4. When setting prices, rounding up to $.99 will generate $.04 additional gross margin versus pricing at $.95.

EXAMPLE:

For All Seasons Pricing Policy

Regular	.00 price point endings
Promotional	.40 price point endings*
Clearance	.99 price point endings

* For All Seasons stocks merchandise for *four* seasons, and $.40 price point endings reinforces the store's image during promotions.

1. What factors are involved in determining what the customer would be willing to pay?

2. For All Seasons just received the following merchandise:

 a. White sweat socks

 b. Mink ear muffs

 c. Ski wax

 Determine which category each item would be priced under and explain why.

 Pricing above the competition:

 Pricing equal to the competition:

 Pricing below the competition:

3. Explain the difference between a loss leader and the concept of leader pricing.

4. For All Seasons stocks a variety of 100% wool hats. Refer to Figure 4.2 to answer the questions.

HIGH	$55.00
MEDIAN OR VOLUME	$35.00 $30.00 $25.00 $20.00
LOW	$15.00

Figure 4.2. 100% Wool Hats Price Zones

 a. What are the price zones for the 100% wool hats?

b. What are the price lines of the hats?

c. What are the price points For All Seasons has chosen for retail sale of the hats?

5. As the For All Seasons outerwear buyer, you must set up price zones for ski jackets.

Sales records revealed:

500 pieces sold @ $80.00	75 pieces sold @ $120.00
200 pieces sold @ $60.00	25 pieces sold @ $150.00
325 pieces sold @ $95.00	75 pieces sold @ $ 50.00

Set up the following price zones:

Lowest price zone:

Median price zone:

Highest price zone:

What opportunities for adjustments to the existing price lines and price zones exist?

PRICING TERMS

cost price–actual cost of merchandise shown on invoice or purchase order, including trade, quantity, seasonal and promotional discounts, and transportation charges when applicable

markup–amount added to the cost, which covers the "overhead" burden (operating expenses) and which will yield the desired net profit

original retail price–first price set on goods for sale

selling retail price–actual dollar amount received for goods sold

Before the individual retail prices can be set, the retailer must understand the three basic elements of pricing:

1. **Cost price**, or the actual cost of the merchandise as shown on the invoice or purchase order. This includes trade discounts, quantity, seasonal and promotional discounts, and transportation charges if applicable.

2. **Markup**, or the amount added to the cost, which covers the "overhead burden" (the operating expenses) and which will yield the desired net profit. Markup is abbreviated as **MU**.

3. **Retail Price**, which is defined two ways:

 a. **Original retail price**—the *first* price set on goods for sale

 b. **Selling retail price**—the *actual* dollar amount received

Formulas for Interaction of the Three Pricing Elements

Cost + Markup = Retail	Retail − Cost = Markup	Retail − Markup = Cost

These three elements enable profitable pricing calculations to be made.

The retailer uses three pricing methods in determining the retail price for goods.

1. Markup on cost

2. Markup on retail

3. Keystone

The illustration in Figure 4.3 displays the relationship of markup to retail or cost dollars, and how it is calculated using each of the three pricing methods.

Column A assumes a cost price of $7.00 and a retail price of $10.00, hence, the markup dollars equal $3.00.

Formula for Calculating Markup on Cost

$$\frac{\text{Retail Price} - \text{Cost Price}}{\text{Markup Dollars}} \quad \frac{\text{Markup \$}}{\text{Cost \$}} = \textbf{MU\% on Cost}$$

Therefore,

$$\frac{\$10.00 - 7.00}{\$\ 3.00\ \text{MU\$}} \quad \frac{\$3.00\ \text{MU\$}}{\$7.00\ \text{C\$}} = \textbf{42.9\% MU\%}$$

Formula for Calculating Markup on Retail

$$\frac{\text{Retail Price} - \text{Cost Price}}{\text{Markup Dollars}} \quad \frac{\text{Markup \$}}{\text{Retail \$}} = \textbf{MU\% on Retail}$$

Therefore,

$$\frac{\$10.00 - 7.00}{\$\ 3.00\ \text{MU\$}} \quad \frac{\$\ 3.00\ \text{MU\$}}{\$10.00\ \text{R\$}} = \textbf{30\% MU\%}$$

Column B displays the same relationship but assumes a cost price of $6.00 and a retail price of $10.00, hence the markup dollars equal $4.00.

Retail$	$10.00	$10.00	$10.00
Cost$	$7.00	$6.00	$5.00
Markup$	$3.00	$4.00	$5.00
Markup on Cost	42.9%	66.7%	100.0%
Markup on Retail	30.0%	40.0%	50.0%

Figure 4.3. The Three Pricing Methods

Markup on Cost:

$$
\begin{array}{r}
\$10.00 \\
-\ \underline{6.00} \\
\$\ 4.00\ \textbf{MU\$}
\end{array}
\qquad
\frac{\$4.00\ \text{MU\$}}{\$6.00\quad \text{C\$}}\ =\ \textbf{66.7\% MU\%}
$$

Markup on Retail:

$$
\begin{array}{r}
\$10.00 \\
-\ \underline{6.00} \\
\$\ 4.00\ \textbf{MU\$}
\end{array}
\qquad
\frac{\$\ 4.00\ \text{MU\$}}{\$10.00\quad \text{R\$}}\ =\ \textbf{40.0\% MU\%}
$$

Column C addresses the keystone approach and the resultant markup percents based on markup on cost and markup on retail. The keystone approach is the method of pricing in which the cost of an item is doubled to arrive at the retail price.

Therefore, assuming a cost of $5.00, the retail price becomes $10.00.

$$
\begin{array}{r}
\$\ 5.00\ \text{C\$} \\
\text{x}\ \underline{\quad 2} \\
\textbf{\$10.00\ R\$}
\end{array}
$$

$$
\begin{array}{r}
\$10.00\ \text{R\$} \\
-\ \underline{5.00\ \text{C\$}} \\
\$\ 5.00\ \textbf{MU\$}
\end{array}
\qquad
\frac{\$5.00\ \text{MU\$}}{\$5.00\quad \text{C\$}}\ =\ \textbf{100.0\% MU\%}
$$

The markup percent under the markup on cost method equals 100.0%.

Under the markup on retail method,

$$
\begin{array}{c}
\$10.00 \text{ R\$} \\
- \quad 5.00 \text{ C\$} \\
\hline
\$\ 5.00 \text{ MU\$}
\end{array}
\qquad
\frac{\$\ 5.00 \text{ MU\$}}{\$10.00 \quad \text{R\$}} = \ \mathbf{50.0\%\ MU\%}
$$

The markup equals 50.0%.

These concepts will be fully detailed in Chapter 5.

SELF QUIZ

1. Name the three basic elements of pricing and define each.

2. Fill in the blanks.

 Retail – Cost = _____

 Retail – Markup = _____

 Cost + _____ = Retail

3. Define retail price in two ways.

4. Complete the following chart by supplying the cost price, the markup, or the retail price.

Cost	Markup	Retail
$5.00	$	$15.00
$	$9.75	$18.99
$4.25	$5.15	$

5. Complete the formulas given that retail is $18.00, cost is $9.00.

 Markup $_____

 Markup Percent on Cost _____%

 Markup Percent on Retail _____%

 What method of setting the retail price was used in this example?

GROSS MARGIN PERCENT PLAN

gross margin percent plan—margin percent necessary to cover overhead and produce a profit

The **gross margin percent plan** is used as the overall guide in determining an initial markup figure on which to base pricing decisions. It is the margin percent necessary to cover the overhead and produce a profit.

Existing income statements are analyzed first to ensure that gross margin percent is high enough to operate the business profitably. If it is not sufficient, or if there are no records to date, projected income statements are created and the potential results are reviewed and analyzed until a realistic and achievable gross margin percent is determined.

For planning purposes, the gross margin percent plan is calculated without adjustments for cash discounts and *alteration and workroom expenses* (total costs incurred in preparing merchandise for sale). It is the difference of *net sales volume* (gross sales less discounts and customer returns and allowances) and *gross cost of goods sold* (the inventory value before alteration and workroom costs), divided by net sales volume.

Formula for Calculating Gross Margin Percent Plan

$$\frac{\$ \text{ Net Sales Volume} - \$ \text{ Gross Cost of Goods Sold}}{\$ \text{ Net Sales Volume}} =$$

$$\frac{\$ \text{ Gross Margin (GM)}}{\$ \text{ Net Sales Volume}} = \textbf{GM\%}$$

maintained markup percent—difference of net sales volume and gross cost of goods sold divided by net sales volume

The gross margin percent is also referred to as the maintained markup percent. The **maintained markup (MMU) percent** is equal to gross margin if alteration and workroom expenses and cash discounts are not factors in the cost of goods sold calculation. Maintained markup is an historical figure just as actual gross margin is, but both are useful in planning the necessary margin percent to cover operating expenses and to produce a profit.

Something to Consider: Basic Maintained Markup and Gross Margin Formulas

Maintained Markup

$$\begin{array}{r} \text{Net Sales} \\ - \underline{\text{ Gross Cost of Goods Sold}} \\ \textbf{Maintained Markup \$ (MMU\$)} \end{array}$$

$$\frac{\text{MMU\$}}{\text{Net Sales \$}} = \textbf{MMU\%}$$

The actual results after inventory reductions are taken into account. Markdowns, discounts, and theft reduce the value of inventory.

Gross Margin

$$\begin{array}{r} \text{Net Sales} \\ - \underline{\text{ Total Cost of Goods Sold}} \\ \textbf{Gross Margin \$ (GM\$)} \end{array}$$

$$\frac{\text{GM\$}}{\text{Net Sales \$}} = \textbf{GM\%}$$

When there are no workroom or alteration costs, then GM$ = MMU$.

Formula for Calculating Maintained Markup Percent

$$\frac{\$ \text{ Net Sales Volume} - \$ \text{ Gross Cost of Goods Sold}}{\$ \text{ Net Sales Volume}} =$$

$$\frac{\$ \text{ Gross Margin (GM)}}{\$ \text{ Net Sales Volume}} = \textbf{MMU \% or GM \%}^*$$

EXAMPLE:

For All Seasons November net sales volume was $100,000 with a gross cost of goods sold totaling $58,000.

$$\frac{\$100,000 - \$58,000}{\$100,000} =$$

$$\frac{\$ \ 42,000}{\$100,000} = \textbf{42\% MMU\% or GM\%}^*$$

* Gross margin percent is the result if alteration and workroom expenses and cash discounts are not factors in the cost of goods sold calculation.

If they are factors gross margin percent is calculated as:

MMU% + Cash Discounts % – Alteration & Workroom % = **GM%**

EXAMPLE:

Using the 42% MMU% illustrated in the previous example, include alteration and workroom costs, which represent 2% of net sales volume and cash discounts of 10%.

42% MMU% + 10% Cash Discounts - 2% Alteration & Workroom Costs = **50% GM%**

SELF QUIZ

1. Define gross margin percent plan and explain its importance.

2. Maintained markup percent is equal to gross margin percent if alteration and workroom expenses and cash discounts are not factors in the cost of merchandise calculation.

 True **False**

3. Write the GM% formula below if alteration and workroom expenses and cash discounts are factors in the cost of goods sold calculation.

4. For All Seasons net sales volume was $110,000. The gross cost of goods sold was $55,000.

a. What is the gross margin dollar amount?

b. Compute the gross margin percent plan and show your calculations below.

c. Calculate the maintained markup percent (MMU%).

INITIAL MARKUP/MARKON

initial markup/markon—difference between original retail price and cost price; when expressed as a percent, it is a percentage of the retail price

After determining the necessary gross margin percent, the initial markup figure is calculated. **Initial markup (IMU)**, also called **markon** (the first markup), is the difference between the original retail price and the cost price. When expressed as a percent, it is a percentage of the retail price.

Formula for Calculating Initial Markup

Original Retail Price	$20.00
Less: Cost Price	− 10.00
Initial Markup	**$10.00**

Formula for Calculating Initial Markup Percent

$$\frac{\$\ \text{Initial Markup}}{\$\ \text{Original Retail Price}} = \frac{\$10.00}{\$20.00} = \textbf{50\% IMU}$$

The initial markup takes into account the gross margin percent plan. The initial markup also includes the fact that not all merchandise will sell at the original price affixed to goods. Some merchandise will be sold at a reduced price to satisfy customers and employees, promote values, and correct operating and buying errors. Other merchandise will "disappear"—there will be a **shortage**, the difference between two physical inventory counts not accounted for in sales. The initial markup provides the "cushion" for reductions—the inherent part of doing business.

shortage— difference between two physical inventory counts not accounted for in sales

Formula for Initial Markup of Pricing

COST	+	MARKUP	=	RETAIL
merchandise cost		desired net profit		net sales
shipping charges		reductions		reductions
trade & quantity discounts		operating expenses*		shortage

* Operating expenses include shortages because they are a result of poor operating controls of pilferage and paperwork errors in receiving and processing goods.

The initial markup (IMU) is greater than the planned gross margin because it anticipates reductions.

Formula for Initial Markup
GROSS MARGIN*

$$\frac{\text{Reductions} + [\text{Operating Expenses} + \text{Profit}]}{\text{Reductions} + \text{Shortage} + \text{Net Sales Volume}} = \text{IMU}$$

* Planned operating expenses plus planned profit are equal to gross margin.

The initial markup formula is illustrated in dollars and percents below.

EXAMPLE:

IMU Dollars

$$\frac{\substack{\$5,000 \\ \text{Reductions}} + \substack{\$40,000 \\ \text{Gross Margin}}}{\substack{\$5,000 \\ \text{Reductions}} + \substack{\$100,000 \\ \text{Net Sales Volume}}} =$$

$$\frac{\$45,000}{\$105,000} = \begin{matrix}42.9\% \\ (42.85)\end{matrix} = \textbf{IMU\%}$$

EXAMPLE:

IMU Percent

$$\frac{.05 + .40}{.05 + 1.00} = \frac{.45}{1.05} = \frac{42.9\%}{(42.85)} = \textbf{IMU\%}$$

The initial markup percent of net sales volume is the important factor for comparison to income statements and industry results. As illustrated, \$.429 or \$.43 per sales dollar must be added to the cost price to cover operating expenses and produce a profit.

SELF QUIZ

1. Complete the formula below.

 $$\frac{\substack{\text{Original Retail} \\ - \,\rule{2cm}{0.4pt}} }{\text{Initial Markup}} \quad \frac{\rule{2cm}{0.4pt}}{\text{Original Retail}} = \rule{2cm}{0.4pt} \%$$

2. Define the term shortage and explain its relationship to initial markup.

3. For All Seasons stocks ski poles, which retail @ \$129.00. Their cost is @ \$90.00.

 a. What is the initial markup in dollars?

b. What is the initial markup percent?

4. Below are the season's income statement plans, which have been analyzed and are satisfactory for the retailer's goals and comparable to industry standards. Calculate the IMU%.

Net Sales Volume	$600,000	100.0 %
Cost of Goods Sold	390,000	65.0 %
Gross Margin	$210,000	35.0 %
Total Reductions	$ 36,000	6.0 %
Shortage	$ 12,000	2.0 %

CHAPTER REVIEW

1. As the sports shoe buyer for For All Seasons, sales have fallen behind plan. Describe what steps you would take to correct slipping sales.

2. As the workout wear buyer, you must select and present two items for leader pricing at the upcoming management meeting. Make your selection from the merchandise list below and prepare your written presentation explaining why each item was selected and the benefits that your department will contribute to sales, profits, and customer relations.

Sweat bands	Leggings
Sports bottles	Warmup Suits
Leotards	Sports socks
Tank tops	Workout shorts

3. Name five advantages of price lining.

4. You have been given carte blanche in developing the new Gift Department for For All Seasons. Select 12 items, set price lines, and group under three price zones. Explain your selection, pricing, and grouping of the 12 items.

5. The price lines for tennis rackets are as follows:
$78 $40 $65 $54 $75 $69 $72 $60 $58

 a. Group the price lines into the lowest, median, and highest price zones.

 b. Examine the price lines within each price zone and describe what adjustments you would make.

6. Explain the advantages of having both odd and even price point endings on merchandise.

7. Visit three stores and prepare a report on each store's price point ending policy.

8. List and define two types of retail prices.

9. The three pricing elements interact as follows. Place an X under the True or False column.

	True	False
Cost + Retail = Markup		
Markup + Cost = Retail		
Retail – Cost = Markup		
Markup – Retail = Cost		

10. What costs must be considered before setting initial retail prices?

11. Explain the importance of determining a gross margin percent plan on which to base pricing decisions.

12. Under what circumstances does the gross margin percent equal the maintained markup percent?

13. Define IMU and IMU%.

14. Explain in detail why the IMU% plan is greater than the GM% plan.

15. Explain why gross margin and maintained markup are historical figures and why they are useful in planning.

<div style="text-align:center">**CHAPTER TEST**</div>

1. Fill in the blank spaces in the chart below.

#	Cost	Markup	Retail
A	$.	$ 11.25	$ 21.50
B	$ 4.32	$.	$ 9.40
C	$16.00	$ 18.00	$.
D	$12.00 dz.	$ 1.40 ea.	.
E	$ 9.18	$.	$ 26.00
F	$.	$166.90	$299.00
G	$72.00 dz.	$.	$ 12.40

2. An item cost $6.50 and retails for $12.40. What is the markup on cost? The markup on retail?

3. Use the figures provided below and show your calculations for each problem.

	$	%
Net Sales Volume	$92,000	100.0
Gross Cost of Goods Sold	47,840	52.0
Cash Discounts	2,760	3.0
Alteration & Workroom Costs	3,680	4.0

a. Compute the gross margin percent plan without adjustments for cash discounts and alteration and workroom costs.

b. Calculate the maintained markup percent.

c. Include cash discounts and alteration and workroom costs to determine the gross margin percent plan.

d. Which answer would you select for planning purposes? Why?

4. For All Seasons' management has decided to include a 2% cash discount percent and a 1% alteration and workroom percent in the gross margin percent plans. Planned net sales total $105,000, with a gross cost of goods sold of $52,000.

a. Compute the maintained markup percent (MMU%).

b. What is the gross margin percent plan?

5. April plans are as follows:

Net Sales Volume	$125,000
Gross Cost of Goods Sold	50,000
Cash Discounts	1,200
Alteration & Workroom Costs	2,800

a. Complete the Cost of Goods Sold formula.

Gross Cost of Goods Sold	$
Less: Cash Discounts	–
Plus: Alteration & Workroom Costs	+
Cost of Goods Sold	$

b. Compute the gross margin percent plan.

c. What is the gross margin percent plan without cash discounts and alteration and workroom costs? Show your calculations below.

d. Calculate the maintained markup percent.

6. Licensed sports caps cost $9.80 each and the initial retail price is $14.00.

a. Calculate the initial markup (IMU).

b. Compute the initial markup percent (IMU%).

7. 120 flashlights are purchased at $6.00 each. The invoice includes shipping charges totaling $15.00.

a. What is the cost per flashlight?

b. The initial retail price is $15.00. Compute the IMU.

c. What is the IMU%?

8. The gift department of For All Seasons is planning a 52.5% initial markup percent (IMU%). Anticipated reductions total 4.5%. Find the maintained markup percent (MMU%).

9. For All Seasons' quarterly plans are as follows:

Net Sales Volume	$335,000
Operating Expenses	97,200
($6,700 planned shortage)	
Reductions	16,750
Profit	62,800

a. Calculate the IMU%.

b. What amount per sales dollar must be added to individual cost prices to cover operating expenses and produce a profit?

10. The accessories buyer's March plans include net sales of $25,400, operating expenses totaling $3,888, shortage of $279, $660 in reductions, with a planned profit of $2,512.

a. What is the gross margin plan in dollars and percent?

b. Compute the initial markup necessary to cover expenses and produce the planned March profit.

c. Explain why the answer to (a) is greater than the answer to (b).

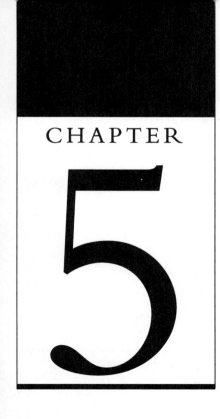

CHAPTER 5

ITEM PRICING

Pricing is the act of fixing or establishing a price for goods. While keeping the five key pricing factors in mind (what the customer would be willing to pay, pricing strategy, pricing terms, gross margin percent plan, initial markup/markon), the retailer calculates a retail price using one of three pricing methods.

1. Markup on cost

2. Markup on retail

3. Keystone

Each pricing method enables the retailer to set a price for the goods. The most commonly used is the markup on retail method. It is important to understand each method because suppliers quote potential margins by all three methods.

THE MARKUP ON COST METHOD OF ITEM PRICING

pricing—fixing or establishing a price for goods

markup on cost—cash or percentage difference between retail price and cost price; when expressed as a percent, it is a percentage of the cost price

markup percent on cost method—used by retailer to arrive at selling price by taking cost price and marking it up or by adding a percentage

cost complement percent—percentage difference between total retail price, valued at 100%, and initial markup percent (CC%)

Markup on cost is defined as the cash or percentage difference between the retail price and the cost price. When expressed as a percent, it is a percentage of the cost price. For example, if an item costs $6.00 and is priced at $15.00, the markup is $9.00, which is 150% of cost.

Formula for Calculating Markup on Cost

$$
\text{Less:} \quad \frac{\substack{\text{Retail Price} \\ \text{Cost Price}}}{\textbf{Markup Dollars}} \qquad \frac{\text{Markup \$}}{\text{Cost \$}} = \textbf{MU\%}
$$

In using the **markup percent on cost method**, the retailer takes the cost price and marks it up, or adds a percentage, to arrive at the selling price.

Formula for Calculating Retail Price

Cost price and the desired initial markup percent are known:

$$C\$ = \$ 6.00 \qquad\qquad IMU\% = 60\%$$

First, calculate the **cost complement percent.** Initial markup percent is always a percent of retail, so retail = 100%. The difference between 100% and the selected IMU% = cost complement percent (CC%).

EXAMPLE:

$$
\begin{array}{r}
100\% \\
- \quad 60\% \\
\hline
= \quad \textbf{40\% CC\%}
\end{array}
$$

markup percent on cost—found by dividing the initial markup percent by the cost complement percent

Second, find the **markup percent on cost**.
Divide the initial markup percent by the cost complement percent.

EXAMPLE:

$$\frac{60\%}{40\%} = \textbf{150\% MU\%}$$

markup dollars—the difference between retail and cost price; the markup percent on cost multiplied by the cost price

Third, calculate the **markup dollars.**
Multiply the markup percent on cost times the cost price.

EXAMPLE:

$$\begin{array}{r} \$6.00 \\ \times\ 1.50 \\ \hline \textbf{\$9.00 MU\$} \end{array}$$

Finally, find the retail price.
Add cost and markup dollars.

Something to Consider: Short-Cut Method of Calculating Markup Dollars

markup percent multiplier—cost, valued at 100% plus markup percent

First, calculate the **markup percent multiplier**: 100% + MU% = Multiplier. 100% represents the value of these calculations as they are all based as a percentage of cost. Cost, therefore, represents 100%.

Then, find the retail price.
Multiply the cost by the mutiplier.

EXAMPLE:

$$\begin{array}{r} 100\% \\ +\ 150\% \\ \hline \textbf{250\%} \end{array} \textbf{Multiplier} \qquad\qquad \begin{array}{r} \$6.00 \\ \times\ 2.50 \\ \hline \textbf{\$15.00 R\$} \end{array}$$

EXAMPLE:

$$\begin{array}{r} \$6.00 \\ +\ 9.00 \\ \hline \textbf{\$15.00 R\$} \end{array}$$

Formula for Calculating Cost Price

Retail price and markup percent on cost are known:

R\$ = \$15.00 $\qquad\qquad$ MU% on Cost = 150%

$$\frac{R\$}{100\% + MU\%\text{ on Cost}} \qquad\qquad \frac{\$15.00}{100\% + 150\%} =$$

$$\frac{\$15.00}{250\%} = \frac{\$15.00}{2.50} = \textbf{\$ 6.00 C\$}$$

Formula for Calculating Markup Percent on Cost

Retail price and cost price are known:

$$R\$ = \$15.00 \qquad\qquad C\$ = \$6.00$$

$$\frac{R\$ - C\$}{C\$} = \frac{MU\$}{C\$} = \frac{\$9.00}{\$6.00} = 1.50 = 150\%\ MU\%$$

It is important to understand this method of pricing because many vendors will quote potential markup figures with the cost method. The cost method markup percent will always be a higher markup figure than under the retail method. The $9.00 markup for an item that costs $6.00 and retails for $15.00 has a markup on cost of 150% and a markup on retail of 60%. This will help prevent you from purchasing goods under incorrect profit assumptions and avoid incorrect percentage comparisons to income statements and other financial documents.

SELF QUIZ

1. Calculate the retail price for each of the following problems.

 a. A flashlight costs $15.00. The desired IMU% is 45%.

 b. The desired IMU% is 60%. What is the retail price for baseball caps that cost $3.25? $3.74?

 c. A sports bag costs $9.00. The desired IMU% is 58%.

 d. The desired IMU% is 50%. What is the retail price for baseball mitts that cost $18.00? $22.00?

2. Find the cost price for the following items.

 a. A picnic basket set retails for $59.99. MU% on cost is 85%.

b. A 30-quart foam cooler is priced at $4.99. MU% on cost is 92%.

c. A pair of water skis retails for $199.00. MU% on cost is 45%.

d. A water ski tow rope is priced at $39.99. MU% on cost is 64%.

3. Find the markup percent on cost for the merchandise listed below.
 a. Key chains sell for $3.50. They cost $1.50.

 b. Sunblock costs $4.00 and is priced at $5.99.

 c. Ladies lightweight jackets retail for $65.00. They cost $30.00.

 d. Spring ski hats cost $12.00 and are priced at $18.00.

4. Use the markup on cost short-cut method to find the retail price for cross country skis having a 30% initial markup and a cost of $120.00.

THE MARKUP ON RETAIL METHOD OF ITEM PRICING

markup on retail— cash or percentage difference between retail price and cost price; when expressed as a percent, it is a percent of the retail price

markup percent on retail method— difference between cost and retail expressed as a percentage of the retail price, which is valued at 100%

Markup on retail is defined as the cash or percentage difference between the retail price and the cost price. When expressed as a percent, it is a percentage of the retail price. For example, if an item costs $6.00 and is priced at $15.00, the markup is $9.00, which is 60% of retail.

Formula for Calculating Markup on Retail

Retail Price

Less: Cost Price

Markup Dollars

$$\frac{\text{Markup \$}}{\text{Retail \$}} = \textbf{MU\%}$$

Markup percent on retail method means that the retail price is valued at 100%. Everything else is a lesser percent of that.

This method of calculating retail price, expressed as a percent of net sales volume, provides insight into the financial aspect of a business by providing ratios for comparison and analysis of income statements and other financial documents. As detailed in Chapter 3, financial statement results are represented as a percentage (ratio to 100) of net sales volume.

Note: Retailers and vendors who work within the gift, drug, convenience store, and mass merchandise markets will frequently refer to markup, under the retail method, as gross margin or gross profit to emphasize that when setting a retail price the planned markup is expressed as a percentage of the retail price, not the cost price.

Formula for Calculating Retail Price

Cost price and initial markup percent are known:

C$ = $6.00 IMU% = 60%

First, find the cost complement percent:

	100%		100% R%
−	MU%	−	60% MU%
	CC%		**40% CC%**

Then, calculate the retail price:

Divide the cost price by the cost complement percent.

$$\frac{\text{C\$}}{\text{CC\%}} = \frac{\$\,6.00}{.40} = \textbf{\$15.00 Retail}$$

Formula for Calculating Cost Price

Retail price and markup percent on retail are known:

R$= $15.00 MU% = 60%

	R$		$15.00
x	CC%	x	.40
	C$ =		**$ 6.00 C$**

Formula for Calculating Markup Percent on Retail

Retail price and cost price are known:

$$R\$ = \$15.00 \qquad\qquad C\$ = \$6.00$$

$$\frac{R\$ - C\$}{R\$} \;=\; \frac{MU\$}{R\$} \;=\; \frac{\$9.00}{\$15.00} \;=\; .60 \;=\; 60\%\ MU\%$$

SELF QUIZ

1. Calculate the retail price for each of the following problems.

 a. Sun visors cost $4.25. The desired IMU% is 55%.

 b. Golf balls cost $2.25. The desired IMU% is 54%.

 c. Biking gloves cost $9.50. The desired IMU% is 52.5%.

 d. The desired IMU% for tennis rackets is 42%. Three brands are stocked costing $25.00, $38.00, and $45.00 each. Calculate the retail price for each brand of tennis racket.

2. Compute the cost price for the following items.

 a. Soccer balls retail for $29.00. The IMU% is 36%.

b. A set of golf tees is priced at $9.50. The IMU% is 55%.

c. Swimming goggles retail for $6.00 and have an IMU% of 62%.

d. Knee pads are priced at $18.00. The IMU% is 43.5%.

3. Calculate the markup percent on retail for the merchandise listed below.

 a. Sweat bands retail for $6.00. They cost $2.30.

 b. Football jerseys cost $18.00 and are priced to sell for $40.00.

 c. Backpacks cost $15.00 and retail for $29.00.

 d. 100% cotton turtlenecks sell for $20.00. They cost $9.50.

MARKUP ON COST VERSUS MARKUP ON RETAIL PRICING METHODS

Markup on cost and *markup on retail* are two methods of arriving at a selling price. Each produces the same dollars of markup, yet give two very different percentage figures as illustrated in Figure 5.1.

Figure 5.1. Markup on Cost Versus Markup on Retail Pricing Methods

At the outset, calculating markup on cost may be the easier method. However, to comprehend the "whole picture" of business one will find that it is easier to understand the costs of doing business as a percentage of sales or revenue. If markup is quoted on the cost basis, it will not be obvious if expenses are covered and profit is generated. It is in this light that markup on retail is obviously the preferred method. Markup is a term that must be used carefully. The meanings of markup on cost and markup on retail should be fully understood to avoid confusion and costly errors.

To recap the difference between markup on cost and markup on retail:

MU% Cost	**MU% Retail**
R$	R$
− C$	− C$
= MU$	= MU$
MU% = **Percent of Cost**	MU% = **Percent of Retail**
Cost = **100%**	Retail = **100%**
MU% = $\dfrac{\text{MU\$}}{\text{C\$}}$	**MU%** = $\dfrac{\text{MU\$}}{\text{R\$}}$

Markup percent on cost is *always* greater than markup percent on retail, as shown below.

EXAMPLE:

The retail price is $10.00; cost price is $5.00; markup is $5.00.

$$\text{MU\%} = \frac{\$5}{\$5} = \textbf{100\% of C} \qquad \text{MU\%} = \frac{\$5}{\$10} = \textbf{50\% of R}$$

As Table 5.1 clearly illustrates, MU% on cost (column C) is greater than MU% on retail (column A).

Table 5.1. Markup Percent Pricing Table

A Markup on Retail % (IMU%, GM%, GP%)	B Cost Complement (CC%)	C Markup on Cost % (MU%)	D Multiplier MU% + 100%
30%	70%	43%	1.43
35%	65%	54%	1.54
40%	60%	67%	1.67
45%	55%	82%	1.82
50%	50%	100%	2.00
55%	45%	122%	2.22
60%	40%	150%	2.50
70%	30%	233%	3.33
IMU% is always a percent of Retail	100% − IMU% = CC%	$\frac{IMU\%}{CC\%}$ = MU% Cost	MU% + 100% = Multiplier

MARKUP ON COST METHOD | MARKUP ON RETAIL METHOD

To compute retail price:

MARKUP ON COST METHOD	MARKUP ON RETAIL METHOD
1. Find desired IMU% (column A).	1. Find desired IMU% (column A).
2. Multiply Cost x Multiplier in column D.	2. Divide Cost by Cost Complement in column B.

SELF QUIZ

1. Calculate each retail price and write your answers on the lines provided.

Cost	Multiplier	Retail Price
4.20	1.82	$_____
15.95	1.54	_____
118.22	1.67	_____

Cost	IMU %	Retail Price
4.20	45%	$_____
15.95	35%	_____
118.22	40%	_____

2. The retail price of 100% cotton pocket tee shirts is $18.00. The cost price is $10.50. Calculate the markup percent on cost and the markup percent on retail. Show your computations.

 Markup on cost method: _____%

 Markup on retail method: _____%

3. Pima cotton turtlenecks retail for $27.00. The markup percent is 54%. What would their cost be under the markup percent on cost method? The markup on retail method? Show your calculations below.

 Markup on cost method: $_____

 Markup on retail method: $_____

CONVERSIONS OF MARKUP METHODS

The following conversion formulas will enable the retailer to avoid purchasing under incorrect assumptions.

Formula to Convert MU% on Retail to MU% on Cost

Using the following figures to illustrate the conversion of the retail markup to the cost markup:

	$	%
Cost	$ 6.00	40%
Markup	$ 9.00	60%
Retail	$15.00	100%

$$MU\% = \frac{IMU\%}{100\% - IMU\%} \quad \frac{60\%}{100\% - 60\%} =$$

$$\frac{60\%}{40\%} = \textbf{150\% MU\% on Cost}$$

Formula to Convert MU% on Cost to Retail

Using the following figures to illustrate the conversion from the cost markup to the retail markup:

	$	%
Cost	$ 6.00	100%
Markup	$ 9.00	150%
Retail	$15.00	250%

$$MU\% = \frac{MU\%}{100\% + MU\%} \quad \frac{150\%}{100\% + 150\%} =$$

$$\frac{150\%}{250\%} = \textbf{60\% MU\% on Retail}$$

Figure 5.2 provides both formulas for easy markup conversion.

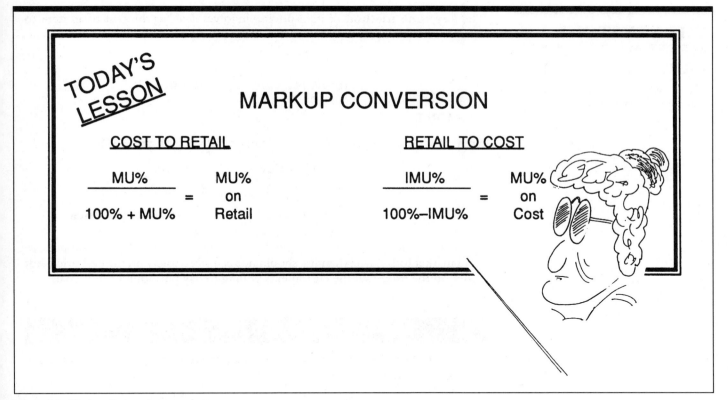

Figure 5.2. Markup Conversion

<div style="background:black; color:white">SELF QUIZ</div>

1. Convert MU% on retail to MU% on cost.

MU% on Retail	MU% on Cost
25%	_____
45%	_____
48%	_____
56%	_____

2. Convert MU% on cost to MU% on retail.

MU% on Cost	MU% on Retail
40%	_____
45%	_____
50%	_____
55%	_____

THE KEYSTONE METHOD OF ITEM PRICING

keystone method–doubling cost of an item to arrive at the retail price

The **keystone method** of item pricing involves *doubling* the cost of an item to arrive at the retail price.

Formula for Calculating Keystone

EXAMPLE:

An item with a cost price of $2.00 is marked with a retail price of $4.00.

Cost Price		**$2.00**	
x	2	x	2
Retail Price		**$4.00 Retail Price**	

This is the easiest approach to pricing but is it the best?

The keystone approach is no longer the best method of pricing in the competitive retail market today. Merchandise should not be priced solely on the cost price, but rather on the price that the customer is willing to pay plus sound profit goals.

SELF QUIZ

1. Given the following cost prices, compute the retail prices using the keystone pricing method.

Cost	Retail Price
2.00	$ _____
9.99	_____
4.50	_____
12.80	_____
16.00	_____
52.65	_____

2. Ladies down ski jackets cost $75.00 each. At what price would they retail using the keystone pricing method?

 a. $135.00

 b. $150.00

 c. $110.00

 d. none of the above

3. A popular brand of rollerblades retails for $80.00. Under the keystone method of pricing, what is the cost of the rollerblades?

4. Using the keystone pricing method, calculate the retail price for thermal underwear sets that cost $23.50.

PRICING METHODS CONSIDERED

The markup on retail method of calculating retail price is the most commonly used and all calculations for the remainder of the chapter will be based on it. The most effective method is the one best for the type of operation, but remember that the retail method provides ratios (quantitative relationships) for comparison to financial statements and comparable industry operations. Hence, it proves to be a valuable approach to pricing for the retailer.

AVERAGING MARKUPS

It is important for the retailer to understand the mechanics of averaging markups when purchasing and pricing more than one item at a time. The retailer asks "How will the planned initial markup percent be met?" The costs vary yet the retail price will be identical, or the costs are the same and the retail prices will vary.

Merchandise must be priced according to what the market will bear and planned profit goals.

Formula 1 for Averaging Markups

Costs vary, but all items will retail for the same price. Total the cost prices, markup dollars, retail dollars, and calculate the MU%.

EXAMPLE 1:

Item	Cost	+	Markup	=	Retail
1	5.00		10.00		15.00
2	9.00		6.00		15.00
3	7.00		8.00		15.00
Total	$21.00	+	$24.00	=	$45.00

$$\frac{MU\$}{R\$} = MU\% \qquad \frac{\$24.00}{\$45.00} = 53.3\% \; MU\%$$

EXAMPLE 2:

The retailer is planning to purchase sport socks and retail each pair @ $3.00. The cost prices are listed below:

 a. 400 pairs @ $1.00

 b. 200 pairs @ $1.40

 c. 150 pairs @ $1.50

1. Total the cost of all socks.

 a. $400.00

 b. $280.00

 c. $225.00

 $905.00 C$

2. Calculate the total retail amount.

$$\begin{array}{r} \$3.00 \\ \times \quad 750 \\ \hline \$2{,}250.00 \; R\$ \end{array}$$

3. Compute the markup dollars.

$$\begin{array}{r} \$2{,}250.00 \\ - \quad 905.00 \\ \hline \$1{,}345.00 \; MU\$ \end{array}$$

4. Calculate average markup %.

$$\frac{\$1{,}345.00}{\$2{,}250.00} = 59.8\% \; MU\%$$

Formula 2 for Averaging Markups

Retail prices vary, but all items have the identical cost price.

EXAMPLE:

A vendor has offered an assortment of 150 jogging outfits. The For All Seasons buyer decided that they should be priced as follows:

- **a.** 50 @ $69.40
- **b.** 50 @ $59.40
- **c.** 50 @ $49.40

The buyer's planned markup is 52%. What is the total cost price that needs to be negotiated with the vendor to meet markup plan?

First, calculate the total dollar amount per price point and the grand total.

- **a.** $3,470.00
- **b.** $2,970.00
- **c.** $2,470.00

 $8,910.00 R$

Second, compute the cost complement percentage.

$$
\begin{array}{r}
100\% \\
- \quad 52\% \\
\hline
\textbf{48\% CC\%}
\end{array}
$$

Finally, multiply the total retail price by the CC% to find the total cost price.

$$
\begin{array}{r}
\$8,910.00 \\
\times \quad .48 \\
\hline
\textbf{\$4,276.80 C\$}
\end{array}
$$

SELF QUIZ

For All Seasons is planning their 100th Anniversary Sale.

1. For this "roll back the prices" event all tee shirts must be priced at $10.40. The costs are:

 500 @ $4.00

 350 @ $5.00

 a. What is the total cost price for this order?

 b. Compute the total retail amount.

c. Calculate the total markup dollars.

d. Compute the average markup percent.

2. Management has decided that the tee shirt sale must achieve a 62% markup. What cost must be negotiated to meet management's goal?

3. A buyer would like to include sport watches in the Anniversary Sale and has determined that 1000 watches need to be purchased as follows:

750 @ $49.40 R$

250 @ $56.40 R$

The buyer needs to achieve a 53% markup.

a. Compute the total retail price for this order.

b. What is the total cost amount the buyer can afford to spend?

c. Calculate the average cost price per sport watch.

4. For All Seasons' management decided to include tennis shoes in the "roll back the prices" event. Four styles of tennis shoes will be offered at the retail price of $45.40 a pair. The costs prices are:

a. 100 pairs @ $24.00

b. 75 pairs @ $26.00

c. 50 pairs @ $28.00

d. 25 pairs @ $30.00

What is the average markup percent? _____ %

a. 40.0%

b. 42.5%

c. 42.7%

d. 43.0%

e. none of the above

AVERAGE MARKUP PERCENT FOR UPCOMING PURCHASES

markup tracking log—form to post all purchases and monitor progress toward achieving initial markup percent (IMU%) plan

average markup percent—percentage difference between cost and retail totals for a group of merchandise

When effectively managing stocks, the retailer knows the planned monthly inventory requirements and the initial markup percent plan. To monitor one's progress in attaining the initial markup percent (IMU%), the successful retailer posts all orders as they are placed, and regularly calculates his or her progress using a **markup tracking log**, which is a form used to post all purchases and monitor progress toward achieving initial markup percent plan. An example of a markup tracking log is shown in Figure 5.3. Please note that the log is set up for each month, and as each order is placed the markup percentage is calculated.

The retailer subtotals the cost and retail columns every week and computes the **average markup percent**, which is the percentage of difference between cost and retail totals for a group of merchandise. Using the figures posted on the markup tracking log:

Cost $	Retail $	Markup $
$10,000	$20,000	$60,000
5,500	10,000	−31,000
15,500	30,000	
$31,000 C$	$60,000 R$	$29,000 MU$

$$\frac{\$29,000}{\$60,000} = 48.3\% \text{ Average MU\%}$$

Dept. outerwear Month Dec. IMU% Plan 48%

Planned Purchases: R$ 100,000 C$ 52,000

VENDOR	PO#	COMPLETION DATE	COST $	RETAIL $	MARKUP %
Jax	144	12/1	10,000	20,000	50%
Crown	147	12/7	5,500	10,000	45%
Hed	154	12/10	15,500	30,000	48.3%

Figure 5.3. Markup Tracking Log

After calculating the progress toward achieving the IMU$ plan, the retailer must calculate the average markup percent that must be attained on the month's remaining purchases. This is accomplished by:

1. Posting the total of purchases to date by cost, markup, and retail dollars, and then computing the average markup percent.

2. Determining the dollar difference between total purchases to date and the planned month's purchase figure for cost, markup, and retail values.

3. Computing the remaining cost, retail, and markup amounts for the remaining month's purchases to achieve the planned MU%.

EXAMPLE:

Month's Purchases	Cost $	Markup $	Retail $	MU %
Purchases to Date	$31,000	$29,000	$ 60,000	48.3 %
Purchases Remaining	$21,000	$19,000	$ 40,000	**47.5%**
Total Purchases	$52,000	$48,000	$100,000	48.0%

For the remaining month's purchases, the average markup percent must be 47.5% or higher to achieve or surpass the month's IMU% plan.

SELF QUIZ

1. Fill in the blank spaces on the markup tracking log, Figure 5.4.

2. Using the figures from problem 1, calculate the average MU% for the month's purchases to date. Show cost, retail, markup dollar, and markup percentage computations.

Dept. Workout Wear Month March IMU% Plan 52%

Planned Purchases: R$ _____ C$ 64,560

VENDOR	PO#	COMPLETION DATE	COST $	RETAIL $	MARKUP %
Rebarr	5943	3/1		18,596	53%
Stretch	6010	3/1	18,900		55%
Runnex	6021	3/10	5,040	14,105	

Figure 5.4. Markup Tracking Log

3. Using the information from problems 1 and 2, complete the form below to determine the necessary remaining month's purchases average markup percentage.

Month's Purchases	Cost $	Markup $	Retail $	MU%
Purchases to Date				
Purchases Remaining				
Total Purchases				

CHAPTER REVIEW

1. Circle true or false for each of the following statements.

a. Markup on cost is defined as the cash or percentage difference between the markup dollars and cost price.

True **False**

b. In using the markup percent on cost method, the retailer takes the cost price and marks it up, or adds a percentage, to arrive at the selling price.

True **False**

c. When given the retail price and the cost price of an item, it is possible to calculate its markup percent on cost.

True **False**

d. Markup percent on cost method means that the retail price is valued at 100%. Everything else is a lesser percent of that.

True **False**

e. Markup on retail is defined as the cash or percentage difference between the retail price and the cost price. When expressed as a percent, it is a percentage of the retail price.

True **False**

f. The cost method markup percent will always be a lower markup figure than under the retail method.

True **False**

g. The cost complement percent is used in calculating a retail price.

True **False**

h. A 40% markup on retail equals a 67% markup on cost.

True **False**

i. The keystone approach is the best method of pricing in the competitive retail market today.

True **False**

2. Name the three methods of pricing and briefly describe each.

3. Which pricing method is most commonly used and considered most effective? Why?

4. Briefly define cost complement percent and explain how it is used.

5. Explain how the markup percent on retail method may be used as a valuable tool in analyzing the financial "health" of a business.

6. Name and explain the markup method that will yield the higher markup percentage.

7. Explain the purpose of the retailer maintaining a markup tracking log.

8. Why is it important for the retailer to understand how to average markups?

9. After calculating the progress toward achieving the IMU$ plan, the retailer must calculate the average markup percent that must be attained on the month's remaining purchases. Explain the three steps to accomplish this goal.

10. For All Seasons' accessories buyer would like to offer sunglasses during a storewide sale. The planned markup is 60%. What calculations must be made in planning the total cost price to be negotiated with the sunglasses vendor?

CHAPTER TEST

1. Complete the pricing chart below.

Cost $	Markup $	Retail $	Markup % on Retail	Markup % on Cost
$5.00	$7.50			150.0%
	$5.00		65%	
$1.25		$5.00		
$7.50			50%	
	$.35	$9.60 dz.		
		$6.49	55%	

2. The retail price for white cotton crew socks is $5.00, and the markup percent on cost is 60%. The cost price of the socks is:

a. $2.87

b. $3.00

c. $3.12

d. $3.05

e. none of the above

3. Ladies' figure skates retail for $29.00 and $34.00. The initial markup percent of the skates is 40%. Calculate the cost price of skates.

$29.00 _____

$34.00 _____

4. Use the information provided in Figure 5.5 to fill in the blanks using the markup on cost method.

VENDOR	PO#	COMPLETION DATE	COST $	RETAIL $	MARKUP %
Atlas	1598	5/24	6.00	8.00	
Pinehill	1615	6/11	7.00		45%
Trax	1701	7/2		4.00	62%

Figure 5.5. Markup Tracking Log: Markup on Cost Method

5. Fill in the blanks in Figure 5.6 using the markup on retail method.

VENDOR	PO#	COMPLETION DATE	COST $	RETAIL $	MARKUP %
Sunrise	1125	5/10	10.00	24.00	
Olympia	1177	5/29	22.00		40%
Marjam	1221	6/12		18.00	30%

Figure 5.6. Markup Tracking Log: Markup on Retail Method

6. Wool ski hats cost $11.50. The desired initial markup percent is 60%. At what price would they retail for under the markup on cost method and under the markup on retail method? Show your computations.

MU% on cost method: $_____

MU% on retail method: $_____

7 For a popular brand of twill walking shorts, the cost price is $15.95, and the initial markup percent is 52%. Calculate and show your computations for:

a. Cost complement percent

b. Markup percent on cost

c. Markup dollars

d. Retail price

8. For All Seasons May swimwear sales totaled $19,500. The total cost was $10,000. Fill in the blanks on the markup diagram (Figure 5.7) to illustrate the relationship between retail, cost, and markup under both markup methods.

MARKUP ON RETAIL METHOD	VERSUS	MARKUP ON COST METHOD
MARKUP $ _____ _____ %		**MARKUP** $ _____ _____ %
COST $ _____ _____ %		**COST** $ _____ _____ %

Figure 5.7. Markup Diagram

9. For All Seasons retails men's leather gloves in three different styles. Based on the chart below, write in the markup method used to arrive at the retail price.

Glove Style	Retail Price	Cost Price	MU%	Markup Method
Suede	$39.00	$24.38	60%	
Deerskin	$44.00	$28.39	55%	
Lambskin	$52.00	$24.96	52%	

10. Convert each markup.

Markup on Retail	Markup on Cost
32%	_____
44%	_____
52%	_____
55%	_____
64%	_____
_____	48%
_____	52%
_____	60%
_____	75%
_____	80%

11. Total summer sales of lip balm amounted to $1,075.00. The lip balm was marked up using the keystone approach. How many sold in total if the cost was @ $1.25?

12. Fill in the blanks and total the cost prices, markup dollars, retail dollars, and calculate the average markup percent.

Item	Cost	+	Markup	=	Retail
1	4.00		____		8.00
2	____		9.00		18.00
3	7.00		8.00		____
Totals		+		=	

Average Markup %_____

13. The sports equipment buyer is planning to purchase downhill skis and retail each pair @ $250.00. The cost prices are:

150 pairs @ $130.00

100 pairs @ $150.00

80 pairs @ $170.00

a. Find the total cost of all skis.

b. Calculate the total retail amount.

c. Compute the markup dollars.

d. Calculate the average markup percentage.

14. Use the figures provided to compute and write in the markup dollar amounts and to answer the questions.

Cost $	Retail $	Markup $
$15,000	$28,000	$
$ 9,000	$18,000	$
$12,000	$26,000	$_____
$36,000	$72,000	$

a. If total planned purchases for the month equals $80,000 at cost and $150,000 at retail, what are the total purchases remaining at cost? At retail?

b. What are the total remaining markup dollars?

c. Compute the average markup percent for remaining purchases.

15. For All Seasons purchased 600 sweatshirts @ $9.00 and would like to purchase another 1,200 pieces. They must attain a 52% average markup and retail for $16.40. What is the cost price per sweatshirt they need to secure to meet the targeted retail price per unit and the markup plan?

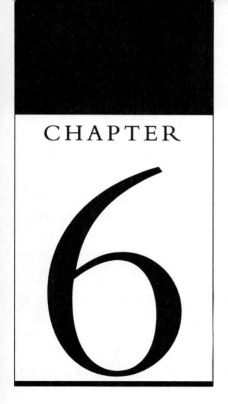

Price Adjustments

It would be ideal if all merchandise sold at the original retail prices. But we know that things are not always ideal...customers do not respond to merchandise offerings; resources change pricing structures; receipts are incorrectly ticketed. Therefore, a section on price adjustments is necessary.

MARKDOWNS

As explained previously, a *markdown* is any reduction in the original retail price of an item, whether permanent or temporary. Any reduction in price usually results in lower profits. Markdowns used correctly can keep stock fresh, clear out old merchandise, provide dollars for more salable merchandise, and build customer traffic. Heavy and sharp price reductions become necessary for retailers who do not react fast enough in recognizing their mistakes.

MARKDOWN PURPOSES

Markdowns are a necessary part of any retail business. It is not possible to eliminate all price reductions because it is impossible to forecast all the needs and wants of customers "perfectly" as well as to avoid damaged merchandise—accidents happen. Markdowns are an inherent part of retailing.

The three major purposes of markdowns are:

- To *promote* "values"
- To *satisfy* customers
- To *correct* errors

MARKDOWN CATEGORIES

The primary causes for markdowns can be classified under three categories—promotional, satisfaction, and correction.

Promotional Markdowns

promotional markdowns–price reductions created by need to project store image and build traffic

Promotional markdowns are price reductions created by the need to project a store image and to build traffic. Examples of promotional markdowns include:

1. Items used for in-window and in-store displays
2. Theme sales such as Back-to-School Specials or Holiday Gifts Under $10.00

3. Price reductions of basic stock and best sellers to offer "special savings" and stimulate sales

4. Multiple pricing, such as 2 for the price of 1

Satisfaction Markdowns

satisfaction markdowns—price reductions to correct the customer service policy of the store

Satisfaction markdowns are designed to meet the customer service policy of the store. Causes of satisfaction markdowns include:

1. Customer allowances—price adjustments made for donations for local charity events, special group (e.g., senior citizen, student, designer) discounts, and in lieu of unsatisfactory merchandise returns

2. Meeting the competition's prices to avoid issuing full refunds and losing customers

3. Employee discounts to build loyalty, goodwill, and merchandise advertising

Correction Markdowns

correction markdowns—price reductions to correct merchandise problems

Correction markdowns do just that—"correct" merchandise problems. These may include:

1. Buying errors—selecting the wrong items, styles, colors, and sizes and introducing them at the wrong times and prices, in the wrong quantities as shown in Figure 6.1.

2. Resource errors—commonly referred to as "pet" purchases; buying from favored vendors when their merchandise no longer satisfies the customer

3. Financial errors—delaying necessary markdowns until promotional remainders, odd size lots, and damages restrict cash flow and the opportunity to introduce fresh, new, exciting merchandise

4. Operational errors—allowing the buildup of dirty, shopworn merchandise due to poor stockkeeping guidelines and uninformed salespeople

5. Conditional errors—delaying the necessary price reductions due to weather, economic, and local business trends

By analyzing previous causes of markdowns, the retailer can make a plan to prevent, minimize, and control them in the future.

Note: Inventory shortages are not included in these markdown categories. Shortage is an indicator of poor controls; it is not something that can be "caused" by a markdown. The solution is to increase controls in the store to reduce shortage, which is an operating expense.

MINIMIZING MARKDOWNS

Retailers can control each dollar and cent that is lost by analyzing markdown records and learning from mistakes. To reduce future price reductions and protect the resultant gross margin, retailers should consider the following:

1. *Promotional*

 a. Ask vendors to ship display items at no cost. If their items are used for in-window and in-store displays, the potential for increased sales and reorders increases.

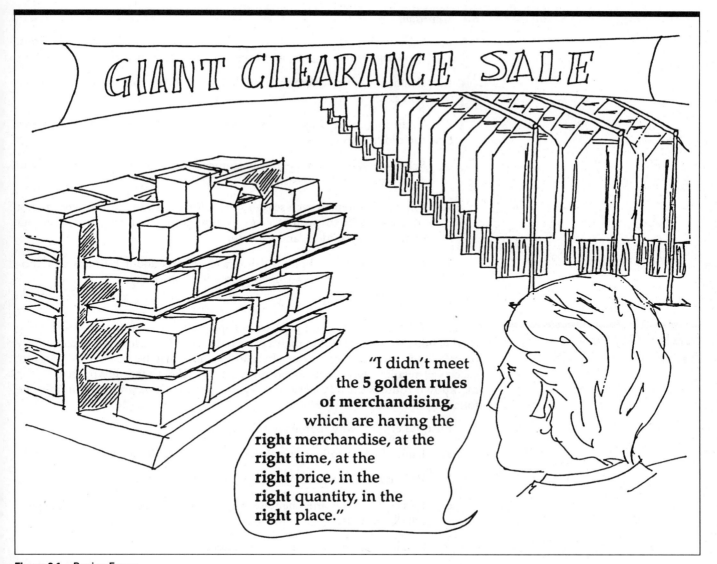

Figure 6.1. Buying Errors

 b. Preplan promotions so that when purchases are made, profitable negotiations to maintain gross margin percent will occur.

 c. Avoid "buying" for advertising dollars. Decisions must be made for the customer, not an advertisement.

 2. *Satisfaction*

 a. Review stock assortments and ensure they are directed at satisfying the customer's needs and wants, in advance.

 b. Spend time on the selling floor speaking and listening to customers so that objective purchases are made, not subjective retailer purchases based on the retailer's taste.

 c. Competitive shop on a regular basis so that initial retail prices are competitive on identical and similar merchandise offerings.

 d. Ask vendors to "donate" merchandise for charities, as well as for customer and employee contests.

3. *Correction*

 a. "Know thy Customers" by listening to them, reading trade publications, speaking with suppliers, and reviewing past sales records.

 b. Evaluate each resource on a quarterly basis. Are you getting the service you deserve? Are items purchased suiting your customers?

 c. Train internal and external salespeople to rotate stock regularly. Move the old item receipts first.

 d. Schedule vendor sales seminars to increase the product knowledge and selling skills of the sales staff.

 e. Financially preplan each season's markdowns as a calculation within cost of goods sold to protect gross margin plans, and regularly clear out damages, remainders, and so forth.

 f. Consistently read about and listen to reports about business and economic trends to forecast upcoming sales realistically.

MARKDOWN ALTERNATIVES

Often, too little attention is paid to the possibilities of moving slow-selling merchandise by methods other than a price reduction. Markdowns must obviously be taken in some instances, but alternatives must first be considered. As one successful retailer says, "It takes no ingenuity to take a markdown. In fact, the markdown route is the lazy person's way to a profitless operation!" Consider the following markdown alternatives.

1. First, determine why merchandise is not selling.

 a. Lack of sales product knowledge? Salespeople do not like the vendor?

 b. Poor display location? Will relocation generate sales?

 c. Dirty? Can the merchandise be cleaned? Reticketed? Is a rotation schedule in effect?

 d. Stubborn? Failure to meet competition?

 e. Timed wrong? Delivered too early or too late in the selling season?

2. Second can the merchandise be returned or exchanged?

 a. Have you established a WIN/WIN partnership with your vendor?

 b. Will your vendor provide markdown dollars?

 c. How often have you requested help? Is the assortment mix wrong?

 d. Additional considerations include the quantity involved, the time of year, and the line of business.

3. Third and finally, should seasonal items be stored and held over for next year?

 a. Will the merchandise still be salable? In style?

 b. Can you afford to tie up inventory dollars, reducing the flow of fresh, new merchandise?

 c. How much stored merchandise will be stolen?

 d. Is the stockroom adequate to store nonsalable stock for 6 to 11 months?

 e. What will the storage costs and additional handling charges amount be?

Note: As a general rule, the disadvantages of storing merchandise outweigh the advantages. This is the least recommended markdown alternative.

Judgment is required in selecting merchandise for markdown. Consider the following when determining which items will be selected for price reduction:

DECIDING WHAT MERCHANDISE SHOULD BE SELECTED FOR MARKDOWN

1. List your 10 most expensive items and check for inventory buildup.

2. Make a "least wanted" list and ask for employees' suggestions when compiling this list.

3. Do a dust check—which items on the floor and in the stockroom are dust collectors?

4. Monitor sales for 4 weeks on specialty gift items and fashion apparel to determine if early, timely markdowns are necessary.

Remember: This merchandise should be cleared out in 6 to 8 weeks if sales volume is lagging.

5. Are you timing the promotion of regular stock or special merchandise before the peak selling period, while sales are on the way up, or past the selling season, particularly with seasonal merchandise?

6. On regular stock selection, will sales increase enough to protect markup dollars?

THE TIMING OF MARKDOWNS

The timing of markdowns is important to minimize the amount of markdowns needed to sell merchandise and to protect the gross margin of profit potential. Markdowns may be taken either early or later and each method has advantages and disadvantages.

1. *Advantages of early markdowns*

 a. Sell-through the merchandise is available during the selling season while an active demand still exists and before it becomes difficult to sell the merchandise out of season.

 b. History has proven that the first markdown is the least expensive. Frequently price reductions will shift higher price line merchandise into lower price line zones where the customer group of the lower price zone immediately responds.

 c. Take necessary price reductions as they occur—admit mistakes and move on. As a result, space is freed up for new, exciting merchandise.

 d. Speeds up turnover, and therefore, cash flow.

 e. Reduces selling expense and the additional costs incurred to staff for major clearance sales.

2. *Disadvantages of early markdowns*

 a. Prestige merchandise retailers may create a "discount" image.

 b. Shoppers may delay regular price purchases because retailers become known for early, in-season sales.

 c. Premature markdowns, taken before reaching the prepeak of their life cycle, are costly and unnecessary.

3. *Advantages of late markdowns*

 a. Known for holding major sale events—such as January Clearance Sale, July Summer Sales, etc.—which avoids the delay of regularly priced, in-season purchases.

 b. Upholds an "exclusive" image and attracts lower-end customers only during semiannual or annual sales events.

4. *Disadvantages of late markdowns*

 a. Meaningful markdowns equal substantial reductions to clear merchandise that will not sell at their original retail prices.

 b. Presents a poor image to frequent customers who repeatedly see the same old merchandise that the competition already has reduced.

 c. Ties up stockroom and selling space.

 d. Slows stock turnover, which restricts cash flow.

SELF QUIZ

1. For All Seasons is located in a reknown ski area. There are 20 resorts within a 5-mile radius. Listed below are factors that are beginning to slow sales.

Forty dirty white ski jackets

Buildup of ear muffs

Snagged silk long underwear

Fifty pairs of damaged reflector sunglasses

Excess size 4 ski suits, minimal stock on hand of best selling sizes

Competition undercutting the price on identical down jackets

Large quantities of yellow and pink turtlenecks, out of stock in white and red

Refer to this list while answering the following questions.

 a. What markdown alternatives are possible? Describe in detail.

 b. What items should be selected for markdown and why? For what purpose? To promote, satisfy, or correct?

 c. What opportunities to increase sales are available? Explain thoroughly.

 d. How would you minimize markdowns in the future?

THE AMOUNT OF THE MARKDOWN

The amount of the markdown is a major factor in controlling markdowns and gross margin. The "correct amount" depends on:

1. The merchandise selection

2. The cost, original markup, and planned gross margin

3. The quantity involved

4. The timing—early or late in the selling season

The purpose of a markdown is to sell merchandise rapidly. The following rules should be considered in setting the markdown price:

1. Markdowns should be significant in perceived "value savings" to attract many customers. The retailer asks "What amount will prompt my targeted customer group to respond? At what price does the competition have the identical or similar goods? What are the current local economic conditions?"

2. The first markdown should clear 33% to 50% of the merchandise.

3. Low original retail priced items need greater price reductions to draw customers—Save $1.00 versus Save $.50. Big ticket items can be reduced less because the dollar savings are more important—Save $55.00! $99.99!

4. Holiday remainders should be reduced a few hours before the holiday begins to clear all stock and avoid leftovers and storage.

5. Promotional leftovers should be sharply reduced immediately following the event.

6. Merchandise late in the selling season requires the largest markdown. Bite the bullet and clear it out.

7. Monitor the first markdown and reduce again if movement of stock is not significant to clear at least one third immediately.

8. Donate the merchandise that just will not sell and save carrying costs and receive full value deductions on the income tax return.

MARKDOWN FORMULAS

markdown price–reduced retail price

total markdown dollars–markdown dollars times the number of marked down pieces

percent of markdown–difference between original retail price and new retail price divided by original retail price

The dollar amount of a markdown is the difference between the original retail price and the new retail price. This gives you the **markdown price**. The markdown dollars multiplied by the number of marked down pieces gives the **total markdown dollars**. The markdown difference divided by the original price gives the **percent of markdown**.

Formula for Calculating the Markdown Price:

1. Select the desired markdown percent.

2. Multiply the current retail (usually the original retail price unless an item has already been reduced) by the desired markdown percent.

3. Subtract the markdown dollar amount from the current price to arrive at the new, reduced retail price.

EXAMPLE:

Desired Markdown Percent = 30%

Original Retail Price = $50.00

	$50.00	$50.00
x	.30	– 15.00
	$15.00 MD$	**$35.00 New R$**

Note: The $35.00 is now rounded down to $34.99 to meet For All Seasons' price point ending policy for clearance merchandise.

Something to Consider: Short-Cut Formula for Calculating the Markdown Price

1. Determine the desired markdown price.

2. Compute the **markdown percent cost complement**, defined as the difference between 100% and the desired markdown percent. So, subtract the desired markdown percent from 100%.

3. Multiply the markdown percent cost complement by the current retail to arrive at the new retail price.

EXAMPLE:

Desired Markdown Percent = 30%

Current Retail Price = $50.00

100%		$50.00
− 30%		x .70
70% MD CC%		**$35.00 New R$**

Formula for Calculating Total Markdown Dollars (MD$)

Original Retail		Markdown Dollars
− New Retail		x Number of Pieces
Markdown Dollars		**Total Markdown Dollars**

EXAMPLE:

$50.00		$15.01
− 34.99		− 5
$15.01 MD$		**$75.05 Total MD$**

Formula for Calculating Markdown Percent (MD%)

$$\frac{\text{Original Retail Price} - \text{New Retail Price}}{\text{Original Retail Price}} = \text{MD\%}$$

EXAMPLE:

$$\frac{\$50.00 - \$34.99}{\$50.00} = \frac{\$15.01}{\$50.00} = .30 \text{ or } 30\% \text{ MD\%}$$

Formula for Calculating Department or Total Store Markdown Percent as a Percent of Net Sales Volume

$$\frac{\text{Total Department or Store Markdown Dollars}}{\text{Total Department or Store Net Sales Volume}} = \text{MD\%}$$

EXAMPLE:

$$\frac{\$5,400.00 \text{ (Total Store MD\$)}}{\$90,000.00 \text{ (Total Store Net Sales Volume)}} = .06 = 6\% \text{ MD\%}$$

1. It's been a mild winter, so the thermal underwear set sales, priced originally at $21.00, have been slow. Two hundred sets are on hand, so you decide to issue a 35% markdown. As a result, you immediately sell 120 sets.

 a. What is the new retail price of the thermal sets? Show your calculations as you use both markdown methods.

 b. Calculate the total markdown dollars.

2. Coffee mugs were originally priced at $5.00. The sale price is now $3.99. What is the markdown percent?

3. Leggings are currently priced at $12.00. The store manager would like to run a special at 30% off. What is the sale price?

4. As the For All Seasons' accessories buyer, you have calculated that the projected sunglasses sales are behind plan. You decide to hold a 1-week 30% off-the-original-price sale for the total sunglasses department. The beginning inventory count is:

 50 pairs @ $65.00

 75 pairs @ $45.00

 175 pairs @ $25.00

 a. What are the new reduced retail prices? (Round to $.40 price point endings.)

 Original $65.00, now $_____

 Original $45.00, now $_____

 Original $25.00, now $_____

 b. Calculate the markdown dollars per price point.

 $65.00, now $_____. MD$_____

 $45.00, now $_____. MD$_____

 $25.00, now $_____. MD$_____

c. Using your previously calculated markdown dollar figures and the following sales results, calculate the total markdown dollars per price point.

Sales		Total Markdown Dollars
$65	30 pairs	_____
$45	60 pairs	_____
$25	150 pairs	_____

d. Compute the total sunglasses sale markdown dollar amount.

e. Calculate the 1-week sunglasses sale MD%.

MARKDOWN CANCELLATIONS

markdown cancellation–cancellation of a temporary markdown to bring merchandise back to its original price or previous markdown price

A **markdown cancellation** is just that—a cancellation of a markdown. Remember, a markdown may be permanent or temporary. Markdown cancellations are used when stock is temporarily reduced to stimulate sales and reduce inventory levels. After the specified sale time period ends, the markdowns are cancelled and the merchandise is back to its original retail price.

Markdown Cancellation Procedure

1. Select merchandise to be included in temporary sale.

2. Set the start and end sale dates.

3. Determine the markdown percent and new sale retail prices.

4. Count the merchandise on hand before the sale begins.

5. At the end of the sale, count the number of pieces remaining and calculate the quantities sold.

6. Record actual markdowns during the sale.

7. Issue the markdown cancellation for the remaining pieces on hand and reprice the merchandise back to the original retail prices.

EXAMPLE:

1. Workout wear is the selected merchandise group for a temporary sale.

2. The sale will begin on Friday and end the following Sunday (10-day sale).

3. 30% off the original prices as follows:
 Leotards reg. $32.00 now $22.40 save $9.60
 Leggings reg. $22.00 now $15.40 save $6.60
 Tights reg. $12.00 now $ 8.40 save $3.60

4. Stock on hand before the sale:

Leotards	150 pieces	@ $32.00
Leggings	225 pieces	@ $22.00
Tights	100 pieces	@ $12.00

5. Sale results:

	On Hand	Quantity Sold
Leotards	20	130
Leggings	50	175
Tights	30	70

6. Markdowns taken:

Leotards	130 x $9.60 = $1248.00
Leggings	175 x $6.60 = $1155.00
Tights	70 x $3.60 = $ 252.00
Total Markdown $	= $2655.00

7. Markdown cancellation:

Leotards	20 pieces reprice to $32.00
Leggings	50 pieces reprice to $22.00
Tights	30 pieces reprice to $12.00

The widespread use of computer cash register terminals provides retailers with the necessary stock counts, markdown calculations, quantities sold, and remaining pieces for the issuance of markdown cancellations. But it is still important to understand the procedures and calculations for protecting gross margins and understanding computer reports.

SELF QUIZ

1. A 7-day outdoor shoe sale was held. Answer the following questions using the information provided below:

Shoe Style	Quantity	Initial Price	Ending Quantity
Walking	175	$45.00	75
Backpacking	350	$80.00	90
Hiking	190	$75.00	110

a. The selected shoe styles were on sale for 35% off their original price. Calculate the sale price for each shoe style and adjust each sale price to have a $.40 price point ending to be consistent with For All Seasons' price point ending policy.

b. What quantity of each style was sold during the sale?

c. Calculate total markdown dollars.

d. List the markdown cancellation amounts for each shoe style.

THE EFFECTS OF MARKDOWNS ON PROFIT

Every price change has an impact on markup and therefore on gross margin and net profit. Every cent taken off the original retail price is a cent taken away from markup dollars.

The value of balancing inventories and eliminating promotional remainders, shopworn merchandise, and so forth must be weighed against the loss of markup dollars (MU$).

EXAMPLE:

To stimulate movement of overstocked merchandise:

	Original		**Proposed**
Retail	$1.00	20% markdown	$.79*
Cost	– .60		–.60
IMU$	**$.40 or 40%**	**MU$**	**$.19 or 24%**

*Adjusted $.01 to be consistent with For All Seasons' price point ending policy for clearance merchandise

The 20% markdown equals a 47.5% difference in markup.

Formula for Calculating Markup Percent Difference

$$\frac{\text{New Markup Dollars}}{\text{Old Markup Dollars}} = \text{Markup Percent Difference}$$

As in the previous example,

$$\frac{\$.19}{\$.40} = .475$$

47.5% difference in markup dollars.

Therefore, the higher the markdown amount, the more units you have to sell to achieve the same markup dollars.

EXAMPLE:

Your goal is to increase traffic by an in-store or advertised sale. Using the previous example, you have a 47.5% MU difference and current sales are 20 pieces per week.

Formula for Calculating the New Sales Rate

$$\frac{\text{Current Net Sales Volume}}{\text{MU\% Difference}} = \textbf{New Sales Rate}$$

$$\frac{20 \text{ pieces}}{.475(47.5\%)} = \textbf{42 pieces}$$

An additional 22 pieces (new rate, 42; existing rate, 20) must be sold to achieve the identical markup dollars.

Figure 6.2 illustrates how retailers complete a markdown worksheet to protect their markup dollars.

To ensure that a sale generates the purchase of additional units to protect the markup dollars, you could:

1. Promote multiple sales (e.g., Buy 3, save an additional ____%)

2. Have your sales staff concentrate on suggestive selling of high margin merchandise as a companion piece for sale items

3. Run a staff sales contest with "push" (incentive) monies donated by vendors

4. In advance of purchasing merchandise for promotion, negotiate with cost figures, sale retails, and potential sale quantities with vendors to secure the best cost prices.

Markdown Planning Worksheet

Item __Biking Gloves__ Markdown % __30%__

Original		Proposed	
Retail:	$20.00	Retail:	$13.99
– Cost:	8.00	– Cost:	8.00
= IMU$:	12.00	= MU$:	5.99
IMU%:	60.0%	MU%:	42.8%

Current Sales Rate

$$\frac{140}{\text{(\# pieces)}} \quad \text{per} \quad \frac{\text{month}}{\text{(week, month, etc.)}}$$

Markup % Difference

$$\frac{\text{MU\$}}{\text{IMU\$}} \quad \frac{\$\ 5.99}{\$12.00} = \underline{\ 49.9\ }\ \%$$

New Sales Requirement to Maintain Markup Dollars

$$\frac{\text{Current Sales Rate}}{\text{Markup \% Difference}} = \frac{140 \text{ pcs.}}{49.9\%} = \underline{\ 281\ }\ \text{pcs.}$$

Additional Sales Requirement to Maintain Markup Dollars

$$\frac{281}{\text{New Sales Requirement}} - \frac{140}{\text{Current Sales}} = \frac{141}{\text{Additional Sales}}$$

Figure 6.2

1. Licensed tee-shirts are marked down from $16.00 to $11.99. The original cost was $6.25 each.

 a. What is the initial markup dollar amount and percent per tee-shirt?

 b. What is the new markup dollar and percent amount?

Markdown Planning Worksheet

Item _____ Markdown % _____

Original	Proposed
Retail: _____	Retail: _____
– Cost: _____	– Cost: _____
= IMU$: _____	= MU$: _____
IMU%: _____ %	MU%: _____ %

Current Sales Rate

_____ per _____
(# pieces) (week, month, etc.)

Markup % Difference

MU$ $ _____ = _____ %
IMU$ $

New Sales Requirement to Maintain Markup Dollars

Current Sales Rate
———————————————— = _____ = _____ pcs.
Markup % Difference

Additional Sales Requirement to Maintain Markup Dollars

_____ – _____ = _____
New Sales Requirement Current Sales Additional Sales

Figure 6.3.

c. Calculate the difference in markup in both dollars and percent.

2. Unusually warm temperatures and light snowfall has caused the $24.00 ski glove assortment sales to decline: only 40 pairs a week. The ski gloves cost $10.00 a pair. You are contemplating a 25% off sale. Show the results of a 25% markdown on your Markdown Sheet, Figure 6.3 (page 135).

ADDITIONAL MARKUPS

additional markup—used to raise original retail price of merchandise in stock

An **additional markup** is used to raise the original retail price of merchandise already in stock. It increases the current set retail price.

Additional markups usually occur for the following reasons:

1. Price ticketing mistakes

2. Resource cost price increases

3. Competition is selling in volume identical merchandise at a higher price

MARKUP CANCELLATIONS

markup cancellations—cancellation of original markup errors

Markup cancellations (MUCs) cancel out original markup errors. Inadvertently, merchandise markups are incorrectly calculated; therefore, the original retail price must be adjusted.

These are not to be confused with markdowns. Markup cancellations are initial pricing errors, not temporary or permanent price reductions when used correctly.

Markup cancellations must be tightly controlled to avoid the manipulation of inventories. For example, new receipts are sometimes priced with an excessively high initial markup. Then the markup cancellation reflects what the original retail price should have been—the true price the customer would have been willing to pay. Although this practice may help to achieve departmental or total store markup plans, it is unethical. Frequent shoppers interpret this activity suspiciously. One week an item is regularly priced too high, and the next week it is on sale at the price they were initially looking to pay. Some retailers also knowingly institute markup cancellations, which reduce the total value of stock on hand to free up dollars for the purchase of new merchandise. Conversely, they issue markup cancellations to inflate the total inventory figure on hand so that it "appears" their department is stocked according to plan.

ADDITIONAL MARKUP CANCELLATIONS

additional markup cancellations—cancellation of additional markups

Additional markup cancellations are merely cancellations of additional markups taken. Most frequently, they are taken to correct repricing errors and meet the competition's prices.

A system for reporting and recording price changes is important for three reasons:

1. Markdowns can be reviewed and analyzed for causes, types, merchandise, and quantities involved.

2. New management will have records to avoid repetition of previous buying and selling errors.

3. Inventory records and stock shortages are accurate.

Price Change Reporting Procedure

1. Price change is authorized

 a. Store or department manager

 b. Employee designated by manager

2. Price change is issued by category/classification

 a. Type of price change is written in box

 b. Reason for price change is indicated in reason column

 c. Item number and description listed

 d. Original, new retail, difference is calculated

3. Price change procedure

 a. Count stockroom first

 b. Count selling floor second

 c. Enter quantity on price change form

 d. Extend price change amount (difference x quantity)

 e. Reprice merchandise

 (1) Price increase—remove price ticket and replace

 (2) Markdown—add sale price ticket or draw a red diagonal line through the current price and write new sale price

 f. Turn price change form in to manager

 g. Remerchandise and sign

4. Price change finalization

 a. Manager or designated employee rechecks completed price change form, as shown in Figure 6.4 (page 138)

 (1) Verifies quantity and new pricing on form

 (2) Ensures all information is accurate

 b. Manager forwards one copy to accounting

 c. Manager files price change for future reference

THE EMPLOYEE PURCHASE LOG

It is important to provide a separate form to record employee discounts as they occur on the selling floor. Note on Figure 6.5 (page 139) that a manager approves every employee discount to prevent misuse of this benefit.

PRICE CHANGE REPORT

DATE _June 5_

CLASS _Accessories_

Write Type

| 1 |

1 MARKDOWN 2 MARKUP 3 ADDITIONAL MARKUP 4 MARKUP CANCELLATION 5 ADDITIONAL MARKUP CANCELLATION

REASON	STYLE NUMBER	DESCRIPTION	OLD RETAIL	NEW RETAIL	DIFF	QTY	EXTENSION
D	2230	Crew Socks	8.00	6.40	1.60	180	288.00
C	1422	Wool Socks	12.00	～	12.00	2	24.00

TOTAL $312.00

Show Reason by Letter

A. Promotional Markdown
B. Satifaction Markdown
C. Correction Markdown
D. Special Temporary Sale
E. Market Price Increase
F. Original Pricing Error

TAKEN BY: _S. Chrisman_

AUTHORIZED BY: _Joseph L. Romdili_

APPROVED BY: _Mary McGovay_

Original to Accounting

Copy to Class File

Figure 6.4.

EMPLOYEE PURCHASE LOG

Department_____ Month_____ Year_____

DATE	EMPLOYEE	CLASS	SKU#	OLD RETAIL	NEW RETAIL	DIFF	QTY	EXTENSION	MANAGER

TOTAL _____

Original to Accounting

Copy to Employee Discount File

Figure 6.5.

CHAPTER REVIEW

1. Define and explain the purposes of markdowns.

2. Name the three primary causes for markdowns. Describe each.

3. What are some alternatives retailers should consider in an effort to minimize markdowns? Briefly discuss five alternatives.

4. How does the retailer select merchandise for markdown?

5. Discuss the advantages and disadvantages of early and late markdowns.

6. List and discuss four of the eight rules retailers should follow when determining a markdown price.

7. Percent of a markdown is defined as the markdown difference divided by the original retail price.

 True **False**

8. Fill in the missing information in the formulas below:

 Original Retail Markdown Dollars

 $-$ _____ x _____

 = Markdown Dollars = Total Markdown Dollars

 $\dfrac{\text{Original Retail Price} - \text{New Retail Price}}{}$ = MD%

9. Explain the purpose of a markdown cancellation and list the seven steps of the markdown cancellation procedure.

10. Every price change has an impact on markup, and therefore on gross margin and net profit.

<div style="text-align:center">True False</div>

11. Define additional markup and list three reasons why they usually occur.

12. Explain how markup cancellations and additional markup cancellations differ.

13. What safeguards does a price change reporting system provide?

14. For All Seasons stocks a waterproof watch with special features. Customers show interest and ask detailed questions about the features, but they leave without purchasing. The watch retails for $299.00. Inventory on hand is 100 waterproof watches. Sales are falling and it is discovered that the competition is carrying the identical watch. Answer the following questions.

 a. You are the buyer of watches. What alternatives would you consider?

 b. Your decision is to mark down the watches. Describe:

 (1) Reason for markdown

 (2) Type of markdown

 (3) Amount of the markdown

 (4) New sale price

c. What steps would you take to avoid repeating this markdown?

15. The direct competition has warm-up suits priced to sell at $69.00. For All Seasons' average retail price is $89.00. What factors would you consider in determining if and when a price reduction would be necessary? Why?

CHAPTER TEST

1. For All Seasons is promoting its stock of swimwear to make room for early fall merchandise. All swimsuits have been marked down 40%. Answer the following questions using the provided information.

Number of Swimsuits	Original Retail	MD%	New Retail Price
20	$34.00	40%	$_____
10	$44.00	40%	$_____
15	$54.00	40%	$_____
5	$64.00	40%	$_____
8	$74.00	40%	$_____

a. Calculate the new retail prices.

b. Compute the total markdown dollar amount.

2. During a recent sales event, ski boots were marked down from $150.00 to $99.99. Compute the markdown percent.

3. Total accessories markdowns amounted to $1,500 in March. March net sales results totaled $25,000. Compute the accessories department's markdown percent.

4. Sunglasses that retail for $30.00 and cost $15.00 have been reduced 20%. Find the adjusted markup dollars and the markup percent difference.

5. Men's tennis apparel is on sale at 30% off the regularly ticketed prices from May 1 to May 8. The assortment selected is counted before the sale begins and the results are:

5/1 On Hand	Original Retail Price	5/8 On Hand	Sale Retail
224	$62.00	186	$_____
115	$65.00	42	$_____
122	$70.00	48	$_____
131	$75.00	62	$_____
173	$84.00	101	$_____

a. Determine the individual sale price, applying For All Seasons' price point ending policy of $.40.

b. Calculate and list below the number of pieces sold.

Original OH	Current OH	Quantity Sold
224		
115		
122		
131		
177		

c. What is the total markdown amount? Show your computations.

d. Define the type of markdown procedure used for this sale.

PART

III

MERCHANDISE PLANNING

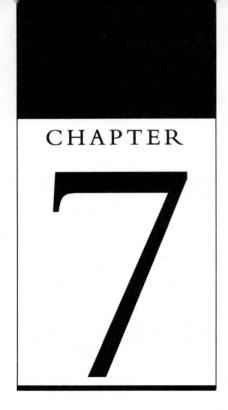

CHAPTER 7

Assortment Planning

If all retailers had a crystal ball that could forecast the future, then anticipating their customers' needs and wants would not be necessary. Assortment planning is the major success component for retailers. A well-planned merchandise assortment not only reflects the customers' needs, but also projects the store's image, effectively controls the inventory investment, uses the store's space profitability, increases sales, and generates profits.

Balanced merchandise assortments enable retailers to attain their goals while satisfying their targeted customers. This is achieved through assortment planning and its continual review, analysis, and adjustment to meet the everchanging needs and wants of customers.

EFFECTIVE MERCHANDISE ASSORTMENTS

merchandise assortment–ideal combination of merchandise that meets needs of targeted customer group at right time

An effective **merchandise assortment**, or mix, is the ideal combination of merchandise that meets the needs of the targeted customer group at the right time.

This may be illustrated by an analogy of three boxers, as shown in Figure 7.1.

- An underweight boxer
- An overweight boxer
- An ideal weight boxer

The underweight boxer is weak, lacks stamina, and has no power behind his punch. He will never make it in the long run.

The overweight boxer is slow and sluggish. He does not stand a chance.

The ideal weight boxer is strong and fast. He possesses the ideal combination to win—with power and speed.

The three boxers relate to the three types of merchandise assortments:

- The underweight assortment
- The overweight assortment
- The ideal weight assortment

THE UNDERWEIGHT ASSORTMENT

The *underweight assortment* makes a poor merchandise presentation. Shelves and fixtures are sparsely stocked. The customer asks, "Is the retailer going out of business?" Basic stock items, the items customers expect to find, are typically out of stock. This results in dissatisfied customers and falling sales.

THE OVERWEIGHT ASSORTMENT

The *overweight assortment* is just that. The fixtures are bulging, usually with merchandise that has become shopworn and dirty. The overstocked condition

Figure 7.1. The Three Boxers Analogy

reduces profits because inventory dollars are tied up in merchandise that is not selling, therefore producing a slow return on dollars invested and restricting the flow of new, fresh, exciting merchandise.

THE IDEAL WEIGHT ASSORTMENT

The ideal merchandise assortment meets the five golden rules of merchandising, which are:

1. The <u>right</u> merchandise
2. At the <u>right</u> time
3. In the <u>right</u> place
4. At the <u>right</u> price
5. In the <u>right</u> stock quantity

What steps are involved in blending the "ideal" merchandise mix?

1. Targeting and analyzing customer types by merchandise classifications
2. Identifying the needs and wants of targeted customers through basic market research

3. Defining each primary merchandise classification and the subclasses/subcategories within each

4. Considering stock factors that influence sales volume

5. Determining the life span of merchandise—the timing of "in," "peak," and "out"

6. Searching for new products to satisfy the customers' changing needs and wants

7. Evaluating the potential of new merchandise introductions

SELF QUIZ

1. List and describe the components of an ideal merchandise assortment and how it meets the five golden rules of merchandising.

2. If a store is overstocked it would seem that there should be merchandise to address each customer's needs and wants and increase sales and profits. Explain what factors contradict this premise.

3. An underweight assortment will never make it in the long run. Why is this statement true?

THE CUSTOMER COMES FIRST

The first step toward ensuring that the five golden rules are met is through the identification and analysis of the retailer's targeted customer group.

OBJECTIVE BUYING DECISIONS

Any store can be fully stocked with merchandise that the retailer personally thinks the customers need and want; however, that will not guarantee success. Subjective buying should be replaced with *objective buying*. Objective buying decisions are based on the following:

1. Customer identification and analysis

2. Basic market research

Customer identification and analysis. The essence of merchandising, the act of buying and selling merchandise, rests on the retailer understanding the targeted customer group to direct all activities toward ensuring that the customer comes first. Who are the targeted customers and what are their needs and wants?

First, the retailer reviews the demographic descriptions of customer buying habits in his or her trading area and profiles the targeted customer group by age, income levels, life-styles, and similar parameters.

For All Seasons' targeted customer group is tourists. Located in a renown mountain range, For All Seasons has an established international reputation for its European-styled sports apparel, its extensive sports equipment selection, and its specialized sports training programs. Although tourists arrive year-round, approximately 60% of the tourist business is generated during the summer and winter months. The tourists who patronize For All Seasons are between the ages of 25 and 45 with average incomes of $25,000+, and a life-style that includes travel and adventure. This group looks for the newest sports apparel and equipment, and each individual is best described as an **updated customer**. These customers understand fashion and have the confidence to make their own fashion statements; color and fashion are the primary selling features.

updated customers–individuals who look to color and fashion in all purchases, understand fashion, and have the confidence to make their own fashion statements

Although there is a year-round tourist business in the For All Seasons trading area, during the spring and fall the local residents become the primary customer group. This group is on average the same age and income level as the tourist group but is generally more traditional in its buying habits. The group whose buying habits are referred to as **traditional customers** accept fashion change gradually and look to purchase quality tailored looks with an emphasis on fashion.

traditional customers–conservative individuals who accept fashion change gradually, are quality minded, brand loyal, and purchase tailored looks with an emphasis on fashion

Second, the retailer periodically reviews the customer profile and makes any necessary merchandise adjustments to better serve the customers. For All Seasons adjusts its merchandise offerings to accommodate the change in its customer groups' buying habits—increasing updated fashions during the primary tourist seasons and decreasing them during the primary local resident seasons.

Basic market research. To further focus on identifying and satisfying customers' needs, basic market research is necessary. **Basic market research** is an orderly, objective way of learning about the people the retailer wants to target for sales. It eliminates "subjective" biases that result in inappropriate business decisions.

basic market research–orderly, objective way of learning about targeted customers

Basic market research involves:

1. *Consideration of market factors.* Ideally, retailers, such as For All Seasons, consider the following market factors each quarter:

 a. *Are there particular months when a customer group becomes more important?* For All Seasons makes adjustments to its assortment as the primary targeted customer group alternates each season.

 b. *Are the local and tourist customer demographics changing?* Is there an increase in the age of the targeted customer group? Is a new sport emerging that requires unique apparel and equipment?

 c. *Are local and economic changes occurring that may affect business?* Is the number of area resorts increasing or decreasing? Is a local employer cutting back or expanding? Are airlines offering reduced fares?

 d. *What makes For All Seasons stand above the competition?* Is it the specialized sports training programs? The European apparel styling? The quality of merchandise offerings? Or the complimentary gift wrapping and delivery service? The regularly scheduled in-store events?

 e. *Where else do the customers shop and why?* How does the competition's merchandise, pricing, and service differ?

2. *Competitive shopping.* Every day, the retailer is bidding for customers on the basis of merchandise assortment, pricing strategy, and service level. To build a customer base, the retailer must be well informed regarding all of the competitors' activities...in merchandise, price, and service offerings.

Shopping the competition is one of the keys to winning in today's highly competitive market place. Competitive shopping provides the retailer with merchandising strategies that will make him or her stand above the competition by offering unique products and services. Each month, the successful retailer shops the competition and discusses observations with his or her staff.

Some retailers enter their competitors' stores with the point of view that they have just been hired to take over a store, sight unseen. As a new "employee" they enter to discover what work load is cut out for them. They approach the store to discover the following:

a. *What is the initial impact?* Is the store inviting? Are there eye-catching window displays? What is the first impression on entering the store?

b. *How is the merchandise presented?* Are there logical merchandise groupings? Are the fixtures under- or overstocked?

c. *How does the merchandise mix differ?* What unique products does the competition stock? Are any special services provided?

d. *What is the pricing strategy?* Is the merchandise priced below, equal to, or above the competition? What merchandise is on markdown and at what markdown percent?

e. *Who are their customers?* Does their customer profile differ? In what ways?

3. *Consumer surveys.* These are effective tools to "check" the targeted customer profile. They can quickly highlight opportunities and pinpoint problems for an immediate response. For basic market research, the **store intercept**, or questionnaire, is the most frequently used research vehicle. Guidelines for in-store questionnaires include:

a. *Define the problem.* For All Seasons provides a high service level and the pricing structure is competitive, yet men's sports apparel sales are falling. They determine that the problem must be within the merchandise offerings.

b. *List the objective(s) of the survey.* For All Seasons' objective is to receive customer feedback on its merchandise assortment components. These include style, brand, silhouette, color, quality, and size range offerings.

c. *Design and write the questionnaire.* Many retailers contact several market research firms for bids to design and write the store intercept. The cost varies from state to state, but approximate costs are in the range of $200 to $500 and up, depending on the services requested. For All Seasons hires a firm to interview management, determine the appropriate questions, and design and print the questionnaire.

d. *Set a time limit.* For All Seasons sets a 3-week response time to create the sense of urgency for the customer to respond.

e. *Create a "hook."* For All Seasons is considering offering the following on completion of the survey:

 (1) A free cup of hot chocolate

 (2) A register-to-win ski trip to Switzerland

 (3) A premium offering—a free gift of a fanny pack with the store logo imprinted on each

f. *Plan signing and display areas.* For All Seasons will coordinate the presentation at the check-out station within each merchandise department.

g. *Tabulate and analyze the results.* Compute the percent each answer represents and compare the results to the targeted customer profile and merchandise assortment.

h. *React!* The retailer responds immediately, creating and implementing necessary action plans.

TARGETED CUSTOMER GROUP REVIEW

The primary goal of the retailer is to build a group of satisfied customers, producing a profit as a result. The required action steps are:

1. Monthly, shop the competition and react when necessary

2. Quarterly, review the targeted customer profile and market factor considerations

3. Annually, conduct a customer survey if the business warrants it

Customer identification and analysis and basic market research enable the retailer to predict which items will best satisfy the customers' needs and wants and ensure that the customer comes first.

SELF QUIZ

1. Objective buying decisions on the part of the retailer are based on customer identification and analysis and basic market research. Explain these concepts and discuss their importance.

2. For All Seasons requires each buyer to spend a day a week on the selling floor and to shop a minimum of two competitors each month. Explain the purpose of this policy.

3. For All Seasons is experiencing a decline in spring sales volume. Suggest specific steps For All Seasons should take to reverse this decline in sales.

MERCHANDISE GROUPINGS

merchandise classifications–specific merchandise assortment groups; also known as categories

All items stocked in a store are logically organized into departments containing related merchandise groups. These specific merchandise assortment groups are defined as **merchandise classifications** (classes) or **categories** (the terms are interchangeable). Within each class, assortments may be broken into subclasses to define the merchandise by style, and then may be further divided into subcategories to identify the styles by fabrication, silhouette, color, and so forth.

EXAMPLE:

Department	Class	Subclass	Subcategory
Men's Sports Apparel	Tennis	Shorts	Nylon
Women's Sports Apparel	Exercise wear	Leggings	Lycra
Accessories	Outerwear	Men's gloves	Thermal
Shoe	Aerobic	Women's	Leather
Sports Equipment	Winter sports	Skis	Downhill
Gift	Art	Numbered prints	Wildlife

EXAMPLE:

Class	Subclass	Subcategory
Tennis	Warm-up suits	Nylon
		Nylon/poly
		Velour
	Shorts	Nylon
		Stretch poplin
		Poly twill
	Tops	Cotton pique
		Cotton jersey
		100% cotton

CONSIDERATION OF STOCK FACTORS THAT INFLUENCE SALES VOLUME

Specific stock assortment groupings are defined further through consideration of factors that influence sales volume. These six factors are:

1. Basic stock lists

2. Best sellers

3. Seasonal merchandise

4. Promotional merchandise

5. Volume price points

6. Merchandise life spans

basic stock lists–merchandise within each classification that has consistent customer demand and that customers expect to always find

Basic stock lists. Merchandise within each classification that has a consistent customer demand comprise **basic stock lists**. Staple basics are considered "never outs" and are in stock 12 months a year. Poly/twill tennis shorts have consistent customer demand throughout the year, and therefore are included on the men's tennis basic stock list. The monitoring of shopworn items and the competition's pricing of identical items is crucial in maintaining the consumer demand for items that comprise basic stock lists.

best sellers–items producing the greatest sales volume

Best sellers. Items that produce the greatest sales volume are referred to as **best sellers** or "key items," select products that the customers must have. Nylon warm-up suits are best sellers within the men's tennis classification. It is best to buy in depth after identifying a best seller to prevent out-of-stocks and broken sizes (out-of-stocks within offered size ranges). Key items are watched so that reorders are reduced as popularity wanes.

seasonal merchandise—broad assortment of merchandise purchased for a specific season or holiday

Seasonal merchandise. A broad assortment of merchandise purchased for a specific season or holiday is defined as **seasonal merchandise**. Men's velour warm-up suits are warranted by the change of seasons, so they are included in seasonal merchandise groupings. The merchandise mix offers a range of items, not in depth, except for specific best sellers. Seasonal merchandise sales are closely monitored to ensure that remainders are reduced and cleared out before the end of the season. Seasonal merchandise should never be "stored" for the next year's season or holiday.

promotional merchandise—select products purchased to promote values to customers to increase store traffic and generate additional sales volume

Promotional merchandise. **Promotional merchandise** includes select products purchased to promote "values" to customers, increase store traffic, and generate additional sales volume. These items are not to be confused with clearance merchandise—the goods that the customer did not want. The For All Seasons' one-pocket tennis tee shirt with the store's logo is a major promotional vehicle within the men's tennis classification.

volume price points—prices that produce strongest sales volume

Volume price points. Within each subclassification, it is possible to capitalize on the retail pricing structure. For example, For All Seasons offers tennis shorts at $24.40, $42.00, and $54.00. Through unit stock control, the records show that the majority of regular priced sales are at the $42.00 price point. Therefore, $42.00 becomes the **volume price point** and purchases are concentrated here.

merchandise life span—identifiable sales timetable of merchandise

Merchandise life spans. All merchandise has an identifiable sales timetable or **merchandise life span**. Greater sales and profits are produced by the proper timing of incoming merchandise and the correct timing of reducing or eliminating stock items as their popularity declines, as illustrated in Figure 7.2 (page 154).

The sales timetable classifications indicated in this figure are:

1. *In.* Merchandise is received at the <u>right</u> time.

2. *Testing.* With proper planning unknown, new items are to be purchased in minimum quantities and sales are closely monitored for consumer response. If the customers respond, immediate reorders are placed. If not, the merchandise is quickly phased out at a minimal cost to the retailer.

3. *Incoming.* There is a proven demand yet the sales potential remains unknown. The assortment is expanded. Vendors usually have a limited quantity in stock.

4. *Prepeak.* Increasing sales that are key item oriented. The suppliers are adequately stocked to meet the retailer's needs.

5. *Peak.* Maximum sales, broadest assortment, optimal profits.

6. *Postpeak.* Regular price sales are falling. Markdowns are taken and the promotional sales generate substantial volume. Retailers begin to narrow the assortment. Resources are well stocked.

7. *Outgoing.* Declining customer response. Markdowns are taken to clear out the stock or reduce to the normal stock level.

Note: Basic stock items have relatively even sales timetables, so their merchandise life cycles are usually planned for upcoming promotional events only, when basic model stock levels will be increased in anticipation of the additional sales volume. Conversely, fashion merchandise, where style and color are the most important selling features, have relatively short life cycles and must be monitored closely.

Figure 7.2. Sales Timetable

How does the retailer determine a selling cycle?

1. *Sales records.* Past sales histories show seasonal and fashion trends.

2. *Competitive shopping.* When competitors reduce their prices, the retailer must react on widely distributed merchandise.

3. *Vendors.* Suppliers start offering specials on goods other than basic stock items.

SELF QUIZ

1. Best sellers are also referred to as _____ _____.

2. The introduction of particular goods warranted by the change in seasons are called _____ _____.

3. _____ _____ items are in stock 12 months a year and are considered _____ _____.

4. Explain the difference between promotional and clearance merchandise.

MERCHANDISE ASSORTMENT PLANNING

model stock—an outline of the necessary inventory items, with similar assortment and financial characteristics, which create an ideal assortment to meet the customers' needs and wants

class buying plans—related merchandise group plans by classification for unit and dollar control purposes

sourcing—continual search for the next emerging trend, the next best seller to predict and meet the customers' changing needs

The retailer plans each merchandise classification by creating a **model stock**, an outline of the necessary inventory items, which create an "ideal" assortment. These items are selected based on the customer's viewpoint and in terms of similar financial characteristics such as initial markups and/or stock turns. The retailer then defines each stock factor that influences sales volume.

1. The retailer lists every item that must be stocked within the merchandise class.

2. Each item is designated as a basic stock item, best seller, seasonal, or promotional item. (Some items will be categorized under each definition.)

3. The "ideal" retail, maximum cost, and desired initial markup percent are calculated.

4. Finally, the sales timetable is determined.

Refer to Figure 7.3 (page 156), which shows a skeletal merchandise plan for the For All Seasons' men's sports apparel department.

Class buying plans are developed from these model stock plans to allow close monitoring and analysis for profitability and sufficient inventory levels. An overabundance of a classification ties up dollars in slow moving merchandise and the unprofitable use of space. Conversely, understocking a classification reduces profitability by restricting potential sales and projects a poor merchandise image.

THE ONGOING SEARCH FOR NEW PRODUCTS

Continual **sourcing** for the next emerging trend—the next best seller—is necessary to meet the retailer's targeted customers' changing needs and wants. The successful retailer sources by:

1. Listening to customers, vendors, and employees

2. Conducting competitive shopping

3. Attending trade shows and apparel markets

4. Reading trade and local publications

Note: Refer to Figure 10.10 in Chapter 10, page 234, which lists the locations of the country's apparel markets and their approximate apparel market dates. Successful retailers contact their respective apparel market centers to obtain all mailings of the exact show dates and current market guides for advance planning. Examples of the Chicago Apparel Center's market directory page, which identifies each vendor's line by merchandise category, and a market schedule are illustrated in Figures 7.4 and 7.5 (pages 157 and 158).

THE SALES POTENTIAL OF NEW MERCHANDISE

The retailer considers the following questions when determining the sales potential of new merchandise:

1. Will it appeal to the retailer's targeted customer group?

2. With what merchandise classification will it be categorized?

3. Is it a duplication? Is a duplication necessary?

4. What is the initial markup potential? In what price range can it be grouped?

5. What is the selling cycle? Does that coordinate with the vendor's delivery schedule? Is there time to test first?

6. What merchandise will be discontinued to make room for the new entry?

7. Is it unique or widely distributed in the trading area?

8. What are the opinions of the sales staff? Will it be salable?

MERCHANDISE ASSORTMENT PLAN

Department **Men's Sports Apparel** Class **Tennis** Season **Fall** Year _____

MERCHANDISE DESCRIPTION	VENDOR	BASIC STOCK ITEM	BEST SELLER	SEASONAL ITEM	PROMOTIONAL ITEM	MAXIMUM COSTS	IDEAL RETAIL	IMU%	IN	PEAK	OUT
Warm-Up Suits:											
Nylon	Hart	X	X			70.00	148.00	52.7			
Nylon / Poly	Hart	X				80.00	160.00	50.0			
Velour	Velex			X	X	62.00	124.40	50.2	Oct.	Dec.	March
Shorts:											
Nylon	Hart	X			X	12.00	24.40	50.8			
Stretch Poplin	Conte	X				27.00	54.00	50.0			
Poly / Twill	Ash	X	X			21.00	42.00	50.0			
Tops: S/S											
Cotton Pique	Ash	X	X			22.00	48.00	54.2			
Cotton Jersey	Ash	X				25.00	54.00	53.7			
T-Shirts	Mast	X			X	8.00	16.40	51.2			
Tops: L/S											
Cotton/Poly	Ash			X		30.00	64.00	53.1	July	Dec.	May
Fleece	Mast			X		34.00	68.00	50.0	Aug.	Dec.	March

LADIES SPORTSWEAR—ACTIVE

COUTURE & DESIGNER	BRIDGE & BETTER	MODERATE	BUDGET	LINES	ROOM	PETITE	JUNIOR	MISSES	HALF & LARGE	TALL	Accessories	Beachwear	Cover-ups	Exercise	Golf	Jogging	Leotards	Racquet Ball	Ski, After Ski	Swimwear	Tennis	Unisex	Warm-ups	
		•		Design Zone	1156			•	•				•	•									•	
	•			Designs by Debbie Activewear	604			•					•	•										
		•	•	Directions	1217	•	•	•					•	•									•	
		•		Disney	1164		•						•							•				
	•			Dotti	1290			•			•	•	•											
	•	•		Duffel Sportswear Womens	Bth 2512	•		•					•		•	•						•		•
	•			Dunia	1348		•	•					•											
	•			E. Stewart Swimwear	1360			•			•	•							•					
	•			Ebelle	Bth 1129			•				•	•	•										
	•			Elisabeth Swimwear	1360			•											•					
•	•			Ellesse	1160	•	•	•	•	•				•						•	•		•	
				Emilio Rossi Sweaters	1337																		•	
				E.N.U.F.	1254									•			•						•	
	•	•		Etienne Aigner	960			•			•												•	
		•		Euro Joy	1281			•						•		•							•	
		•		Eurojoy	Bth 1208			•						•	•	•							•	
			•	E.V.E. Ltd.	11-105				•										•					
		•		Fanny by Martinique	Bth 1319		•	•			•													
		•		Fitigues	1348		•	•						•										
	•	•		Flexatard	1127		•	•			•			•			•							
		•		Flirt USA	11-118		•	•															•	
				Flirt USA Plus	11-118																		•	
		•		Flyte Action Wear	1162		•							•									•	
		•		Frog Pond	1398			•						•		•							•	
				G Apparel	1154									•									•	
				G Casuals	1154									•										
	•	•		Gabar Missy Swimwear	1102			•					•							•			•	
•	•			Gauzeling International	1297	•	•	•	•				•	•	•					•	•		•	
	•	•		Gear 1 Apparel	1162			•			•		•	•		•	•	•					•	
	•		•	Gerry	9-100			•					•	•									•	
		•		Gertrude Davenport	604			•					•	•									•	
	•	•		Gilda Marx Industries	1127		•	•			•		•	•		•							•	
	•	•	•	Gitano	10-109	•	•	•			•	•	•							•			•	
	•	•	•	Gitano Juniors	10-109		•				•	•	•							•			•	
	•	•	•	Gitano Misses	10-109			•			•	•	•							•			•	
	•	•	•	Gitano Plus	10-109				•		•					•				•			•	
				Gitano Swimwear	10-109		•	•	•		•	•								•				
	•	•		Gitano Women	10-109			•			•									•			•	
		•		Gopher Activewear	Bth 1309		•	•	•		•	•	•							•		•		
	•			Gordon Sport	1267			•								•							•	
	•	•		Gotcha Sportswear	7-128		•																	
	•	•		Gotta Have It	1162			•						•		•	•	•	•	•				
•	•			Gottex Swimwear	1221			•					•							•				
	•	•		Great Cavalier	Bth 1215			•						•							•	•	•	
	•			H. Harlequin Inc.	Bth 1027		•	•			•													
		•		Harbour Casuals	1108		•	•	•		•	•												
		•		Harley Davidson Clothing	Bth 1305		•	•	•													•		
		•		Haymaker Activewear	604			•							•									
		•		Heather	1297	•	•	•				•	•	•		•	•				•		•	
				Heatwave Bodywear	1160													•		•				
		•		Hot Coles	1100		•													•				
	•	•		Hot Stuff	Bth 1026						•													
	•	•	•	Hot Stuff	11-108	•	•		•				•											
	•	•		Huit - Ready to Wear	9-104			•						•			•							
			•	Impanema Swimwear	1150			•												•				

Figure 7.4. Chicago Apparel Center's Market Directory

Quick View
Market Schedule

 Make plans today: Call Mart Center Travel Service, 800/528-8700; or General Market Information, 800/677-6278.

Admission to all events is FREE; tickets are required

TIME	FRIDAY, JANUARY, 15
9 am-6 pm	PREVIEW DAY in Permanent Showrooms Only.

	SATURDAY, JANUARY 16
9 am-6pm	MARKET HOURS
7 pm	DESIGNER FASHION SHOW
	Featuring Memphis • Ballroom, 14th floor

	SUNDAY, JANUARY 17
9 am-6pm	MARKET HOURS
8 am	TRENDSETTER FASHION SHOW
	Featuring Windridge • Ballroom, 14th floor
9:30 am	CONTINENTAL BREAKFAST, ExpoCenter
9 am-10pm	SWIMWEAR SELLING CLINIC, ROOM 1131
6 PM	ACCESSORY FASHION PREVIEW/
	WINE & CHEESE RECEPTION
	Conference Center, 2nd floor

	MONDAY, JANUARY 18
9 am-6 pm	MARKET HOURS
9 am-10am	TRACKING THE TRENDS WITH
	ACCESSORIES MAGAZINE, Room 9-111
6 pm-7:30 pm	MARKET GET-TOGETHER
	T.G.I. Friday's • 1st floor, The Merchandise Mart
	(take pedestrian bridge)

	TUESDAY, JANUARY 19
9 am-6pm	MARKET HOURS

	WEDNESDAY, JANUARY, 20
9 am-4pm	MARKET HOURS, ExpoCenter
9 am-6pm	MARKET HOURS, Permanent Showrooms

Figure 7.5. Chicago Apparel Center's Market Schedule

SELF QUIZ

1. For All Seasons has experienced a rising demand for polo apparel and equipment. The store's management has decided to consider carrying a limited amount of the merchandise and has asked the sports equipment buyer to develop an ideal merchandise assortment plan. Explain what steps this buyer will take to develop this ideal merchandise assortment plan and what factors should be considered in determining the sales potential of this potential merchandise.

2. Recently, there has been increased publicity by the media regarding the area in which For All Seasons is located due to the World Cup Ski Championships to be held there next January. How should For All Seasons prepare for this major event with regard to its merchandise offerings?

3. As one of the For All Seasons buyers, you are preparing to shop the competition. Outline what you will look for when you enter each competitor's store.

4. For All Seasons' past month's sales records indicate the following:

Subclass	Retail Price	Quantity Sold
Downhill skis	$180.00	25
	$210.00	48
	$298.00	30
Cross country skis	$140.00	41
	$190.00	29
	$230.00	15
Ski boots	$ 80.00	29
	$105.00	14
	$125.00	32
Down ski jackets	$ 95.00	18
	$110.00	22
	$150.00	43

a. What is the volume price point for each subclass listing?

Downhill skis　　　　＿＿＿＿＿＿

Cross country skis　　＿＿＿＿＿＿

Ski boots　　　　　　＿＿＿＿＿＿

Down ski jackets　　　＿＿＿＿＿＿

b. Review the subclass groupings and describe the adjustments For All Seasons should make immediately.

Figure 7.6. Chicago Tribune Letter to the Editor

A MESSAGE TO RETAILERS

Merchandise classifications must be analyzed and updated on an ongoing basis to enable the retailer to predict, in advance, the customers' needs and wants. Then consumer responses would not be as shown in Figure 7.6.

Periodic review and analysis of the targeted customer and merchandise assortment will help the retailer to satisfy customers and:

1. Control the dollar investment in merchandise

2. Use the store's space profitably

3. Increase sales

4. Minimize markdowns

5. Generate profits

1. Distinguish among an underweight assortment, an overweight assortment, and an ideal weight assortment.

2. What steps are involved in blending the "ideal" merchandise mix?

3. Explain why subjective buying on the part of the retailer results in inappropriate business decisions.

4. Discuss the three ways in which the retailer may conduct basic market research.

5. Fill in the blanks for each of the following statements:

 a. Merchandise within each classification that has a consistent customer demand comprises _____ _____ _____.

 b. Items that produce the greatest sales volume are referred to as _____ _____.

 c. A broad assortment of merchandise purchased for a specific season or holiday is defined as _____ _____.

 d. _____ _____ includes select products purchased to promote "values" to customers, increase store traffic, and generate additional sales volume.

 e. Prices that produce the strongest sales volume are defined as _____ _____ _____.

 f. The sales timetable of merchandise is the _____ _____ _____.

6. What are the seven components of a sales timetable?

7. Explain how merchandise classifications are determined and planned.

8. List the four ways in which retailers continually source for the next emerging trend or best seller.

9. Discuss how the retailer determines the sales potential of new merchandise.

10. An assortment of Christmas motif items was received on November 1. On December 26, 64 pairs of gloves, 78 pairs of socks, 88 hats, and 112 sweaters are on hand.

 a. Was this seasonal assortment ordered properly? What factors possibly affected the sales results?

b. What steps should the buyer take after reviewing the quantities remaining?

c. Write your recommendations for ordering Christmas motif items for next year's holiday season.

CHAPTER TEST

1. You have been hired by For All Seasons to competitive shop the local competition. Select two similar stores in your area. Report your observations on the Competitive Shopping Report below.

COMPETITIVE SHOPPING REPORT

Store #1 _____ Store #2 _____

Date _____ Date _____

INITIAL IMPACT

Window displays and signing? Overall appearance? Eye-catching? First impression on entering the store?

Store #1	Store #2

MERCHANDISE PRESENTATION

What are the two or three strongest category statements? Where are they located (sketch store layout, if possible)? Does the merchandise relate to adjacent category presentations? Are fixtures over- or understocked? List specifics.

Store #1	Store #2

MERCHANDISE DEFICIENCIES/SPECIALITIES

How does the merchandise assortment differ from yours? Voids? Unique products? Special services?

Store #1	Store #2

PRICING STRATEGY

List prices on basic stock items. How do they compare? Are they priced above, level, or below your prices? What merchandise is on markdown? At what markdown percent?

Store #1	Store #2

TARGETED CUSTOMER PROFILE

Do their customers differ from yours? How (dress, age, etc.)?

Store #1	Store #2

OTHER COMMENTS

Did any sales events catch your eye? Explain why and how they captured your attention. How is their customer service, approach, and product knowledge?

Store #1	Store #2

2. For All Seasons' average weather and tourist trends are recapped below.

By the end of September the daily temperature averages between 40° and 50°. The first snowfall usually occurs by the end of October and continues through February. By the end of March daytime temperatures range in the high 50s. Determine the selling cycle for each item listed below and write the approximate selling cycle dates below the headings of In, Peak, and Out.

Item	In	Peak	Out
Thermal gloves			
Down ski jackets			
Flannel lined jeans			
Mink ear muffs			

Explain the thought process behind your plotted selling cycle of each item.

3. As the For All Seasons workout wear buyer you must create a spring class plan for women's workout wear. Using the provided assortment plan form in Figure 7.7, create the merchandise plan according to the following guidelines:

a. List a minimum of eight items.

b. Identify each item as a basic stock item, best seller, seasonal, or promotional item by placing an X under the appropriate heading.

c. Create ideal retails for each item and then calculate the maximum cost figure based on an IMU% plan of 52%.

d. Determine the life cycle for each listed item.

MERCHANDISE ASSORTMENT PLAN

Department_____ Class_____ Season_____ Year_____

MERCHANDISE DESCRIPTION	VENDOR	BASIC STOCK ITEM	BEST SELLER	SEASONAL ITEM	PROMOTIONAL ITEM	MAXIMUM COSTS	IDEAL RETAIL	IMU%	IN	PEAK	OUT

Figure 7.7. Merchandise Assortment Plan

4. Men's 100% nylon pants are a promotional item within the men's sports apparel department. Their ideal retail is $36.40 and the IMU% is 52.5%.

 a. Calculate the maximum cost to be negotiated with a vendor.

 b. Although these pants are classified as a promotional item, should For All Seasons stock these pants year-round?

 c. Based on the description of For All Seasons' local weather trends, determine the merchandise life span and explain your thought process.

5. Past sales records show that customers purchase women's warm-up suits according to the following size breakdown:

25%	Small
55%	Medium
20%	Large

 For All Seasons hired a new women's sports apparel buyer 3 months ago. (The new buyer can be described as petite.) On reviewing the current size ranges on the selling floor and in the stockroom, management determines that of 60 pieces on hand, 27 are size small, 21 are size medium, and 12 are size large.

 a. Describe the current buying technique and formulate what management will discuss with the new buyer.

 b. Calculate the percentage each size currently represents by size and compare the results to the women's warm-up suit sales history record. Explain what steps should be taken immediately by the new buyer.

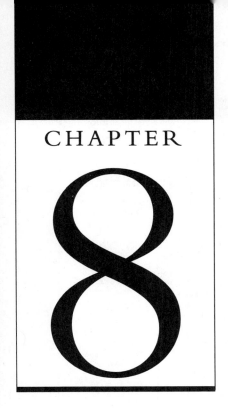

CHAPTER 8

Stock/Sales Budgeting

Once the assortment planning process is completed, the retailer must control this major investment to ensure profitability. This is accomplished through stock/sales budgeting. Profit is the result of inventory planning and control.

THE MERCHANDISE PLAN

merchandise plan—a 6- or 12-month financial plan that forecasts and controls purchase and sale of merchandise; also referred to as *merchandise budget* or *stock/sales plan*

master budget—sum total of each department's stock/sales plans

The **merchandise plan**, also referred to as the **merchandise budget** or **stock/sales plan**, is a 6- or 12-month financial plan that forecasts and controls the purchase and sale of merchandise. Typically, a master merchandise budget is prepared for the total operation annually, and is then divided into two 6-month selling seasons. The **master budget** is the sum total of each department's stock/sales plans. A master budget is illustrated in Figure 8.1.

The merchandise plan serves many purposes. It:

1. Provides a financial guide to maintain a profitable balance between stock and sales
2. Aids the retailer in buying decisions
3. Develops records of merchandising successes and failures
4. Provides advance cash flow planning for upcoming merchandise purchases
5. Monitors the progress of achieving gross margin goals and the desired net profit

The merchandise plan includes seven primary ingredients:

1. Projected monthly sales figures
2. Beginning-of-the-month (B.O.M.) inventory levels
3. Stock turnover rate for the selling season
4. Monthly stock-to-sales ratios
5. Planned markdown dollars per month
6. Purchase requirements by month
7. Seasonal gross margin percent goal

Each ingredient will be thoroughly explained and demonstrated as a merchandise plan is created step-by-step in this chapter. Figure 8.2 (page 172) presents an example of a completed merchandise plan for a hypothetical retail operation.

Figure 8.1. Master Merchandise Budget

	AUGUST		SEPTEMBER		OCTOBER		NOVEMBER		DECEMBER		JANUARY		FEBRUARY		TOTAL SEASON		MISC INFO	
	LAST YR	PLAN	LAST YR	PLAN	LAST YR	PLAN	LAST YR	PLAN	LAST YR	PLAN	LAST YR	PLAN	LAST YR	PLAN	LAST YR	PLAN	LAST YR	PLAN
BUYER 42																	% INCR	9.6
SALES	196.9	221.1	232.8	274.7	193.7	204.0	173.2	207.9	266.8	282.3	95.6	104.6			1186.0	1306.0		
BOM	796.2	549.6	884.0	618.1	737.6	576.0	764.1	599.9	688.2	587.0	412.6	466.3	684.7	548.4	4974.8	3945.3	SHRINKAGE	
WOS																	0.042	0.034
GRS RCPTS	354.6	339.2	223.0	330.1	264.8	284.1	154.8	252.1	134.0	270.0	447.6	223.7			1574.8	1701.2		
GRS MU%	57.2	56.3	55.1	58.7	53.9	53.9	61.0	53.8	57.4	57.8	59.3	57.9			57.3	56.7	TURNOVER	
MUC'S	5.4	5.4	39.1	39.1	1.7	1.7	13.5	3.3	26.2	26.2	11.3	11.3			97.2	87.2	1.7	2.3
NET RCPTS	349.2	333.8	183.9	291.0	759.1	282.4	141.3	248.6	107.8	243.8	436.3	214.4			1477.6	1614.0		
PURCH C	151.9	148.4	100.2	134.4	129.3	130.9	60.4	111.5	57.1	114.0	182.3	95.0			672.2	734.1	M/D % TO SALES	
MD	44.3	44.2	57.4	54.1	53.0	50.3	44.6	53.6	117.2	82.2	15.7	28.3			338.4	313.2	28.3	24.2
CURR MU%	54.5	55.5	45.3	53.1	53.6	53.7	57.3	53.2	47.0	53.2	58.2	55.7			54.5	54.4		
CUM MU%	53.5	52.5	52.3	52.6	52.5	52.8	52.9	53.2	52.6	53.2	53.4	53.4			53.7	53.4	AVG INV	
GM-$	94.1	107.2	113.2	133.9	85.0	95.6	81.8	96.8	95.1	126.1	39.6	32.1			508.8	591.6	710.7	563.6
%	47.3	48.5	44.8	48.4	43.9	46.6	46.7	46.5	35.6	44.7	44.2	30.8			42.9	45.5		
BUYER 44																	% INCR	-1.3
SALES	137.3	143.2	189.0	188.7	157.6	145.8	120.2	121.1	217.1	204.9	50.4	62.9			873.6	862.4		
BOM	499.0	505.8	597.9	518.8	709.2	704.2	677.0	419.6	752.1	468.8	456.4	374.3	441.9	341.3	4253.2	3109.4	SHRINKAGE	
WOS																	0.046	0.023
GRS RCPTS	274.3	199.3	371.0	235.2	302.1	131.7	133.3	216.2	67.7	187.6	104.1	53.0			1252.7	1023.0		
GRS MU%	57.7	53.5	58.0	61.5	54.8	54.9	62.0	53.8	54.7	58.1	57.0	53.1			57.8	57.4	TURNOVER	
MUC'S	16.3	12.6	46.0	44.8	20.8	13.5	4.3	10.8	27.4	21.6	0.7	3.6			115.5	106.9	1.4	1.9
NET RCPTS	258.0	184.7	325.9	190.4	281.3	118.2	121.2	205.4	40.3	166.0	103.4	51.4			1137.2	918.1		
PURCH C	116.0	88.7	153.9	99.6	130.9	56.7	50.8	95.3	30.6	78.5	44.8	24.7			528.3	434.6	M/D % TO SALES	
MD	19.0	30.5	33.3	39.7	34.3	33.6	44.6	33.1	119.0	59.6	12.6	21.3			263.8	220.9	30.4	25.5
CURR MU%	55.0	52.5	52.0	52.5	53.6	52.6	60.7	52.5	24.0	52.2	54.7	52.0			53.5	52.7		
CUM MU%	53.1	51.9	52.8	52.0	53.0	52.0	53.6	52.3	52.3	52.3	53.1	52.3			53.1	52.3	AVG INV	
GM-$	71.0	60.7	91.5	82.7	73.4	62.4	53.5	49.8	64.7	85.6	10.9	14.6			364.9	355.9	607.9	444.2
%	50.9	42.4	48.4	43.9	44.6	42.8	44.5	41.1	29.8	42.6	21.5	23.3			41.8	41.3		
BUYER 45																	% INCR	34.0
SALES	181.6	234.9	309.0	415.4	217.9	267.4	173.5	242.1	270.9	362.3	73.6	117.9			1226.5	1644.0		
BOM	612.7	633.3	680.0	799.2	644.3	739.3	552.3	688.9	674.6	699.9	447.3	563.0	556.6	653.9	4168.8	4800.3	SHRINKAGE	
WOS																	0.019	0.019
GRS RCPTS	294.4	431.2	374.2	458.8	179.4	274.5	341.0	318.5	168.3	349.6	219.2	244.9			1576.5	2077.5		
GRS MU%	54.2	52.9	54.4	53.9	53.6	54.0	55.7	54.8	59.6	54.7	51.9	53.0			54.7	54.2	TURNOVER	
MUC'S	5.2	5.6	19.8	20.8	5.1	5.1	10.5	13.2	34.3	34.3	1.3	1.3			76.2	79.9	2.1	2.4
NET RCPTS	289.2	424.0	354.4	438.0	174.3	269.4	330.5	325.3	134.0	315.3	217.9	243.6			1500.3	1997.6		
PURCH C	134.8	203.2	170.5	211.3	83.7	126.2	151.2	153.9	68.0	151.3	105.4	115.2			713.6	951.0	M/D % TO SALES	
MD	40.3	43.2	79.2	82.5	50.3	52.4	51.6	52.2	90.6	89.1	11.8	35.6			304.8	355.0	25.0	21.6
CURR MU%	52.4	52.3	51.9	51.8	52.0	53.2	54.3	52.9	49.2	52.0	51.6	52.7			52.4	52.4		
CUM MU%	52.6	52.3	52.4	52.1	52.4	52.3	52.7	52.4	52.5	52.3	52.4	52.4			52.4	52.4	AVG INV	
GM-$	85.1	115.6	157.4	194.9	98.6	127.0	84.7	112.8	110.0	164.4	25.3	37.6			541.3	752.3	595.7	685.8
%	46.9	46.4	44.5	44.9	43.3	47.5	48.8	44.6	40.6	45.4	34.6	31.9			44.1	45.8		
BUYER 47																	% INCR	79.7
SALES	143.7	242.0	206.8	373.0	153.7	269.2	125.1	244.0	199.5	343.0	47.7	83.8			876.5	1575.0		
BOM	565.1	704.7	622.7	911.2	644.7	849.4	667.1	834.3	557.5	771.3	391.7	510.9	417.7	641.3	3866.5	5227.1	SHRINKAGE	
WOS																	0.083	0.078
GRS RCPTS	252.5	530.5	311.6	413.0	227.0	331.5	57.3	258.4	149.3	213.6	179.9	269.5			1183.6	2016.5		
GRS MU%	54.6	55.6	42.7	57.4	55.1	53.4	53.8	53.7	53.4	52.7	52.5	54.1			54.8	55.2	TURNOVER	
MUC'S	23.8	23.8	44.5	44.5	18.4	18.4	2.7	2.7	4.0	4.0	9.5	9.5			104.9	104.9	1.6	2.1
NET RCPTS	234.7	506.7	265.1	366.5	204.6	313.1	54.6	255.7	145.3	209.6	170.4	260.0			1078.7	1911.6		
PURCH C	112.1	233.6	116.3	176.1	102.0	147.8	26.5	119.5	69.4	101.1	85.4	123.8			511.7	903.9	M/D % TO SALES	
MD	33.4	62.2	34.2	55.3	32.4	59.0	39.3	74.7	111.7	107.0	23.4	45.8			274.4	404.0	31.5	25.7
CURR MU%	52.2	53.5	54.1	52.0	51.1	52.8	51.5	53.3	52.1	51.8	49.9	52.4			52.6	52.7		
CUM MU%	52.0	52.3	53.0	52.2	52.7	52.3	52.6	52.4	52.6	52.3	52.3	52.4			52.3	52.4	AVG INV	
GM-$	65.7	109.6	102.6	183.0	79.6	124.2	52.9	104.6	63.4	156.3	-16.7	-27.8			338.4	649.3	552.4	746.7
%	45.7	45.0	49.6	49.1	45.8	46.1	42.3	42.9	31.8	43.1	-35.0	-33.2			38.6	41.2		
BUYER 49																	% INCR	-15.0
SALES	188.8	154.0	235.2	178.2	158.6	129.6	129.7	113.6	195.4	194.0	43.3	40.8			952.8	810.0		
BOM	589.4	495.0	609.7	380.4	534.6	366.2	727.1	344.6	585.7	345.0	311.3	269.0	408.7	278.7	3768.7	2416.9	SHRINKAGE	
WOS																	0.016	0.016
GRS RCPTS	276.7	195.4	237.2	222.0	372.2	153.8	47.2	198.8	66.4	185.0	164.7	78.0			1164.4	1008.2		
GRS MU%	62.2	62.3	62.3	61.5	64.0	64.3	64.9	58.7	72.8	61.9	54.7	58.7			62.3	60.9	TURNOVER	
MUC'S	34.1	34.0	31.4	32.0	15.8	15.0	11.3	23.5	15.5	25.0	0.5	5.0			116.6	122.5	1.8	2.3
NET RCPTS	242.6	165.4	205.8	198.0	374.4	140.8	35.9	165.8	22.5	168.0	164.2	63.0			1047.8	884.2		
PURCH C	104.5	73.6	89.4	85.5	141.2	61.6	16.6	74.6	12.6	76.4	74.7	9.2			439.0	394.6	M/D % TO SALES	
MD	34.4	28.0	43.7	34.0	27.3	32.0	47.5	32.8	98.8	78.8	4.2	14.3			264.9	202.3	27.4	25.0
CURR MU%	54.4	55.5	54.6	55.0	62.5	54.0	53.9	53.8	44.9	54.6	54.5	55.3			58.1	53.3		
CUM MU%	54.6	54.0	54.3	54.3	57.6	54.3	54.7	53.7	54.7	54.8	54.5	54.8			54.5	54.8	AVG INV	
GM-$	93.6	77.3	119.3	88.3	72.1	64.7	59.6	53.1	86.1	90.5	14.6	13.5			461.6	383.4	538.8	345.3
%	50.9	54.2	56.8	49.5	58.1	44.9	43.8	44.8	44.6	44.7	34.0	33.2			46.4	47.3		
GROUP 4																	% INCR	21.0
SALES	851.5	999.2	1192.8	1432.0	881.3	1020.0	723.7	928.5	1152.7	1402.5	313.4	409.4			5115.4	6191.6		
BOM	3046.4	2824.4	3394.3	3235.7	3285.4	3011.7	3502.3	2887.3	3258.1	2892.0	2018.9	2184.3	2529.6	2463.6	21035.0	19499.0	SHRINKAGE	
WOS																	0.038	0.038
GRS RCPTS	1458.5	1695.6	1517.0	1659.1	1361.5	1176.8	733.8	1225.0	565.7	1205.8	1115.5	865.1			6752.0	7828.4		
GRS MU%	57.5	55.8	58.3	57.8	57.6	55.5	58.4	55.5	57.9	57.3	55.9	55.2			57.6	56.3	TURNOVER	
MUC'S	84.8	77.0	182.8	183.2	61.8	53.7	42.3	45.2	115.4	111.1	23.3	30.7			510.4	500.9	1.7	2.2
NET RCPTS	1373.7	1618.6	1334.2	1475.9	1299.7	1123.1	691.5	1180.8	450.3	1094.7	1092.2	834.4			6241.6	7327.5		
PURCH C	619.3	749.4	632.3	699.7	577.6	523.2	305.4	545.0	238.0	515.4	492.5	387.6			2865.0	3420.3	M/D % TO SALES	
MD	174.4	208.1	250.0	267.9	201.3	227.5	212.6	247.6	537.3	399.9	72.7	145.7			1448.3	1496.7	28.3	24.2
CURR MU%	54.9	53.7	52.6	52.6	55.6	53.4	55.8	53.8	47.2	52.9	54.9	53.6			54.1	53.3		
CUM MU%	53.2	52.5	52.5	52.5	53.5	52.7	53.7	52.8	53.1	52.8	53.5	52.9			53.5	52.9	AVG INV	
GM-$	411.6	469.7	564.2	682.8	415.5	469.9	332.4	417.0	413.3	623.0	73.9	69.9			2214.9	2732.4	3005.0	2785.6
%	48.3	47.0	47.3	47.7	47.6	46.1	45.9	44.9	35.9	44.4	23.6	17.1			43.3	44.1		

Beginning
of
Month
(B.O.M.)

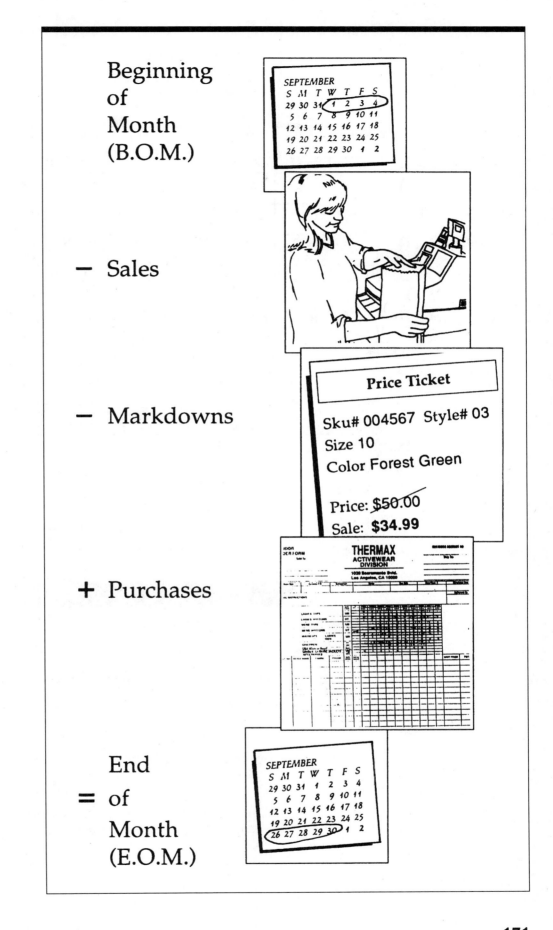

− Sales

− Markdowns

Price Ticket

Sku# 004567 Style# 03

Size 10

Color Forest Green

Price: $50.00

Sale: **$34.99**

THERMAX
ACTIVEWEAR
DIVISION

+ Purchases

End
= of
Month
(E.O.M.)

MERCHANDISE PLAN

(PLANNING PERIOD)

	MONTH	Feb.	March	April	May	June	July	Aug.	STOCK TOTAL	AVG.
B.O.M STOCK	LY	239.5	202.7	431.7	466.5	522.8	493.2	393.0	2748.4	392.6
	PLAN	493.5	427.2	467.0	443.0	464.0	366.0	403.0	3063.7	437.7
	ACTUAL									

			Feb		March		April		May		June		July		SALES TOTAL	%
STOCK: SALES RATIO	LY	PLAN	3.0	5.5	1.2	2.3	2.4	2.2	2.8	2.1	2.6	1.9	4.1	2.7		

	MONTH	Feb.	March	April	May	June	July	Aug.	SALES TOTAL	%
SALES	LY	80.5	166.7	178.5	165.4	204.8	119.3		915.2	14.8
	PLAN	90.0	183.8	209.2	212.5	241.5	137.0		1074.0	17.4
	ACTUAL									
MARKDOWNS	LY	31.7	26.1	36.2	31.1	41.0	44.4		MARKDOWNS TOTAL 210.5	23
	PLAN	23.0	34.0	42.0	39.0	50.0	30.0		218.0	20.3
	ACTUAL									
PURCHASES	LY	76.4	421.8	249.5	252.8	216.2	63.5		PURCHASES TOTAL 1280.2	
	PLAN	46.7	257.6	227.2	272.5	193.5	204.0		1201.5	
	ACTUAL									

GROSS MARGIN %

LY _46.9_ %
PLAN _49.1_ %
ACTUAL _____ %

STOCK TURN

LY _2.33_
PLAN _2.45_
ACTUAL _____

Figure 8.2. Completed Merchandise Plan

SELF QUIZ

1. The merchandise plan is also referred to as the _____ _____ or the _____ _____

2. The merchandise plan provides a financial guide to maintain a profitable balance between _____ and _____.

3. The merchandise plan is a _____ or _____ month financial plan that _____ and _____ the purchase and sale of merchandise.

4. One of the purposes of the merchandise plan is to aid the retailer in buying decisions. What are three other purposes?

5. What are the seven primary ingredients of the merchandise plan?

MERCHANDISE PLANNING PROCEDURES

Remove the blank merchandise plan shown in Figure 8.3 because you will be completing this form in detail throughout the chapter.

SEASONAL PLANNING

The first step in completing a merchandise plan is to fill in the Planning Period heading. This identifies the selling season. From a merchandising viewpoint, there are two selling seasons: spring/summer and fall/winter, shortened to spring and fall. Spring includes the months of February through July; fall includes August through January. Each season consists of 26 weeks. The seasons are delineated as such as suppliers begin offering specials, referred to as *close-outs* and *off-price merchandise*, to make room for the next major cycle of planned goods.

MERCHANDISE PLAN

(PLANNING PERIOD)

	MONTH								STOCK	
									TOTAL	AVG.
B.O.M STOCK	LY									
	PLAN									
	ACTUAL									
STOCK: SALES RATIO	LY PLAN								**SALES**	
									TOTAL	%
SALES	LY									
	PLAN									
	ACTUAL									
									MARKDOWNS	
									TOTAL	%
MARKDOWNS	LY									
	PLAN									
	ACTUAL									
									PURCHASES	
									TOTAL	
PURCHASES	LY									
	PLAN									
	ACTUAL									

GROSS MARGIN %

LY _____ %
PLAN _____ %
ACTUAL _____ %

STOCK TURN

LY _____
PLAN _____
ACTUAL _____

Figure 8.3.

Something to Consider: THE RETAIL CALENDAR

The majority of retailers use the **retail calendar**, which allows for comparisons of each day of a year to the same day from the previous year. For example, if the retailer wants to compare the results of Saturday's business to the previous year's Saturday results, this calendar method for maintaining merchandise and accounting data provides these correlations easily. Unlike the conventional calendar year, the retail calendar year is divided into four quarters, each comprised of 13 weeks. Each week begins with a Sunday and ends on a Saturday, therefore eliminating split conventional calendar weeks. The retail calendar begins on a Sunday in the end of January or early February with the first month containing 4 weeks, the second month 5 weeks, the third month 4 weeks, and so on; hence, the retail calendar is also referred to as the 4-5-4 week calendar.

Fill in "fall" as the planning period and the months August through January. There is an additional space in the month row, which will be explained later. For now, just write in "February."

SALES PLANNING FACTORS

To begin a merchandise plan, net sales volume must be projected. Inventory can then be held at a level corresponding to sales (sales in merchandise plans are net).

When planning sales, several factors must be considered:

1. *Last year's (LY) net sales volume for the planning period.* In this case, last year's fall sales (August – January).

 For All Seasons' last fall's net sales volume results are:

Aug.	Sept.	Oct.	Nov.	Dec.	Jan.
$200.0	180.0	200.0	220.0	260.0	270.0

 (Throughout this planning process **financial notation** will be used; this is a way of abbreviating numbers when formulating planned financial reports. The decimal point acts as the holding point for thousands. For example, $200,000 = $200.0, $1,100 = $1.1. When using financial notation, round off all numbers to the nearest hundred: $750 = $.8; $820 = $.8; $75 = $.1; $35 = omit. For further reference see Appendix 3, "Rounding Numbers and Financial Notation.")

2. *Last year's (LY) sales percent increase or decrease over the previous year.*

Formula for Calculating Percentage Change:

$$\frac{\text{Dollar Amount of Most Recent Time Period} - \text{Dollar Amount of Comparison Period}}{\text{Dollar Amount of Comparison Period}} = \text{\% Change}$$

EXAMPLE:

For All Seasons' last year's fall sales totaled $1330.0. The previous fall season generated sales of $1236.0.

$$\frac{\$1330.0 - \$1236.0}{\$1236.0} = \frac{\$\ 94.0}{\$1236.0} = \textbf{7.6\% Increase}$$

For All Seasons' last year's sales percent increase over the previous year's fall season was 7.6%.

3. *Current sales trend.* This is calculated using the formula provided above using the spring season-to-date figures. First quarter sales (February, March, April) total $705.9. Last year's sales for the same period were $673.6.

$$\frac{\$705.9 - \$673.6}{\$673.6} = .0479$$

$$.0479 = 4.8\%$$

For All Seasons' current sales trend is 4.8%.

4. *Upcoming possible changes that can affect sales, favorably or unfavorably, such as:*

 a. Renovation of the store

 b. Changes in the local competition

 c. Economic changes

 d. Industry trends

 e. Local community changes

 f. Increases or decreases in advertising and promotional activity

 g. Shifts in the months in which holidays occur

For All Seasons foresees three changes that will affect the upcoming fall season:

 a Continued economic downward trend

 b. Increased level of vendor partnerships, therefore improved negotiating results

 c. 100th Anniversary Event, scheduled for October

5. *Management's proposed sales increase (or decrease due to extraordinary conditions).* This is referred to as **"top-down" planning**, which occurs when top management specifies sales goals and dollar or unit budgets.

 Management's proposed increase is 6.0%.

"top-down" planning–top management specifies sales goals and dollar and/or unit budgets

Fill in the following blanks using the For All Seasons information previously noted. Remember to use financial notation: $200,000 = $200.0, $1,500 = $1.5.

Planning Period: spring fall

(Circle planning period)

Last Year's (LY) Net Sales Volume: $ _____

(for the planning period)

LY Sales % Increase or Decrease: _____ %

(over the previous season)

Current Sales Trend Percent + or (-): _____ %

Management's Proposed Increase*: _____ %

*A decrease would only be planned due to extraordinarily adverse business factors.

"bottom-up planning"–planning method in which assortment plans are built based on targeted customers' needs and wants; model stocks are formulated for each merchandise classification and the sum total creates the master merchandise plan

The previous figures and facts are analyzed by the merchant. Is the management's proposed increase attainable? If not, factual data to support a proposed change would be presented to management to possibly gain approval for an adjustment. If approved, the merchant succeeds in the ideal method of merchandise planning, referred to as **"bottom-up" planning.** Bottom-up planning means to build assortment plans based on the customer, totaling the dollar amounts, creating merchandise classification stock/sales plans, which in turn formulate the master merchandise plan. This method focuses on serving the customer, rather than management pushing down controls that can deter addressing the customer's needs and wants.

On reviewing For All Seasons' sales planning factors, a 6% increase is a figure to reach for and is reasonably attainable.

sales forecasting–projecting future sales volume for specific period of time based on past sales records, current sales trend, management's direction, and local economic and market factors

Sales forecasting. **Sales forecasting** is the most important step in creating the merchandise plan because all the ingredients of the plan depend on realistically planned sales to achieve the season's planned goals.

1. Write in last year's fall sales figures on the Forecasting Sales Worksheet in LY's sales column.

2. The percent increase per month has been determined based on the factors that may affect business. Notice that they fluctuate each month to reflect sound decisions and are not calculated at a constant 6% each month.

3. Compute the sales change for the planning season.

<div align="center">

Formula for Calculating Sales Change

LY Sales by Month	$200.00 LY August Sales
× % Planned Increase	× .06
Sales Change	**$ 12.00 = $12,000 Increase**

</div>

4. Calculate planned sales.

<div align="center">

Formula for Calculating Planned Sales

LY Sales by Month	$200.0 LY August Sales
+ Sales Change	+ 12.0
Planned Sales	**$212.0 = $212,000 August Sales Plan**

</div>

FORECASTING SALES WORKSHEET

MONTH	LY SALES		PERCENT		SALES CHANGE		PLAN SALES
Aug.	$200.0	×	.06	=	$12.0	=	$212.0
Sept.	$	×	.10	=	$	=	$
Oct.	$	×	.15	=	$	=	$
Nov.	$	×	.04	=	$	=	$
Dec.	$	×	.035	=	$	=	$
Jan.	$	×	.01	=	$	=	$

Once the sales plan has been computed for each month, turn to your merchandise plan and post the figures as follows:

1. On the SALES LY line write in LY sales figures and write the total in the SALES LY TOTAL box.

2. On the SALES PLAN line, write in the planned sales figures, total, and write in the SALES PLAN TOTAL box.

SELF QUIZ

1. Given the For All Seasons' gift department's spring net sales volume figures, compute the percentage change for each month and the total season.

Month	LY Sales	TY Sales	% Change
Feb.	$40.0	$44.0	
March	$42.0	$42.0	
April	$45.0	$41.5	
May	$43.4	$48.0	
June	$46.0	$58.0	
July	$57.5	$61.0	
TOTAL			

2. For All Seasons' second quarter sales totaled $610.0. Last year's sales for the same period were $580.0. Calculate the current sales trend.

3. For All Seasons' gift department last year's spring net sales volume figures and management's planned percentage increases are listed in the table below. Compute the sales change and calculate the planned sales for each month. Round off all numbers to the nearest hundred.

Month	LY Sales	Planned Percentage Increase	Sales Change	Planned Sales
Feb.	$247.6	.064		
March	$230.0	.041		
April	$196.0	.036		
May	$205.0	.051		
June	$190.0	.051		
July	$185.0	.054		

CALCULATING AVERAGE INVENTORY LEVELS

After forecasting the upcoming season's sales volume, further analysis of last year's results are necessary. The next step is to determine the average inventory figure for a specific period of time, at cost or at retail.

Formula for Calculating Annual Average Inventory

Step 1:

1 month	Initial Month B.O.M.
+ 12 months	Beginning-of-Month (B.O.M.) Inventories
13 Months	Total Inventory Valuation

Step 2:

$$\frac{\text{Initial Month B.O.M.} + 12 \text{ B.O.M. Inventories}}{\text{Number of Inventory Figures Used (13)}} = \textbf{Annual Average Inventory}$$

An additional month is always included in retail averaging to reflect the last month's changes in stock value (actual sales, markdowns, and so on).

Formula for Calculating Seasonal Average Inventory

Step 1:

1 month	Initial Month B.O.M.
+ 6 months	Beginning-of-Month (B.O.M.) Inventories
7 Months	Total Inventory Valuation

Step 2:

$$\frac{\text{Initial Month B.O.M.} + 6 \text{ B.O.M. Inventories}}{\text{Number of Inventory Figures Used (7)}} = \textbf{Seasonal Average Inventory}$$

EXAMPLE:

Step 1:

MONTH	B.O.M.	
Aug.	92.0	
Sept.	88.0	
Oct.	90.0	
Nov.	96.0	
Dec.	104.0	
Jan.	120.0	
Feb.	90.0	
TOTAL	**$680.0**	**Total Inventory Valuation**

Step 2:

$$\frac{\text{Total Inventory Valuation}}{\text{7 Months}} = \frac{\$680.0}{7} = \$97.1 \text{ Seasonal Average Inventory}$$

Using For All Seasons' inventory figures listed below, calculate last year's fall average inventory figure:

Step 1:

MONTH	B.O.M.
Aug.	$643.0
Sept.	623.0
Oct.	643.0
Nov.	663.0
Dec.	703.0
Jan.	713.0
Feb.	690.0
TOTAL	**$**

Step 2:

$$\frac{\$\underline{\hspace{2cm}}}{7} = \frac{\$\underline{\hspace{2cm}}}{\textbf{Average Inventory}}$$

Turn to your merchandise plan and complete the following:

1. Post last year's inventory figures in the B.O.M. STOCK LY row under the correct month. Write in the total inventory figure in the LY TOTAL STOCK box and the average inventory in the LY AVG STOCK box.

Note: Your merchandise plan is stated in retail dollars. If it is necessary to convert cost inventory figures to retail, follow these steps:

a. The gross margin percent plan is _____%.(40%)

b. The gross margin complement percent is:

$$
\begin{array}{cc}
100\% & 100\% \\
\underline{-\ GM\%} & \underline{-\ 40} \\
CC\% & 60\%\ CC\%
\end{array}
$$

c. Divide the cost inventory by the gross margin complement percent to arrive at the inventory figure in retail dollars.

$$
\frac{\text{Cost Inventory}}{\text{GM Complement \%}} = \textbf{Retail Inventory}
$$

$$
\frac{\$60.00}{.60} = \textbf{\$100.0 Retail Inventory}
$$

SELF QUIZ

1. Write in the number of inventory figures used to compute the average stock for a season and a year.

 Season _____

 Year _____

2. Explain why it is necessary to use 7 or 13 beginning inventory figures to calculate the average stock level versus using 6 or 12.

3. The ending inventory figure equals the following month's beginning inventory figure.

 True **False**

4. Given the following information, compute the average stock levels.

Feb.	$65.0
March	70.0
April	72.0
May	68.0
June	64.0
July	65.0
Aug.	70.0

 Average Stock:_____

Aug.	$505.0
Sept.	518.0
Oct.	481.0
Nov.	505.0
Dec.	542.0
Jan.	483.0
Feb.	472.0

 Average Stock:_____

STOCK TURNOVER

After the average inventory is calculated, the stock turnover rate is determined.

Stock turnover (stock turn) is a mathematical calculation that measures how fast merchandise is being sold and replaced for a specific period of time, usually a season or a year.

stock turnover–mathematical calculation that measures how fast merchandise is being sold and replaced for specific period of time; also referred to as stock turn

Formula for Calculating Retail Stock Turn

$$\frac{\text{Total Sales for Planning Period}}{\text{Average Inventory \$ at Retail}} = \frac{\$295.0}{\$97.1} = 3.04 \text{ Stock Turn}$$

Formula for Calculating Cost Stock Turn

For the specified planning period:

$$\frac{\text{Total Cost of Goods Sold}}{\text{Average Inventory \$ at Cost}} = \frac{\$177.0}{\$58.3} = 3.04 \text{ Stock Turn}$$

Note: The retail figures used in the retail stock turn example were converted to cost to illustrate that calculating stock turn at retail or cost provides the same number of turns for either calculation approach. The best method is the one in which the retailer has the easiest access to the most reliable inventory numbers. As stated earlier, the retail method is the one used in this book.

Fill in For All Seasons' figures and compute the stock turn.

Planning Period: spring fall

(Circle the season)

LY Average Inventory: $ _____

LY Total Sales: $ _____

To calculate LY Stock Turn:

$$\frac{\text{Total LY Sales}}{\text{LY Average Inventory}} = \text{LY Stock Turn}$$

Calculate For All Seasons' LY stock turn below:

$$\frac{\$ _____}{\$ _____} = \frac{_____}{\text{LY Stock Turn}}$$

Post on the merchandise plan in the lower right hand section on the STOCK TURN LY line.

Stock turn analysis. The inventory turnover rate is a crucial component of generating profits. In theory, every time the inventory turns over, cash, and hopefully profit, is generated. Therefore, the velocity of stock turning over is important. A carefully planned turnover rate will produce just the right flow of merchandise to generate a profitable balance between stock and sales.

What was For All Seasons' stock turn for last fall?

Write in: _____ .

The industry guideline for comparable operations is 4.0 turns a year or 2.0 turns a season. (Industry guidelines are published annually in trade publications. They are also available from respective trade associations and Dun & Bradstreet Key Business Ratio reports.)

The industry number of 2.0 turns a season is a guideline. The retailer then compares the turnover rate to previous records and evaluates the results: Does the turnover vary from the industry norm and previous store results?

If the turnover is low (turns more slowly and ties up investment dollars) the retailer asks:

1. Is there too much inventory on hand?

2. Are there merchandise buildups in particular merchandise classifications?

3. Is the stock room filling up with slow sellers?

4. Are the prices too high? Does the pricing strategy need to be reworked?

If it is too high (turns faster and minimizes up-front inventory investment), the retailer asks:

1. Are basic and key items out of stock before the next order arrives?

2. Am I addressing my customers' needs?

The retailer then considers ways to increase stock turn, which include:

1. Speeding up the time it takes to get merchandise out to the selling floor

2. Improving inventory control and reorder procedures to reduce out-of-stocks of basic stock items and key items

3. Shopping the competition and comparing pricing strategies, especially on widely distributed items

4. Reviewing merchandise classifications for the buildup of fringe items, sizes, and duplications

5. Regularly clearing out promotional remainders, odd sizes, and broken assortments to increase the flow of new merchandise

Every store, including those within a chain of stores, will produce varying stock turnover rates. Turnover rates will generally be higher in high traffic stores as compared to low traffic locations. Industry standards and past performance are guidelines to be considered when analyzing stock turn results. The retailer selects a turnover rate that balances the customers' needs for selection and achieves targeted gross margin plans to ensure success.

For All Seasons' stock turn of 1.99 is close to industry guidelines. It is decided that it should increase to 2.07, slightly above the industry guidelines. Management expects everyone to follow the steps listed above to increase stock turn.

SELF QUIZ

1. What are the two components of stock turnover?

2. Complete the formula for stock turnover.

$$\frac{\rule{3cm}{0.4pt}}{\text{Average Stock}} = \text{Stock Turnover}$$

3. Calculate the rate of stock turnover for each example and write your answers on the provided lines.

Net Sales	Average Stock	Stock Turn
$143.0	$48.0	_____
$185.0	$74.0	_____
$152.5	$45.0	_____
$176.2	$75.0	_____

4. For All Seasons' management has decided to increase its stock turn from 1.99 to 2.07. What steps should be taken to help ensure the increase?

STOCK-TO-SALES RATIOS

The next step to building the merchandise plan is to determine the monthly inventory levels for the upcoming year or season. Although various methods are used to calculate monthly inventory levels, the most accurate is the *stock-to-sales ratio method*. This will be used in conjunction with the average inventory based on stock turn as a "backup" to ensure proper and profitable inventory planning.

To estimate the amount of inventory required each month to achieve the sales plan, the B.O.M. stock-to-sales ratio method is used.

stock-to-sales ratio (S:S)—relationship between stock on hand at beginning of month and sales for month expressed as a ratio

Stock-to-sales ratio (S:S) is the relationship between stock on hand at the beginning of the month (B.O.M.) and sales for the month. The ratio determines how much stock must be on hand at the beginning of each month to achieve the planned sales figure and the required stock turn.

Formula for Calculating Stock-to-Sales Ratio

$$\frac{\text{B.O.M. Stock}}{\text{Sales for Month}} = \textbf{Stock-to-Sales (S:S) Ratio}$$

EXAMPLE:

$$\frac{\text{Nov. LY B.O.M.}}{\text{Nov. LY Sales}} = \frac{\$663.0}{\$220.0} = \frac{3}{1} = \textbf{3:1 Stock-to-Sales Ratio}$$
(read as 3 to 1)

Three months of stock on hand was required for last year's November sales.

Calculator Formula

1. Enter 663.0.
2. Press the division key.
3. Enter 220.0.
4. Press the equal (=) sign.

The calculator will read 3.01. This is the stock-to-sales ratio (S:S). Using 623.0 as September's LY B.O.M. and September's LY sales of 180.0, the calculator will read 3.46 rounded up to 3.5, which means that the S:S ratio is 3.5:1 (or 3 1/2 to 1).

Step 1: Calculate For All Seasons' last year's fall S:S ratios for each month and post in the small boxes on the left side of each dividing line, under each month, in the B.O.M. stock section on the STOCK:SALES RATIO line of the merchandise plan.

Stock-to-sales ratio planning. After the calculation and posting of last year's S:S ratios, ratios for the planning period are then determined.

Step 2: Review each month's last year's S:S ratio and notice the S:S differences. The higher S:S ratios reflect lower sales; the lower ratios, higher sale results. Was it too high? Could last year's sales have been achieved with less stock? Or, was the stock level necessary to generate the month's sales volume?

Consider For All Seasons' industry stock turn of 2.0 for a season.

$$\frac{6 \text{ months}}{\text{Industry Seasonal Turn}} = \text{Industry S:S Ratio}$$

$$\frac{6}{2} = \begin{array}{l} 3 \text{ months' stock on hand to} \\ \text{achieve 1 month's sales} \end{array}$$

Can the industry S:S ratio relate to the plan the retailer is creating? In For All Seasons' fall plan, the answer is yes. Remember, the lower the S:S ratio, the higher the turn and resulting profit.

For All Seasons' management previously determined that the stock turn would increase to slightly over the industry norm, so the S:S ratio must ideally be 3.0 each month. Inventory levels vary each month due to selling cycles and preplanned events so the S:S ratios are not planned evenly across. Last year's fall's S:S ratios illustrate this fact.

For All Seasons determined the following S:S ratios for the upcoming fall season after analysis of last year's results:

MONTH	S:S RATIO
Aug.	3.1
Sept.	3.3
Oct.	2.9
Nov.	2.9
Dec.	2.7
Jan.	2.6

Write the S:S ratios in the right hand STOCK:SALES RATIO box, under each month, on your merchandise plan.

Some of the ratios decreased as a result of reviewing last year's inventory records, others remain equal to last year because the right amount of stock was on hand to meet sales goals.

Step 3: Calculate the season's planned **B.O.M. (beginning-of-the-month) inventory levels.**

beginning-of-month inventory—dollar amount on hand from a physical stock count or from perpetual inventory control records; abbreviated as B.O.M.

Formula for Calculating B.O.M. Plan

$$\frac{\text{Sales Plan for Month} \times \text{S:S Ratio Plan}}{\text{B.O.M. Plan}}$$

For All Seasons' August B.O.M. Plan:

August Sales Plan	$212.0
August S:S Ratio Plan	× 3.1
August B.O.M. Plan	$657.2

Post For All Seasons' August B.O.M. plan on the B.O.M. STOCK PLAN line under the month August. Continue to compute the season's planned B.O.M. figures and post them as outlined above.

Note: To complete planned inventory calculations for the last month:

1. Review last year's sales. Last year's February sales were $247.6.

2. Plan February sales for the new year. A 6.4% increase is determined after review of market factors and past records. February's sales plan is $263.4.

3. Last year's records show an S:S ratio of 2.6. The S:S ratio will remain the same, 2.6.

4. Calculate the planned B.O.M.
 $263.4 x 2.6 = $685.0 (684.8).

Your merchandise plan does not include a space for posting last year's actual or planned last month's sales because the planning period is for 6 months. Therefore, it is necessary to make these calculations aside from the plan and post them to arrive at an accurate average inventory figure for the planning period. Post the February planned B.O.M. figure provided.

Step 4: Total the posted planned B.O.M. figures and write in the total dollar amount in the B.O.M. STOCK PLAN TOTAL box.

Calculate the planned average (AVG.) stock and post the result in the B.O.M. STOCK PLAN AVG. box located to the right of the posted B.O.M. PLAN TOTAL amount.

Step 5: The inventory planning by the S:S method is used in conjunction with the average inventory/planned stock turn method. The ratio method emphasizes stock levels; the turn method concentrates on sales.

Formula for Calculating Planned Stock Turn

$$\frac{\text{Total Season's Planned Sales}}{\text{Season's Planned Average Inventory}} = \textbf{Planned Season's Stock Turn}$$

$$\frac{\$\underline{\hspace{2cm}}}{\$} = \underline{\hspace{2cm}} \textbf{Planned Season's Stock Turn}$$

Compare it to the posted plan stock turn in the lower right hand corner of the merchandise plan. Are they close? Is there a large difference?

Review and adjust the S:S ratios or planned stock turn, if necessary. Frequently, the inventory levels have to be fine-tuned and recalculated.

1. The S:S ratio shows how much _____ is on hand in relation to _____ for a month.

2. The S:S formula is $\dfrac{\$\text{_____}}{\$}$.

3. Compute the S:S ratios for each example.

B.O.M.	$52.0	B.O.M.	$78.5
Sales	20.0	Sales	30.0
S:S	_____	S:S	_____

B.O.M.	$48.0	B.O.M.	$65.0
Sales	15.0	Sales	22.0
S:S	_____	S:S	_____

4. Given the following information, calculate the B.O.M. plan for each month.

Sales	S:S Ratio	B.O.M.
$ 67.0	3.0	
$112.5	2.1	
$ 79.8	1.5	
$181.2	1.6	

PLANNING MARKDOWNS

When vendors propose stock/sales plans to retailers, markdowns are not included, but retailers must plan markdowns for the following reasons:

1. Markdowns are an inherent part of retailing. Not all merchandise will sell at the original prices, and planning reduces the actual amount of markdowns.

2. Markdowns affect profits, so preplanning enables the retailer to meet profit goals and regularly clear out promotional remainders, shopworn merchandise, and damaged items that are not refundable.

3. The inventory value is reduced by markdowns, therefore, reducing the necessary inventory amount on hand to produce the planned sales figure. Planning ensures the proper inventory on hand to meet sales plans.

4. Planning provides a buying guide for promotional plans when vendor support is not available.

What amount should markdowns represent as a percent to sales? The retailer follows the same steps as outlined in stock turn planning and analysis. The retailer reviews past performance and markdown results of comparable industry operations.

Markdowns vary according to the type of merchandise. Basic stock items have relatively low markdown percents, whereas fashion and trend items have higher markdown percents.

For All Seasons has kept markdown records and last year's fall results were:

MONTH	MARKDOWN DOLLARS
Aug.	$ 54.0
Sept.	43.2
Oct.	40.0
Nov.	39.6
Dec.	41.6
Jan.	54.0
TOTAL MD$	**$272.4**

Post last year's markdown dollar amounts in each month's box on the MARKDOWNS LY line on your merchandise plan and write the total in the LY TOTAL MARKDOWNS box.

What percent did markdown dollars represent to last year's total sales?

Formula for Calculating Markdown Percent

$$\frac{\text{Total LY MD\$}}{\text{Total LY Sales}} = \frac{\$\ 272.4}{\$1330.0} = \begin{array}{c} \textbf{20.5\% MD\%} \\ (20.48) \end{array}$$

Write the LY MD% of total sales in the LY% MARKDOWN box on the far right hand side of your merchandise plan.

The retailer determines the season's markdown percent goal. For All Seasons decides a 19.4% goal is both reasonable and achievable, and follows past performance and industry guidelines.

Markdowns are not distributed evenly each month; they are distributed where they will benefit business the most. The retailer maps out last year's monthly markdown dollars and calculates the markdown percent for each month last year and analyzes the monthly results. The retailer then determines the monthly markdown percent figure based on the market factors considered in the planning process, promotional plans, and management's desired goals. The results are as follows:

MONTH	LY SALES	LY MD%	TY PLAN SALES	TY PLAN MD%
Aug.	$ 200.0	27.0%	$ 212.0	25.0%
Sept.	180.0	24.0%	198.0	22.0%
Oct.	200.0	20.0%	230.0	20.0%
Nov.	220.0	18.0%	228.8	16.0%
Dec.	260.0	16.0%	269.1	16.0%
Jan.	270.0	20.0%	272.7	19.0%
TOTALS	**$1330.0**	**20.5%***	**$1410.6**	**19.4%**

*Refer to the preceding markdown percent formula.

Formula for Calculating Total Markdown Dollar Plan

Total Sales Plan	$1410.6
× Planned MD%	× .194
Total MD$ Plan	$ 274.0 Total MD$
	(273.65)

Formula for Calculating Monthly Markdown Dollars

Monthly Sales Plan	$212.00
× Monthly MD%	× .25
Monthly MD$	**$ 53.00 Aug. MD$**

Complete the chart below for planned monthly markdown dollars:

MONTH	MD%	×	SALES	=	MD$
Aug.	.25		$212.0		$ 53.0
Sept.	.22		198.0		43.6
Oct.	_____		_____		_____
Nov.	_____		_____		_____
Dec.	_____		_____		_____
Jan.	_____		_____		_____
PLANNED MARKDOWN TOTAL					$ ____

On completion, review the planned markdown total amount. How does it compare to the planned total markdown amount that was initially determined? Are the figures equal or close? If they are close, the planning of markdowns is complete. If not, markdown percents and dollars must be adjusted to arrive at or become close to the initial markdown total. For All Seasons' planned total markdown dollars are close enough, therefore, acceptable.

Post the following:

1. The planned MD$ amounts on the MARKDOWN $ PLAN line under each month

2. The total MD$ amount in the MARKDOWN TOTAL box

3. The planned MD% in the PLANNED MD% box

SELF QUIZ

1. Explain why retailers must plan markdowns.

2. Basic stock items have relatively _____ markdown percents, whereas fashion and trend items have _____ markdown percents. Explain why this is true.

3. For All Seasons' markdown dollars and net sales volume figures for last year's spring season are included in the following table. Calculate the markdown percent for each month and the total markdown percentage.

Month	Net Sales Volume	Markdown Dollars	Markdown Percentage
Feb.	$247.6	$42.0	
March	230.0	35.0	
April	196.0	31.0	
May	205.0	31.5	
June	190.0	28.5	
July	185.0	31.0	
TOTAL			

CALCULATING MONTHLY PURCHASES

At this point in the merchandise plan, all dollar amounts are brought together to calculate the amount of merchandise to be purchased each month.

Formula for Calculating Planned Purchases

B.O.M. Plan

Less: Month's Planned Sales

Less: Month's Planned Markdown Dollars

Less: E.O.M. Plan (Following Month's B.O.M.)*

Month's Planned Purchases

*The **E.O.M., end-of-month inventory** figure, is always equal to the next month's B.O.M., beginning-of-the month inventory figure.

end-of-month inventory—equal to the beginning of the following month inventory figure, the B.O.M.; abbreviated as E.O.M.

This formula is similar to using a checkbook. At the beginning of each month a checkbook reflects the amount of dollars on hand. Checks are then written throughout the month and a dollar amount is planned to be on hand the beginning of the next month. The difference is the amount of money that may be spent.

EXAMPLE:

AUG. B.O.M.	$ 657.2
Less: AUG. Planned Sales	212.0
Less: AUG. Planned MD	$ 53.0
Less: AUG. E.O.M. = SEPT. B.O.M.	653.4
AUG. Planned Purchases	($261.2)*

*Planned purchases appear as a negative number on the calculator's readout. The negative indicates the shortfall that will occur if the necessary planned purchases are not made and

emphasizes the importance of maintaining proper S:S ratios. This is also a "short-cut" method for calculating purchases—disregard the negative when posting on the merchandise plan.

Calculate each month's LY purchases and post on the LY PURCHASES line. Write the total in the far right hand LY PURCHASES box. Then calculate planned purchases and post on the PLANNED PURCHASE line and write the total in the PLANNED PURCHASES box.

Note: There is another formula for calculating purchases. However, the best method is the one that is easiest to compute.

Formula for Calculating Purchases

Planned E.O.M.

Plus: Planned Sales

Plus: Planned Markdowns

Total Month's Inventory Required

Less: Planned B.O.M.

Planned Month's Purchases

EXAMPLE:

	August Planned E.O.M.	$653.4
Plus:	August Planned Sales	212.0
Plus:	August Planned Markdowns	53.0
	Total August Inventory Required	$918.4
Less:	August B.O.M.	657.2
	August Planned Purchases	**$261.2**

SELF QUIZ

1. Fill in the blanks to complete the following formulas.

 B.O.M. Plan

 Less: _____

 Less: _____

 Less: E.O.M. Plan (Following Month's B.O.M.)
 Month's Planned Purchases

 Planned E.O.M.

 Plus: _____

 Plus: _____
 Total Month's Inventory Required

 Total Month's Inventory Required

 Less: _____
 Month's Planned Purchases

2. The_____ _____ _____ figure is always equal to the next month's _____ _____ _____ _____ _____ figure.

3. Compute planned purchases for the month of October using the following figures.

Planned sales	$223.0
B.O.M.	685.0
Planned markdowns	49.0
E.O.M.	681.0

4. Using the October figures noted above, assume that October planned sales were increased by 15% and the markdowns were reduced by 10%. Compute the new planned purchases figure.

GROSS MARGIN PERCENT GOAL

To complete your merchandise plan, the last step is to bring all the numbers together and calculate the gross margin percent goal. As discussed in Chapter 3, Components for Profit, gross margin is an historical figure, but may be easily calculated to approximate and provide goals and to monitor the retailer's progress toward achieving profitability.

Quick Formula for Calculating Gross Margin Percent

Using LY fall For All Seasons' figures,

1. Enter the IMU%: **52% IMU%**

2. Find the cost complement percent:

$$
\begin{array}{r}
100\% \\
-\ 52 \\
\hline
48\%
\end{array}
$$

 48% = CC%

3. Compute total reductions:

Total Sales	$1330.0
Total Markdowns	+ 272.4
	$1602.4

 $1602.4 Total Reductions

4. Calculate an approximate cost of goods sold (COGS):

Total Reductions	$1602.4
Cost Complement %	× .48
	$ 769.15
	$ 769.2 COGS

5. Compute gross margin dollars:

Total Sales	$1330.0
Cost of Goods Sold	- 769.2
	$ 560.8
	$ 560.8 GM$

6. Calculate gross margin percent:

Gross Margin Dollars	$ 560.8
Total Sales	$1330.0
	42.2% GM%
	(42.16)

Write the last year gross margin percent figure on the line marked LY%, located in the lower left hand corner of the merchandise plan.

Calculate For All Seasons' planned gross margin percent:

1. **IMU%** **52.0%**

2. **CC%** _____ %

3. Total Sales $

 Total Markdowns + _____

 Total Reductions $ _____

4. Total Reductions $

 Cost Complement % × _____

 Cost of Goods Sold $ _____

5. Total Sales $

 Cost of Goods Sold - _____

 Gross Margin Dollars $ _____

6. Gross Margin Dollars $ _____

 Total Sales $

 Gross Margin Percent _____ %

Write the planned gross margin percent figure on the left line marked GROSS MARGIN %, located in the lower left hand corner of the merchandise plan. This figure represents an approximate gross margin percent goal.

SELF QUIZ

1. Discuss the importance of the gross margin percent goal to the retailer.

2. Using the figures that follow, compute For All Seasons' gross margin percent for last year's spring season.

IMU%	53%
Total Sales	$1,315.9
Total Markdowns	$ 204.0

3. For All Seasons is projecting a 7% sales increase for the upcoming spring season over last year's spring season with an IMU% plan of 54% and a 12% reduction in total markdowns. Refer to the figures in problem 2 and calculate the new gross margin dollar amount and gross margin percent.

MERCHANDISE PLANNING

Merchandise planning is one of the most important functions to ensure profitability. The retailer's major dollar investment is tied up in inventory. The merchandise plan provides a guide to profitably balance stock in relation to sales and control the retailer's investment.

The master merchandise plan is the sum total of departmental plans that represent the sum total of merchandise classification plans. Ideally "bottom-up" planning results in the master merchandise plan, not "top-down" planning, to focus on the goal, "The Customer Comes First."

The merchandise plan is now complete and shows the planned profitable balance between stock and sales, planned markdowns available, and planned purchases. It represents the "ideal world." As the season progresses, actual figures are posted to compare to last year and to plan figures.

CHAPTER REVIEW

1. Name and explain the seven primary ingredients of the merchandise plan.

2. The retail calendar is also referred to as the _____ - _____ - _____ calendar. Explain the difference between the retail calendar and the conventional calendar and discuss the benefits the retail calendar provides retailers.

3. Explain the benefits gained in holding inventory in proportion to planned sales.

4. What factors must be considered in formulating a sales plan for an upcoming season?

5. When computing an average inventory, an additional month is always included to reflect the last month's changes in stock value.

 True **False**

6. Calculating stock turn at retail or cost provides the same number of turns for either approach.

 True **False**

7. The stock-to-sales ratio method responds to sales variances in individual months.

 True **False**

8. The season's planned markdown percent is 4%; therefore, the markdown figure for each month should be 4% of net sales.

 True **False**

9. Define and explain the difference between "top-down" and "bottom-up" planning. Which method best serves the customer? Why?

10. Seven inventory figures must be posted on the merchandise plan to arrive at the correct average inventory valuation, yet only 6 months of sales figures are posted on the plan. What step must be taken when completing B.O.M. calculations?

11. Why is the stock:sales method used in conjunction with the planned stock turn?

12. Explain in detail the method retailers use to define seasons and why.

13. Sales planning can be affected favorably or unfavorably by many internal and external factors and changes. Following is a list of possible upcoming changes. Mark the appropriate column to indicate whether the affect on sales would be favorable, unfavorable, or both.

Upcoming Possible Changes	Sales Result	
	Favorable	Unfavorable
Renovation of the store		
Reduction of local competition		
Slow-down in economy		
Improved customer service		
Increased level of vendor partnerships		
Increase in local competition		
Increase in advertising		
Economic upswing		
Introduction of several new promotions		
Poor weather conditions		
Decrease in advertising		
Changes in local demographics		
Shifts in the months in which holidays occur		

14. The stock turnover rate is a crucial component of generating profits. Explain the theory on which this statement is based.

15. For All Seasons has hired you as a consultant to help the store achieve an optimum inventory level. In gathering your data from past inventory and sales records, you have decided to prepare the following outline to present to management before making your recommendations. Fill in the following spaces.

 a. Causes and results of an inventory level lower than desired:

 (1) _____

 (2) _____

 b. Causes and results of an inventory level higher than desired:

 (1) _____

 (2) _____

 c. Possible causes of declining or reduced sales:

 (1) _____

 (2) _____

 (3) _____

CHAPTER TEST

1. Fill in the blanks on the Forecasting Sales Worksheet.

FORECASTING SALES WORKSHEET

MONTH	LY SALES		PERCENT		SALES CHANGE		PLAN SALES
Feb.	$78.0	×	.05	=	$	=	$
March	$	×	.047	=	$	=	$95.0
April	$89.5	×	.	=	$9.5	=	$
May	$	×	.064	=	$	=	$98.0
June	$76.0	×	.	=	$	=	$87.5
July	$79.2	×	.063	=	$	=	$

2. Use the following information to complete the exercises.

Month	B.O.M.	Sales	S:S
July	96.0	32.0	
Aug.	108.0	36.0	
Sept.	112.5	45.0	
Oct.	113.0	39.0	
Nov.	122.5	49.0	
Dec.	130.0	65.0	
Jan.	105.0		

a. Calculate the average stock figure.

b. Compute the season's stock turn.

c. Determine the S:S ratio for each month and write the answers under the S:S column.

3. Fill in the blanks.

	B.O.M.	Sales	S:S
a.	86.0	22.0	_____
b.	200.0	_____	2
c.	_____	65.0	3
d.	184.0	_____	4
e.	450.0	180.0	_____
f.	763.2	424.0	_____

4. If total sales for a month equal $298.0, the average retail inventory is $96.2, the total cost of goods sold is $177.9, and the average inventory at cost is $57.4, what is the stock turn at cost and at retail?

5. For All Seasons' stock turn results are below:

LY Stock Turn	1.93
TY Stock Turn	1.99
Industry Stock Turn Guideline	2.00

a. How would you evaluate the stock turn figures against the industry guideline?

b. What are your recommendations for adjusting the stock turn if necessary, and why?

6. The planned stock turn for the For All Seasons' accessories department for the spring/summer season is 3.0. Mid-season the stock turn must be computed to gauge the progress toward attaining the season's goal. The results to date are:

Month	B.O.M.	Sales
Feb.	$232.0	$ 96.0
March	$224.0	$106.0
April	$196.0	$ 93.0
May	$200.0	

a. Compute the average inventory.

b. What is the mid-season stock turn?

c. Analyze the stock turn and plan a strategy for the accessories buyer to follow to ensure the achievement of the season's planned stock turn.

7. The industry's spring season stock turn guideline is 2.2. The spring For All Seasons' proposed merchandise plan includes total planned sales of $1315.9 and an average inventory figure of $658.0. The last year's stock turn was 1.87. Calculate the season's planned stock turn and compare the results to the industry's stock turn guideline and last year's stock turn and determine if the proposed merchandise plan is feasible or if adjustments need to be made before final approval, and why. Explain in detail.

8. If For All Seasons' planned sales volume for next year's spring season equals $1315.9 and the planned markdown percent is 15.5%, what is the total markdown dollar plan?

9. Use the following figures to determine the planned purchases for May, June, and July. Show your computations using both planned purchases formulas.

Month	B.O.M.	Planned Sales	Planned MD$	E.O.M.
May	$97.0	$44.0	$.9	$94.2
June	$94.2	$42.0	$.8	$94.5
July	$94.5	$45.0	$.9	$94.7

May: Formula 1:

 Formula 2:

June: Formula 1:

 Formula 2:

July: Formula 1:

 Formula 2:

10. Using the following net sales volume figures for the spring season, compute the planned sales percentage increase for next year by month and for the season.

Month	TY	Planned Sales Next Year	Percentage Increase
Feb.	$263.4	$271.5	%
March	239.5	248.0	
April	203.0	214.0	
May	215.5	228.0	
June	199.5	212.5	
July	195.0	208.0	
Totals			

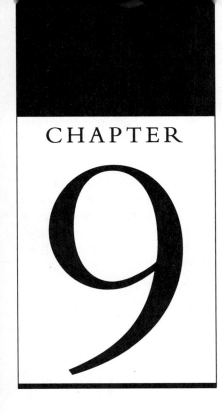

Open-To-Buy

The merchandise plan is now complete, providing a guide for a profitable balance between stock and sales. How can the retailer ensure that purchases are made in the correct amounts and that inventory levels are maintained in proportion to sales?

The **open-to-buy (OTB)** ties into the merchandise plan using actual figures. It is the "checkbook" for writing orders. It protects retailers from making excess purchases so that they may control their dollar investment and generate profits.

The open-to-buy:

1. Calculates the amount of dollars available for purchases each month, based on an actual B.O.M. inventory figure

2. Ensures the correct inventory level to achieve the projected sales figure, which is based on the month's actual sales trend

3. Maximizes the return on capital invested in merchandise by holding purchases in relation to sales

OPEN-TO-BUY ELEMENTS

open-to-buy (OTB)–money available to retailer to spend on purchases to be received during a specific period

The OTB contains four primary elements:

1. The B.O.M., which is the beginning-of-the-month actual stock figure

2. The E.O.M., which is the end-of-the-month actual stock figure, the inventory dollar amount that must be achieved to maintain the proper relation between stock and sales

3. Factors that increase the monthly value of the stock:

 a. On order purchases that are planned to arrive during the specified month

 b. Delayed previous month's orders that are expected to be received during the specified month

 c. Additional markups such as price increases

 d. Markdown cancellations

4. Factors that decrease the monthly value of the inventory:

 a. Projected sales based on actual sales trend

 b. Planned markdowns to liquidate stock

 c. Vendor returns

 d. Markup cancellations

 e. Purchase order receipt date changes and order cancellations

OPEN-TO-BUY FORMATS

Retailers tailor OTB forms to best serve their merchandising policies. The two different OTB formats illustrated in Figures 9.1 and 9.2 are representative of the various forms used in retail operations.

Figure 9.1 not only reflects current inventory, orders, sales, and markdowns, but provides comparison of last year's sales and markdowns without referral to the season's merchandise plan. Within the markdown section it shows that the retailer permits the ordering of merchandise in the dollar amounts of negotiated vendor markdown allowances. With MUCs included on this OTB form, it indicates that this retailer's merchandising policy includes the frequent use of markup cancellations. Included in the adjustment section is shrinkage, which allows orders to cover the anticipated loss of merchandise. This retailer recognizes that all reductions decrease the value of the inventory and affect the profitable balance between stock and sales. Therefore, each department purchases merchandise under these terms.

The OTB form pictured in Figure 9.2 (page 204) illustrates a more commonly used, simpler format, which be used throughout this chapter.

OPEN-TO-BUY PROCEDURES

The OTB form shown in Figure 9.2 should be referred to as we walk through the procedures to complete the OTB.

Step 1:

actual B.O.M.–dollar amount on hand from a physical stock count or from perpetual inventory control records

 A. Actual B.O.M.
 This is the dollar amount on hand from a physical stock count or from the perpetual inventory controls records. If inventory figures are at cost, they should be converted to retail dollars. After the OTB is started, the following month's B.O.M. may be actual or projected, based on the first month's calculations. This enables the retailer who takes inventory every other month or every 3 months to effectively maintain an OTB.

on order–total of all purchase orders, with expected receipt dates for month being calculated in retail dollars

 B. On Order
 This is the total of all purchase orders, with expected receipt dates for the month being calculated in retail dollars.

additional on order–orders placed for delivery the same month and written after the first calculation of the specified month's OTB

 C. Additional on Order
 These are orders placed for delivery the same month and written after the first calculation of the month's OTB.

total stock on hand–sum of all stock on hand plus incoming receipts for the specified month

 D. Total Stock on Hand
 This is the sum of all stock on hand, plus incoming receipts for the month.

Step 2:

projected sales–planned sales that may be adjusted upward or downward depending on the current sales trend

 E. Projected Sales
 Taken from the merchandise plan, this figure is reviewed and adjusted upward or downward depending on the current sales trend.

 F. Markdowns
 Planned markdowns are taken from the merchandise plan. This budgeted amount is used to improve the business and continue the flow of fresh, new merchandise. If necessary markdowns fail to reach the budgeted amount, and stock levels and sales are reached, the result is that additional monies fall to the bottom line.

cancellations–order cancellations initiated and issued by either retailer or vendor

 G. Cancellations
 These are order cancellations initiated and issued by the retailer or the vendor or both.

returns–merchandise returns to vendor

 H. Returns
 These are merchandise returns to vendors (RTVs).

total stock reductions–sum of all stock reductions, which may include sales, markdowns, order cancellations, etc.

 I. Total Stock Reductions
 This is the sum of all stock reductions.

| | PL. | STD. | **OTB** | Dept. # _____ |
| MU % | _____ | _____ | | W / E _____ |

CURRENT OH						
ON-ORDER						
ORDER SHIFTS (+/−)						
ORDERS PLACED SINCE CUT-OFF						
ADDITIONAL ORDERS TO BE PLACED						
TOTAL LIABILITY						
—SALES—						
LY-SALES						
PLAN-SALES						
PROJ. SALES						
SALES (MTD/BAL.)						
SUBTOTAL						
—MARKDOWNS—						
LY-NET MD's						
PLAN-NET MD's						
PROJ-NET MD's (MTD/BAL.)						
VENDOR MD ALLOW						
M.U.C.						
SUBTOTAL						
—ADJUSTMENTS—						
CANCELLATIONS (FIRM)						
ADDITIONAL PROJ. CANCEL						
SHRINKAGE ADJ.						
VENDOR RETURNS						
AVAL. EXCESS M.U. $						
OTHER						
OTHER						
OTHER						
SUBTOTAL						
TOTAL — SALES/MD's/ADJ						
EST. EOM						
PLAN EOM						
VARIANCE (+/−)						

COMMENTS:

Figure 9.1. Open-to-Buy Format A

OPEN-TO-BUY

	OPEN-TO-BUY:	Month:			
STEP 1	A. ACTUAL B.O.M.				
	B. ON ORDER	+			
	C. ADDITIONAL ON ORDER	+			
	D. TOTAL STOCK ON HAND				
STEP 2	E. PROJECTED SALES				
	F. MARKDOWNS	+			
	G. CANCELLATIONS	+			
	H. RETURNS	+			
	I. TOTAL STOCK REDUCTIONS				
STEP 3	D. TOTAL STOCK ON HAND				
	I. TOTAL STOCK REDUCTIONS	−			
	J. PROJECTED E.O.M.	=			
STEP 4	K. *PLANNED E.O.M.				
	J. PROJECTED E.O.M.	−			
	L. OPEN-TO-BUY $	=			
STEP 5	M. OPEN-TO-BUY AT COST				
	[OTB X (100% − IMU %) = OTB COST]				

* REMEMBER, This month's E.O.M. is next month's B.O.M.

Figure 9.2. Open-to-Buy Format B

Step 3:

Refer to the "letter guidelines" on the OTB form in Figure 9.2.

Total Stock on Hand (D)

− Total Stock Reductions (I)

J.　　　　Projected E.O.M.

Step 4:

K.　　Planned E.O.M. (Equals next month's Planned B.O.M.)

− Projected E.O.M. (J)

L.　　Open-to-Buy $ (Money to spend on purchases to be received that month)

If the OTB figure is a negative number, it alerts the retailer that a problem exists between the balance of stock to sales. The merchandise assortment must be examined immediately because reorders for basic stock and key items will probably be necessary.

Step 5:

open-to-buy at cost dollars–computed by multiplying OTB retail dollars by the cost complement of the initial markup percent (100% - IMU% = CC%)

Formula for Calculating Open-to-Buy at Cost Dollars

1. The **IMU%** is: **40.0%**

2. The **cost complement** of the IMU% is: **60.0%**
 (100% - IMU% = CC%)

3. OTB **dollars at cost** are: **$30.0***

OTB Dollars at Retail	$50.0	($50,000)
× Cost Complement %	.60	
OTB at Cost Dollars	**$30.0**	($30,000)

Note: Refer to Appendix 3, "Rounding Numbers and Financial Notation."

OPEN-TO-BUY ILLUSTRATIONS

Now turn to For All Season's fall open-to-buy in Figure 9.3. Three examples, labeled A, B, and C, for the month of August are shown:

EXAMPLE A:

This example shows the merchandise plan figures—the "ideal world" situation created for August (refer to the For All Seasons' merchandise plan that was created in Chapter 8, "Stock/Sales Budgeting").

EXAMPLE B:

Note that in this example all necessary purchases have not yet been made. The retailer has also secured a $10.0 return to vendor. The result is remaining dollars open-to-spend in the amount of $171.2, at retail.

EXAMPLE C:

The B.O.M. is higher than planned, yet not high enough to cause unnecessary alarm. However, the retailer does react and immediately reviews the merchandise assortment on order and determines that $10.0 worth of goods will not address the customers' needs. This retailer is able to cancel a total of $10.0 on order. The remaining OTB dollars are $117.4, retail dollars.

SELF QUIZ

1. The For All Seasons' OTB illustrated in Figure 9.3 is missing the OTB at cost calculation. The IMU% is 52%. Compute the OTB dollars at cost for columns B and C and show your calculations.

 B.

OPEN TO BUY

	OPEN TO BUY: Month:		A Aug.	B Aug.	C Aug.
STEP 1	A. ACTUAL B.O.M.		657.2	657.2	659.0
	B. ON ORDER	+	261.2	100.0	150.0
	C. ADDITIONAL ON ORDER	+			
	D. TOTAL STOCK ON HAND		918.4	757.2	809.0
STEP 2	E. PROJECTED SALES		212.0	212.0	200.0
	F. MARKDOWNS	+	53.0	53.0	53.0
	G. CANCELLATIONS	+			10.0
	H. RETURNS	+		10.0	10.0
	I. TOTAL STOCK REDUCTIONS		265.0	275.0	273.0
STEP 3	D. TOTAL STOCK ON HAND		918.4	757.2	809.0
	I. TOTAL STOCK REDUCTIONS	−	265.0	275.0	273.0
	J. PROJECTED E.O.M.	=	653.4	482.2	536.0
STEP 4	K. *PLANNED E.O.M.		653.4	653.4	653.4
	J. PROJECTED E.O.M.	−	653.4	653.4	536.0
	L. OPEN TO BUY $	=		171.2	117.4
STEP 5	M. OPEN TO BUY AT COST [OTB X (100% – IMU %) = OTB COST]				

* REMEMBER, This month's E.O.M. is next month's B.O.M.

Figure 9.3. For All Seasons' Open-to-Buy Form

C.

2. Compute the OTB at retail and at cost for each situation below when planned purchases total $80.0 and the IMU% is 51.5%.

 a. On order totals $52.5.
 Retail $: _____
 Cost $: _____

 b. On order totals $83.3.
 Retail $: _____
 Cost $: _____

c. On order totals $58.0.
Order cancellations total $8.4.
Retail $:_____
Cost $:_____

3. Using the OTB form provided in Figure 9.4, complete the OTB using the following information provided on the OTB form and listed as follows:

Sept. Projected sales are $45.0. The IMU% is 40.0%.

Oct. The actual B.O.M. is last month's E.O.M., $96.0. Returns total $2.0. The IMU% remains 40.0%.

Nov. On order is $29.0. Planned markdowns are $1.0, and $3.0 in orders have been cancelled.

OPEN TO BUY

	OPEN TO BUY: Month:		Sept.	Oct.	Nov.
STEP 1	A. ACTUAL B.O.M.		90.0		104.0
	B. ON ORDER	+	~	15.0	
	C. ADDITIONAL ON ORDER	+	~	~	15.0
	D. TOTAL STOCK ON HAND				
STEP 2	E. PROJECTED SALES			48.0	34.0
	F. MARKDOWNS	+	.8	1.5	
	G. CANCELLATIONS	+	~	~	
	H. RETURNS	+	~		~
	I. TOTAL STOCK REDUCTIONS				
STEP 3	D. TOTAL STOCK ON HAND				
	I. TOTAL STOCK REDUCTIONS	−			
	J. PROJECTED E.O.M.	=			
STEP 4	K. *PLANNED E.O.M.		96.0		120.0
	J. PROJECTED E.O.M.	−			
	L. OPEN TO BUY $	=			
STEP 5	M. OPEN TO BUY AT COST [OTB X (100% − %) = OTB COST]				

* REMEMBER, This month's E.O.M. is next month's B.O.M.

Figure 9.4. Open-to-Buy Form

4. The July 31 physical inventory results total $215.0. The August sales plan is $71.6 with a markdown plan of 4%. The September B.O.M. plan is $220.0. What is the OTB for August?

SPENDING THE OPEN-TO-BUY

On the average, 70% of the OTB dollars will be used for reorders of basic, constantly in-stock merchandise, and key items. These are best sellers that the customer must have.

The remaining 30% is for:

- Seasonal goods

- Fashion merchandise

- Testing of new items

- New product introductions

- Special buys—off price

Allocating expenditures, or determining how to spend the available OTB dollars, requires careful planning. If the OTB dollars are randomly used, the retailer usually creates an overbought situation. In other words, basic merchandise orders remain to be placed but no monies are left.

SPENDING THE OTB

BASICS

70%

TESTS

FASHION

30%
NEW INTROS

SPECIALS

SEASONAL

Formula for Allocating Open-to-Buy Expenditures

Step 1:

Month's OTB Dollars at Cost	$30.0
× Basic and Key Item Merchandise	× .70
Dollars to Spend on Basics, Key Items	$21.0
	70% of OTB$

Step 2:

Month's OTB Dollars at Cost	$30.0
− Dollars for Basics, Key Items	−21.0
Dollars Available for Other Goods	$ 9.0
	30% of OTB$

SELF QUIZ

1. The OTB cost dollars from the previous self quiz were as follows:

Sept.	$31.1
Oct.	$26.7
Nov.	$ 6.0

Use the 70/30 guideline to compute each month's expenditures.

Sept.

 a. 70% _____ %

 b. 30% _____ %

Oct.

 a. 70% _____ %

 b. 30% _____ %

Nov.

 a. 70% _____ %

 b. 30% _____ %

FLEXIBILITY IN MERCHANDISING

The merchandise plan and the OTB plan are the keys to running a profitable retail operation. They must be flexible. Consider the following:

1. Sales exceed the sales plan 2 months in a row. What would the retailer do?

 a. Determine if the sales increase is a trend. If so, then inventory levels would be increased according to a determined S:S ratio.

 b. Gain approval of management to be overbought until a solid track record is established to revise official plans (2+ month's results signal definite changes).

2. Sales decrease 2 months in a row. How would the retailer react?

 a. Review the merchandise assortment and analyze duplications, fringe items, sizes, the customer targeted profile, market factor considerations, and so forth.

b. Discuss overstock situations with vendors for markdown support, merchandise exchanges or returns.

 c. Reallocate markdown dollars and increase promotional activity.

 A 5% variance is acceptable due to uncontrollable factors such as delayed deliveries, unexpected weather conditions.

PULLING IT ALL TOGETHER

The merchandise plan sets the "ideal world" and the OTB acts as the official "checkbook" to maintain the profitable balance between inventory levels and sales. Without these two controls the retailer may succumb to the pressure to buy more. The successful retailer, therefore:

1. Monitors progress by posting sales, inventory, purchases, and markdowns each month

2. Analyzes the results to capitalize on merchandise strengths and to reduce weaknesses

3. Preplans promotional activity with suppliers to buy advantageously

4. Realistically projects sales for each month

5. Balances the monthly inventory level in relation to the sales trend

CHAPTER REVIEW

1. Identify the purposes of the merchandise plan and the OTB and how they interact.

2. The OTB is $10.0 (retail dollars) over plan and you need to replenish the white crew socks inventory. Would you place an order? Explain.

3. What occurrences would prompt the retailer to revise an OTB upward or downward? Explain in detail.

4. If it is the retailer's policy not to include markdowns and returns to vendors in the OTB calculation, what might occur?

5. Determine if each factor listed below increases or decreases the value of inventory. Place an X in either the + (increase) or − (decrease) column for each factor.

	+	−
Additional markups		
On order		
Returns		
Sales		
Additional on order		
Cancellations		
Markdowns		
Markup cancellations		
Markdown cancellations		

CHAPTER TEST

1. The spring/summer accessories merchandise plan for the month of February is:

B.O.M.	$87.0
Sales	22.0
Markdowns	2.0
E.O.M.	96.9

a. Calculate the February planned purchase figure.

b. $10.0 in orders are already placed for February. Compute the OTB for February.

c. On February 5, you receive the return authorization label to ship back $3.0 in damages to Penet, a watch vendor. Recalculate the OTB.

2. The gift department's July planned figures include:

B.O.M.	$35.0
Sales	11.5
Markdowns	.4
E.O.M.	40.0

a. Compute the July planned purchase amount.

b. Orders placed and scheduled to be received in July currently total $6.0. Recalculate the OTB.

c. On July 2, Jene, a crystal vendor, notifies you that they are unable to ship the $3.0 order you placed for July delivery until August. Recalculate the OTB computed in b.

d. By July 15, $8.0 in additional orders have been placed. Recalculate the remaining July OTB figure from c.

e. The initial markup plan for July is 52%. Compute the OTB at cost for the OTB answers calculated in problems a, b, c, and d.

3. Given the following ladies' sports apparel information for the month of October, complete the exercises.

B.O.M.	$210.0
Sales	100.0
Markdowns	9.5
E.O.M.	240.0
Orders placed as of October 1:	$80.0

As of October 10:

Sales	$28.0
Markdowns	4.3
Orders Received	65.0

 a. Calculate October's B.O.M. planned purchases figure.

 b. As of October 10, complete the remaining month's:

Sales figure

Markdown dollars

Purchases

OTB

4. For the month of June, the planned accessories figures are posted in column 1 of Figure 9.5. Use this information to complete the following exercises.

 a. Compute the OTB in retail dollars and cost dollars (IMU% is 57%).

 b. During the last 2 weeks of May store traffic dropped dramatically. As a result, the May sales plan of $50.0 was missed by $10.0. May planned purchases and markdowns were on plan.

 (1) Calculate the actual June B.O.M. figure and post it in column 2 of the OTB form.

 (2) What is the June OTB at retail and at cost?

 c. $46.0 in orders were placed in May for June delivery. Recalculate the June OTB in column 3, using the June actual B.O.M. figure in column 2 and the planned sales, markdowns, and E.O.M. figures.

 d. Explain the results of column 3 and the steps that should be taken.

OPEN-TO-BUY

	OPEN-TO-BUY:	Month:	1 June	2	3
STEP 1	A. ACTUAL B.O.M.		100.0		
	B. ON ORDER	+			
	C. ADDITIONAL ON ORDER	+			
	D. TOTAL STOCK ON HAND				
STEP 2	E. PROJECTED SALES		42.0		
	F. MARKDOWNS	+	3.0		
	G. CANCELLATIONS	+			
	H. RETURNS	+			
	I. TOTAL STOCK REDUCTIONS				
STEP 3	D. TOTAL STOCK ON HAND				
	I. TOTAL STOCK REDUCTIONS	–			
	J. PROJECTED E.O.M.	=			
STEP 4	K. *PLANNED E.O.M.		108.0		
	J. PROJECTED E.O.M.	–			
	L. OPEN-TO-BUY $	=			
STEP 5	M. OPEN-TO-BUY AT COST [OTB X (100% – IMU %) = OTB COST]				

* REMEMBER, This month's E.O.M. is next month's B.O.M.

Figure 9.5. Open-to-Buy Form

5. Use the provided March planned figures to complete following exercises.

B.O.M.	$40.0
Sales	12.0
Markdowns	.5
E.O.M.	38.0

The current March on order is $15.0.

a. Compute the March planned purchases.

b. Calculate the March OTB.

c. Analyze the OTB and detail your strategy below.

INVENTORY MANAGEMENT

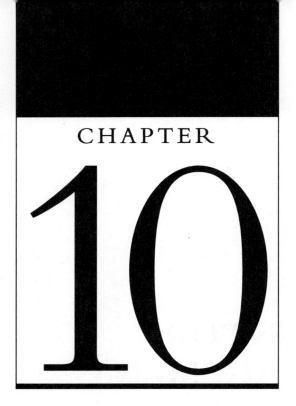

Ordering Systems

"Retail is detail" has often been stated by one of the country's outstanding merchants. **Ordering systems** are a necessity for generating maximum sales, minimizing markdowns, and producing the greatest profits. These control systems work in tandem with the merchandise plan and open-to-buy for effective dollar control and budgeted buying. They document sales patterns to pinpoint areas for growth and improvement and highlight potential problem areas.

Because each store is the sum total of items carried, effective ordering systems will:

1. Balance stock and sales for improved stock turns and return on inventory investments

2. Eliminate duplication of items

3. Reduce out–of–stocks and overstocks

4. Produce sales histories to minimize "buying errors"

5. Flag emerging trends

6. Provide data for vendor evaluations

7. Increase customer satisfaction

ordering systems–methods used by retailer to purchase goods and maintain profitable balance between stock and sales

ORDERING METHODS

The retailer can use a variety of ordering methods. One method may be used throughout the operation or several may be combined.

INTUITIVE ORDERING METHOD

intuitive ordering method–ordering by intuition

Using the **intuitive ordering method**, the retailer just "knows" when reorders are needed and in what quantities. Frequently, there are no dollar control plans so stock imbalances build up, and the flow of new merchandise constricts as cash flow tightens. The retailer's innate ordering method is not transferable to others; sales histories, order quantities, and buying errors are recorded "mentally."

OUT-OF-STOCK ORDERING METHOD

out-of-stock ordering method–stock ordered when previous stock has been totally sold

When retailers order based on empty pegs, shelf spaces, lightly stocked fixtures, and so on, they are using the **out-of-stock ordering method.** Maintaining proper inventory levels and balanced assortments is difficult with this method. Basic and key items, which the customers expect to always find, will represent the majority of merchandise out-of-stock situations. The result is dissatisfied or lost customers.

VENDOR ORDERING METHOD

The **vendor ordering method** is used when the retailer waits for the vendor's arrival or phone call before considering reorders. What occurs when vendors do not visit regularly or never return phone calls? This may result in lost opportunities.

vendor ordering method–reorder on visit or phone call of vendor

VISUAL ORDERING METHOD

Using the **visual ordering method,** the retailer spends time on the selling floor and regularly "eyeballs" stock levels. The "eyeball" method works effectively for items with stable rates of sale and allocated display space.

visual ordering method–orders placed after visual inspection of item stock levels in stock room and on selling floor

The necessary ingredients for the visual method of ordering are:

1. Following a "checklist **planogram**" set in sequence of the floor presentation and stockroom to ensure that all merchandise is "eyeballed" for reorders

planogram–item-by-item fixture presentation guidelines

2. Using hanging reorder tags or shelf markers that include order-up-to levels (see Figure 10.1)

3. Periodically reviewing and adjusting the merchandise assortments for popularity increases and decreases

ROTATING ORDERING METHOD

Regularly scheduled physical inventory counts are taken and posted in stock control books. Using the **rotating ordering method,** orders are then written according to the rate of sale and established **model stock levels** (also referred to as **par levels** and **order-up-to levels**). The terminology varies depending on the respective trading market. Figure 10.2 shows an example of a stock book with model stock levels.

Regularly scheduled counts and reorders minimize out-of-stock situations for basic and key items, increase customer satisfaction, and create sales histories for future purchases.

rotating ordering method–orders written based on rate of sale and established model stock levels after regularly scheduled physical inventory counts are taken

model stock levels–ideal stock quantity for each item stocked that should be on hand to meet everyday sales demands, plus a "cushion" amount for unanticipated additional sales and unforeseen delivery problems; also known as *par levels* and *order-up-to levels*

Effective management steps for the rotating ordering method are:

1. Selecting merchandise that has a relatively stable rate of sale

2. Delegating stock counts and stock book maintenance to employees or vendors (or both)

3. Visually checking the inventory and the receipt records for accuracy before passing orders

4. Reviewing the stock books every 3 months to adjust for sales trends

PERPETUAL ORDERING METHOD

The **perpetual ordering method** records the daily additions of receipts and the subtractions of sales and returns. If more than one store is involved, it acknowledges incoming and outgoing merchandise transfers. The perpetual method keeps a running track record of individual item activity.

The perpetual ordering method works effectively for:

1. Merchandise with irregular sales such as seasonal goods, promotional items, and fashion apparel

2. Close monitoring of sales rates

3. Continual evaluation to pinpoint peak and postpeak merchandise life spans

OOPS! SORRY WE'RE OUT

SLOPE SUPPLIES, INC.

Number_____
Description_____

Par Level_____

**Call 1-800-555-1345
or
1-800-555-2218**

Figure 10.1. Hanging Reorder Tag

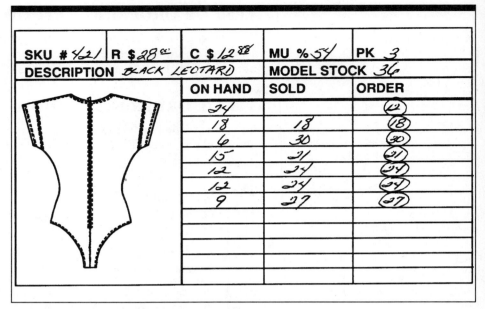

Figure 10.2. Stock Book with Model Stock Levels

weeks of supply ordering method—orders written based on recent weekly sales rates and number of weeks of inventory on hand and on order

WEEKS OF SUPPLY ORDERING METHOD

The **weeks of supply ordering method** bases orders on recent weekly sales rates and the number of weeks of inventory on hand and on order. It works best for items with stable sales rates. The orders reflect current sales trends and the weeks of supply number allows for comparison to planned stock turn rates.

Formula for Calculating Weeks of Supply Ordering Method

Step 1:

$$\frac{\text{Number of Weeks in Planning Period}}{\text{Planned Stock Turn}} = \textbf{Planned Number of Weeks Supply}$$

Step 2:

$$\frac{\text{Total on Hand Pieces} + \text{On Order}}{\text{Average Weekly Sales}} = \textbf{Weeks of Supply}$$

Step 3:

$$\begin{aligned} &\text{Average Weekly Sales} \\ \times\; &\text{Planned Number of Weeks Supply} \\ \hline =\, &\textbf{Order-up-to Level} \end{aligned}$$

Step 4:

$$\begin{aligned} &\text{Order-up-to Level} \\ -\; &\text{Total Inventory} \\ \hline =\, &\textbf{Order Quantity} \end{aligned}$$

EXAMPLE:

A season equals 26 weeks. To achieve a stock turn of 3 turns:

$$\frac{26}{3} = 8.67 \text{ weeks of supply on hand per item (8.666)}$$

To determine the order quantity assume weekly sales of 12:

$$\frac{\text{Total on Hand Pieces} + \text{On Order}}{\text{Average Weekly Sales}} = \frac{60 + 24}{12} = \textbf{7 Weeks of Supply}$$

Average Weekly Sales	12
× Planned Number of Weeks of Supply	× 8.67
Order-up-to Level	**104.04**

Order-up-to Level	104 pieces
– Total Inventory	– 84
Order Quantity	**20 pieces**

If not managed properly this method can build stock levels as sales peak and starve stock assortments when sales fall off. This method works best in conjunction with a class open-to-buy, in both dollars and units.

COMPUTER ORDERING METHOD

computer ordering method–orders written based on each computerized item's model stock level in conjunction with the daily activity of each item

Computers are fast, efficient, and speed up the ordering process after the painstaking job of data input is complete. The **computer ordering method** allows orders to be written based on each computerized item's stock level in conjunction with the daily activity of each item. The requisites for efficient computer ordering systems are:

1. Prior working knowledge of manual ordering techniques

2. Accurate manual sales records and data entry

3. Correct model stocks, which are periodically reviewed and adjusted, if necessary

4. Standardized merchandise tags, point-of-sale (POS) terminals (registers), and merchandise scanners

An example of a computerized ordering report is illustrated in Figure 10.3. This weekly style summary reports 4 weeks unit and dollar sales (current week through week 3) and the current on hand quantity. It also automatically calculates the current weeks of supply (WKS OH) and the cumulative markup in dollars (CUM) and percent (%). On this summary report nothing is on order because the two styles have been reduced to $39.99 and $29.99.

More retailers are converting to computerized ordering systems because the benefits outweigh the initial start-up costs. These benefits include:

1. Immediate sales results are captured at the point of purchase, increasing reorder cycles

2. Sales people can concentrate on servicing the customer rather than completing inventory counts

```
REPORT 'D    MFS31ORO1 - 1221                                                           GMM
                        4172              WEEKLY STYLE SUMMARY REPORT                     DMM
                                                  WEEK 27                                 BYR
                      PAGE    164         DEPT   428

                            ORIG  CURR       ----- RECEIPTS ------  -------------- SALES ------------  ON   WKS   ON    LAST CUM  CUM
STYLE  DESCRIPTION         RETL  RETL STAT   FST  LST AGE TOTAL  CUM  %   WK-3 WK-2 WK-1 CURR  HAND  OH  ORDER  CLM  CLMS  RTNS

MFR    321                           CLASS    91 TROUSERS

REGULAR PRICE
  4200 GARM WASH TWIL     56.00 39.99  PC 05/14 05/15 12   77   12  16   0    1    0    5    65  13.0   0          0    1

       CLASS  UNIT TOTALS - REGULAR                        77   12  16   0    1    0    5    65  13.0   0          0    1
              DOLLAR TOTALS  (X100)                        43    5       0    1    0    1    26          0

       CLASS  UNIT TOTALS - COMBINED                       77   12  16   0    1    0    5    65  13.0   0          0    1
              DOLLAR TOTALS  (X100)                        43    5       0    1    0    1    26          0

MFR    321                           CLASS    96 SHORTS

REGULAR PRICE
  4205 PLAID SHORTS       44.00 29.99  PC 05/14 05/15 12   30   16  53   0    2    5    4    14   3.5   0          0    1

       CLASS  UNIT TOTALS - REGULAR                        30   16  53   0    2    5    4    14   3.5   0          0    1
              DOLLAR TOTALS  (X100)                        13    5       0    1    1    1     4          0

       CLASS  UNIT TOTALS - COMBINED                       30   16  53   0    2    5    4    14   3.5   0          0    1
              DOLLAR TOTALS  (X100)                        13    5       0    1    1    1     4          0

       MFR    UNIT TOTALS - REGULAR                       419   98  23   1    8   11   49   321   6.6   0          0    9
              DOLLAR TOTALS  (X100)                       225   35       1    3    3   12   122          0

       MFR    UNIT TOTALS - COMBINED                      419   98  23   1    8   11   49   321   6.6   0          0    9
              DOLLAR TOTALS  (X100)                       225   35       1    3    3   12   122          0
```

Figure 10.3. Weekly Style Summary Report

3. Favoritism of "pet" vendors is minimized and vendor manipulation of stock books is eliminated (these are infrequent but important to mention)

4. Customer satisfaction increases with reduced out-of-stock positions

SELF QUIZ

1. Listed below are the eight types of ordering methods. Write the letter next to the ordering method it best describes.

Intuitive	_____	A.	Weekly sales rates
Out-of-stock	_____	B.	Eyeballs
Vendor	_____	C.	Empty shelves
Computer	_____	D.	Just "knows"
Rotating	_____	E.	Vendor visits
Perpetual	_____	F.	Scheduled counts
Weeks of supply	_____	G.	Running record
Visual	_____	H.	Knowledge of manual ordering methods

2. Fill in the blanks.

 a. A season equals _____ weeks.

 b. To achieve a stock turn of 2.5, the weeks of supply plan must be_____.

 c. If the planned weeks of supply is 13, the season's planned stock turn is

 _____.

 d. Fifty pieces are sold on the average each week and the planned weeks of

 supply is 4.3, therefore, the order-up-to level is _____.

3. Average weekly sales during the spring/summer season is 90 pieces. The season's planned turn is 4. Currently, the total number of pieces on hand is 280 and 144 pieces are on order.

 a. Compute the weeks of supply.

 b. Calculate the planned number of weeks supply.

 c. What is the order-up-to-level?

 d. How many pieces are to be ordered?

4. What are the prerequisites of computer ordering systems?

ORDERING

How does the retailer or vendor determine how much to order and reorder?

Initial model stock unit levels are determined by reviewing similar item sales for correlations and by discussing typical sales rates with vendors. These levels are written on peg hang tags, coded price tickets, or posted in stock books or computers.

The initial levels must be monitored closely until the unit rate of sale may be determined. These are best determined after three months, although adjustments will be made in the interim. The *order-up-to level*, based on the actual sales trend, may then be set.

ORDER-UP-TO LEVEL

order-up-to level–quantity of stock necessary to be on hand at a specific time to meet customers' needs and maintain profitable balance between stock and sales

The **order-up-to level**, as explained earlier in this chapter, is also referred to as **par level** and **model stock**. Four elements comprise the order-up-to level and must be qualified before determining the necessary stock level: the *rate of sale*, *turnaround time*, the *reorder period*, the *safety cushion*.

rate of sale–number of average unit sales for specific period of time

Rate of sale. The number of average unit sales for a specific period of time (daily, weekly, monthly) is defined as the **rate of sale**.

Formula for Calculating the Unit Rate of Sale

$$\frac{\text{Unit Sales for Specific Time Period}}{\text{Number of Specific Time Periods}} = \textbf{Rate of Sale}$$

EXAMPLE:

Eighty pieces were sold in the past four weeks. To find the weekly rate of sale:

$$\frac{80 \quad \text{4 Weeks Sales}}{4 \quad \text{4 Time Periods}} = \textbf{20 pieces Weekly Rate of Sale}$$

turnaround time–time between placing an order and receipt of it

Turnaround time. The time between placing an order and receipt of it is known as the **turnaround time**.

reorder period–how often orders are placed

Reorder period. How often reorders are placed (daily, weekly, monthly) is the **reorder period**.

safety cushion–reserve stock units to cover uncertainties in sales and deliveries

Safety cushion. The reserve stock units to cover uncertainties in sales and deliveries—an "educated judgment," usually one half the rate of sale quantity—is desired as the **safety cushion**.

Formula for Calculating the Order-up-to Level

	Rate of Sale	20	units per week
Plus:	Turnaround Time	40	20 times 2 weeks
Plus:	Reorder Period	40	20 times 2 weeks
Plus:	Safety Cushion	10	1/2 rate of sale
	Stock Level	**110 Pieces**	

The order-up-to level is 110 pieces.

The next step is to determine the order quantity:

Formula for Calculating Order Quantity

	Order-up-to Level	110
Less:	On Hand Count	60
Less:	On Order	24
	Order Quantity	**26**

An order for 26 pieces is needed. If the vendor has minimum order requirements such as a minimum order of one dozen, the retailer would order 24 pieces.

1. What two names are used interchangeably with order-up-to level?

2. Define rate of sale and write the formula for calculating it.

3. February's sales are listed below. Calculate the weekly rate of sale for each group of merchandise.

Merchandise Group	Sales	Rate of Sale
Sweatshirts	180	_____
Sweatpants	100	_____
Warm-up suits	130	_____
Leotards	156	_____
Leggings	210	_____

4. In the last 4 weeks, 144 boxes of chocolate mints have sold. Orders are placed every 2 weeks and it takes 3 weeks to receive new shipments. The safety cushion is half the weekly rate of sale. The on hand quantity is 85 boxes, with 84 boxes on order.

 a. What is the weekly rate of sale?

 b. Establish the order-up-to level. Show your calculations.

 c. How many boxes should be ordered? (Minimum order quantity is one dozen.)

5. In the last 4 weeks, 120 pairs of hiking boots have sold. Orders are placed every 2 weeks and it takes 2 weeks to receive new shipments. The safety cushion is half the weekly rate of sale. The on hand quantity is 70 pairs, with 24 pairs on order.

a. What is the weekly rate of sale?

b. How many pairs of boots are included in the order-up-to level for the turnaround time and the reorder period?

c. If the safety cushion is changed from half the weekly rate of sale to 3/10 of the weekly rate of sale, how many pairs would make up the safety cushion? Calculate the new order-up-to level.

d. How many hiking boots should be ordered?

STOCK BOOK PROCEDURES

It is important to have a working knowledge of manual ordering techniques before going to computerized systems. This is best accomplished by **unit stock control books**, which provide written records for establishing order-up-to levels.

Unit stock book formats vary. Rotating method stock books will have simpler formats (refer to Figure 10.2 (page 220) and Figure 10.4) as compared to perpetual method stock books (on hand, on order, received, transferred in and out, returned, sold). In Figure 10.7 (page 230) you will see a perpetual stock book example, which also summarizes total unit and dollar transactions.

ROTATING METHOD STOCK BOOK PROCEDURES

Refer to the illustrated rotating method stock page in Figure 10.4 as the procedure for this stock book method is explained.

Step 1:

All pertinent merchandise information is posted to each stock book page. This may include SKU (stockkeeping unit number), unit cost and retail, markup percent, pack size, description, model stock, sizes, colors, and so on. As shown in Figure 10.4, white elastic band tennis skirts, style #627, cost $14.08, retail for $32.00, with a markup of 56%. The order pack (PK) is 3 with a model stock plan set at 36.

SKU #627	R $32.00	C $14.08	MU %56	PK 3
DESCRIPTION WHITE ELASTIC BAND TENNIS SKIRT			MODEL STOCK 36	

ON HAND		SOLD	ORDER
18	6		(12)
12	6	18	(18)
6	–	30	(30)
9	6	21	(21)
12	–	24	(24)
12	–	24	(24)
9	–	27	(27)

Figure 10.4. Rotating Stock Book

on hand–total number of pieces on selling floor and in stock room

on order–orders placed but not yet received

received–quantity received

Step 2:

A physical count of each item in stock is made. The count total listed in the **on hand** (OH) box represents the total number of pieces on the selling floor and in the stock room. The selling floor on hand is posted on the left side of the diagonal line. The stock room quantity is written in the lower right side of the diagonal line. The first on hand count of tennis skirts totaled 24 pieces.

Step 3:

As orders are placed they are entered into the **on order** box. On receipt, the quantity is circled. If an item is not received or shorted (merchandise is received but is not the total quantity ordered), the order figure is crossed out and the actual quantity **received** is then entered. When introducing a new item, such as tennis skirts, it is understood, unless otherwise noted, that the initial order placed and received is equal to the planned model stock figure. Therefore, 36 tennis skirts were ordered and received and the first count showed 24 pieces on hand.

Step 4:

Sales results are calculated and order quantities are determined. Using the simpler rotating stock page format, sales are easily computed by subtracting the current on hand figure and order amount from the model stock figure. The order amount is always added in, although the merchandise may not have arrived at the time of the next on hand count.

EXAMPLE:

The first count shows 24 white tennis skirts on hand. In an introductory situation nothing is on order until after the first stock count occurs.

Model Stock	36
- On Hand	- 24
Pieces Sold	**= 12 Tennis Skirts Sold**

Since,

On Hand	24
+Sales	+12
Model Stock	= 36 Model Stock Level for Tennis Skirts

The retailer orders 12 tennis skirts to bring the stock level back to the planned model stock figure. This is written in the order column on the first line.

EXAMPLE:

The second count totals 18 pieces on hand, 12 on the selling floor with 6 in the stockroom. To calculate sales and an order quantity:

Last On Hand Count	24
+Order Quantity	+12
- Current On Hand Count	- 18
Pieces Sold	**=18**

Therefore,

Model Stock Level	36
- Current On Hand	- 18
Order Quantity	**=18**

The retailer places an order for 18 white tennis skirts.

It is important to thoroughly understand the mechanics of stock books to maintain the proper stock levels in relation to sales and merchandise life cycles and to monitor vendor-maintained stock books. In many instances, retailers allow their vendors to count, maintain, and write orders in the stock books. The knowledgeable retailer will be able to avoid unpleasant vendor surprises by understanding the mechanics of each stock book and by overseeing the setting of model stock levels and order quantities. Unfortunately, some retailers hand over the responsibility to some vendors who take advantage of the retailer's lack of knowledge. For this reason, another example of a rotating stock page is explained.

EXAMPLE:

Refer to the illustrated stock book page in Figure 10.5.

All orders were received on time. The actual receipt quantity is entered into a received box (REC). The established order-up-to level, referred to as par level in this example, is 80. The count dates are posted across the top, every 2 weeks. The on hand (OH) count is posted in the upper left hand side of each box and the order (OO) amount in the bottom right hand box. Sales are calculated for the 2-week selling periods as follows:

	5/1 to 5/15	5/15 to 5/29	5/29 to 6/11
On Hand	60	44	60
+Order	+24	+36	+24
- On Hand	- 44	- 60	- 52
Sales	**40**	**20**	**32**

Figure 10.5. Stock Book Page

VENDOR: Vale		DATE 5/1	DATE 5/15	DATE 5/29	DATE 6/11	DATE	DATE	DATE
DESCRIPTION #V 2122 100% Nylon Short	PAR	OH	OH	OH	OH	OH	OH	OH
	LEVEL	OO	OO	OO	OO	OO	OO	OO
Black	80	60 / 24	44 / 36	60 / 24	52 / 24			

Something to Consider: Par Level Calculation for Vale, Black 100% Nylon Shorts

The par level of 80 was determined by:

6 weeks sales total 92 pieces (40 + 20 + 32 = 92).
92 pieces divided by 6 weeks equals the average weekly sales rate of 15 pieces

	Rate of Sale	15	units per week
Plus:	Turnaround Time	30	15 times 2 weeks
Plus:	Reorder Period	30	15 times 2 weeks
Plus:	Safety Cushion	5	1/3 rate of sale
	Par Level	**80**	**Pieces**

Notice that there is no space to write in sale results. This example is more difficult to calculate order quantities, track receipts, and monitor established par levels. By altering this vendor supplied stock page, the tracking of receipts and the recording of sales results is much clearer, as illustrated in Figure 10.6.

VENDOR: Vale		DATE 5/1	DATE	DATE 5/15	DATE	DATE 5/29	DATE	DATE 6/11
DESCRIPTION #V 2122 100% Nylon Short	PAR	OH	REC.	OH	REC.	OH	REC.	OH
	LEVEL	OO	SOLD	OO	SOLD	OO	SOLD	OO
Black	80	60 / 24	(24) / 40	44 / 36	(36) / 20	60 / 24	(24) / 32	52

Figure 10.6. Updated Stock Page

PERPETUAL STOCK BOOK PROCEDURES

The perpetual stock book procedure differs from the simpler, rotating stock book procedure in three ways. First, the perpetual method maintains a running track record of the inward and outward movement of mechandise, which not only includes receipts, but also transfers in and out and vendor returns and damages. Second, the stock page posting is more detailed, yet easier to calculate sales and order quantities. Third, it clearly shows sales results over a period of time. Figure 10.7 provides an excellent example of the perpetual stock book procedure.

This example not only identifies all merchandise information, it also provides an area to post count dates, order dates, and received dates as illustrated under the month of January.

The on hand count taken on December 31, reflects 3 pieces on hand of product #0304-33. Ordering prepack minimum is 3, with a retail price of $7.00. The activity for this product in January is outlined below.

Figure 10.7. Perpetual Stock Book Page

1. On December 31, 3 pieces were in stock.

2. On January 2, 6 pieces were ordered.

3. On January 15, the 6 ordered pieces were received.

4. Three pieces were transferred out to another store and there were no returns or damages.

5. The February count totaled 6 pieces on hand, therefore there were no sales for the month of January for this product. This was arrived at by adding the previous on hand count figure and the received quantity and subtracting the transfers out amount and the current on hand figure.

Last Count On Hand Figure	3
+Order Quantity Received	+6
– Transfers Out	– 3
– Current On Hand Figure	– 6

Note: The third product received (REC'D) box has the notation B/O. This represents back order. A **back order** is an order placed, yet is unable to be shipped because the supplier is currently out of stock. With the retailer's approval, the supplier will ship the order as soon as the supplier has the goods to fill it. A back order is included in the calculation of determining order quantities just as merchandise on order, yet not received, is included.

Both the rotating and the perpetual stock method procedures are invaluable tools for achieving the five golden rules of merchandising (having the *right* merchandise, at the *right* time, at the *right* price, in the *right* quantity, in the *right* place).

back order–an order placed, yet unable to be shipped because supplier is out of stock. With the retailer's approval, the goods will be shipped as soon as the supplier has the goods to ship.

SELF QUIZ

1. Use the stock book page in Figure 10.8 to answer the following questions.

 a. Compute the order quantities, pieces received (all stock is received as ordered) and pieces sold and write in the answers on stock page in the on order (OO), received (REC.), and sold spaces.

 b. Calculate the rate of sale.

 c. The safety cushion is 1/3 the rate of sale. The turnaround time is 2 weeks, as is the reorder period. Compute the current par level.

Figure 10.8. Stock Book Page

VENDOR: Maxim		DATE 2/5	DATE 2/20	DATE 3/5	DATE 3/20	DATE 4/5	DATE 4/20	DATE 5/5
DESCRIPTION 100% Cotton Polo Shirt	PAR LEVEL	OH / OO	REC. / SOLD	OH / OO	REC. / SOLD	OH / OO	REC. / SOLD	OH / OO
Navy	60	44		48		52		54

d. After computing the current par level, what are your observations?

2. Use the stock page in Figure 10.9 to answer the following questions.

 a. Compute the retail price and the markup dollar amount for long-sleeved cotton jersey striped turtlenecks and write your answers on the stock page.

SKU #B262	R$		C$12.00	MU$		MU %56.5	PK 2
DESCRIPTION LS Cotton Jersey Striped T-neck				COLOR BK+WHT	MODEL STOCK 42		

	ON HAND	ORDER	REC'D	SOLD
	22			20
	26	20	(20)	16
	18	16	(16)	24
	14			
	26			
	12			
	15			

Figure 10.9. Stock Book Page

b. Three counts have been taken as shown on the stock page. Twenty pieces were ordered and received and 16 pieces were ordered and received. A total of 60 turtlenecks have been sold to date. Complete the stock book page calculations. (Assume all orders are received as ordered.)

c. What important component is missing on this stock page format?

3. Evaluate both stock book format examples above. Which method is easier or clearer?

ORDERING TIMETABLES

Basic stock items are available year-round, but fashion and seasonal merchandise have specific ordering timetables.

FASHION MERCHANDISE

electronic data interchange–process by which computer-to-computer communication occurs between a business and its suppliers to increase order accuracy and shorten order cycles to increase customer service levels

Most manufacturers of fashion merchandise require 60- to 90-day lead times to produce the merchandise requested by retailers, although the lead times are decreasing through the growth of **electronic data interchange** between retailers and vendors, which decreases the order turnaround times. What follows is the general fashion wholesale market ordering cycle. Retailers will adjust receipt dates according to supplier delivery schedules and their geographical climates and customers' buying habits.

Spring: Orders are placed in November for January/February deliveries.

Summer: In January orders are placed to be received in March/April.

Fall: March/April are the month fall orders are placed to arrive in July/August.

Winter: Winter merchandise is ordered in August for scheduled October/November deliveries.

Trade publications for each respective industry (i.e., women's apparel, men's apparel) assist retailers in determining their fashion ordering timetables. A women's apparel trade publication, *Women's Wear Daily*, annually publishes the upcoming year's market schedule, as illustrated in Figure 10.10.

Typically, when the first day of a new season begins, the current season's merchandise should begin to be marked down to make room for the flow of the next season's goods. Vendors will offer special purchase prices around these dates to clear their warehouses for the incoming season's goods.

Regular price reorders of in-stock fashion merchandise should occur only if resources can deliver the reorder before the peak selling cycle arrives. If vendors

MARKET LOCATIONS & ANNUAL SCHEDULE

The approximate market weeks annual schedule for women's apparel in various regional markets and in New York. Unless separately listed, children's wear is timed in conjunction with women's apparel. It is advisable to establish contact with your respective regional market and request to receive all market information directly to be informed on exact dates and other market shows (menswear, giftware).

	SUMMER	FALL I	FALL II	RESORT	SPRING
ATLANTA					
Atlanta Apparel Mart	Jan. 28-Feb. 3	April 15-21	June 10-16	Aug. 26-Sept. 1	Oct. 28-Nov. 3
BIRMINGHAM, Ala.					
Birmingham Jefferson Civic Center	Jan. 24-26	March 21-23	June 6-8	Aug. 16-17	Oct. 24-26
BOSTON					
Bayside Expo Center	Jan. 17-20	March 28-31	June 6-9	Aug. 22-25	Oct. 24-27
Children's Market (Bayside Merchandise Mart)	Jan. 17-20	Feb. 28-March 3	March 28-31	Aug. 15-18 Sept. 19-22	Oct. 24-27
CHARLOTTE					
Charlotte Apparel Center	Jan. 22-26	March 26-30	June 4-8	Aug. 20-24	Oct. 22-24
Children's Market (Charlotte Merchandise Market)	Jan. 22-24	March 26-30	June 4-7	Aug. 20-23	Oct. 22-26
CHICAGO					
Chicago Apparel Center	Jan. 22-26	March 26-30	June 4-8	Aug. 20-24	Oct. 22-24
DALLAS					
Dallas Apparel Mart	Jan. 21-25	March 25-29	June 3-7	Aug. 19-23	Oct. 21-25
DENVER					
Denver Merchandise Mart	Jan. 29-Feb. 1	April 2-5	June 18-20	July 30-Aug. 2	Oct. 15-18
KANSAS CITY					
Kansas City Market Center	Jan. 9-12	April 2-6	June 26-29	Aug. 28-31	Oct. 15-18
LOS ANGELES					
California Mart Pacific-Coast Travelers	Jan. 15-19	March 19-23	June 11-15	Aug. 13-17	Nov. 5-9
MIAMI					
Miami International Merchandise Mart					
Southern Apparel Exhibitors Inc.	Jan. 8-11	March 26-29	June 4-7	Aug. 6-9	Oct. 8-11
MINNEAPOLIS					
Hyatt Merchandise Mart	Jan. 24-27	Feb. 28-March 3	June 13-16 March 28-31	Aug. 15-18	Oct. 17-20
NEW YORK	Jan. 11-22	Feb. 8-19	March 29-April 9	Aug. 9-13	Oct. 25-Nov. 5
PITTSBURGH					
Pittsburgh Expo Market, Monroeville	Jan. 17-19	April 18-20	June 13-15	Sept. 12-14	Oct. 31-Nov. 2
Children's Market	Jan. 26-27	March 18-21		July 25-27	Oct. 31-Nov. 2
PORTLAND					
Montgomery Park	Jan. 17-18	March 21-22		Aug. 1-2	Oct. 17-18
SAN FRANCISCO					
Fashion Center, 699 Eighth Street	Jan. 30-Feb. 2	April 17-20	June 19-22	Aug. 21-24	Oct. 30-Nov. 2
SEATTLE					
Seattle International Trade Center	Jan. 23-26	March 27-30	June 5-8	Aug. 7-10	Oct. 23-26
VIRGINIA					
Old Dominion Fashion Exhibitors					
The Omni, Virginia Beach	Feb. 10-11	April 28-29	June 23-24	Sept. 8-9	Nov. 18-19
Embassy Suites Hotel, Tyson's Corner	Feb. 7-8	May 2-3	June 27-28	Sept. 12-13	Nov. 14-15

Figure 10.10.

cannot respond fast enough for regular price selling, the retailer should request off price buys, which will still produce strong sales of the best selling fashion items.

Shrewd merchants identify the characteristics of the best sellers, which may include a collar treatment, a length, a color, or a silhouette, and duplicate the successful selling features.

SEASONAL MERCHANDISE

Seasonal merchandise includes specific holiday items and particular goods warranted by the change in seasons. Vendors typically offer special purchase prices (early bird discounts) well in advance of the selling season to preplan their production schedules.

Holiday merchandise buys ideally should be received 30 days before the holiday arrives, with the exception of Christmas. Retailers produce the majority of their annual sales volume during this selling season. The volume of receipts necessitates that Christmas merchandise begins arriving the beginning of November.

Changing seasons also requires altering the basic merchandise assortments. For example, insect repellent sales during the summer and cold and cough remedy sales in the winter will increase and ordering levels must be changed, in advance, to respond to the customer's changing needs.

UNIT CONTROL SYSTEMS CONSIDERED

Unit control systems tied into dollar control systems will:

1. Eliminate excess inventory

2. Increase stock turns and resultant profits

3. Support the "right" stock

4. Build sales histories

5. Prevent recurrences of "mistakes"

6. Better serve the targeted customer group

CHAPTER REVIEW

1. Briefly define the following ordering methods and list their advantages and disadvantages:

 a. Intuitive ordering method

 b. Out-of-stock ordering method

c. Vendor ordering method

d. Visual ordering method

e. Rotating ordering method

f. Perpetual ordering method

g. Weeks of supply ordering method

h. Computer ordering method

2. What are the benefits that the retailer will realize from the use of computerizd ordering systems?

3. Initial model stock unit levels are determined by reviewing similar item sales for correlations and by discussing typical sales rates with vendors.

 True **False**

4. What four elements comprise the order-up-to level?

5. If the delivery period shortens, would the retailer adjust the safety cushion? Why or why not?

6. What purpose(s) does the unit stock control book serve?

7. Basic stock items are available to retailers year-round, but fashion and seasonal merchandise have specific ordering timetables.

True	**False**

8. Place an X under True or False for each of the following. Unit control systems tied into dollar control systems will:

	True	**False**
a. Eliminate excess inventory		
b. Decrease stock turns and resultant profits		
c. Support the "right" stock		
d. Build sales histories		
e. Make recurrences of "mistakes" more frequent		
f. Fail to serve the targeted customer group		

9. While walking the sales floor, the For All Seasons' accessory buyer notices empty slots in the sunglasses fixture. After checking the stock room and discovering no back stock, the buyer checks the purchase on order log. The sunglasses fill-in is scheduled to arrive tomorrow.

a. Is this effective stock management? Support your response with specifics.

b. As the consultant for For All Seasons, what recommendations would you discuss with the accessory buyer?

10. Out-of-stock situations have been occurring frequently in the following items:

 a. White sport socks

 b. Lined leather gloves

 c. Fur lined parkas

 d. Hand-held workout weights

For each item listed above, which ordering method(s) would you implement and why?

 a.

 b.

 c.

 d.

CHAPTER TEST

1. For All Seasons' swimwear buyer must determine the order quantity for ladies' swimsuits. Using the weeks of supply method and the information provided, calculate the order quantity.

Total swimsuits OH	70
Total swimsuits OO	25
Average weekly sales	16
Planned weeks of supply	8

2. Use the information provided below to complete the following exercises.

Rate of sale	50 units/week
Turnaround time	4 weeks
Reorder period	4 weeks
Safety cushion	1/2 rate of sale

 a. Calculate the order-up-to level.

 b. Assume that the on hand count is 175 pieces and that the on order quantity is 50. Compute the order quantity.

3. Given the following information, answer the questions. Sports caps average monthly sales total 240 units. Orders are placed and received every 4 weeks. The planned safety cushion is 1/3 the rate of sale.

 a. Write and calculate the order-up-to level formula below. Show your computations.

 b. The new stock count figure for sports caps total 290. How many dozen sports caps should be ordered?

4. Complete the stock book page for 100% cotton sweat pants in Figure 10.11 by computing and posting the retail price, markup dollar amount, and order and sold quantities. Assume all orders are received as ordered.

SKU # 5151	R $		C $16.00	MU $		MU % 52	PK 6
DESCRIPTION Size large 100% Cotton Sweat Pants				COLOR White	MODEL STOCK 48		
		ON HAND	ORDER	REC'D	SOLD		
		24					
		36					
		27					
		18					
		30					
		12					
		16					

Figure 10.11. Stock Book Page

5. White 100% cotton crew socks are ordered every 2 weeks. The turnaround time is 1 week and the safety cushion is 1/4 the weekly rate of sale. Last year's spring/summer season's white crew sock sales averaged 360 pairs a month. Use Figure 10.12 to do the following.

 a. Compute the average weekly sales rate based on 4.5 weeks per month.

VENDOR: Crewex			DATE 6/11	DATE	DATE 6/15	DATE	DATE 6/29	DATE	DATE 7/11
DESCRIPTION 100% Cotton Crew Socks 9-11	PAR LEVEL		OH	REC.	OH	REC.	OH	REC.	OH
			OO	SOLD	OO	SOLD	OO	SOLD	OO
White									
Red				31					

Figure 10.12. Stock Book Page

b. Calculate the par level and post on the stock page.

c. The on hand counts for the period from 6/1 to 7/11 were:

6/1	140 pairs
6/15	165 pairs
6/29	189 pairs
7/11	122 pairs

On the stock page post the on hand counts and calculate and write in the on order (OO), received (REC.), and sold quantities on the stock book page.

d. Evaluate the 6-week sales results and compare them to the set par level. As the retailer, would you make any adjustments to the par level? Explain.

e. Red 100% cotton crew socks last year spring/summer sales were 1/4 the average monthly sales of white crew socks. Compute the average weekly sales rate based on 4.5 weeks per month.

f. Determine the par level and post the figure on the stock page.

g. Calculate and fill in the empty spaces for red crew socks.

h. Does the par level need adjusting? Explain your reasons why or why not.

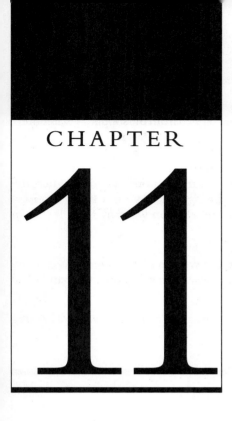

CHAPTER

11

Purchase Order Management

Properly executed **purchase orders (POs)** constitute written contracts. They represent legal documentation of agreed-on purchase terms. Orders are placed using either vendor-supplied or the retailer's own purchase order forms.

A purchase order has many benefits, including:

1. Locks in quoted purchase prices
2. Controls receipts—no substitutions, back orders, partials accepted without prior approval
3. Allocates dollars according to the available open-to-buy dollars
4. Programs deliveries according to selling cycles
5. Allows gross margin plan monitoring

PURCHASE ORDER COMPONENTS

purchase order–written contract between retailer and vendor that includes specifics of an order

The main components of all purchase orders are:

1. Vendor name and address
2. Purchase order number (PO#)
3. Department number, classification number
4. Payment terms
5. Ship/cancel dates
6. Shipping instructions
7. Item number, description, order quantity
8. Unit cost, total cost
9. Tax identification number and for resale only stamp
10. Purchaser's signature

THREE KEY PURCHASE ORDER ELEMENTS

The three key elements of purchase orders are the *purchase order number, ship/cancel dates,* and *cost and retail figures.*

Purchase order number. The **purchase order number** provides external and internal controls. It prevents unauthorized orders and provides an internal checking system for the incoming receipts and paperwork flow.

purchase order number–specific number for each purchase order to provide both internal and external controls

Ship/cancel dates. Having a clear **ship/cancel date** structure is important for three reasons:

ship/cancel date–specific start shipment date and specific last date shipment may leave the vendor's, or arrive at the retailer's, specified destination point

1. Supplies a specific flow of newness

2. Maintains the profitable balance between stock and sales

3. Controls cash flow and the bottom line

Ship "as ready" should be replaced with a specific start date. The cancel date must specify either the last date merchandise may be shipped from the supplier's warehouse, or the last day it must arrive at the retailer's distribution center or store. If a space for either the start or cancel date is missing on the vendor's purchase order, it should be written in. Remember, the purchase order constitutes a binding contract.

Many retailers use a cancellation warning form to notify vendors when the completion date of an order is near or when goods have not been received by the cancellation date. An example of a cancellation warning form is shown in Figure 11.1.

Cost/retail figures. Retail figures should be written on the internal store copy of the purchase order unless the vendor pretickets the merchandise. Cost and retail amounts enable the retailer to:

1. Compute the initial markup percent to monitor progress toward achieving planned goals

<table>
<tr><td colspan="2" align="center">**Cancellation Warning**</td></tr>
<tr><td></td><td align="right">Date _____</td></tr>
<tr><td>Resource Name</td><td>_____</td></tr>
<tr><td>Address</td><td>_____</td></tr>
<tr><td>City, State</td><td>_____</td></tr>
</table>

Subject:

 Purchase Order #: _____

 Dated: _____

Attn: _____

Please be advised that merchandise ordered on the above purchase order calling for a completion date of _____

☐ Has not been received.

☐ Is not of the same quality as the sample–cancel the balance.

☐ Do not ship the following styles–they are too late for our selling season.

☐ Has been partially received and the following styles are outstanding–RUSH.

We will not accept delivery on goods shipped beyond their completion date unless written authorization is forwarded to you. Please expedite delivery. Thank you.

 Respectfully,

Figure 11.1 Cancellation Warning Form

markup tracking log–form to post all purchases and monitor progress toward achieving initial markup percent (IMU%) plan

purchase on order log–form that provides a running record of all purchase information

2. Easily update the open-to-buy, **markup tracking log**, and **purchase on order log**

3. Save time in receiving and ticketing goods

The vendor's order form will also include vital information regarding the retailer's order so that all conditions of the order are fully understood by both parties. Figure 11.2 is an example of a vendor order form illustrating this practice.

<div style="text-align:center; background:black; color:white;">SELF QUIZ</div>

1. Briefly describe three of the benefits the purchase order provides.

2. Properly executed purchase orders constitute written contracts and represent legal documentation of agreed-on purchase terms.

 True **False**

3. Name and explain in detail the three key elements of purchase orders.

4. For All Seasons annually reviews its paperwork controls. Management requests the buying staff to submit recommendations for purchase order revisions. Refer to Figure 11.3 (page 247) and analyze and proposed changes for the existing purchase order form.

PURCHASE ORDER CONTROLS

purchase order controls–guidelines to prevent vendor order discrepancies

It is necessary for the retailer to provide the following **purchase order controls** to prevent infrequent, unprofitable surprises from vendors.

1. Draw a wavy line through remaining open order entry lines on all completed purchase orders to eliminate additions.

2. Retotal and verify vendor order totals before signing purchase orders.

3. If vendors are writing orders and will mail copies, make sure the copy is received and checked within a week.

4. Call vendors and verify shipping. Two to 3 days after the scheduled ship date, call and request the **bill of lading** number, the number of packages shipped, and the weight.

bill of lading–document indicating transport company's (common carrier) receipt of delivery from supplier

These precautions will help the retailer maintain financial control and ensure receipt of the right merchandise, at the right time, in the right quantities, and at

VENDOR ORDER FORM

Sold To:

THERMAX
ACTIVEWEAR DIVISION

1020 Sacramento Bvld.
Los Angeles, CA 10000

CUSTOMER ACCOUNT NO.

Ship To:

Order Date	Customer P.O.	Salesperson	Terms	Due Date	Store/Dept. #	Completion Date
4/20	1092	B. Jones	8/10 E.O.M.	6/1	010/562	6/10

Authorized By

M. Peters

SPECIAL INSTRUCTIONS:

	SIZE CODE	4	ITALY / U.S.A.	ITALY / U.S.A.	ITALY / U.S.A.	ITALY / U.S.A.	ITALY / U.S.A.	ITALY / U.S.A.	ITALY / U.S.A.	ITALY / U.S.A.	ITALY / U.S.A.	ITALY / U.S.A.
LADIES' TOPS	UD		00 / 4	0 / 6	1 / 8	2 / 10	3 / 12	4 / 14	5 / 16	6 / 18	7 /	/
LADIES' BOTTOMS	DT		38 / 4	40 / 6	42 / 8	44 / 10	46 / 12	48 / 14	50 / 16	52 / 18	/	/
MENS' TOPS	UD		/	/	1 / 32	2 / 34	3 / 36	4 / 38	5 / 40	6 / 42	7 / 44	8 / 46
MENS' BOTTOMS	UT	WAIST	/	/	42 / 26	44 / 28	46 / 30	48 / 32	50 / 34	52 / 36	54 / 38	56 / 40
WARM-UPS LADIES	UD		00 / 4	0 / 6	1 / 8	2 / 10	3 / 12	4 / 14	5 / 16	6 / 18	7 /	8 /
MEN							/ 36	/ 38	/ 40	/ 42	/ 44	/ 46
CHILDREN	RT / RM				32 / I	34 / II	36 / III	38 / IV	40 / V	42 / VI		
USA (Girls or Boys)	SIZE			6	8	10	12	14	16	18		
UNISEX: LEISURE JACKETS	VU		XS	S	M	L	XL					
ACCESSORIES	VT		—									

STYLE NO.	STYLE NAME	FABRIC	COLOR	SIZE CODE	TOTAL UNITS								UNIT PRICE	TOTAL

ALL SALES ARE
F.O.B. SELLERS WAREHOUSE

NO CANCELLATION, IN TOTAL OR IN PART, IS PERMITTED AFTER
10 DAYS FROM THE DATE OF THE ORDER.
ALL PAST DUE ACCOUNTS WILL BE SUBJECTED TO A 1½% PER MONTH SERVICE CHARGE.

Figure 11.2. Vendor Order Form

GREYHOUND FOOD MANAGEMENT, INC.		TRADE DISCOUNT	VENDOR:	P.O. NUMBER
PURCHASE ORDER			SHOW ORDER NUMBER ON INVOICE THIS ORDER IS CANCELLED IF ITEMS NOT SHIPPED	284000
F-802 8-71				

SHIPPING POINT | CASH TERMS | FREIGHT TERMS | BEFORE / / . | ORDER DATE / /

VENDOR NUMBER _____

V E N D O R { _____ SHIP TO AND INVOICE { _____

ENTER FOR RETAIL ITEMS ONLY

G.F.M. ORDER NO.	MFG. NUMBER	ITEM DESCRIPTION	QUANTITY	UNIT OF MEASURE	UNIT COST	TOTAL COST	UNIT SELL (EACH)
						$	

ABOVE MERCHANDISE IS BOUGHT SUBJECT TO TERMS AND CONDITIONS ON REVERSE.

EQUIPMENT AND REPLACEMENT APPROVALS {

SIGNATURE TITLE DATE

SIGNATURE TITLE DATE

ORDER TOTAL $ _____ .

ORDERED BY _____

ACCOUNTS PAYABLE COPY

ENTER FOR RETAIL ITEMS ONLY

Figure 11.3. Purchase Order

the right price to meet the customers' needs as well as to meet required inventory levels to achieve sales plans.

PURCHASE ORDER MANAGEMENT

The best way to track purchase orders is to post them on a purchase on order log and then file them alphabetically by vendor. The purchase on order log illustrated in Figure 11.4 details by department and class:

1. Date of the order

2. Purchase order number

3. Vendor

4. Total purchase cost

5. Total retail

6. Initial markup percent

7. Ship and cancel dates

8. Month dollars allocated according to the merchandise plan, open-to-buy, and selling cycle

9. Cancellation dollars

10. Return to vendor amounts

11. Date of cancellations and returns

Department __Gifts__ Class __Crystal__

Date	PO #	Vendor	Cost	Retail	IMU%	Ship	Cancel	Month $ June	Month $ July	Cancel $	RTV $	Date Can/ RTV
5/1	5621	STUB	4.0	8.3	51.8	5/15	6/1	8.3				
5/4	5632	JAMBO	3.5	7.1	50.7	5/20	6/5	7.1				
5/4	5633	JENE	6.0	12.5	52.0	5/25	6/15	12.5				
5/10	5660	JAMBO	5.2	10.8	51.9	6/15	7/5		10.8			
JUNE	SUB	TOTAL:	13.5	27.9	Average 51.6% ←		Compare to Progress	IMU %	Plan to monitor			

Figure 11.4. Purchase on Order Log

The purchase on order log offers many benefits:

1. Provides an overview of incoming receipts

2. Allocates receipt dollars by month according to the open-to-buy

3. Allows for the ongoing computation of average markup percent status

4. States clear ship/cancel dates to vendors

5. Specifies order cancellation dates to avoid receiving errors

6. Manages the outward flow of returns and dollars for open-to-buy control

7. Acts as a document with which to compare to the actual receiving record— the **purchase journal**

purchase journal–records inward movement of goods received from suppliers

PURCHASE ORDER RECEIVING PROCEDURES

It is vital to establish procedures for receiving merchandise. Multistore operations will have receiving facilities staffed with employees who specialize in handling and distributing the merchandise. Guidelines for smaller retailers include the following:

1. When a shipment arrives, check the purchase order number marked on the cartons against the on order log. Is it a valid order? Is it past its cancel date? A decision must be made to accept merchandise past the cancellation date—if the goods are still timely and open-to-buy dollars are available, accept the order. Next, contact the vendor for a possible past cancellation date discount. Many retailers charge approximately 5% to vendors for every late order, so requesting a discount versus returning the goods is reasonable.

2. Physically count the number of cartons. This number should match the freight bill or UPS signoff log. Any discrepancies must be noted on the freight bill/UPS log. Make sure the driver signs off on noted differences.

 If there are missing cartons, notify the vendor and shipper within 3 days, verbally and in writing. File a missing carton claim if the missing items do not arrive within a week.

3. Note obvious visual damage and breakage on the freight bill. If possible, open the damaged cartons and note all discrepancies. If this is not possible, sign off noting that the shipment is damaged but unexamined.

4. Remove the packing slip affixed to one of the cartons and pull the purchase order from the file (if possible, have purchase order copies in both the buying office and receiving area).

5. Unpack the cartons and sort by item number, color, size, and so forth.

6. On the packing slip and purchase order, circle in red what has actually arrived. Note any discrepancies. If the packing slip lists 3 pieces and there are 2, note the actual received quantity for future follow-up. This includes style, color, and size substitutions.

7. Initial and date the packing slip and purchase order. Ideally, two individuals should check and verify each shipment.

8. Post all required information onto a purchase journal (Figure 11.5, page 251).

Experienced retailers always stay informed of vendors' ordering terms and conditions. This way, when a problem arises on receipt of an order (damaged or defective merchandise, shortage), the retailer knows exactly what steps to follow to secure a timely credit or replacement of the merchandise and avoid costly mistakes due to misunderstanding the purchasing terms.

Prices and Policies

Effective for orders until further notification.

Prices

Prices are subject to change without notice and orders are subject to acceptance.

Terms

8/10 E.O.M. All past due accounts will be subject to a 1 1/2% per month service charge.

Freight

F.O.B. New York, NY.

Cancellations

No cancellation, in total or in part, is permitted after 10 days from the date of order.

Damaged or Defective Merchandise

All returns must have a return authorization label. Return authorization labels may be obtained by writing the New York office and stating the defect or by contacting the local sales representative. The return authorization label must be affixed to the outside of the box. All returns are to be sent via UPS unless other written instructions are received from the New York traffic department. Each return will be inspected on receipt and credit will be issued as follows:

Full credit will be given for any merchandise with manufacturing defects.

No credit will be issued for merchandise with no discernable defects or abused merchandise. This merchandise will be automatically returned to the purchaser.

Restocking Charges

A 15% restocking/handling fee will be charged to each account for authorized nondefective merchandise returns. Nondefective returns must be shipped with transportation charges prepaid, arrive in the original packaging, be in the same condition as when shipped from our warehouse, and not be ticketed. Any discrepancies will result in an additional 5% restocking/handling charge.

Shortages

Risk of loss of merchandise en route from our F.O.B. point is the purchaser's responsibility. We suggest that all shipments be inspected on receipt for damage, shortage, or tampering. Tampered boxes should be refused at delivery. All claims for shortages must be received within 10 days of receipt for credit.

Department Gifts			Class Crystal				Month June			
Date Rec'd	Vendor Name	Invoice Number	Invoice Date	Invoice Cost	Freight Cost	Total Retail	MU %	PO #	Notes	
6/1	Stub	4424	5/29	4.0	—	8.3	51.8	5621		
6/4	Jambo	1317	6/4	3.5	—	7.1	50.7	5632		
		TOTALS								

Figure 11.5. Purchase Journal

9. Process the order quickly so that the new receipts will arrive on the selling floor as soon as possible. Goods do not sell in the stock room.

10. On receipt of the invoice, make sure that the following items agree:

 a. Purchase order

 b. Freight bill

 c. Packing slip

 Payment terms, discounts, freight, shortages, damages, prices, quantities, and so on, must also be verified.

 Notify the vendor by phone and in writing of all discrepancies as soon as possible. Delays result in possible losses.

11. Approve the vendor's invoice for payment and forward to the accounting department.

Purchase orders are binding contracts between the seller and buyer. As legal documents, sound control procedures are necessary to manage the retailer's largest dollar investment—inventory.

Profit is the result of planning and control.

1. List the 10 main components that all purchase orders must include.

2. The three key elements of all purchase orders are the purchase order number, ship/cancel date, and cost and retail figures. Explain why it is of utmost importance that these elements be included in every purchase order.

3. What are the four purchase order controls that the retailer may execute to prevent unprofitable surprises from vendors?

4. Answer each of the statements below by writing an X under either True or False with regard to the purchase on order log.

		True	False
a.	Provides an overview of incoming receipts		
b.	Allocates receipt dollars by month according to the open-to-buy		
c.	Does not allow ongoing computation of average markup percent status		
d.	Does not state clear ship/cancel dates to vendors		
e.	Specifies order cancellation dates to avoid receiving errors		
f.	Complicates the outward flow of returns and dollars for open-to-buy control		
g.	Acts as a document with which to compare to the actual receiving record—the purchase journal		

5. The For All Seasons receiving clerk accepted a shipment of workout wear today. Review each of the steps the clerk took in checking the order and the problems encountered. What would you do if you were the receiving clerk?

<u>Action to Take</u>

a. Purchase order number matches, but the order is 5 days past the cancellation date.

b. Two cartons are missing according to the purchase order.

c. One carton looks as if it has been dropped, with the sides splitting and contents spilling out.

d. The receiving clerk realized there were differences in quantities on order and what was actually received.

e. The receiving clerk dated and initialed the packing slip and purchase order. Should another person verify the order? Explain.

f. The shipment was not posted. Why or why is this not satisfactory?

g. This order was processed and on the selling floor within 10 days after receipt. Is this effective merchandise management? Explain.

h. The invoice was reconciled, or checked, with the purchase order and freight bill. What document, if any, was forgotten during reconciliation?

i. Thirty days after the shipment was received, the receiving clerk found the vendor's invoice and forwarded it to acccounting. What possible problems were created?

CHAPTER TEST

1. Refer to the purchase on order log in Figure 11.6 (page 254) and compute and fill in the missing information.

Date	PO #	Vendor	Cost	Retail	IMU%	Ship	Cancel	Month $ April	Month $ May	Cancel $	RTV $	Date Can/ RTV
4/1	3206		1.8	4.4		5/1	5/15		4.4			
4/5	3280			5.5	51	5/10	5/20		5.5			
4/10	3310		20		57.4	5/15	5/31					
May	Sub total:											

Figure 11.6. Purchase on Order Log

2. During the month of August, For All Seasons received five orders with the following cost and retail information known. Calculate the IMU% for each order and determine the average MU% for the month.

PO#	Cost	Retail	IMU%
1	4.0	8.3	
2	6.0	11.9	
3	2.3	6.2	
4	1.5	2.0	
5	7.7	13.2	

3. Refer to the purchase journal in Figure 11.7 and compute and fill in the missing information.

4. Refer to the purchase on order log in Figure 11.8 and list what important information is missing for each purchase order logged in.

Department SKi Apparel Class Ladies Month November

Date Rec'd	Vendor Name	Invoice Number	Invoice Date	Invoice Cost	Freight Cost	Total Retail	MU %	PO #	Notes
11/1		20912	10/31	3.4	.5		617	7501	
11/7	.	6429	11/5		—	6.4	51.5	7539	
11/15		4821	11/12	5.5	.7	10.8		7600	
	TOTALS								

Figure 11.7. Purchase Journal

Department Swimwear Class Mens

	Date	PO #	Vendor	Cost	Retail	IMU%	Ship	Cancel	Month $ March	Month $ April	Cancel $	RTV $	Date Can/ RTV
A.	3/1	4230		2.1	3.2	50	3/31		3.2				
B.		4351	Raytex		5.5	52		4/15					
C.	3/15		Sands	5.0	7.5		4/15			7.5			
D.	4/1		Ilse		6.5	54	4/15	4/30		6.5			

Figure 11.8. Purchase on Order Log

Department _Sports Equipment_ Class _Winter_ Month _October_

Date Rec'd	Vendor Name	Invoice Number	Invoice Date	Invoice Cost	Freight Cost	Total Retail	MU %	PO #	Notes
		TOTALS							

Figure 11.9. Purchase Journal

5. During the month of October, For All Seasons accepted the following shipments of merchandise. Use the purchase journal in Figure 11.9 to log in the receipts (refer to Appendix 3, "Rounding Numbers and Financial Notation"), calculate the MU%, and compute the totals.

Shipment 1: Received on 10/1 from Sunvue, invoice #8220 dated 9/30, invoice cost 1.5, retail 2.3, PO#2904, freight cost .2

Shipment 2: Received on 10/7 from Marsh, Inc., invoice #13120 dated 10/4, invoice cost 3.0, retail 4.4, PO# 3092

Shipment 3: Received on 10/15 from Willow Co., invoice #29253 dated 10/12, invoice cost 4.0, retail 6.2, PO#3112

Shipment 4: Received on 10/21 from Peppertree, Inc., invoice #9311 dated 10/19, invoice cost 3.8, retail 5.8, PO#3187, freight cost .4

CHAPTER 12

Inventory Valuation

To effectively manage the inventory investment in merchandise, physical stock counts must be taken on a regular basis. A regular basis is defined in two ways depending on the type of **inventory valuation** method used:

1. The *cost method of inventory valuation*, by which inventory is valued at cost

2. The *retail method of inventory valuation*, by which inventory is valued at retail

Under the cost method, physical inventories must be taken monthly or quarterly to generate financial statements and determine the progress toward achieving gross margin goals. Under the retail method, only semiannual physical stock counts are necessary.

Both methods are based on the movement of goods. Although the majority of retailers work under the retail method, some retailers and the majority of vendors work under the cost method. Table 12.1 compares the cost and retail methods.

THE COST METHOD OF INVENTORY VALUATION

inventory valuation—placing a cost or retail dollar value on stock

cost method of inventory valuation—value of inventory determined in actual cost dollars or market cost value, whichever is lower

"running book" inventory method—a running dollar summary based on every item's value

The **cost method of inventory valuation** is efficient for retailers who create a finished product for resale (restaurants), who carry little or no ending inventory of finished goods for resale (barber shops), and who maintain an inventory that is stocked primarily of supplies necessary to create, process, or convert merchandise into finished products (shoe repair shops). The characteristics of these retail operations necessitate that the direct labor costs incurred be included in the selling price.

Retailers who specialize exclusively in high ticket merchandise (i.e., boats or furs), where unit sales are low and frequently the selling price is negotiable, as well as retailers with limited merchandise assortments (millinery shops) may also use this inventory valuation method. Working on a cost basis is the best method for these businesspeople.

The cost method may be effectively used if:

1. Price tickets are cost coded

2. All markdowns are recorded so that shortages may be pinpointed

3. A **"running book" inventory method** is used in conjunction with the merchandise plan and open-to-buy plan

Financial statement results are represented as a percentage of net sales volume. By tracking markdowns, the retail inventory value will not be overstated when the cost results are converted to retail dollars to complete financial reports. The value of markdowns is included. If an item has been marked down, the merchandise has depreciated in value, and the retailer would no longer purchase the item at the same cost.

Table 12.1 The Cost and Retail Methods of Inventory Valuation

Cost Method	*Retail Method*
1. Inventory is valued at cost dollars.	1. Inventory is valued at retail dollars.
2. All purchases are tracked at cost.	2. All purchases are tracked at both retail and cost dollars.
3. Inventory valuation is based on unit cost records or cost codes on price tickets, after a physical stock count is taken.	3. Inventory valuation is based on perpetual inventory records, a running dollar summary based on every item's value at retail dollars.

Disadvantages	*Disadvantages*
1. The gross margin cannot by calculated until the results of a physical inventory are calculated.	1. Requires a large volume of recordkeeping.
2. Shortage (shrinkage) is not identifiable as a separate expense component.	2. System of averages—does not provide a precise coat.
3. A large time factor is involved in referencing vendor invoices for item costs.	
4. There is no perpetual book inventory with which to compare the results of physical inventory findings.	
5. The value at cost may or may not reflect the true market value due to markdowns and depreciation factors.	

Advantages	*Advantages*
1. Less recordkeeping time is required.	1. It is possible to determine the cost value of inventory at any time.
	2. The status of the gross margin is always known.
	3. Shortage is identifiable as a separate expense. The book inventory can be compared to the physical inventory results.
	4. Financial statements can be drawn up at any time.
	5. Results reflect the true depreciation value of the inventory.
	6. Provides a basis for insurance claims.

EXAMPLE: Sun visors cost $4.00 each with an original retail price of $9.40 each:

Original		**Markdown**	
$9.40	Original Retail	$5.99	R$
−4.00	Cost	−4.00	C$
$5.40	Initial Markup $	$1.99	MU$
57.4%	**IMU%**	**33.2%**	**MU%**

When cost is converted to retail by dividing the cost by the cost complement percent (CC%) of the IMU% (100% − 57.4%), the retail value is overstated by $3.41 ($9.40 − $5.99).

$$\frac{\$4.00 \text{ Cost}}{.426 \text{ IMU\% CC\%}} = \begin{array}{c} \textbf{\$9.40 Original Retail} \\ (9.389) \end{array}$$

By dividing the cost by the cost complement percent of the markup percent (100% − 33.2%), the retail now represents its approximate current market value.

$$\frac{\$4.00 \text{ Cost}}{.668 \text{ MU\% CC\%}} = \begin{array}{c} \textbf{\$5.99 Selling Retail} \\ (5.988) \end{array}$$

EXAMPLE: An item originally cost $5.00 and was priced to sell for $10.00:

Original	Markdown
Original	**Markdown**
$10.00 Original Retail	$6.99 R$
− 5.00 Cost	−5.00 C$
$ 5.00 Initial Markup $	$1.99 MU$
50% IMU%	**28.5% MU%**

When cost for this item is converted to retail by using the IMU% cost complement method, the retail value will be overstated by $3.01 ($10.00 − $6.99).

$$\frac{\$5.00 \text{ Cost}}{.50 \text{ IMU\% CC\%}} = \textbf{\$10.00 Original Retail}$$

When tracking markdowns and therefore, recognizing the depreciation of cost for this item, by using the markup percent cost complement method to convert to retail, the retail now represents its approximate current market value.

$$\frac{\$ 5.00 \text{ Cost}}{.715 \text{ MU\% CC\%}} = \begin{array}{c} \textbf{\$6.99 Selling Retail} \\ (6.993) \end{array}$$

If markdowns have not been taken, retailers must determine the current market value of their stock to avoid overstating the cost value of their inventory and resultant profits. Shopworn and damaged merchandise, out-of-style fashion items, and seasonal items that have been in stock longer than 3 months would no longer "cost" as much in the current market. They have depreciated in value and their cost must be reduced to represent the true approximate cost value.

Retailers will use two methods to obtain the current market value costs:

1. Obtain current wholesale market prices for identical goods
2. Use an aging schedule that sets specific depreciation factors.

Age	Depreciation Factor
0–3 months	–0–
3–6 months	25%
6–9 months	40%

These steps are obviously more time consuming than taking and recording timely markdowns.

Some cost method retailers will take a physical inventory at retail, at original retail* prices, or at current retail prices, and then convert them to cost. The results are as follows:

Original R$ × IMU% CC%

$10.00 Original Retail

× .50 Initial Markup % Cost Complement %

$ 5.00 Cost Overstated Valuation

Current Price × IMU% CC%

$6.99 Current Retail

× .50 Initial Markup % Cost Complement %

$3.50 Cost Approximate Valuation
(3.495)

The second illustration acknowledges the decrease in value and prevents overstating inventory value on the financial reports. If inventories are overstated, the retailer pays higher taxes on his or her profit results.

Note: It must be stated that retail stock counts should always reflect current prices not original; however, manipulation of inventories does occur.

SELF QUIZ

Sweatbands originally cost $2.50 each. The original retail price was $6.00 each. The sweatbands are now priced at $3.99 each.

1. Compute the initial markup dollars (IMU$).

2. Calculate the initial markup percent (IMU%).

3. Find the markup dollar figure (MU$).

4. What is the markup percent (MU%)?

5. Calculate the cost complement percent of the IMU% and convert the cost to retail. Show your computations.

6. Compute the retail, using the MU% cost complement percent method. Show your calculations.

7. Convert the original retail price to cost. Show your calculations.

8. Convert the current retail price to cost. Show your computations.

9. Which retail figure best represents the approximate current market value? Why?

THE RETAIL METHOD OF INVENTORY VALUATION

retail method of inventory valuation—value of inventory determined in retail dollars and converted to cost

opening book inventory—total retail value of complete physical inventory at the beginning of a specified period

The **retail method of inventory valuation** is a "running record" of the daily movement of goods. It allows the retailer to determine the retail value of the stock on hand at frequent intervals without taking regular physical counts. It also ties into the merchandise plan and open-to-buy for successful inventory investment control.

To begin this method, a complete physical inventory must be taken. The total retail value of the physical inventory is used as the **opening book inventory** figure.

After the starting book value is established, accurate records that track the movement of goods must be kept.

These records include the *purchase journal, interstore transfer form, price change form, vendor chargeback,* and *daily sales flash.*

THE PURCHASE JOURNAL

As discussed in Chapter 11, "Purchase Order Management," the **purchase journal** records the inward movement of goods received from suppliers into the store or specific department (Figure 12.1). The illustrated purchase journal reports the weekly receipts by vendor, invoice number, cost, retail, quantity, markup percent, and payment terms.

Dept: 0555 Group: 01

CUMULATIVE UNJOURNALIZED FROM PRIOR WEEKS REPORT

Redi No	Date	Vendor Name	Invoice Number	Inv Cost (If Diff)	Received		Qty Hash	Store Pay Frt. Header Invoice	Mkup Pct	Trms Pct	Disc Amt	Batch No.	Date Jrnlzed
					Cost	Retail							
8638810	02/04	J G	0038810		19.63	39.25	4		45.5	2.0	.39		
W243210	06/06	J G	0519492		2679.00	5358.00	282	12.45	45.3	2.0	53.58		
W252780	06/08	J G	0519959		1211.00	2450.00	140	8.34	45.8	2.0	24.22		
W256540	06/09	J G	0520294		5794.65	11731.50	711	22.00	46.0	2.0	115.73		
				New Shipments This Week									
W264190	06/13	J G	0520580	6993.60	6981.75	14136.00	575	57.40	45.8	2.0	139.87	FM	
W275890	06/17	J G			1976.00	3999.00	218	22.97	44.5				
		TOTAL JOURNALIZED		10903.23		21983.25		78.19	45.6		218.06		
		TOTAL C. M. JOURNALIZED											
		TOTAL UNJOURNALIZED			7770.65	15730.50		TOTAL NO ORDERS = 0			NO ORD PCT = 0.0		

Figure 12.1.

THE INTERSTORE TRANSFER FORM

interstore transfer form–records inward and outward movement of merchandise between departments or other branch stores

The **interstore transfer form** tracks merchandise as it moves into another department or store. As shown in Figure 12.2, the interstore transfer form lists merchandise by department, class, item number, description, unit and total cost, and unit retail and total retail.

THE PRICE CHANGE FORM

price change form–records all increases and decreases of retail prices

The **price change form** records all increases and decreases of the original retail prices. The price change form and employee discount log are illustrated in Chapter 6, "Price Adjustments" (Figures 6.4 and 6.5, pages 138 and 139).

THE VENDOR CHARGEBACK

vendor chargeback–return to vendor form to document outward movement of merchandise

The **vendor chargeback** is a return to vendors form to document the outward movement of vendor merchandise (Figure 12.3, page 264). The returned merchandise invoice not only includes style, quantity, description, and cost and retail prices, but also notes who pays freight and the reason for the return.

THE DAILY SALES FLASH

daily sales flash–recaps daily sales and reconciles cash register readings

daily sales report–form that records and provides all necessary information for the calculation of daily net sales volume

The **daily sales flash** recaps daily sales and reconciles the cash register readings. The **daily sales report**, shown in Figure 12.4 (page 265), includes all necessary information to compute net sales volume.

INTERSTORE TRANSFER

Date _____

FROM: STORE NO. _____ STORE INITIALS _____ **TO:** STORE NO. _____ STORE INITIALS _____

DEPT.	LINE NO.	CLASS	ITEM NUMBER	DESCRIPTION	UNIT COST	UNIT RETAIL	QUANTITY	TOTAL COST	TOTAL RETAIL
	1								
	2								
	3								
	4								
	5								
	6								
	7								
	8								
	9								

MDSE. CHECKED IN BY _____ DATE _____

DISCREPANCIES, IF ANY, VERIFIED BY _____ DATE _____

EMPLOYEE NO. _____ EMPLOYEE NAME _____

MDSE. TRANSFERRED BY

ORIGINAL AUDIT COPY

ENTER MERCHANDISE FOR ONLY ONE DEPARTMENT ON A PAGE. ALL MERCHANDISE GOING FROM OR TO ANY STORE MUST BE RECORDED BY THE STORE'S TRANSFER ROOM.

TOTALS

NO. 287956-7

Figure 12.2.

The records will detail increases and decreases to the opening book inventory.

Opening Book Inventory

Plus:	**Minus:**
Increases to Inventory	Decreases to Inventory
Purchases	Gross sales
Transfers in	Transfers out
Customer returns	Returns to vendors
Vendor allowances	Markdowns
Price increases	Additional markup cancellations
Total Increase	**Total Decrease**

Equals: **Ending Book Inventory**

ending book inventory—opening book inventory plus purchases, transfers in, customer returns, vendor allowances, price increases minus gross sales, transfers out, returns to vendors, markdowns, and additional markup cancellations; in other words, opening book inventory plus increases to inventory minus decreases to inventory for a specific period of time

EXAMPLE:

Step 1: Calculate total increase of inventory and total decrease of inventory for a specific period.

Opening Retail Book Inventory (Feb. 1)	$25,000
Retail Purchases (Feb. 1–July 30)	35,000
Customer Returns	5,000
Total Increase of Inventory	**$65,000**

RETURNED MERCHANDISE INVOICE

DEPT. NO.	INVOICE NO.		DEPT. NO. OR EXPENSE ACCT. NO.
	160488		

DATE		3 DIGIT	VENDOR NO.	5 DIGIT
/ /				

SHIPPED BY

- ☐ PARCEL POST
- ☐ FREIGHT
- ☐ U.P.S.
- ☐ PICK-UP
- ☐

SHIP

- ☐ COLLECT
- ☐ PREPAID — CHARGE
- ☐ PREPAID — NO CHARGE

IF MERCHANDISE IS BEING RETURNED FOR CREDIT BY SELLING DEPT., FILL IN BELOW. PAYMENT FOR THIS RETURN WILL COME FROM—

- ☐ HELD PAYMENT
- ☐ PURCHASE ORDER IN MAIL
- ☐ ORDER TO BE PLACED

ON _____
- ☐ VENDOR WILL SEND CHECK

TO: _____

WEIGHT	AUTH'D.
NO. CARTONS	

PLEASE SHOW OUR DEPT. NO. AND INVOICE NO. ON ANY CORRESPONDENCE CONCERNING THIS RETURN

STYLE	QUANTITY	DESCRIPTION	UNIT COST PCS.	DOZ.	TOTAL MDSE. COST	UNIT RETAIL	TOTAL RETAIL

TOTAL MDSE. COST		OUTGOING TRANSP.
TRANSPORTATION IN OUT		
HANDLING CHARGE		TOTAL RETAIL
TOTAL COST		

DEPT. NO.	

WE ARE RETURNING THE MERCHANDIE LISTED ABOVE FOR:

☐ **CREDIT** ☐ **EXCHANGE** ☐ **REPAIR** ☐ **CLEANING**

REASON FOR RETURN

☐ SHIPPED PAST CANCELLATION ☐ OVERSHIPPED ☐ NO ORDER ☐ DUPLICATE SHIPMENT

OTHER _____

(BUYER OR DEPT. MGR.)

IF ADDITIONAL SPACE FOR REASON FOR RETURN IS NEEDED, USE SEPARATE SHEET OF PAPER AND ATTACH TO ACCOUNTS PAYABLE (2nd) COPY.

VENDOR COPY

Figure 12.3.

Gross Sales	30,000
Returns to Vendors	10,000
Markdowns	6,000
Total Decrease of Inventory	**$46,000**

DAILY SALES REPORT

Figure 12.4.

RETURNED ITEMS & PETTY CASH
ACCOUNTABILITY

NAME (Last Name, First Initial)	DATE	REASON	AMOUNT	COMMENTS
TERRY, S	9/2/76	NSF	5.75	CALLED REPEATEDLY, NA

PETTY CASH

CASH COUNT			VOUCHERS	
DENOMINATION	**AMOUNT**		**W/E DATE**	**AMOUNT**
PENNIES	.58		4/29	32.27
NICKELS	12.05		9/9	52.53
DIMES	6.00		9/23	33.25
QUARTERS	15.00		9/30	11.32
HALVES			TOTAL VOUCHERS	129.37
DOLLARS				
TOTAL COIN*	33.63		*TOTAL COIN	33.63
			*TOTAL CURR.	87.00
ONES	52.00		REG. FUND	50.00
FIVES	15.00			
TENS			TOTAL	300.00
TWENTIES	20.00			
FIFTIES			AMT. CHG'D	300.00
HUNDREDS				
TOTAL CURRENCY*	87.00		DIFFERENCE	Ø

INSTRUCTIONS FOR DAILY SALES REPORT

LINE NO.	INSTRUCTIONS	SUPPORT ATTACHED	LINE NO.	INSTRUCTIONS	SUPPORT ATTACHED
1	Today's Closing Sales Reading for Reg. No. 1	Reading Tape	32	Register No. 1 Difference (Line 30 — 31)	
2	Yesterday's Closing Sales Reading for Reg. No. 1		33	Today's Closing Tax Reading for Reg. No. 2	
3	Register No. 1 Difference (Line 1 — Line 2)		34	Yesterday's Closing Tax Reading for Reg. No. 2	
4	Today's Closing Sales Reading for Register No. 2	Reading Tape	35	Reg. No. 2 Difference (Line 33 — 34)	
5	Yesterday's Closing Sales Reading for Reg. No. 2		36	Total Difference (Line 32 + 35)	
6	Register No. 2 Difference		37	Tax on Voids & Refunds (Line 8 + 9 x Tax Rate)	
7	Total Difference (Line 3 + Line 6)		38	Net Tax (Line 36 — 37)	
8	Amount of Voids Transacted	Form 2807	39	Net Sales (Line 10 — 38)	
9	Amount of Refunds Given (Cash or Chg Credit)	Form 2807	40	Tax Exempt Sales (Amt of Sales Not Taxed)	
10	Gross Sales (Line 7 — Line 8 — Line 9)		43-50	Items Ret'd (Detail of Lines 12 thru 15)	
11	Returned Items on Hand Beginning Today		43-50	Items Re-dep'td (Detail of Lines 21-24)	
12	Amount of Bad Checks Received Today		Proof	Line 2 must agree to Line 1 of Yesterday's Report	
13-15	Amount of Bad Chgs Rec'd Today (By Chg Plan)			Line 5 must agree to Line 4 of Yesterday's Report	
16	Accountability (Total of Lines 10 thru 15)			Line 11 must agree to Line 26 of Yesterday's Report	
17	Amount of Cash Deposited	Vldtd Dep Slips		Line 31 must agree to Line 30 of Yesterday's Report	
18-20	Amount of Bad Chgs Rec'd Today (By Chg Plan)	Vldtd Dep Slips		Line 34 must agree to Line 33 of Yesterday's Report	
21-23	Amount of Bad Chgs Redep'td (By Chg Plan)	Vldtd Dep Slips		MINUS Bad Cks & Chgs Rec'd (Lines 12-15)	
24	Amount of Bad Checks Redeposited	Vldtd Dep Slips		PLUS Deposits (Lines 17-24)	
25	Amount of Ret'd Items Sent to Conley Off (Auth'd)	Authorization		PLUS Total Cash Short (Line 28)	
26	Items Retained (Lines 11-15 minus Lines 18-24)			MINUS Total Cash Over (Line 29)	
27	Accounted For (Total of Lines 17 thru 26)			MINUS Total Net Tax (Line 38)	
28	Cash Short (Amt if Line 16 is Greater Than Line 27)			MINUS Total Net Sales (Line 39)	
29	Cash Over (Amt if Line 16 is Less Than Line 27)			PLUS Items Ret'd (Lines 43-50)	
30	Today's Closing Tax Reading For Reg. No. 1	Reading Tape		MINUS Items Re-dep'td (Lines 43-50)	
31	Yesterday's Closing Tax Reading for Reg. No. 1				

Figure 12.4. (continued)

Step 2: Calculate the ending book inventory.

Total Inward Merchandise	$65,000
–Total Outward Merchandise	–46,000
Book Inventory	**$19,000**

physical inventory–manual counting of all stock on hand

The February 1 **physical inventory** totaled $25,000 in retail dollars; therefore, the book inventory for February 1 was $25,000. From February 1 through July 30, $40,000 in goods moved into stock, and $46,000 in goods moved out of stock. The ending book inventory result is $19,000.

July 30 was the end of the store's accounting period, so another physical inventory was taken. The results were $18,500, a $500 difference between the ending book inventory and the physical inventory totals. The discrepancy between the dollar value of the book stock and the actual stock value is **inventory shortage** (also referred to as **shrinkage**) if the book inventory is larger, and **inventory overage** if the physical inventory is larger. In this example, the book inventory was greater than the physical inventory, so a $500 shortage occurred. The book inventory is then adjusted to reflect the actual inventory figure ($19,000 × $500 = $18,500). $18,500 becomes the opening book inventory figure for August 1.

inventory shortage–discrepancy between dollar value of book stock and actual stock value when book inventory is greater figure; also known as *shrinkage*

inventory overage–discrepancy between dollar value of book stock and actual stock value when physical inventory is greater figure

Shortages and overages are unavoidable. If the book and physical inventory results match perfectly, the retailer should be alerted that an internal manipulation of prices and inventory is occurring. Small differences are acceptable, but if they exceed 2.0% stringent paperwork controls must be undertaken. Both shortages and overages indicate operational problems. The major reasons for shortages are incorrect recordkeeping, inaccurate physical inventory counts, and theft, both internal and external. Overages are caused by poor recordkeeping.

Formulas for Calculating Shortage

Dollars:

Physical Inventory	$18,500
–Book Inventory	–19,000
Shortage Dollars	**($500) Shortage $**

Percent:

$$\frac{\text{Shortage Dollars}}{\text{Net Sales Volume}} \quad \frac{\$\ \ 500}{\$25,000} \quad = \quad \textbf{2.00 Shortage \%}$$

Reminder: Net sales volume = gross sales–customer returns and allowances

SELF QUIZ

1. Given the following figures, calculate the book inventory.

Opening Inventory	$300,000
Purchases	120,000
Gross sales	90,000
Markdowns	5,000
Customer returns	3,000
Transfers out	4,000

2. On August 1, For All Seasons' physical inventory results totaled $643,000. From August 1 through January 31, net sales volume was $1,330,000 and purchases were $1,649,400. Returns to vendors totaled $90,000 and $272,400 was spent in markdowns.

 a. What was the book inventory on February 1?

 b. The January 31 physical inventory result was $580,000. Was there an overage or shortage? In what dollar amount? If there was a shortage, calculate the shortage percent. If there was an overage, explain what causes an overage.

CLOSING COST INVENTORY

cost multiplier method–percentage value of cost price when retail price is valued at 100%; indicates the average relationship of cost to retail value of goods handled in an accounting period

cumulative markup percent cost complement percent–percent difference between retail, valued at 100%, and the cumulative markup percent

cumulative markup–dollar or percent difference between total cost and total retail value of all merchandise handled for a specific period of time

To complete financial statements, the cost of goods sold must be determined for a specific period of time. Under the retail method of inventory valuation, cost is arrived at by determining the average relationship between the retail and cost value of all merchandise available for sale.

All inward and outward merchandise is valued at both cost and retail. This permits the use of an averaging process, either by using the **cost multiplier method** or by computing the **cumulative markup percent cost complement percent**. The cost multiplier method may be easier to calculate; however, cumulative markup provides both dollar and percent figures to compare results to merchandising budgets, past performance records, and similiar operations. A review of cumulative markup is necessary before computing its cost complement.

CUMULATIVE MARKUP

Cumulative markup is the dollar or percent difference between the total cost and the total retail value of all merchandise handled for a specific period of time, including the inventory at the beginning of the period. It reflects the markup on the opening inventory and the markup of every month's receipts within the specified accounting period.

Formula for Calculating Cumulative Markup

Step 1: Determine the total cost and retail value of merchandise available for sale for a specific period of time.

	COST	RETAIL
Opening Inventory	$ 30,000	$ 45,000
Plus:		
Purchases	+ 90,000	+130,000
Transfers In	+ 5,000	+ 8,000
Additional Markups		+ 1,000

Less:

Returns to Vendors	– 8,000	– 11,000
Transfers Out	– 3,000	– 5,000
Additional Markup Cancellations		– 3,000
Total Cumulative Value	**$114,000**	**$165,000**

Note: Additional markups increase the retail value of the total merchandise handled without increasing the cost value. Additional markup cancellations decrease the retail value of the total merchandise handled without increasing the cost value.

Step 2: Find the cumulative markup dollars.

$ Total Cumulative Retail Value	$ 165,000
–Total Cumulative Cost Value	– 114,000
$ Cumulative Markup	**$ 67,000 CUM MU$**

Step 3: Calculate the cumulative markup percent (CUM MU%).

$$\frac{\$ \text{ Cumulative Markup}}{\$ \text{ Cumulative Retail}} = \frac{\$\ 51,000}{\$165,000} = \begin{array}{l} \textbf{31\% CUM MU\%} \\ (.309) \end{array}$$

SELF QUIZ

The beginning inventory on February 1 was $20,000 at cost, $30,000 at retail. Receipts for February, March, and April cost $10,000 and retailed for $19,000. Answer the questions below.

1. What is the cumulative cost value of merchandise handled? What is the cumulative retail value?

2. Calculate the cumulative markup dollar figure.

3. Compute the cumulative markup percent.

The cumulative markup percent is an historical figure; using the retail method it may be computed at any time. It provides a gauge to monitor the achievement of planned initial markup goals. If the cumulative markup percent is 33%, and the

initial markup percent plan is 40%, then obviously profit goals are not obtainable and immediate changes must occur.

CUMULATIVE MARKUP PERCENT COST COMPLEMENT PERCENT

The cumulative markup percent cost complement percent shows the average relationship of the cost value of goods handled to the retail value of goods handled for a specific accounting period.

Formula for Calculating Cumulative Markup Percent Cost Complement Percent

Continuing with the same figures illustrated in the cumulative markup segment, cost + markup = retail; therefore, the cost complement percent is:

100.00%	100%
– CUM MU%	– 31%
CUM MU% CC%	**69% CUM MU% CC%**

CLOSING COST INVENTORY

Now that the average relationship between the cost and retail value of total goods handled has been established, the closing cost inventory figure can be calculated.

closing cost inventory—under retail method of inventory, is computed by multiplying closing retail inventory figure by cumulative markup cost complement percent

Formula for Calculating Closing Cost Inventory

$Closing Retail Inventory	$165,000
×Cumulative Markup CC%	× .69
$Closing Cost Inventory	**$113,850 Closing C$**

SELF QUIZ

Use the information below to complete each question. Show your computations.

	COST	RETAIL
Opening inventory	$25,000	$40,000
May purchases	6,000	9,000
June purchases	5,000	7,000
July purchases	8,000	11,000
Total Cumulative Value	**$**	**$**

1. Determine the total cost and total retail value of merchandise available for sale.

2. Compute the cumulative markup percent.

3. What is the cumulative markup percent cost complement percent?

4. Calculate the closing cost inventory figure. Show your computations.

RETAIL VERSUS COST INVENTORY VALUATION

Unless the retailer stocks a limited amount of items, has direct labor costs, or specializes in "negotiable" price merchandise, the retail method of inventory valuation is far superior to the cost method for the following reasons:

1. Retailers sell items for "retail" prices

2. All financial components represent a percentage of "retail" sales

3. Merchandise plans and open-to-buys require "retail" figures

4. "Retail" physical inventories reduce costs when only "retail" prices need to be computed

CHAPTER REVIEW

1. For All Seasons is a specialty sports apparel and equipment retailer. Which inventory valuation method would you recommend? Why?

2. Each inventory valuation method has advantages and disadvantages. List the advantages and disadvantages of the method you recommended for For All Seasons.

3. A represents the cost method of inventory valuation.

B represents the retail method of inventory valuation.

Select the most appropriate inventory valuation method for each of the following retail operations and write in either A or B on the lines provided. Briefly explain your reason for each decision on the right-hand side of the page.

_____Video shop

_____Dress boutique

_____Dry cleaner

_____Bakery

_____Toy store

_____Beauty salon

_____Piano store

_____Bookstore

_____Manicure salon

_____Antique store

4. What is the first step in beginning an inventory valuation method?

5. There are five records required to maintain the retail method of inventory valuation after the starting book value is established.

 a. List and define them.

 b. Which record is not necessary for a single store retailer who stocks only tee shirts?

6. Sweatshirts at For All Seasons originally retailed at $16.40 each and are now priced at $10.99 each. Which retail price would you report during a physical inventory? Why?

7. For All Seasons creates an in-store coffee bar for purchases such as cappuccino and expresso. Which inventory valuation method would you select and why?

8. List the three steps that can make the cost method more effective to use and explain your reasons.

9. If markdowns are not recorded, how do retailers determine the current market cost value of their stock?

10. What occurs when inventory value is overstated on financial reports?

11. The opening book inventory figure changes during a specific period of time, resulting in an ending book inventory figure. Describe the factors that cause these changes.

12. Define the terms and explain the causes of inventory shortage and inventory overage.

13. What is the definition of cumulative markup?

14. Explain how the closing cost inventory is determined under the retail method of inventory valuation.

15. Define cumulative markup percent cost complement percent and explain the advantages of using this formula versus the cost multiplier method.

1. Mink ear muffs at For All Seasons cost $24.00. The initial markup is $36.00. The markup percent (MU%) is 40%.

 a. Compute the original retail price.

 b. Calculate the initial markup percent (IMU%).

 c. Convert the cost of the mink ear muffs to retail using the IMU% cost complement method. Show your calculations.

 d. What is the current retail price (round down to .99 price point ending)?

 e. Compute the current approximate market cost value of the mink ear muffs.

2. The physical inventory was taken at retail. Convert the merchandise to individual and total cost price figures.

 a. 10 pairs of leggings

 Original retail: $18.00 each
 IMU%: 50%

 b. 22 pairs of tights

 Original retail: $10.00 each
 IMU%: 60%

 c. 50 pairs of sweat socks

 Retail: $2.99 each
 MU%: 42%

3. Leotards originally retailed for $25.00 each and cost $10.00 each. Currently, they are retailing for $16.99 each.

 a. Calculate the initial markup percent (IMU%).

 b. Compute the markup percent (MU%).

 c. Find the approximate cost valuation of the leotards.

4. Given the following figures, calculate the book inventory figure.

Opening Book Inventory		$300,000
Gross sales	175,000	
Purchases	168,000	
Markdowns	10,575	
Returns to vendors	18,225	
Price increases	2,100	
Vendor allowances	12,500	

5. The October 1 physical inventory totaled $40,000 in retail dollars. Use the information provided and calculate the ending book inventory for October 31.

Purchases	$10,000
Markdowns	1,000
Transfers out	2,000
Customer returns	100
Gross sales	22,500

6. In retail dollars, the physical inventory results totaled $65,000 and the book inventory, $72,000.

 a. Calculate the dollar difference. Does it represent an inventory shortage or overage?

b. Net sales volume was $143,000. If there was a shortage, compute the shortage percent. If there was an overage, explain the causes of overages.

c. What is the new opening book inventory figure?

7. The ending retail inventory totaled $135,000 and the cumulative markup percent is 38.7%.

 a. Compute the cumulative markup percent cost complement percent.

 b. Determine the closing cost inventory.

8. Calculate the closing cost inventory based on the following quarterly data.

	COST	RETAIL
Opening book inventory	$ 50,000	$ 90,000
Purchases	180,000	340,000
Returns to vendors	5,000	9,000
Customer returns	1,000	3,000
Vendor allowances	500	1,000
Additional markups		500
Additional markup cancellations		600

Calculations:

Closing Cost Inventory: $ _____

9. Find the closing book inventory using the information provided.

Physical inventory	$ 90,000
Shortage	2,000
Gross sales	270,000
Customer returns	5,500
Markdowns	16,500
Purchases	265,000

Calculations:

Closing Book Inventory: $ _____

Inventory Reconciliation

Month **July** Department **Accessories**

		A COST $	B RETAIL $
1. Beginning Inventory		60.0	1000
2. Purchases (Freight Included)	+	80.0	133.3
3. Transfers In, Out	+(−)	1.8	3.0
4. Additional Markups	+	—	—
5. Markdowns	−	—	4.0
6. Merchandise Available (Total Items 1–5)	=		
7. Cost of Goods % (6A÷6B)		_____	
8. Cumulative Markup % (100%−7)		_____	
9. Gross Sales (9B from Daily Sales Summary, 9A = 9B × 7)			40.0
10. Ending Book Inventory (6−9)			
11. Physical Inventory			180.0
12. Overage/Shortage (11−10)			
13. Net Sales (9B−5B)			$_____
14. Gross Margin Dollars (13−9A)			$_____
15. Gross Margin Percent (14÷13)			_____ %

Figure 12.5.

10. At a merchandising seminar, inventory valuation methods are discussed. Everyone attending has been assigned to complete two inventory reconciliations for the month of July, using both the cost and retail methods of inventory valuation. Some figures are provided on Figures 12.5 and 12.6 to determine July's ending book inventory. The remaining figures must be computed.

a. Using the retail method of inventory valuation, complete the reconciliation form, Figure 12.5.

b. Figure 12.6 represents the cost method of inventory valuation. Note that the physical inventory was taken in retail dollars. Complete the reconciliation form.

c. Analyze and describe the results of both methods. What are the advantages and disadvantages of each method?

Inventory Reconciliation		
Month _July_	Department _Accessories_	
	A COST $	B RETAIL $
1. Beginning Inventory	60.0	100.0
2. Purchases + (Freight Included)	80.0	133.0
3. Transfers In, Out +(−)	1.8	3.0
4. Additional Markups +	—	—
5. Markdowns −	—	—
6. Merchandise Available = (Total Items 1–5)		
7. Cost of Goods % (6A÷6B)		
8. Cumulative Markup % (100%−7)		
9. Gross Sales (9B from Daily Sales Summary, 9A = 9B × 7)		40.0
10. Ending Book Inventory (6−9)		
11. Physical Inventory	109.8	
12. Overage/Shortage (11−10)		
13. Net Sales (9B−5B)	$	
14. Gross Margin Dollars (13−9A)	$	
15. Gross Margin Percent (14÷13)	%	

Figure 12.6.

SALES PROMOTION

CHAPTER 13

Sales Promotion

The primary purpose of **sales promotion** is to please customers while increasing market share, sales, and profits. The goals of sales promotions are to:

1. Invite customers into the store

2. Encourage customers to shop

3. Persuade customers with perceived "values"

4. Stimulate customers to buy now

All promotional activities are designed to sell more merchandise. The successful retailer realizes that to accomplish this goal, all promotions must be planned in advance. Therefore, sales promotions exclude last minute cash flow generating sales and old merchandise clearance sales.

ADVANCE PLANNING

sales promotion—all events and devices designed to please customers while increasing market share, sales, and profits

6-month sales and promotional plan—a summary of the previous 2 year's seasons sales, competitive activities, and an outline of the new season's initial planned sales and promotional events to aid in the achievement of the season's merchandise plan

institutional promotions—events aimed at building the store's image over a continuing period of time by promoting the advantages of a store in relation to its competition

merchandise promotions—events designed to immediately build store traffic and increase sales

Winning promotions evolve from two questions:

"How can I reward my customers and make them feel good about shopping here and now?"

"What are the store's goals and how will the store image be reinforced?"

An initial **6-month sales and promotional plan** is developed in conjunction with the seasonal merchandise plan. This plan summarizes the previous 2 years' seasons' sales and competitive activities and outlines the new season's sales and promotional events.

To complete a 6-month sales and promotional plan, the retailer first gathers and posts the previous 2 years' sales histories and the planned season's sales figures. Second, the retailer compiles the previous 2 years' promotional event histories and competitive shopping reports and analyzes the results. How successful were the **institutional promotions**, events aimed at building the store's image over a continuing period of time by promoting the advantages of the store in relation to the competition? Did **merchandise promotions**, whose purpose is to immediately build store traffic and sales, meet or exceed sales projections? Did the competition influence the previous events positively or negatively and why? Were the proper quantities ordered or was too much or too little ordered? Was the selected advertising vehicle effective or ineffective? How can previous events be improved or should they be eliminated? The retailer selects the events that should be repeated and adds new events to support the monthly planned sales on the season's merchandise plan.

The retailer has then completed the upcoming season's initial 6-month sales and promotional plans, which aids in the achievement of the season's planned merchandise plan. Figure 13.1 illustrates the initial For All Seasons 6-month sales and promotional plan for the fall season.

Advance planning helps produce successful events and involves many considerations on the part of the retailer.

FOR ALL SEASONS

SIX-MONTH SALES AND PROMOTIONAL PLAN
SPRING
PROMOTIONAL PLUSES AND MINUSES

	LY	PL	ACT
sales $	1330.0	1410.6	
% change	7.6%	6.1%	

WEEKS		COMPETITION	FOR ALL SEASONS	PLAN	* 2 YRS	* LY $	* TY PLAN	ACTUAL
1	1	PRO SPECIALS	MATCH SET	TENNIS PRO APPEARANCES	54.0	56.0	64.0	
	2				43.5	45.0	46.5	
	3	FALL VALUES	MOUNTAIN CLASSICS	IN-STORE MODELING	43.5	45.0	47.0	
	4		BOOT EXPRESSO	SPECIALIZED FIT BY	49.0	54.0	54.5	
				4 VENDORS, 30% OFF				
				PRINT ADVERTISING				

Comments: Grand opening of new sports apparel & equipment store; approximate opening date: 3rd week increasing in-store activity to maintain sales volume.

				AUG. **TOTAL MONTH 1**	190.0	200.0	212.0	
2	1	BOOT SALE	FISHING SPECIALTIES	FISHING GAME PROMOTION	38.0	42.0	50.0	
	2				29.5	31.0	32.0	
	3	TENNIS CLEARANCE	MOUNTAIN TRAVELERS	FREQUENT SHOPPER'S	34.5	36.0	42.0	
	4			ADVANCE SALE NOTICE -	33.0	36.0	36.5	
	5			PROMOTIONAL PRICING ON	32.0	35.0	37.5	
				SPORTS EQUIPMENT				

Comments: SALT TROUT IS PROVIDING REGISTER-TO-WIN 1 WEEK FISHING TRIP FOR TWO

				SEPT. **TOTAL MONTH 2**	167.0	180.0	198.0	
3	1		100th ANNIVERSARY	STOREWIDE EVENT	41.0	43.0	50.0	
	2	HIKING SALE		CONCENTRATED IN-STORE	47.5	49.0	58.0	
	3			EVENTS SUPPORTED	46.0	47.0	58.0	
	4			BY PRINT ADS, SIGNAGE,	58.5	61.0	64.0	
				FLYERS TO ALL RESORTS				

Comments: VENDOR SUPPORT COMMITTMENTS TO DATE INCLUDE CO-OP AD DOLLARS, IN-STORE APPEARANCES, GWP'S, PWP'S, REGISTER-TO-WIN SHOPPING SPREES & TRIPS, EMPLOYEE INCENTIVES

				OCT. **TOTAL MONTH 3**	193.0	200.0	230.0	
4	1		WEATHERING HEIGHTS	30% OFF WEATHER	47.0	50.5	52.5	
	2			PROTECTION GEAR	50.0	54.0	57.0	
	3			↓	53.0	56.5	59.3	
	4	TURKEY VALUES	APPRECIATION DAYS	COMMUNITY SUPPORT - 10%	55.0	59.0	60.0	
				OF PROFITS TO BE DONATED				
				TO ENVIRONMENTAL GROUPS				

Comments: WEATHERING HEIGHTS - NEW PROMOTION - VENDORS SUPPORTING WITH EXCLUSIVE GWP & IN-STORE SUPPORT

				NOV. **TOTAL MONTH 4**	205.0	220.0	228.8	
5	1	GIFTS FOR $10	WONDERLAND GIFTS	CHRISTMAS CATALOG	42.0	44.0	46.0	
	2			* WILL INCREASE IN-	44.5	47.0	49.0	
	3			STORE EVENTS & WILL	45.5	50.5	54.0	
	4		AFFORDABLE LUXURIES	CONCENTRATE NOT ONLY ON	57.0	63.5	65.0	
	5			TOURISTS BUT LOCALS	47.0	55.0	55.1	
				THIS YEAR				

Comments: GRAND OPENING OF NEW SKI RESORT SCHEDULED FOR DEC. 1ST - WILL PROVIDE CHRISTMAS CATALOGS AT CHECK-IN.

				DEC. **TOTAL MONTH 5**	236.0	260.0	269.1	
6	1	WINTER SPECIALS	WINTER FESTIVAL	ICE SCULPTURE DEMO	70.0	77.0	77.5	
	2			1 DAY SKI CLINIC - NO CHARGE	61.0	67.0	68.5	
	3		SLOPE ENTERTAINMENT	TO PREFERRED CUSTOMERS	64.0	70.5	70.7	
	4			$5 SKI LIFT COUPONS	50.0	55.5	56.0	
				GIVEN WITH EACH $50+				
				PURCHASE				

Comments:

				JAN. **TOTAL MONTH 6**	245.0	270.0	272.7	
				TOTAL SEASON	1236.0	1330.0	1410.6	

COMMENTS: To achieve this season's planned sales volume during economic downturn emphasis is on building in-store events (celebrity appearances, unique GWP's & PWP's), increasing vendor co-op contributions, providing more employee incentives from vendors, establishing greater community goodwill through 10% donation for the area environmental groups - 100th Anniversary will reinforce store's image of quality European styled sports apparel, specialized sports equipment and its training programs.

Figure 13.1.

These considerations include:

- Creation of an "umbrella" theme
- Selection of merchandise
- Scheduled proper timing
- Determination of order quantities
- Establishment of the pricing strategy
- Selection of promotional additives

"UMBRELLA" THEMES

"umbrella" theme–unified sales promotion program tailored to the specific needs of a store and its merchandising situation

The first decision by the retailer must be to determine the **"umbrella" theme** that will incorporate a well-coordinated group of merchandise and present a unified department or total store promotion. The retailer may consider:

- A major merchandise classification
- A total store promotion
- An anniversary event
- A seasonal offering

Suggested "umbrella" themes include:

National Events	*National Themes*
Valentine's Day	Sweetheart Specials
Easter	Basket Goodies
Mother's Day	"Spoilers"
Memorial Day	Memories
Father's Day	Lawn Chair Values
Fourth of July	Firecracker Savings
Halloween	Children's Treats
Thanksgiving	Appreciation Days
Christmas	Wonderland Gifts

Seasonal Themes	*Special Event Themes*
Spring Specials	100th Anniversary
Dive into Summer	Sporting Events
Fall Harvest of Values	Local Events
Winter Warmth	Tourist Attractions

Clientele-Oriented Themes	
Affordable Luxuries	Preferred Customers
Slope Entertainments	Toys for All Ages
Fashion First	European Moments
Match Set	All Pro

During the month of October, For All Seasons will be celebrating its 100th Anniversary. Therefore, the "umbrella" theme is the 100th Anniversary Celebration and the entire store will participate.

MERCHANDISE SELECTION

The second consideration on the part of the retailer when preparing a promotional event is to ensure that, before purchases are made, the merchandise selected for each promotion meets various criteria.

1. Does the merchandise have universal appeal for the existing customer base?

2. Will the merchandise entice potential new customers?

3. What merchandise will have the greatest impact when part of a special promotion?

For All Seasons will select merchandise within each department that emphasizes its merchandise strengths—quality European-styled sports apparel and specialized sports equipment.

TIMING

After the "umbrella" theme and coordinate merchandise have been determined, the third consideration in preplanning a promotional event is: "What is the ideal timing for this promotion?" This is qualified by:

1. Reviewing past sales records and promotional calendars.

2. Examining the sales timetable for each item.

3. Considering basic market factors. What is the outlook of the local economy? What possible changes among the targeted customer group may affect this promotion?

4. Reviewing previous competitive shopping reports. What is the competition's promotional sales timetable? Is it possible to run the promotion when the competition's merchandise is still at its original prices?

Each October, For All Seasons has held an anniversary event. However, they recognize that their 100th birthday can be a major special event to reinforce the store's image when preplanned properly. Each buyer must review past sales records and competitive shopping reports to present for management's review the merchandise choices for the 100th Anniversary Celebration.

QUANTITY

promotional order—merchandise ordered to specifically cover the needs of a planned promotion

Fourth, in preplanning the promotional event, the retailer must determine the promotional order quantity for each item from unit stock control records to establish objectives for the upcoming vendor meetings. A **promotional order** differs from basic stock orders because the merchandise is being ordered to cover the specific needs of a planned promotion. The basic guideline for predetermining promotional ordering quantities is to add the previous 3 month's nonpromotional sales figures. From this sum the current number of pieces that are on order and on hand are subtracted to arrive at the promotional order quantity.

Formula for Calculating Promotional Orders

3 Month's Nonpromotional Sales Total

Less: Current on Order

Less: Current on Hand

Promotional Order Quantity

EXAMPLE:

Black unitard's current 3 month's nonpromotional sales figure totals 150 pieces. The current on order is 36 pieces and 42 unitards are currently in stock.

	150	3 Month's Nonpromotional Sales Total
Less:	36	Current on Order
Less:	42	Current on Hand
	72	**Promotional Order Quantity**

The promotional order quantity for black unitards is 72 pieces.

In planning promotional quantities, the retailer must recognize that buying is not an exact science and that judgments play an important role in determining the order quantities for promotional merchandise purchases. The promotional ordering formula is a guideline for determining promotional order quantities. After an order amount is computed, the retailer reviews each product's sales timetable and analyzes previous promotional sales records of identical and similar items before determining the final order quantity. Unfortunately, there are no guarantees that customers will respond to well-planned promotions as projected. However, these additional considerations will ensure the retailer has planned properly.

SELF QUIZ

1. For the upcoming October For All Seasons 100th Anniversary Celebration the order quantities for basic stock items must be determined. Given the following information, calculate the order quantity for each item and show your computations.

Item	3 Month's Nonpromotional Sales Totals	On Order	On Hand
A. Bridle leather money belt	65	24	20
B. Featherweight jacket	377	84	60
C. Logo tee shirt	520	180	160
D. Unisex canvas shirt	432	96	144
E. Wet/dry gear bag	75	18	30

Order quantity A:

Order quantity B:

Order quantity C:

Order quantity D:

Order quantity E:

2. During the previous 3 months, 182 snap-top water bottles were sold at their original retail price of $12.00. Currently, 24 bottles are on order and 18 are on hand.

 a. Compute the promotional order quantity.

 b. Water bottles are carried year-round, but their inventory level is reduced from 120 pieces to 60 pieces beginning in September as the demand drops with the onset of colder weather. Examine the order quantity computed in A and decide if water bottles should be included in the October 100th Anniversary event. If so, determine the promotional ordering quantity. If not, support your decision.

PRICING

Fifth, the price at which the items will be promoted must be determined by the retailer before each promotional event. Should items be promoted at regular or sale prices? Many retailers assume that a sales promotion may only be successful at sale prices. This is not true. A well-coordinated and timed event before the peak selling period of originally priced items can be successful if it includes the following components:

1. Basic stock and best sellers—the items that the customers always want or those with the highest demand curve

2. An established loss leader—an everyday value item

3. An emphasis on unique merchandise—those items that make the store "stand above the competition"

4. Sales promotion value additives that are purchase enhancers, such as free gifts with a purchase or personal appearances of designers

Regular-priced promotions are successful when concentrated around the store's merchandise strengths. They build the store's image of quality and value, which are key elements in building repeat customers.

Sale-priced promotions are analyzed before purchases are made to determine if

Markdown Planning Worksheet

Item: Black Unitards Markdown %: 25%

	Original		Proposed
Retail:	$54.00	Retail:	$40.40
− Cost:	26.00	− Cost:	26.00
= IMU$:	28.00	= MU$:	14.40
IMU%:	51.85%	MU%:	35.64%

Current Sales Rate

$$\frac{50}{\text{(\# pieces)}} \quad per \quad \frac{\text{month}}{\text{(week, month, etc.)}}$$

Markup % Difference

$$\frac{MU\$}{IMU\$} \quad \frac{\$14.40}{\$28.00} \quad = \quad 51.4 \ \%$$

New Sales Requirement to Maintain Markup Dollars

$$\frac{\text{Current Sales Rate}}{\text{Markup \% Difference}} = \frac{50 \text{ pcs.}}{51.4\%} = 97 \text{ pcs.}$$

Additional Sales Requirement to Maintain Markup Dollars

$$\frac{97}{\text{New Sales Requirement}} - \frac{50}{\text{Current Sales}} = \frac{47}{\text{AdditionalSales}}$$

Figure 13.2.

the strength of a selected promotionally priced item will generate the increased sales requirement to maintain markup dollars. Figure 13.2 illustrates the use of the markdown planning worksheet to determine how many additional black unitards must be sold to maintain markup dollars if the promotional sale price is $40.40. As shown, 97 black unitards must be sold to maintain markup dollars, an additional 47 pieces. The buyer feels this is an achievable sales goal.

In addition, the new unit cost price to maintain the initial markup percent is computed in preparation for upcoming vendor negotiations. The completed chart below illustrates that if the workout wear buyer can negotiate a cost purchase price of $19.45, the original markup percent can be maintained.

Negotiation Unit Cost Price Chart

	Original	Proposed	Negotiate
Retail:	$54.00	$40.40	$40.40
− Cost:	26.00	26.00	19.45
= MU$:	28.00	14.40	20.95
	51.85	35.64%	51.85%
	(IMU%)	(MU%)	(MU%)

Formula for Calculating the Negotiated Unit Cost Price

Step 1: Determine the cost complement of the initial markup percent (IMU%).

100%	100.00
– IMU%	– 51.85
CC%	**48.15%**

Step 2: Multiply the proposed retail by the cost complement percent.

Proposed Retail	$40.40
× Cost Complement %	× .4815
Negotiation Unit Cost	**$19.45**

This cost price provides the base from which to negotiate a promotional purchase price with the unitard vendor. If the buyer secures the $19.45 cost price, or one below the original cost price of $26.00, two things occur:

1. A "cushion" to maintain markup dollars is created because the lowered cost price decreases the sales requirement figure to maintain markup dollars. For example, if the unitard cost price of $23.00 is obtained, the new sales requirement to maintain markup dollars is 80.5 or 80 pieces, instead of 97 pieces as shown in Figure 13.2.

2. The markup percent increases back to its original markup percent (51.85%) or somewhere above the resultant markup percent (35.64%) if the cost price negotiated is lower than the original cost price ($26.00).

The For All Seasons' workout wear buyer now has new cost price and purchase unit targets for the upcoming meetings with vendors to negotiate the best purchase prices to further protect gross margin plans.

For their 100th Anniversary Celebration, For All Seasons will include regularly and promotionally priced basic stock items. The regular versus promotional price basic stock assortment and sales promotion additives will be solidified after vendor negotiations are completed and the overall profit picture is evaluated. One hundred percent white crew socks are an established loss leader and will be advertised during the celebration to further increase store traffic and maximize sales.

SELF QUIZ

1. Sports bags are to be included in the 100th Anniversary Celebration. Fill in the blanks on the markdown worksheet in Figure 13.3 to determine the number of additional sports bags that must be sold to maintain the markup dollar plan.

Markdown Planning Worksheet

Item Sports Bags Markdown % 35%

Original	Proposed
Original	**Proposed**
Retail: $39.00	Retail: $25.40
− Cost: 15.00	− Cost: 15.00
= IMU$: 24.00	= MU$: 10.40
IMU%: ____ %	MU%: ____ %

Current Sales Rate

$$\frac{60}{\text{(\# pieces)}} \quad \text{per} \quad \frac{\text{month}}{\text{(week, month, etc.)}}$$

Markup % Difference

$$\frac{\text{MU\$ \$ ____}}{\text{IMU\$ \$ ____}} = ____ \%$$

New Sales Requirement to Maintain Markup Dollars

$$\frac{\text{Current Sales Rate}}{\text{Markup \% Difference}} = \frac{\text{pcs.}}{\%} = ____ \text{ pcs.}$$

Additional Sales Requirement to Maintain Markup Dollars

New Sales Requirement	−	Current Sales	=	AdditionalSales

Figure 13.3.

2. Using the information provided in problem 1, complete the chart below.

Negotiation Unit Cost Price Chart

	Original	Proposed	Negotiate
Retail:	$ _____	$ _____	$ _____
− Cost:	_____	_____	_____
= MU$:	_____	_____	_____
	_____	_____	_____
	(IMU%)	(MU%)	(MU%)

SALES PROMOTION ADDITIVES

Regardless if the planned sales promotion will be at regular or sale prices, it is important to include some **value additives** to further stimulate demand and spur customer response. These may include any of the following.

premiums–free gifts or specially priced gifts offered at the time of specific item purchases; also referred to as *gift-with-purchase (GWP)* or *purchase-with-purchase (PWP)*

Premiums Free gifts or specially priced gifts that are offered at the time of specific item purchases are referred to as **premiums**. They are also referred to as **gift-with-purchase (GWP)** and **purchase-with-purchase (PWP)**. These items must have universal appeal for success. For All Seasons gives complementary fanny packs with the store logo as a premium offering to each customer who completes the store intercept (questionnaire) as described in Chapter 7, "Merchandise Planning." When customers purchase a mountain bike, they receive a bike sports bottle as a GWP or they may purchase a bike helmet at half price, which is an example of a PWP. For the 100th Anniversary Celebration, For All Seasons has secured vendor product donations for weekly scheduled storewide GWPs with a minimum purchase of $10.00. Some GWP examples include water bottles, athletic caps, imprinted tee shirts, and boxed golf tees. Examples of their negotiated PWPs include gym bags, sports watches, and mountaineer guide books.

coupons–certificates with a stated monetary or merchandise value presented to customer to redeem at time of purchase or for future purchases

Coupons. **Coupons** are certificates with a stated monetary or merchandise value that are presented to the customer to redeem at the time of purchase or for future purchases. For the 100th Anniversary Celebration customers will be awarded a 100 cent coupon to apply for future purchases of $10.00 or more to encourage repeat shoppers.

games–attention-grabbing devices to further stimulate immediate sales

Games. Attention-grabbing devices, known as **games**, may include finding the prize-winning message in a mailing piece and receiving a gift, or an in-store counter fishing game where customers must hook a fish within a specific time period. If they succeed, they draw a reward out of a fish bowl. The fishing game is a proven success at For All Seasons during their fishing specialties annual September event.

trading stamps–stamps received per specified dollar purchase to fill the provided trading stamp booklet, which may be redeemed for merchandise

Trading stamps. Customers receive one stamp per specified dollar purchase to fill the provided trading stamp booklet and then redeem for merchandise. **Trading stamps** work best when an exclusive trading area agreement is obtained.

frequent buyer awards–discount or special gift received when specific dollar amount is reached

Frequent buyer awards. With **frequent buyer awards**, customers receive a booklet or card that is punched or stamped at the time of each purchase. When a specific dollar amount is reached, the customer receives a discount or special gift. For All Seasons offers its most frequent shoppers the opportunity to redeem their punched cards as follows: For every $75 purchase, one of the For All Seasons sports symbols is punched. When all 12 have been punched, the customer is eligible to redeem the card and receive a 25% discount on the next full-price purchase.

Note: For All Seasons protects itself from customer abuses by setting frequent shoppers club rules.

1. Cards are nontransferable.

2. Discount applies to nonsale items only.

3. Card entitles holder to one 25% discount per card.

4. Sale must amount to $75 before sales tax.

5. Card may not be used in conjunction with any other promotion.

6. Discount is effective 1 month after initial purchase.

special events–in-store devices to attract customers to specific merchandise areas to further build sales (i.e., personal appearances, demonstrations, register-to-win)

Special Events. Bloomingdale's and Nordstrom's are known for building excitement at the in-store level by holding **special events** rather than straight sale events. Special events attract customers to specific merchandise areas to further build sales. Ice sculpture demonstrations, sports pro appearances, and register-to-win shopping sprees, and ski trips among others are proven successes at For All

Seasons. In August, the National Tennis Finals will be held at a local resort. For All Seasons planned a Match Set Event to coincide with the finals and obtained the commitment of the three top finalists for personal in-store appearances. For the 100th Anniversary Celebration, vendors are providing register-to-win additives such as $250, $500, and $1000 shopping sprees, two ski trips for two to Switzerland, and four cross country ski equipment packages.

SALES PROMOTION PURCHASES

The necessary advance planning steps have been accomplished: the *right* merchandise has been selected, the *right* quantity calculated, and the *right* timing has been scheduled. The next step is to secure the *right* price for the selected sales promotion merchandise.

The retailer meets with vendors to:

1. Discuss the planned sales promotion and ask for input and feedback. Perhaps the vendor has knowledge of a similar event and can share its results. This also provides an opportunity for the vendor to offer value additives that For All Seasons regularly secures. The vendor may also be able to share ideas for employee incentives during the promotion. One type of employee incentive vendors might provide is called a **spiff**, which is a vendor-provided merchandise or monetary award for achieving specific sales quotas mutually set by the retailer and vendor. An example of a spiff is illustrated in Figure 13.4.

spiff–vendor-provided merchandise or monetary award for achieving specific sales quota(s) mutually set by the retailer and vendor

2. Negotiate the best price while armed with the quantity requirements developed from the markdown planning worksheet to maintain markup dollar plans and the ideal purchase price to maintain markup percent plans. Advance promotional planning provides the retailer with the opportunity to secure desired cost prices on quality and in-season merchandise.

3. Confirm the order with clear-cut delivery dates. Regular price merchandise should arrive no later than a week before the promotion start date. To generate additional gross margins, the selected promotionally priced merchandise should arrive 3 to 4 weeks before the scheduled promotion date for regular price sales opportunities.

4. Secure advance confirmations of promotional monies, referred to as cooperative advertising dollars, for sales promotion additives and advertising vehicles such as a store catalog, mailer, newspaper ad, or billing statement insert.

cooperative advertising dollars–vendor partial or 100% contribution of "co-op dollars" to support retailer's advertising efforts

Cooperative advertising dollars ("co-op" dollars) are partial or 100% contributed monies given to the retailer by the vendor to support the retailer's advertising efforts for the purpose of advertising the vendor's products. Approximately 3% to 5% of the net cost of the retailer's purchases over a specific period of time are awarded to the retailer by the vendor for this purpose.

ADVERTISING PREPARATION

In large operations, promotions are presented, planned, and coordinated through the advertising department. Small retailers rely on advertising direction from local newspaper representatives, printers, independent marketing consultants, and vendors. These sources will provide information on the best advertising vehicle—which may include newspaper, magazine, radio, or television—as well as suggestions as to the best days to advertise for the strongest response. In addition, they will provide ad copy, illustrations, and layout services. It is important for both the large and small merchant to understand basic advertising principles as set forth in this section.

Date October 1

Subject Jumping Jax Spiff **Time** 1st Week of Oct.
To Dept. Managers & Sales Staff **From** Work-Out Wear Dept

Play Jumping Jax Bingo! Jumping Jax is offering a 1-week spiff during the 100th Anniversary Celebration. Sell each item to complete a vertical, horizontal, or diagonal row and receive $5 for each line, potential winnings of **$40**! Fill the entire card and win **$50**!

Attach each sales receipt to the bingo card and turn in with your monthly sales report to receive Jumping Jax dollars! Questions -

Call x 2740
Renee

JUMPING JAX 100TH ANNIVERSARY CELEBRATION BINGO

2 Nylon Warm-Up Suits Promotional Price: **$84.40**	2 Coordinated Work-Out Sets Promotional Price: **$36.40**	2 Leather Women's Pro-Sports Shoes Promotional Price: **$72.40**
2 Heavy Hand Weight Sets Promotional Price: **$30.40**	2 Step Bench & Video Sets Promotional Price: **$94.40**	2 2-pc. Fleece Fitness Sets Promotional Price: **$64.40**
2 Men's Aerostep Fitness Shoes Promotional Price: **$72.40**	2 Cross Training Workout Sets Promotional Price: **$54.40**	2 Capri Length Unitards Promotional Price: **$40.40**

Figure 13.4. For All Seasons' Correspondence

AD COMPOSITION

A headline, body copy, layout, and various illustrations comprise all ads. These integral parts work together to appeal to a need or emotion of the customer, prompting the customer to buy.

headline–attracts customer's attention and sells positive benefits of merchandise

Headline. The **headline** flags the customer's attention and sells the positive benefits of the merchandise. It must appeal to a need or emotion of the customer with a promise to fill that claim. It may promise an improvement or something totally new.

body copy–informs customer of special qualities, design features, sizes, colors, materials, and prices of merchandise

Body copy. **Body copy** is both factual and specific. It informs the customer of special qualities, design features, sizes, colors, materials, and prices.
 Points to include in the body copy are:

1. Regular and sale prices

2. Dollar or percent savings

3. Starting and ending dates of the promotion

4. Special services (i.e., major credit cards accepted, complimentary gift wrapping) and additives

5. Store logo, name, address, and business hours

Generally it is better to state dollar savings to give the customers a clear idea of what can be saved to prompt them to buy now, not later. Retailers must also consider whether most of their customers understand the concept of percentages unless they are 50% or higher. To illustrate, examine the price presentations shown in Figure 13.5. Which would be more eye-catching and meaningful to a customer shopping for savings?

layout–tells typesetter the size and position of body copy and indicates location of each component

Layout. The **layout** includes the headline, body copy, and illustrations. It tells the typesetter the size and position of the body copy and indicates the location of each component.
 The layout should have both "eye" and "sell" appeal, as illustrated in Figure 13.6. Good layouts are simple and include four points.

1. The headline flags the customer's attention and states the objectives of the ad.

2. The illustrations support the headline clearly.

3. The product benefits and features are direct and clear.

4. The total appearance of the ad "tells the sell" and does it simply.

In preparing a layout, the retailer must consider:

1. What message is the ad to convey? Is it to promote merchandise to produce immediate sales results as shown in Figure 13.6 (page 294) or, as illustrated in Figure 13.7 (page 295), to project and promote the store's image through advertising its special customer services image?

2. What are the main selling points?

3. What elements need to be emphasized?

4. How large should the price(s) be?

5. Are the product features more important than the price or vice versa?

6. How can the merchandise best be positioned within the allotted ad space?

7. Are only two typeface styles used to clearly draw the customer's eye?

8. Are special positioning instructions complete? (These include the size and

Figure 13.5. Price Presentations

location of the store logo, the positioning of the type, the use of bold type for sale prices, and normal typeface for regular prices.)

Successful ads are not cluttered with anything that does not directly relate to the headline. Graphics are simple and gimmicks are excluded. The **billboard rule** provides a quick test of proper ad layout. Look quickly at Figure 13.8 (page 296) as you would see a billboard when driving down the road. What do you remember? What caught your eye?

Consistent ad formats build and reinforce a store's image. If the retailer removed the store's logo and the competition would be able to use the ad, then the ad is not properly laid out.

Proof. The **proof** is a tearsheet of the ad presented prior to authorizing printing. The purpose of the proof is to allow the retailer to make corrections in the ad because of incorrect information (wrong prices, spelling errors) or because ad guidelines (headline not eye-catching, sales prices not in bold type) were not followed.

Ad tearsheets are proofed and all corrections noted on them, using proofreader's symbols. The printer is then notified verbally and in writing. It is important to sign and keep a copy of the approved tearsheet. If an ad is misprinted, a copy and signature on the corrected proof will enable the retailer to either not pay for the ad or receive another ad (corrected) at no charge.

billboard rule–as billboards are viewed in split seconds, each advertising vehicle is quickly viewed to determine if the purpose of the ad is clearly expressed and if it will make the consumer want to read the entire ad

proof–tearsheet of the ad presented prior to authorizing printing

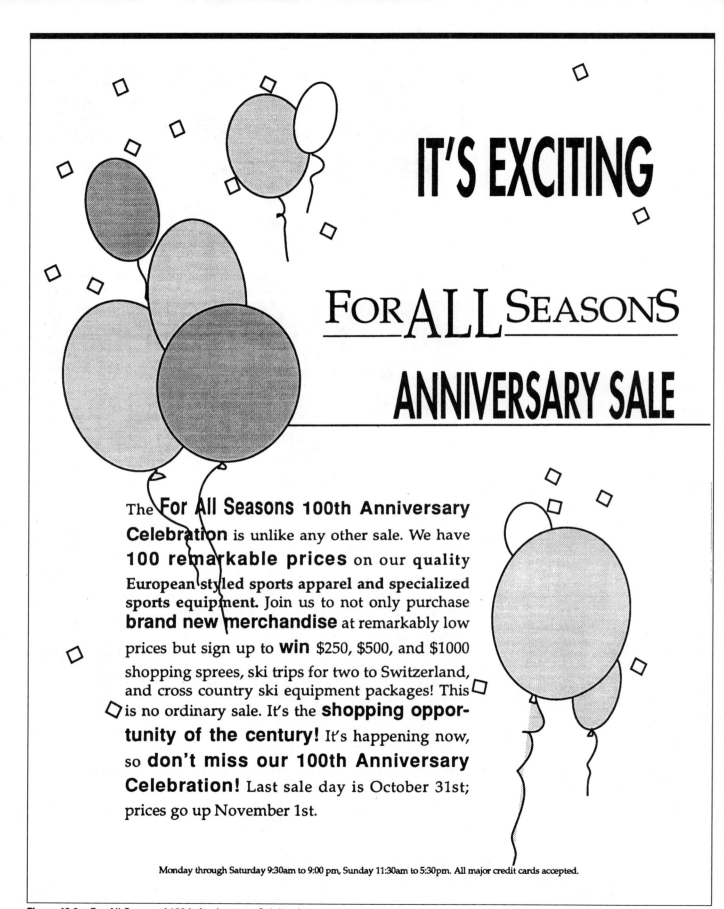

IT'S EXCITING

For ALL Seasons

ANNIVERSARY SALE

The **For All Seasons** 100th **Anniversary Celebration** is unlike any other sale. We have **100 remarkable prices** on our quality European styled sports apparel and specialized sports equipment. Join us to not only purchase **brand new merchandise** at remarkably low prices but sign up to **win** $250, $500, and $1000 shopping sprees, ski trips for two to Switzerland, and cross country ski equipment packages! This is no ordinary sale. It's the **shopping opportunity of the century!** It's happening now, so **don't miss our 100th Anniversary Celebration!** Last sale day is October 31st; prices go up November 1st.

Monday through Saturday 9:30am to 9:00 pm, Sunday 11:30am to 5:30pm. All major credit cards accepted.

Figure 13.6. For All Seasons' 100th Anniversary Celebration

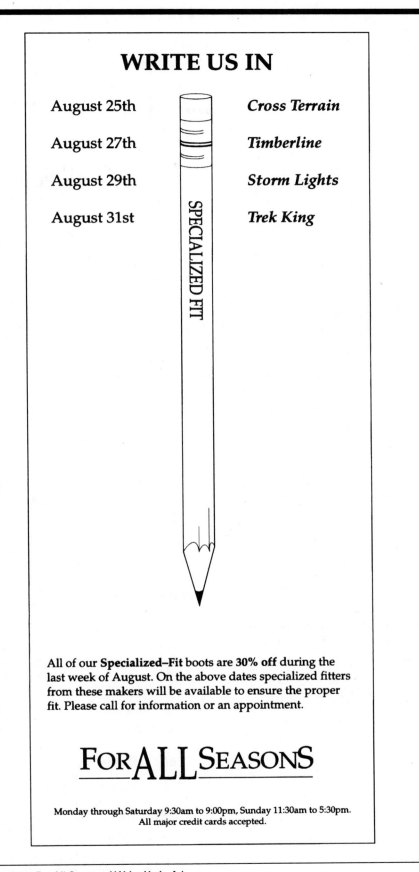

Figure 13.7. For All Seasons' Write Us In Ad

THE WINTER FESTIVAL

From January 2nd to January 15th, the Winter Festival of **specially priced quality European styled sports apparel and specialized sports equipment.**

FOR ALL SEASONS

Monday through Saturday 9:30am to 9:00pm, Sunday 11:30am to 5:30pm.
All major credit cards accepted.

Figure 13.8. For All Seasons Ad

SALES PROMOTION CALENDAR

monthly promotional calendar–detailed blueprint of a month's preplanned sales promotions

After the initial 6-month sales and promotional plans are completed and each event's components are reviewed and adjusted to ensure maximum success, the final details are posted on the **monthly promotional calendar**.

The monthly promotional calendar, illustrated in Figure 13.9, presents a clear picture of each event and records the results for future event planning so that the retailer's efforts and money are well spent. A promotional calendar includes:

1. The dates of the promotion

2. The "umbrella" theme

3. The merchandise selection

4. The pricing strategy (regular or sale prices)

5. The sales promotion additives

6. The advertising vehicles

7. Last year's sales and plan sales

MONTHLY PROMOTIONAL CALENDAR

Month _____ Year _____

LY Sales _____ TY Sales Plan _____ TY Actual Sales _____

WEEK 1 Dates to: HOLIDAYS/EVENTS:	UMBRELLA THEME: MERCHANDISE: PRICING:	ADVERTISING VEHICLE: ADDITIVES:
WEEK 2 Dates to: HOLIDAYS/EVENTS:	UMBRELLA THEME: MERCHANDISE: PRICING:	ADVERTISING VEHICLE: ADDITIVES:
WEEK 3 Dates to: HOLIDAYS/EVENTS:	UMBRELLA THEME: MERCHANDISE: PRICING:	ADVERTISING VEHICLE: ADDITIVES:
WEEK 4 Dates to: HOLIDAYS/EVENTS:	UMBRELLA THEME: MERCHANDISE: PRICING:	ADVERTISING VEHICLE: ADDITIVES:
WEEK 5 Dates to: HOLIDAYS/EVENTS:	UMBRELLA THEME: MERCHANDISE: PRICING:	ADVERTISING VEHICLE: ADDITIVES:

Comments: _____

Figure 13.9.

On completion of the sales promotion, the retailer:

1. Records actual sales on the promotional calendar

2. Notes the weather conditions because they can have a positive or negative effect on store traffic

3. Compiles the markdown forms to initial on hand quantities for each item and computes the dollar and unit sales figures for future event planning

4. Evaluates the success of promotional additives and the advertising vehicles

5. Creates a sales promotion history file that also includes advertising copies

In summary, effective sales promotion practices result in the *right* merchandise selection, at the *right* time, in the *right* quantities, at the *right* prices, and in the *right* place.

Satisfied customers and increased sales and profits are the result of planned sales promotions.

CHAPTER REVIEW

1. Summarize the various purposes of sales promotion and explain why clearance merchandise is not included in sales promotion.

2. Define institutional promotions and merchandise promotions.

3. Explain the purposes of, and the differences between, the 6–month sales and promotional plan and the monthly promotional calendar.

4. List and explain the six steps of successful sales promotion planning.

5. How does a promotional order differ from a basic stock order?

6. When writing promotional orders, what factors must be considered to arrive at a qualified judgment amount?

7. Explain the importance and the benefits of using the markdown planning worksheet and the negotiation unit cost price chart before negotiating the purchase of sales promotion merchandise.

8. Select two ads from a newspaper or a magazine and mount them on plain paper, labeling them ad A and ad B. Then name the headline, identify the body copy, and evaluate the effectiveness and appeal of each in the provided spaces labeled ad A and ad B.

 Ad A:

 Ad B:

9. From the provided merchandise list select four basic stock items, two best sellers, one loss leader, and one unique item to include in a sports apparel and accessories sales promotion and write the items in the spaces labeled in section a and the reason for each item's grouping.

Tennis skirts	Sun visors
Polo shirts	100% cotton crew socks
Fanny packs	Rugby shirts
Biking shorts	Sports caps
Running shorts	Biking gloves
Water bottles	Exclusive chamois shorts
Leotards	Emblem cotton tee shirts
Lycra leggings	White sweat bands

a. Basic stock items: _____

Best sellers: _____

Loss leader: _____

Unique item: _____

b. Determine which merchandise should be selected to remain at regular price and what items should be promotionally priced. Explain your reasoning.

c. Review the selected promotional items and create two value additives.

10. Refer to the For All Seasons' 6-month sales and promotional plans calendar shown in Figure 13.1 (page 281). Two events, Wonderland Gifts and Affordable Luxuries, were planned for the month of December. Thoroughly plan and describe each event for December on the provided monthly promotional calendar.

- Fill in the selected month and year.

- Post last year's and this year's sales figures.

- Set the dates of each event and note any holidays.

- Write in the initial "umbrella" themes or create new For All Seasons holiday "umbrella" themes.

- Define the merchandise selection by department, classification, or item level.

- Set the pricing strategy (regular or promotional) for each event.

- List the advertising vehicle(s).

- Name the value additives to be included in each event.

Attach selected merchandise pictures, suggested advertising layouts, and details of value additives to the completed December promotional calendar.

MONTHLY PROMOTIONAL CALENDAR

Month _____ Year _____

LY Sales _____ TY Sales Plan _____ TY Actual Sales _____

WEEK 1 Dates to: HOLIDAYS/EVENTS:	UMBRELLA THEME: MERCHANDISE: PRICING:	ADVERTISING VEHICLE: ADDITIVES:
WEEK 2 Dates to: HOLIDAYS/EVENTS:	UMBRELLA THEME: MERCHANDISE: PRICING:	ADVERTISING VEHICLE: ADDITIVES:
WEEK 3 Dates to: HOLIDAYS/EVENTS:	UMBRELLA THEME: MERCHANDISE: PRICING:	ADVERTISING VEHICLE: ADDITIVES:
WEEK 4 Dates to: HOLIDAYS/EVENTS:	UMBRELLA THEME: MERCHANDISE: PRICING:	ADVERTISING VEHICLE: ADDITIVES:
WEEK 5 Dates to: HOLIDAYS/EVENTS:	UMBRELLA THEME: MERCHANDISE: PRICING:	ADVERTISING VEHICLE: ADDITIVES:

Comments: _____

Figure 13.10.

1. For All Seasons is planning the annual Boot Expresso promotion for August. This promotion reinforces the store's customer service policy that if any boots purchased do not fit comfortably, For All Seasons will refit them at no charge. Given the following boot sale information, compute the order quantity for each style.

Item	3 Month's Total Nonpromotional Sales Quantity	On Order	On Hand	Order
311244	52	14	22	_____
311245	62	18	18	_____
311246	81	23	31	_____
311247	65	18	24	_____
311248	76	20	28	_____

2. During the Weathering Heights promotions, 25% off all thermal underwear sets is to be included; these sets originally retail for $30.00 each with an initial markup percent of 52%. Last November, 144 thermal underwear sets were sold. Set the promotional sale price following the For All Seasons' promotional price point ending policy of $.40 and complete provided markdown planning worksheet, Figure 13.11, to determine how many additional sets must be sold to maintain markup dollars.

Using the information from Problem 3, complete the Negotiation Unit cost Price Chart to determine the ideal unit cost price to secure to maintain both markup dollars and markup percent.

Negotiation Unit Cost Price Chart

	Original	Adjusted	Negotiate
Retail:	$ _____	$ _____	$ _____
− Cost:	_____	_____	_____
= MU$:	_____	_____	_____
	_____	_____	_____
	(IMU%)	(MU%)	(MU%)

3. Complete negotiation unit cost price charts A and B in preparation for a buying trip in which orders for the Summer Extravaganza Event will be placed.

Negotiation Unit Cost Price Chart A

Item Body Boards Markdown % 26%

	Original	Adjusted	Negotiate
Retail:	$60.00	$44.40	$ _____
− Cost:	30.00	_____	_____
=MU$:	_____	_____	_____
	_____	_____	_____
	(IMU%)	(MU%)	(MU%)

Markdown Planning Worksheet

Item _____ Markdown % _____

	Original		Proposed
Retail: $ _____		Retail: $ _____	
− Cost: _____		− Cost: _____	
= IMU$: _____		= MU$: _____	
IMU%: _____ %		MU%: _____ %	

Current Sales Rate

_____ per _____
(# pieces) (week, month, etc.)

Markup % Difference

$$\frac{MU\$ \quad \$ _____}{IMU\$ \quad \$ _____} = _____ \%$$

New Sales Requirement to Maintain Markup Dollars

$$\frac{\text{Current Sales Rate}}{\text{Markup \% Difference}} = \frac{____ \text{ pcs.}}{____ \%} = ____ \text{ pcs.}$$

Additional Sales Requirement to Maintain Markup Dollars

_____ − _____ = _____
New Sales Requirement Current Sales AdditionalSales

Figure 13.11.

Negotiation Unit Cost Price Chart B

Item _____Dive Fins_____ Markdown % _____30.7%_____

	Original	Adjusted	Negotiate
Retail:	$28.00	$19.40	$ _____
− Cost:	12.00	_____	_____
=MU$:	_____	_____	_____

4. Given the following information, complete the exercises below for soccer shorts.

Retail:	$24.00
Cost:	$10.00
Current sales rate:	120 pieces

a. If the soccer shorts are promoted at $16.40, how many additional units must be sold to maintain markup dollars?

b. Compute the ideal unit cost price to maintain the initial markup percent.

c. If a unit cost price of $13.00 is negotiated, how many additional units must be sold to maintain markup dollars?

d. Calculate the markup percent if the $13.00 unit cost price is obtained.

5. For All Seasons is planning a 1-week 25% off athletic shoe promotion, scheduled to begin April 1. In preparation for a meeting scheduled with Crosstrainer, an athletic shoe vendor, the buyer has gathered the following information:

Style	Retail	3 Month's Total Nonpromotional Sales	On Hand	On Order
CT101	$72.00	66	18	24
CT102	$84.00	54	21	15

The initial markup for Crosstrainer is 48%.

a. Determine the promotional retail prices for each style. Be sure to follow For All Seasons' price point promotional ending policy.

CT101: $ _____ CT102: $ _____

b. Compute the number of additional sale units to maintain markup dollars for each style.

CT101: _____ units

CT102: _____ units

c. Calculate the promotional order quantities and show your computations.

CT101 CT102

Order: _____ Order: _____

d. Determine the ideal negotiation unit cost price to maintain the initial markup percent for each athletic shoe.

CT101: $_____ CT102: $_____

e. Preplan in detail the objectives for the upcoming Crosstrainer meeting.

KEYS TO PROFIT

Retailer Options

Because the majority of purchases are made through middlemen (**wholesalers, jobbers, rack jobbers, routemen**), additional costs are included in quoted purchase prices to cover their services; consequently, the value of these resources or middlemen must be weighed periodically. The merchandise offerings and service level must be high enough to outweigh the "hidden" increase in purchase costs. In essence, retailers must be able to determine whether their expectations are being met by these resources.

Successful retailers continually view new lines of merchandise and compare competitive product lines, pricing structures, and profit potentials to evaluate their regular supplier's merchandise and service offerings.

The **Pareto rule** provides a guideline: Of each line that a retailer carries, approximately 20% of the assortment will represent 80% of the sales.

The retailer then asks, "Are current lines producing profitable sales and meeting or exceeding gross margin goals?"

To evaluate available resources, the retailer needs a completed:

1. Vendor log sheet
2. Receipt, sales, and markdown summary
3. Vendor performance evaluation form

wholesaler–resource of goods purchased from manufacturers or jobbers and then resold to retailers

jobber–resource of goods purchased from manufacturers, which are sold to wholesalers or direct to retailers

rack jobber –jobber who typically provides an opening order on consignment or a guaranteed sales basis; periodically checks stock and refills it

routemen–jobbers whose inventory is carried on trucks; routemen come to retailer's location, see what merchandise is needed, and leave the desired amount of merchandise

Pareto rule–states that of each line carried by a retailer, approximately 20% of the assortment will represent 80% of the sales

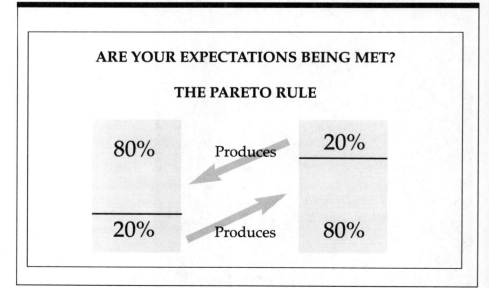

According to the Pareto rule, out of each line of goods that a retailer carries, approximately 20% of the assortment will represent 80% of the sales.

```
┌─────────────────────────────────────────────────────────────────────────────┐
│                              VENDOR LOG                                        │
│                                                                                │
│  Merchandise Category _____     Price Range _____    │
│                                                 Avg. GM _____     │
│                                                                                │
│  Company/Name _____     Rep. Name _____    │
│  Street Address _____     Address _____    │
│  City, State _____     City, State _____    │
│  Zip Code _____     Zip Code _____    │
│  Telephone _____     Tele. _____    │
│  INVOICE ADDRESS (if different)                 Reg./Dist. Mgr. _____     │
│  Street _____     Mgr. Tel. _____     │
│  City, State _____     President _____    │
│  Zip Code _____     Pres. Tel. _____     │
│  Credit Manager _____     Tel. _____    │
│                                                                                │
│  Customer Service Contact or Mgr. _____     Tel. _____    │
│  TERMS AND POLICIES                                                            │
│  PRICING                                        DELIVERY                       │
│  Payment Terms _____     Freight Charges _____    │
│  Rebates _____     Turn Time _____    │
│  Quantitiy Disc. _____ Trade Disc. _____     Cancel. Agreement _____    │
│  Seasonal Disc. _____ Promo Disc. _____     No Back Orders _____    │
└─────────────────────────────────────────────────────────────────────────────┘
```

Figure 14.1.

THE VENDOR LOG

vendor log–detailed outline of each supplier, including pertinent purchasing and negotiating information

The **vendor log** is a detailed outline of each supplier. It displays current product lines and pertinent resource information. This valuable information provides the retailer with:

1. A checklist for meetings with current and prospective vendors

2. Negotiating opportunities

3. Profit potentials

4. Resource evaluation data

A sample vendor log sheet is shown in Figure 14.1.

Although this form is self-explanatory, some important retailer options are discussed in the following sections.

GUARANTEED SALE POLICY _____

CONSIGNMENT POLICY _____

DISTRIBUTION

Limited Distribution _____

Mass Distribution _____

TICKETING _____

Yes/No _____

Coding _____

RETURN PRIVILEGES

Exchange Privileges _____

Damages _____

Defectives _____

Slow Sellers _____

ALLOWANCES

Markdown $'s _____

Advertising _____

Volume _____

Display _____

Shelf _____

OFF-PRICE MERCHANDISE (OP)

Close Outs _____

From Regular Lines _____

SALES AIDS

Type _____

PRODUCT MODIFICATION

Exclusives _____

Private Label _____

Packaging _____

Labeling _____

NEW ITEM INTRO.

Promotions _____

P.O.P. Displays _____

Premiums _____

Register to Win _____

VENDOR SUPPORT

Maintains Stock Books w/Sales Records _____

Rotates and Maintains Stock _____

Writes Credits/Returns Each Visit _____

Notifies, In advance, of Price Increases _____

Communicates Competitive Activities _____

Cordial with Staff _____

Trains Staff _____

ADDITIONAL COMMENTS:

Figure 14.1. (continued)

PRESIDENT OR REGIONAL/DISTRICT MANAGER

Relationships should be developed with the president of a company or with its regional or district manager by phone and in the market. These decision-makers can benefit the retailer if contact is established positively before a problem arises that the direct vendor is not solving.

```
                    RETURN AUTHORIZATION REQUEST

        Return authorization is requested for the following merchandise:

                    Style # _____
                    Style # _____
                    Style # _____
                    Style # _____

        Reason for return:
        1. ___      Merchandise received in damaged condition.
        2. ___      Incorrect size or color.
        3. ___      Late delivery.  Completion date: _____.
        4. ___      Dye lots do not match.
        5. ___      Poor fit.

        INVOICE NUMBER _____.
```

Figure 14.2.

CUSTOMER SERVICE CONTACT

Occasionally, contact with the customer service department can reduce wasted time spent calling vendors for shipping information. This contact can also save time securing necessary return authorization labels for damaged and defective stock.

Note: At times, the best way to secure return authorizations for damaged and defective merchandise is to withhold purchase order committments (confirmations) until obtained.

RETURN PRIVILEGES

return privileges–arrangement whereby vendors allow retailers to return merchandise

When vendors allow retailers to return merchandise, they are extending **return privileges**. The majority of authorized returns are to correct shipping errors and quality problems. When returning damaged items, order substitutions, poor quality merchandise, mismatched dye lot goods, and so on, the retailer should not pay the freight or handling charges. An example of a retailer return authorization request form is shown in Figure 14.2.

Remember: Everything is returnable until the merchandise is paid for. Do not abuse return privileges, but when justified, make sure the resource stands behind its merchandise.

ALLOWANCES

allowances–partial or complete reimbursements for damaged merchandise, price competition, or in lieu of returning unsatisfactory merchandise

Allowances are partial or complete reimbursements for damaged merchandise, price competition, or in lieu of returning unsatisfactory goods. These are the benefits of doing business with resources.

Markdown dollars. In advance, the retailer computes the desired markdown percent and markdown dollar amount to clear out a resource's slow sellers. Then, the retailer compiles receipt and sales histories to illustrate the products' poor performance. When presented with the facts, many vendors will provide full or partial markdown dollars rather than issue a return authorization label. As a negotiating point, requesting markdowns should occur before signing the vendor's purchase order.

Advertising. Although some vendors do not publish their advertising policy, most do support retailer advertising efforts by contributing *cooperative (co-op) advertising dollars*, which means that they pay a portion or 100% of the cost. The vendor's participation includes newspaper advertising, mailers, catalogs, contests, and sales incentive "push" monies.

To a large extent, advertising dollars are negotiable; however, some guidelines should be followed. Vendors compute "co-op" allocations based on their customer's annual cost purchases. For example, the gift industry generally pays 5% of total cost purchases and the apparel industry 3%. The retailer can predetermine advertising allowances using these guidelines.

Display and shelf allowances. Many resources provide signing, fixtures, and cases at no charge or at minimal fees to secure improved positioning. They are also willing to "rent" shelf space to maintain maximum product exposure.

These allowances are not only available for large retailers. If resources have not discussed them, the retailer should ask.

OFF-PRICE (OP) MERCHANDISE

off-price merchandise–merchandise sold at discounts from originally quoted cost prices

Merchandise is sold at discounts from the originally quoted cost prices is known as **off-price merchandise**. Off-price buys must be weighed carefully. The retailer should ask, "Is the merchandise, regardless of its reduced cost, what my targeted customer group wants? What is the remaining selling timetable?"

Off-price merchandise line are also known as *close outs*, and are just that. They are comprised of the manufacturer's leftovers or overages. This merchandise usually ends up in the discount stores. To purchase off-price merchandise from the regular line, in season, is ideal.

POINT-OF-PURCHASE/POINT-OF-SALE DISPLAYS

point of purchase/point of sales displays–P.O.P./P.O.S. displays positioned at or near check-out registers for new product introductions and as impulse sale generators

Point-of-purchase (P.O.P.)/Point-of-sale (P.O.S.) displays are for new product introductions and impulse sale generators. They are positioned at or near the check out register.

Most vendors are skilled in the presentation of their merchandise...with a perfected sales pitch. The use of the vendor log sheet will ensure that the retailer addresses his or her needs during each interaction, especially when confronted by exceptionally strong vendors.

SELF QUIZ

1. Define vendor log and list the five benefits it provides the retailer.

2. On December 1, 120 one-size-fits-all printed sweatshirts were received. On February 1, 60 pieces remain in stock. In preparation for your vendor meeting, complete the following exercises.

 a. Calculate the number of sweatshirts sold.

 b. The sweatshirts were originally priced at $36.00 each, and you plan to mark them down to $26.99. Calculate the markdown dollar and percent figures.

 c. Explain how you would support your request for markdown dollars from this vendor.

3. In return for obtaining vendor supplied fixturing or "rent" monies, what responsibilities does the retailer assume?

4. Your sports equipment buyer intends to introduce a new winter sports item, the snow board, and has narrowed possible resources down to two vendors, Ritel and Cash. Review the following information compiled from the Ritel and Cash vendor log forms and determine which vendor should supply the snow boards. Support your decision with specifics.

	Ritel	Cash
Turn time	3 weeks	2 weeks
Ticketing	no	yes
Return privileges	10% restocking charge	no restocking charge
Advertising	3% net	2% net
Sales aids	–	posters

In addition, the following information was obtained from the initial contact with each potential resource:

Ritel Will provide a register-to-win ski trip to Utah. This vendor has a large territory so it will be the retailer's responsibility to count and merchandise the products. All returns for damages take approximately 3 weeks to process at their headquarters, after submitting a request form.

Cash With each snow board purchase, a customer will receive a free pair of ski goggles. An assistant to the vendor will be assigned to visit For All Seasons each month to maintain the stock book and merchandise, write up any damages and provide return authorization labels, and train the sales staff support.

EVALUATING VENDOR PERFORMANCE

Thorough merchandise analysis and, therefore, vendor evaluations, should be completed every 3 months. Mid-season analysis highlights immediate action steps to protect the season's profit plans. Careful evaluation of vendors and their merchandise offerings will determine the profitability of the vendor/retailer partnership.

First, the retailer should ask the following questions when evaluating vendors:

1. *Merchandise assortment*
 a. Is the merchandise assortment addressing the customers' wants and needs?
 b. Are sales and gross margins increasing?
 c. Is the stock fresh and salable? Is the quality level high?
 d. Is there an accumulation of defective, shopworn, or spoiled merchandise?
 e. What is the rationale behind the vendor's suggested item selection?

Note: Remember the Pareto rule and buy the strength of a product line.

2. *Price and terms*
 a. Are the cost prices in line for the planned initial markup and ideal retails?
 b. Are the payment terms competitive?

Note: One resource discovered that a retailer did not understand the industry payment terms of 8/10, so the retailer received terms of Net 30 days, thereby losing 8%.

3. *Delivery*
 a. What is the length of time between order placement and actual delivery?
 b. Are shipments at least 85% complete, or are items constantly on back order to be reordered under new purchase orders?
 c. Does the resource have a computerized reordering system to speed up deliveries?

4. *Promotional assistance*
 a. Are visual aids provided? Is there advertising assistance?
 b. Are "co-op" advertising dollars available?
 c. Are seasonal programs offered?

5. *Reliability*
 a. Are problems handled promptly?
 b. Is merchandise shipped as vendor samples?
 c. Is consistent service provided?

6. *Service level*

 a. Are appointments scheduled or are drop-by visits the norm?

 b. Is merchandise preticketed with cost codes, date codes, and quantity codes?

 c. Are training seminars provided? Is product literature available?

 d. Is the vendor courteous and helpful toward the sales staff?

Second, for resources that contribute the majority of the retailer's volume, a vendor performance evaluation analysis form should be completed. Although time consuming, the form essentially creates an income statement on each major vendor.

VENDOR PERFORMANCE ANALYSIS

Two forms are necessary to complete a vendor analysis.

1. The receipts, sales, and markdown summary

2. The vendor performance evaluation form

receipts, sales, and markdowns summary form–form that summarizes all activity, by style, for a specific period of time

vendor performance evaluation form–simplified income statement that reflects vendor's performance in comparison to departmental or class plans for a specific period of time

 The **receipts, sales, and markdown summary form** (See Figure 14.3) summarizes all activity, by style, for a specific period of time, usually 3 or 6 months.

 The posted information is pulled from purchase journals, invoices, unit stock control books, and markdown records. Each subhead is numbered on a line underneath which details the computations for specific subheads. This information is then totaled and posted to the **vendor performance evaluation form** (see Figure 14.4), which is broken into four steps:

VENDOR RECEIPTS, SALES, AND MARKDOWN SUMMARY

STYLE	RECEIPT RECORD						REGULAR PRICE SALES RECORD				ORIGINAL MARKDOWNS							CLEARANCE MARKDOWN							
SKU #	DATE RECD	PCS. RECD	UNIT COST	TOTAL COST	UNIT RETAIL	TOTAL RETAIL	COUNT DATE	OH PCS.	PCS. SOLD	TOTAL SALES	MD DATE	OH PCS.	MD%	NEW RETAIL	UNIT MD$	TOTAL MD$	TOTAL SALES	MD DATE	OH PCS.	MD%	NEW RETAIL	UNIT MD$	TOTAL MD'S	OH COUNT	TOTAL SALES
	1	2	3	4	5	6	7	8	9	10	11	12	13	14	15	16	17	18	19	20	21	22	23	24	25
				2×3		2×5		8(a)	2-8(a)	9×5		12-9(a)		5×3 (c90)	5-14	12×15	(22-19) ×14				14×20 (c90)	14×21	22×19		(19-24) ×21
								8(b)	9a-8(b)	9×5															
8000	8-7	100	42.00	4200.00	85.00	8500.00	9-7	60	40	3400.00	11-7	40	30%	59.50	25.50	1020.00	1190.00	12-7	20	20%	47.60	11.90	238.00	—	952.00
							11-7	40	20	1700.00															

Figure 14.3. Vendor Receipts, Sales, and Markdown Summary

Vendor Performance Evaluation Form

Vendor **Jene** Period **Fall Season** Dept. **Crystal** Date **1/20**

STEP 1: Compute MMU%

Total Sales	$7,242.00
Total Cost	−4,200.00
MMU$	$3,042.00
MMU%	42 %
MMU C%	58 %

STEP 2: Calculate Gross COGS

Total Sales	$7,242.00
Total MD$	+1,258.00
Subtotal	$8,500.00
MMU C%	× .58
Gross COGS	$4,930.00

STEP 3: Compute Gross Margin

Total Sales	$7,242.00
Gross COGS	−4,930.00
GM$*	$2,312.00
GM%	31.9 %

STEP 4: Performance Comparison to Dept. Plans

Dept. MD%	15 %
Vendor MD%	17.4 %
Dept. GM%	38.0 %
Vendor GM%	31.9 %
Dept. GM$	$2,751.96
Vendor GM$	−2,312.00
Vendor Allowance	$439.96 or $440.

Gross Margin if at Dept. Plan

Total Sales	$7,242.00
Dept. GM%	× .38 %
Dept. GM$	$2,751.96
Dept. GM%	38 %

*Add Cash Discounts to Gross Margin $ if any.

Figure 14.4. Vendor Performance Evaluation Form

Step 1: Compute the maintained markup percent.

 a. Columns 10, 17, and 25 on the summary sheet are totaled to arrive at total sales.

 b. The total cost figure is found in column 4.

 c. **Maintained markup dollars (MMU$)** is the difference between total sales and total cost dollars.

 d. MMU% is MMU$ divided by total sales.

 e. Find the complement of the MMU% by subtracting the MMU% from 100%.

maintained markup dollars—the difference between total sales and total cost dollars

Step 2: Calculate the **gross cost of goods sold (COGS).** All figures have been computed with the exception of total markdowns, which is the sum total of columns 16 and 23.

gross cost of goods sold—inventory value before alteration and workroom costs

Step 3: Determine the **gross margin**. This is computed with the vendor's figures and with the retailer's department gross margin planned percent.

gross margin—dollar or percentage difference between net sales volume and cost of goods sold

Gross margin percent (GM%) is gross margin dollars (GM$) divided by total sales.

Multiply total sales by the department GM% to find department GM$ if at department plan.

Divide department if at plan GM$ by total sales to determine the vendor's GM% if at plan.

Step 4: Calculate the **performance to departmental plans figure**. This showcases the vendor's performance for a designated period of time. The dollar difference between the department's gross margin plan and the vendor's actual gross margin dollars represents the negotiable vendor allowance retail dollar amount. In this example, the vendor allowance is $440. Important resources will make up for the shortfall in their performance if the retailer has supported the line for the designated period.

Note: It is poor form for a retailer who has had a poor selling season due to circumstances out of the control of the vendor (i.e., poor weather, bad economic times, slow receipt to selling floor processing time) to demand vendor allowances to help the gross margin plan.

SELF QUIZ

1. When a retailer evaluates a vendor, what important questions should be asked? List and discuss five.

2. How often should a retailer review a vendor's performance? Why?

3. What are the four steps that must be taken to complete the vendor performance evaluation form?

4. Complete the vendor performance evaluation form in Figure 14.5.

DETERMINING WORTH

After completing a quarterly review of each resource, the retailer must consider the following questions:

First, is the service level received sufficient in relation to his or her annual cost purchases? Is the retailer receiving the service his or her volume warrants?

This factor is determined by examining purchase records and totaling annual cost purchases. A single store retailer whose annual cost purchases are $10,000 or more is considered important in the gift industry, whereas in the apparel market, $50,000 or more in annual cost purchases warrant higher service levels.

Second, the retailer must determine if it is worth continuing with a resource. The results of one poor selling season must be weighed carefully. What caused the poor performance? Was it due to weather and economic conditions, or was it the quality of the merchandise assortment and lack of vendor support?

Vendor Performance Evaluation Form

Vendor **Patton** Period **Fall** Dept. **525** Date **1/4**

STEP 1: Compute MMU%

Total Sales	$ 75,000
Total Cost	– 35,000
MMU$	$ _____
MMU%	_____ %
MMU C%	_____ %

STEP 2: Calculate Gross COGS

Total Sales	$ _____
Total MD$	+ 7,000
Subtotal	$ _____
MMU C%	× _____
Gross COGS	$ _____

STEP 3: Compute Gross Margin

Total Sales	$ _____
Gross COGS	– _____
GM$*	$ _____
GM%	_____ %

STEP 4: Performance Comparison to Dept. Plans

Dept. MD%	6 %
Vendor MD%	_____ %
Dept. GM%	49.5 %
Vendor GM%	_____ %
Dept. GM$	$ _____
Vendor GM$	– _____
Vendor Allowance	$ _____

Gross Margin if at Dept. Plan

Total Sales	$ _____
Dept. GM%	× _____ %
Dept. GM$	$ _____
Dept. GM%	_____ %

*Add Cash Discounts to Gross Margin $ if any.

Figure 14.5.

Third, what steps may be taken to improve business with a particular resource? Does the communication level need to improve? Are there negotiating opportunities to increase profitability? How can the partnership be developed further?

Fourth, where can the retailer find a replacement and new product lines? New suppliers may be found as a result of vendors' calls, randomly mailed suppliers' catalogs, attendance at trade shows, apparel markets, contacts with trade associations, trade publications, and direct competitors. The successful retailer continually seeks vendors who can do a better job than current vendors. Keeping up with other vendors' offerings provides data comparison and negotiating opportunities as well as new merchandise offerings.

Fifth, the retailer must examine his or her treatment of the vendor. Is he or she asking too much? Is the retailer constantly requesting markdown dollars, return authorizations, and advertising dollars? Is it worth it to the vendor to continue supplying merchandise and servicing the retailer who continually makes such requests?

In summary, existing suppliers may be retained because their merchandise offerings address the targeted customer group, they provide satisfactory profit and service levels, or no comparable competitor's line is available.

Some vendor's personalities may not meld well with the retailer's, but if they can provide the right merchandise, at the right time, in the right place, at the right price, in the right stock quantity, the retailer should work on finding a common ground to improve the relationship.

Remember that the vendor's key responsibility is to curry the retailer's favor, to take over, to be indispensible, and to run the retailer's business. Some vendors sincerely build personal relationships with the retailer whereas others "disappear" when they are no longer the product decision-maker.

Who is minding the merchandise? Is it the vendor? Or is it both the retailer and vendor?

CHAPTER REVIEW

1. Explain in detail the purposes of evaluating vendors.

2. What are the benefits that the retailer gains from meeting with vendors the retailer does not presently buy from?

3. The Pareto rule states that of each product line that a retailer carries, approximately 80% of the sales will be produced from 20% of the merchandise assortment.

 True **False**

4. What alternatives are available to the retailer to obtain necessary return authorizations?

5. Ten small, 25 medium, and 15 large printed nylon shorts were ordered; 25 small, 10 medium, 15 large are received. Is this an acceptable order? What steps would you take? Explain your reasoning in detail.

6. An important resource has not returned your phone calls for 2 weeks. You need a reorder on a best selling item immediately and you need a commitment on "co-op" dollars for the upcoming For All Seasons' Anniversary Event. How would you handle this situation?

7. Is it more advantageous for the retailer to obtain markdown dollars to clear out slow sellers or to secure a return authorization? Explain.

8. You mutually agree on a merchandise plan with White Foot, an important ski boot resource. White Foot's ski boot sales are 25% below plan due to the lack of snow this winter. Prepare for this vendor's visit. Describe the tools you will use, their purposes, and list your objectives for the meeting.

9. What are the best circumstances for purchasing off-price merchandise and why?

10. The retailer must weigh many factors when deciding whether to continue a relationship with an existing vendor. Discuss in detail the overall factors the retailer should consider when making this choice.

CHAPTER TEST

1. After analyzing For All Seasons' athletic shoe assortment, a duplication of style and features is discovered. It is decided that one of the vendors must be eliminated. Based on the performance evaluation forms in Figures 14.6 and 14.7, determine which vendor should be dropped. Explain your choice.

2. On review of the sunglasses resources, the For All Seasons' buyer discovers a duplication of styles and price lines with two vendors, Shades and Clickers. One of the vendors must be eliminated.

Vendor Performance Evaluation Form

Vendor _Trax_ Period _Summer_ Dept. _Athletic Shoes_ Date _8/15_

STEP 1: Compute MMU%

Total Sales	$ 10,950.00
Total Cost	– 5,875.00
MMU$	$ 5,075.00
MMU%	46 %
MMU C%	54 %

STEP 2: Calculate Gross COGS

Total Sales	$ 10,950.00
Total MD$	+ 2,225.00
Subtotal	$ 13,175.00
MMU C%	× .54
Gross COGS	$ 7,114.50

STEP 3: Compute Gross Margin

Total Sales	$ 10,950.00
Gross COGS	– 7,114.50
GM$*	$ 3,835.00
GM%	35 %

*Add Cash Discounts to Gross Margin $ if any.

STEP 4: Performance Comparison to Dept. Plans

Dept. MD%	14 %
Vendor MD%	12 %
Dept. GM%	32 %
Vendor GM%	35 %
Dept. GM$	$ 3,504.00
Vendor GM$	–3,835.50
Vendor Allowance	$ (331.50)

Gross Margin if at Dept. Plan

Total Sales	$ 10,950.00
Dept. GM%	× .32 %
Dept. GM$	$ 3,504.00
Dept. GM%	32 %

Figure 14.6.

a. Complete the provided vendor performance evaluation forms in Figures 14.8 and 14.9 (pages 324 and 325) for both Shades and Clickers.

b. Review each company's vendor log information in Figures 14.10 and 14.11 (pages 326 through 329). Select the vendor to be eliminated and thoroughly substantiate your reasoning.

3. Convert is a major supplier of convertible traveler's packs, which come in medium and extra-large sizes. Sixty pieces of each size were initially ordered. The 60 medium packs sold well and the retailer is planning a reorder. However, 40 extra-large packs remain in stock. The extra-large packs cost

Vendor Performance Evaluation Form

Vendor _Richmond_ Period _Summer_ Dept. _Athletic Shoes_ Date _8/15_

STEP 1: Compute MMU%

Total Sales	$8,490.00
Total Cost	−4,925.00
MMU$	$3,565.00
MMU%	42 %
MMU C%	58 %

STEP 2: Calculate Gross COGS

Total Sales	$8,490.00
Total MD$	+1,580.00
Subtotal	$10,070.00
MMU C%	× .58
Gross COGS	$5,840.60

STEP 3: Compute Gross Margin

Total Sales	$8,490.00
Gross COGS	−5,840.60
GM$*	$2,649.40
GM%	31.2 %

*Add Cash Discounts to Gross Margin $ if any.

STEP 4: Performance Comparison to Dept. Plans

Dept. MD%	14 %
Vendor MD%	16.5 %
Dept. GM%	32 %
Vendor GM%	31.2 %
Dept. GM$	$2,716.80
Vendor GM$	−2,649.40
Vendor Allowance	$67.40

Gross Margin if at Dept. Plan

Total Sales	$8,490.00
Dept. GM%	× .32 %
Dept. GM$	$2,716.80
Dept. GM%	32 %

Figure 14.7.

$52.00 each and retail for $120.00 each. The retailer feels that if they are reduced to sell at $89.99 customers will purchase them. Prepare the necessary markdown information to present to Convert to secure the vendor's markdown participation.

4. What other options should be considered? Why?

Vendor Performance Evaluation Form

Vendor _Shades_ Period _Spring Season_ Dept. _Accessories_ Date _7/5_

STEP 1: Compute MMU%

Total Sales	$ 9,000.00
Total Cost	− 4,675.00
MMU$	$_____
MMU%	_____ %
MMU C%	_____ %

STEP 2: Calculate Gross COGS

Total Sales	$_____
Total MD$	+2,145.00
Subtotal	$_____
MMU C%	×_____
Gross COGS	$_____

STEP 3: Compute Gross Margin

Total Sales	$_____
Gross COGS	−_____
GM$*	$_____
GM%	_____ %

STEP 4: Performance Comparison to Dept. Plans

Dept. MD%	20 %
Vendor MD%	_____ %
Dept. GM%	48 %
Vendor GM%	_____ %
Dept. GM$	$_____
Vendor GM$	−_____
Vendor Allowance	$_____

Gross Margin if at Dept. Plan

Total Sales	$_____
Dept. GM%	×_____ %
Dept. GM$	$_____
Dept. GM%	_____ %

*Add Cash Discounts to Gross Margin $ if any.

Figure 14.8.

5. Actioneer sports accessories sales totaled $62,700 for the past 6 months. Total cost purchases were $22,900. Markdowns represented 15% of total sales, which was below the department's planned MD% of 16%. The sports accessories department's planned gross margin was 56.5%. Follow the format of the vendor performance evaluation form to show your computations below and then write an evaluation of Actioneer's performance to the planned goals of the sports accessories department.

Vendor Performance Evaluation Form

Vendor _Clickers_ Period _Spring Season_ Dept. _Accessories_ Date _7/5_

STEP 1: Compute MMU%

Total Sales	$ 9,200.00
Total Cost	− 4,500.00
MMU$	$_____
MMU%	_____ %
MMU C%	_____ %

STEP 2: Calculate Gross COGS

Total Sales	$_____
Total MD$	+ 2,300.00
Subtotal	$_____
MMU C%	×_____
Gross COGS	$_____

STEP 3: Compute Gross Margin

Total Sales	$_____
Gross COGS	−_____
GM$*	$_____
GM%	_____ %

*Add Cash Discounts to Gross Margin $ if any.

STEP 4: Performance Comparison to Dept. Plans

Dept. MD%	20	%
Vendor MD%	_____	%
Dept. GM%	48	%
Vendor GM%	_____	%
Dept. GM$	$_____	
Vendor GM$	−_____	
Vendor Allowance	$_____	

Gross Margin if at Dept. Plan

Total Sales	$_____	
Dept. GM%	×_____	%
Dept. GM$	$_____	
Dept. GM%	_____	%

Figure 14.9.

VENDOR LOG

Merchandise Category **Accessories**

Price Range **$39 - $52**
Avg. GM **44%**

Company Name **Shades**

Rep. Name **Debi Tolts**

Street Address _____ Address _____

City, State _____ City, State _____

Zip Code _____ Zip Code _____

Telephone _____ Tele. _____

INVOICE ADDRESS (if different) _____ Reg./Dist. Mgr. **Joe Slas**

Street _____ Mgr. Tel. _____

City, State _____ President **Warren Zotts**

Zip Code _____ Pres. Tel. _____

Credit Manager _____ Tel. _____

Customer Service Contact or Mgr. **Mary Wallis** Tel. _____

TERMS AND POLICIES

PRICING

Payment Terms **Net 30**

Rebates _____

Quantity Disc. **✓** Trade Disc. **—**

Seasonal Disc. **✓** Promo Disc. **✓**

GUARANTEED SALE POLICY

N/A

DISTRIBUTION

Limited Distribution _____

Mass Distribution **✓**

RETURN PRIVILEGES

Exchange Priveleges **regularly exchanges styles**

Damages **} yes but not on on-going basis**

Defectives **} they pay freight on defectives**

Slow Sellers **exchanges only**

OFF-PRICE MERCHANDISE-OP

Close Outs **end of season opportunities**

From Regular Lines **—**

PRODUCT MODIFICATION

Exclusives **} can produce Private Label**

Private Label **} for exclusives - very high**

Packaging **} minimum quantities**

Labeling **}**

DELIVERY

Freight Charges **F.O.B. Factory**

Turn Time **3 weeks**

Cancel. Agreement **negotiable**

No Back Orders **✓**

CONSIGNMENT POLICY

N/A

TICKETING

(Yes) No _____

Date Coding **—**

ALLOWANCES

Advertising **3% net purchases**

Markdown $'s **negotiable**

Volume **yes**

Display **N/C picture**

Shelf **—**

SALES AIDS

Type **Sales staff gimmick buttons**

NEW ITEM INTRO.

Promotions **in-store events**

P.O.P. Displays **—**

Premiums **free sunglasses cases**

Register to Win **wardrobe of sunglasses**

Figure 14.10.

VENDOR SUPPORT

Maintains Stock Books w/Sales Records *sloppy records, hard to decipher results*

Rotates and Maintains Stock *rarely works stock*

Writes Credits/Returns Each Visit *Forgets return authorization labels*

Notifies, In advance, of Price Increases *CO does — yes —*

Communicates Competitive Activities *discusses successes of others*

Cordial with Staff *staff looks forward to visits, although brief*

Trains Staff *supplies "push" monies, sales contests, product information*

ADDITIONAL COMMENTS

Key Items *Reflector styles*

Timing, Seasonality *ships 80% complete*

Competitors *Clickers*

Figure 14.10. (continued)

VENDOR LOG

Merchandise Category **Accessories**

Company Name **Clickers**

Street Address	
City, State	
Zip Code	
Telephone	
INVOICE ADDRESS (if different)	
Street	
City, State	
Zip Code	
Credit Manager	
Customer Service Contact or Mgr. **Marjie Ladd**	

Price Range **$39 – $52**

Avg. GM **44%**

Rep. Name **Cindi Barn**

Address	
City, State	
Zip Code	
Tele.	
Reg./Dist. Mgr. **Ron Hubbard**	
Mgr. Tel.	
President **Sam Smith**	
Pres. Tel.	
Tel.	
Tel.	

TERMS AND POLICIES

PRICING

Payment Terms	**Net 30**
Rebates	—
Quantity Disc.	✓
Seasonal Disc.	✓

Trade Disc. **—**

Promo Disc. **✓**

DELIVERY

Freight Charges	**F.O.B. Store**
Turn Time	**2 weeks**
Cancel. Agreement	**negotiable**
No Back Orders	✓

GUARANTEED SALE POLICY

N/A

CONSIGNMENT POLICY

N/A

DISTRIBUTION

Limited Distribution _____

Mass Distribution **✓**

TICKETING

(Yes)/No _____

Date Coding **—**

RETURN PRIVILEGES

Exchange Privileges **regularly exchanges**

Damages **writes up damages each visit**

Defectives **must have box & wrapping or pay 10% restocking charge**

Slow Sellers **exchanges only**

ALLOWANCES

Advertising	**3% net purchases**
Markdown $'s	**no**
Volume	**yes**
Display	**N/C fixture**
Shelf	**—**

OFF-PRICE MERCHANDISE-OP

Close Outs **end of each season**

From Regular Lines **never**

SALES AIDS

Type _____

PRODUCT MODIFICATION

Exclusives	
Private Label	} **lacks capacity to create private label goods**
Packaging	
Labeling	

NEW ITEM INTRO.

Promotions	**—**
P.O.P. Displays	**—**
Premiums	**—**
Register to Win	**biking trip**

Figure 14.11.

VENDOR SUPPORT

Maintains Stock Books w/Sales Records _excellent records_

Rotates and Maintains Stock _every month consistently works the stock_

Writes Credits/Returns Each Visit _yes_

Notifies, In advance, of Price Increases _yes_

Communicates Competitive Activities _no - maintains confidentiality policy_

Cordial with Staff _attitude problem w/ sales staff_

Trains Staff _lacks patience to develop people_

ADDITIONAL COMMENTS

Key Items _Bright colors_

Timing, Seasonality _ships 90% complete_

Competitors _Shades_

Figure 14.11. (continued)

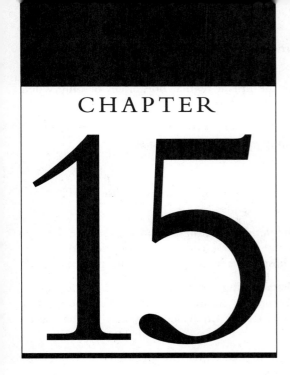

CHAPTER

15

Vendor Opportunities

A prepared vendor has the necessary set of skills to develop and build successful retailer partnerships. Such a vendor recognizes the needs and expectations of not only the retailer, but the retailer's targeted customer group, and tailors his or her presentation toward satisfying their common needs and wants. This creates a WIN/WIN partnership between the vendor and retailer.

Unless it is a potential new customer, the vendor evaluates the retailer's performance in advance of each meeting. The following quote by a leading apparel industry chairman and CEO clearly states the importance of periodically evaluating retailers. "If the only way for retailers to make money is for us to lose money, then we're in trouble. Good partners believe in shared risks and share in each others' problems."

PREPARATION FOR EVALUATING RETAILER PERFORMANCE

Vendors should ask the following questions when evaluating retailers:

1. *Merchandise assortment*

 a. Does the retailer know his or her customers, their size, color, style, and fabric preferences, their price line structures, and the available monies per classification, or is the vendor expected to write the retailer's order and then provide markdown dollars or return authorizations for the items that did not sell?

 b. Are items, not cohesive merchandise assortment statements, being purchased so that a fair representation is not possible, thereby, hurting the product line's potential for success, or are the select items the *right* items grouped with others to make a statement and draw the attention of customers?

 c. Does the retailer allow a build-up of out-of-style, damaged, and defective merchandise, which ties up monies for new, fresh receipts and makes a poor presentation to customers, or is this merchandise handled on a regular basis?

2. *Price and terms*

 a. Is the retailer pricing higher than the vendor's suggested retail or the surrounding competition and slowing the sale of goods, or is he or she effectively pricing the goods for movement and profit?

 b. Are cash discounts taken after the dating period expires or within the contract purchasing terms?

 c. Does the retailer promptly commit to orders to secure the available merchandise offerings or delay until the majority of items desired are no longer available?

 d. Are accurate purchase orders provided with clear ship/cancel dates or are quoted purchase prices, payment terms, and delivery dates altered?

 e. Will the retailer purchase the line at regular line prices or only when off-price?

 f. Are goods prematurely marked down, affecting planned profit results? Is the markdown percent comparable to other retailers?

3. *Delivery*

 a. Does the retailer know the life cycle of the merchandise classifications to properly time the flow of receipts?

 b. Does the retailer allow the vendor to designate how goods are shipped by writing Best Way on the purchase order or clearly designating the carrier to save on freight costs, thus increasing the profit potential?

 c. Is the retailer receptive to establishing *electronic data interchange* (the process by which computer-to-computer communication occurs between a retailer and its suppliers to increase order accuracy and shorten order cycles)?

 d. Are orders refused, although shipped within the specified delivery terms, because of overbought situations of other lines?

 e. What is the turnaround time from receipt to the selling floor? two to 5 days or more?

4. *Promotional assistance*

 a. Does the store support the preplanned promotions? Are they coordinated with the visual and sales promotion departments so signage, prominent display areas, and adequate staffing are provided?

 b. Is the use of "co-op" dollars abused (i.e., applied to the bottom line) or used as intended, to generate sales and produce profits?

 c. Is high visibility newspaper positioning secured to maximize exposure and sales?

 d. Are vendor advertising guidelines followed (i.e., using the proper trademark or company logo)?

 e. Are the quoted advertising costs inflated or accurate?

 f. Are vendor-supplied or "rented" display fixtures stocked only with that vendor's merchandise?

Note: Due to the misuse of vendor-supplied "co-op" monies, many vendors require retailers to forward their ad vehicles (i.e., newspaper, catalog) to an **advertising checking bureau**, a bureau that validates retailer's claims for specific advertising dollars within each trading market in the country.

5. *Reliability*

 a. Does the retailer return phone calls promptly?

 b. Are scheduled appointments kept?

 c. Have there been unwarranted or unauthorized returns and order cancellations?

 d. Will the retailer who has committed to a stock/sales plan support the plan or cut open-to-buy (OTB) dollars although the line is performing according to plan?

advertising checking bureau–bureau that validates retailer's claims for specific advertising dollars within each trading market in the country

6. *Service level*

 a. Does the retailer provide an environment conducive for selling? Are the salespeople rewarded appropriately for their efforts?

 b. Is there proper sales staffing, especially during peak selling hours?

 c. Are fixtures kept stocked or empty? What is the overall housekeeping standard?

 d. Does the retailer allow sales staff to attend sales training seminars? Is staff participation in sales contests permitted?

 e. When returning merchandise, does the retailer remove all store tickets and pack the merchandise carefully?

After evaluating the retailer's performance, the successful vendor builds selling skills by being ready to discuss the retailer's business and profit by:

1. Thoroughly knowing the product line. The vendor should be able to answer questions regarding company purchasing terms, the benefits and features per item, customer demand and response factors, selling cycles, competitive markets, promotional techniques, etc.

2. Having a working knowledge of retail math and the industry's buying terms. The vendor understands how to develop a merchandise plan so that goals are mutually set. The vendor knows how to calculate the OTB dollars and is aware that merchants also track markdown dollars and return goods dollars. This enables the vendor to include the markdown and return dollar figures in the next order to bring the merchandise assortment up to the planned stock level. (Some retailers do not allow the inclusion of markdown dollars unless they are for promotional purposes and cooperatively provided by both parties.)

3. Realizing the importance of knowing the "numbers." If a retailer has allocated additional dollars to another resource, someone's OTB will be cut, and the vendor ensures that his or her mutually agreed on stock/sales plan and its corresponding OTB dollars will stay intact.

4. Visiting the selling floor before any meeting to:

 a. Monitor the traffic patterns

 b. Observe the customers and look for possible changes taking place

 c. Talk with the sales staff and receive their feedback about what is selling and what is not and what missed sales opportunities exist. This builds a rapport that usually results in an increased sales effort for a vendor's particular line.

 d. Review the merchandise assortment. Are out-of-stock situations noted? Is there a build-up of items? The vendor may also physically count the merchandise, stock, rotate the assortment (oldest to the front), and merchandise the presentation.

 e. Listen to the customers and sales staff about the overall operation, consumer trends, economic trends, etc.

5. Prepare additional analyses of the business, which may include:

 a. Weeks of supply analysis per item to reinforce the overall order (This may protect the vendor's allocated order dollars, because some retailers will switch methods when approving orders. This can circumvent the reduction of the mutually planned receipts.)

b. Sales per square foot of selling space analysis to discuss the necessity for increased display space

c. Create promotional events to further increase sales. This may include an educational selling seminar for the staff, a scheduled vendor event on the selling floor, or a special gift offering with any purchase.

PRESENTATION GUIDELINES

Now that the vendor has gathered the facts on the performance of his or her line, he or she will create the presentation tailored for the specific customer. This will include:

1. Voicing a statement or question to gain the retailer's attention—perhaps by positively recapping his or her observations while visiting the selling floor, or by asking, "Are you aware that another sports specialty store is considering opening within 15 miles of your store?"

2. Identifying specific account needs and solutions (benefits) to meet them—"I noticed the fixturing is tilting and was unable to correct the problem. Are you aware that we offer a fixture replacement program?"

3. Anticipating the retailer's objections, thus formulating responses (based on previously gathered facts, i.e., sales analyses, promotional plans) to overcome them.

4. Determining his or her limits in negotiating to secure signed purchase orders. What concessions may be necessary? What is a minimum acceptable order amount? Are there slow sellers or damages that should be returned or exchanged? Should markdown dollars be provided? These are possible allowances a vendor may be willing to make.

Note: The astute vendor will have already preplanned an approach to clear out the slow movers and replace the items with new merchandise. This vendor would try to have the stock remain in the store to reduce handling, freight, and possible restocking charges. The initial receipt quantity would have been confirmed, sales and the percent sell-through calculated, and the potential markdown dollar allottment readied to negotiate with the retailer. Slow sellers should be acknowledged, not ignored, to avoid having the retailer bring up problem areas, which the vendor is responsible for overseeing. It benefits both parties to stock the strength of a line to avoid build-ups of slow sellers.

5. Establishing his or her approach to ask for the order to avoid a "yes" or "no" response. The vendor may possibly ask, "Would you like to receive the merchandise at the beginning or at the middle of the month?"

SELF QUIZ

1. Review the questions vendors consider when evaluating retailers. List the buying approaches of retailers that vendors find build mutually profitable WIN/WIN partnerships.

2. Explain what occurs when retailers allow out-of-style, damaged, and defective merchandise of a vendor's to build-up.

3. List the 5 retail selling skills each vendor should possess.

4. When retailers price a vendor's product line higher than the surrounding competition, what is the potential result?

SELLING TOOLS

In selling his or her product line to the retailer, the vendor can use five selling tools to make the sale—*planograms*, *sales per square foot*, *fixture analysis*, *weeks of supply per item analysis*, and *percentage of increase analysis*.

PLANOGRAMS

planogram—item-by-item fixture presentation guidelines

Planograms are item-by-item fixture presentation guidelines based on:

1. Space allocated for each product line

2. Merchandise mix

3. Number of items that comprise the assortment

4. The per item rate of sale, stock turn, gross margin, and size

5. Visual presentation

Although time consuming to create, planograms can secure designated display space on specific traffic aisles for maximum impact of the resource's categories. For All Seasons' display of exercise weights is illustrated in Figure 15.1.

SALES PER SQUARE FOOT

sales per square foot—calculated by dividing sales for specific time period by selling area or total store square footage

Sales per square foot determines the effectiveness of designated display space. It may be computed based on the selling area or the total store areas. The best method is the selling area, excluding the stock room and maintenance area square footage.

Formula for Calculating Sales per Square Foot

$$\frac{\text{Sales for Specific Period}}{\text{Selling Area Square Feet}} = \frac{\$12,000}{12,000} = \$1.00 \text{ Sales per sq. foot}$$

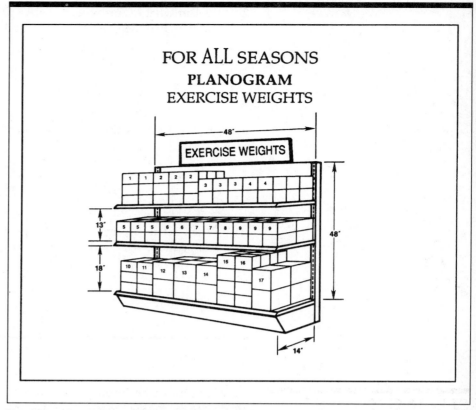

Figure 15.1. For All Seasons' Planogram Exercise Weights

FIXTURE ANALYSIS

In determining the effectiveness of fixture display space, often the linear shelf foot computation is used. A **linear shelf foot** is the total number of consecutive feet (or inches) of shelf space occupied by a vendor's product or line assortment. Each item displayed on the front line of a shelf or in a display case is called a **facing**. Additional pieces are stocked behind and possibly on top of the facing. The sum total of the product line's height and depth units, when fully stocked, is the **shelf inventory**, which may be stated in cost or retail dollars and number of units.

If a vendor's line is merchandised on one full shelf of a four-shelf fixture and each shelf measures 36 inches, the assortment occupies 3 linear shelf feet. If the vendor's line is displayed on half of the 36-inch shelf, the assortment occupies 1 1/2 linear shelf feet. When a vendor's line occupies the total fixture, then the total number of shelves is multiplied by the total number of consecutive feet (or inches). For example, a vendor's line occupies a total fixture, which has four 36-inch long shelves. Four shelves multiplied by the total number of consecutive feet (3) equals 12 linear shelf feet. Also refer to Figure 15.1, which illustrates a 3-shelf fixture with each shelf 48 inches (4 feet) long. If a vendor's goods occupy the total fixture, the linear shelf feet totals 12.

The linear shelf foot is the basic measurement of shelf occupancy. The number of feet (or inches) of occupied shelf space is a basis of comparison and allows for the computation of **sales per linear shelf foot.**

Formula for Calculating Sales per Linear Shelf Foot

Step 1: Determine the linear shelf foot, which is the number of feet (or inches) of consecutive front shelf space allocated to each item.

linear shelf foot–number of consecutive feet, or inches, of front shelf space allocated to an individual item

facing–each item displayed on the front line of a shelf or in a display case

shelf inventory–sum total of product line's height and depth units when fully stocked

sales per linear shelf foot–calculated by dividing sales for a specific time period by linear shelf feet

Step 2: Compute the sales rate per linear shelf foot:

$$\frac{\text{Sales for Specific Period}}{\text{Linear Shelf Feet}} = \text{Sales per Linear Shelf Foot}$$

EXAMPLE:

$$\frac{\$100 \text{ Weekly Rate of Sale}}{10 \text{ Linear Shelf Feet}} = \$10 \text{ Sales per Linear Shelf Foot}$$

WEEKS OF SUPPLY ANALYSIS PER ITEM

As discussed in Chapter 10, "Ordering Systems," the *weeks of supply method of ordering* bases orders on recent weekly sales rates and the number of weeks of inventory on hand and on order. The **weeks of supply analysis per item** is a summary reflecting current sales trends and allowing the comparison to planned stock turn rates. It supports the rationale of the order(s) the vendor is presenting to the retailer for approval by reinforcing the mutually agreed on merchandise plan and concurrent OTB figures to maintain the proper stock-to-sales ratio balance of the vendor's merchandise. It is an effective tool in situations when the retailer attempts to reduce the vendor's specific OTB dollars due to "giving" another vendor extra dollars or attempts to correct another vendor's overbought situation due to poor sales performance.

weeks of supply analysis per item–summary reflecting current sales trends and allowing comparison to planned stock turn rates

EXAMPLE:

As illustrated in Chapter 10, the formula for calculating weeks of supply is as follows:

$$\frac{\text{Number of Weeks in Planning Period}}{\text{Planned Stock Turn}} = \textbf{Planned Number of Weeks Supply}$$

A season equals 26 weeks. To achieve a stock turn of 3 turns:

$$\frac{26}{3} = 8.67 \text{ weeks of supply on hand per item (8.666)}$$

To determine the order quantity assume weekly sales of 12:

$$\frac{\text{Total on Hand Pieces + On Order}}{\text{Average Weekly Sales}} = \frac{60 + 24}{12} = \textbf{7 Weeks of Supply}$$

Average Weekly Sales	12
× Planned Number of Weeks of Supply	× 8.67
Order-up-to Level	**104.04**

Order-up-to Level	104 pieces
– Total Inventory	– 84
Order Quantity	**20 pieces**

PERCENTAGE INCREASE ANALYSIS

percentage increase analysis–reflects the successful performance of vendor's line

Percentage increase analysis reflects the successful performance of the vendor's line. Consistent (2 to 3 months) increases in sales of their goods signifies a sales trend and the opportunity to propose an increase in inventory levels and projected

sales to maximize the sales and profit potential. Vendors who continually analyze the performance of their offerings and provide retailers with solid, financial data have a competitive edge over vendors who do not.

This simple, straightforward calculation lets the retailer know that the vendor is monitoring the movement of goods.

EXAMPLE:

Planned December sales for a vendor's line of all weather parkas was $4,350.00. Actual sales totaled $5,895.00 for the month of December.

To calculate the percentage increase in parka sales:

First, compute the dollar amount difference in sales.

$$\begin{array}{rl} \$5,895.00 & \text{Actual December Sales} \\ - \ 4,350.00 & \text{Planned December Sales} \\ \hline \$1,545.00 & \textbf{December Dollar Difference} \end{array}$$

Second, divide the dollar difference by the planned sales figure.

$$\frac{\$1,545.00}{\$4,350.00} = \frac{.36}{(.355)}$$

Third, convert the decimal to a percent.

$$\begin{array}{r} 100 \\ \times \ .36 \\ \hline \textbf{36\%} \end{array}$$
or: Move the decimal point to 2 places to the right and add the percent sign (%).

To calculate a sales trend, 2 or 3 months' planned sales figures and 2 or 3 months' actual sales would be added together and then the formula steps would be followed.

Note: Vendors should also regularly check for percentage decreases. A percentage decrease signals that the vendor must determine if the retailer's total store business is down or if components of the current assortment are not properly addressing the retailer's customers needs.

SELF QUIZ

1. Compute sales per square foot.

Sales	$50,000
Square feet	5,000
Sales per square foot	_____
Sales	$78,950
Square feet	4,300
Sales per square foot	_____

2. 16 products are displayed, 3 deep, on a shelf measuring 72 inches. Weekly sales average $264.00. Compute the following:

Number of facings	_____
Linear shelf foot	_____
Shelf inventory	_____
Sales per linear shelf foot	_____

For WIN/WIN partnerships to be effective, the resource must treat the retailer as he or she would like to be treated. Fair and honest relations will generate more goodwill and business in the long run. The vendor who leads merchants away from slow moving items to increase the retailer's dollar return on the inventory investment builds credibility while serving the retailer's goal of meeting the targeted customer group needs and producing a profit. In turn, reorders will occur more frequently and a profitable business partnership will be developed for both the vendor and retailer.

Unless a vendor plans to relocate frequently, he or she must work to serve the retailer and the retailer's targeted customer group through the negotiating process of give and take. WIN/WIN rewards will follow.

Remember, an unscrupulous reputation is almost impossible to erase.

CHAPTER REVIEW

1. List the potential retailer abuses that can damage WIN/WIN partnerships.

2. Explain why the vendor ultimately has two customers to provide services for when building a WIN/WIN partnership.

3. What benefits does the vendor gain from visiting the selling floor before meeting with the retailer?

4. Describe the selling opportunities the vendor can formulate after thoroughly evaluating a retailer's performance.

5. Explain the difficulties the vendor encounters when the retailer is not knowledgeable about his or her business.

6. List and discuss four ways in which the vendor should prepare for meetings with retailers.

7. What may occur when a vendor lacks the understanding and working application of retail math?

8. What types of analyses would the vendor prepare to better serve the retailer? Define and describe three.

9. As the major vendor of ladies' exercise wear, you must preplan promotional events to support your proposed seasonal merchandise plan. Create and describe three promotional events to present at your upcoming For All Seasons meeting.

10. You represent a line of goods not presently carried by For All Seasons. Select an accessory, apparel, or sports equipment line to introduce to For All Seasons and prepare a sales presentation. Your sales presentation must include:

 * Thorough product line presentation, including product pictures
 * Profit potential figures
 * Suggested merchandise presentation
 * Introductory promotional event

 Be prepared to overcome the following For All Seasons' buying objections:

 "This is similar to a line currently stocked."

 "I used to carry this line and did fairly well, but then the vendor stopped servicing my account."

1. Given the following information, calculate and write in the sales per shelf foot.

	Total Tennis Balls Sales Area	Vendor #1
Shelf feet	20	5
Sales volume	$1,750.00	$470.00
Sales per shelf foot	$_____	$_____

2. Use the provided information to compute sales per square foot.

	Total Selling Area	Sports Equipment
Square feet	35,000	14,000
Sales volume	$1,750,000	$525,000
Sales per selling area square foot	$_____	$_____

3. For All Seasons' quarterly sales results for swimwear totaled $15,500. Two hundred square feet of selling area is allocated for swimwear. Compute the sales per square foot.

4. Sun products are displayed on the top shelf of a fixture that has three shelves. Each shelf is 3 feet long. Last month's sales were $3000.00.

 a. Calculate the linear shelf feet for sun products.

 b. What is the sales per linear shelf foot figure?

5. The winter ski season lasts approximately 16 weeks. For All Seasons plans to achieve a stock turn of 3 during the winter ski season for its ski poles. The weekly sales rate is 20 pairs, there is a quantity of 50 pairs on hand, and 15 pairs are on order. Calculate the weeks of supply, order-up-to level, and order quantity for ski poles.

6. Refer to the fixture illustrated in Figure 15.1 (page 336) to complete the following exercise.

 a. How many facings are on the top shelf?

 b. Compute the top shelf's total inventory in units.

 c. An equal amount of front shelf space is allocated to each product displayed on the top shelf. Determine the linear shelf foot and then compute the sales per linear shelf foot for the products numbered 1, 2, 3, and 4. Write your answers on the provided lines below.

	Shelf Foot	Rate of Sale	Sales per Shelf Foot
Item 1	_____	$100	$_____
Item 2	_____	$150	$_____
Item 3	_____	$120	$_____
Item 4	_____	$ 80	$_____

7. As a For All Seasons sunglasses vendor, you have just caught up posting the last 3 month's sales results. The results are:

Month	Planned Sales	Actual Sales
May	$ 700	$ 800
June	$ 900	$1100
July	$1000	$1250

 a. Calculate the percentage increase in sunglasses sales for the month's of May, June, and July.

 May _____% Increase

 June _____% Increase

 July _____% Increase

 b. What missed opportunity existed? What steps can the vendor take to improve the performance of this line?

8. As the vendor of 100% cotton mesh knit (pique) unisex polo shirts you must prepare a week's supply analysis per color for your upcoming meeting. The season's planned polo shirt stock turn is 2.5.

Color	On Hand	On Order	Avg. Week Sales	Week's Supply	Order-up-to Level	Order Quantity
Denim	30	12	6			
Coral	41	36	8			
White	62	–	12			
Navy	28	12	6			
Orange	54	60	10			
Royal	36	24	7			

 a. Calculate the weeks of supply, the order-up-to level, and order quantity for each color polo shirt and write the answers in the chart provided.

 b. Analyze and explain the results. Are there any understocking or overstocking problems? Will the retailer easily approve the written order? What potential questions might the retailer ask?

9. Refer to the total selling area allocated for the ladies sports apparel vendor Maxtek as illustrated in Figure 15.2 to answer the following questions.

 a. Each hanging rod section represents 3 feet of selling area. What is the total amount of selling area allocated to this vendor?

 b. Total Maxtek apparel sales for the week were $4,400.00. Calculate the sales per square foot.

c. The display inventory consists of:

30 Down parkas	@ $175.00
15 Fleece pullovers	@ $ 65.00
10 Storm jackets	@ $140.00
22 Anorak jackets	@ $155.00
24 100% wool sweaters	@ $ 85.00

Determine the total dollar inventory figure for the allocated Maxtek selling area.

d. For All Seasons' selling season for down parkas is 12 weeks. The desired stock turn is 3. Total parkas on hand equals 21, with 9 on order. Ten parkas are sold on the average each week. Calculate the weeks of supply, the order-up-to-level, and the order quantity.

e. Use the information provided to determine the percentage increase in sales for November and December. Then calculate the 2-month percentage increase in sales.

Month	Planned Sales	Actual Sales
Nov.	$7,100	$7,230
Dec.	$7,900	$8,400
Nov.	_____ % Increase	
Dec.	_____ % Increase	
Total	_____ % Increase	

f. Analyze the results and prepare for next week's meeting at For All Seasons.

10. Figure 15.3 illustrates For All Seasons' wall selling area designated for men's sports apparel. It measures 12 feet high. Each hanging rod section is equal to 3 feet. Vendors A and C were each allocated 40% of the selling space. Total monthly sales for this area average $15,000, out of which vendor A generates 39% of the total sales volume, vendor B 28%, and vendor C 33%.

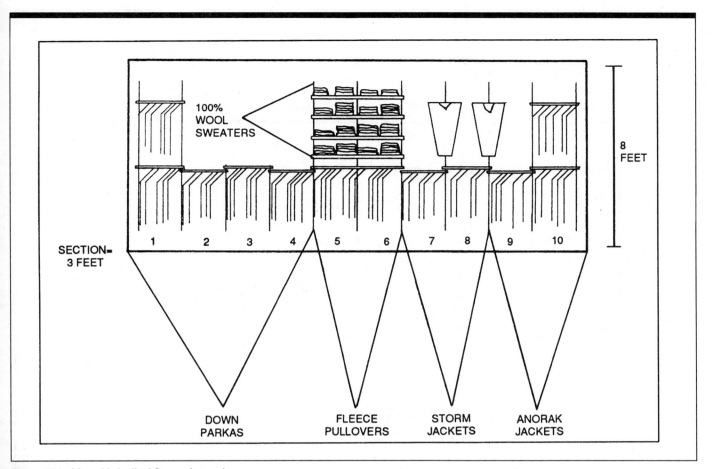

Figure 15.2. Maxtek's Ladies' Sports Apparel

a. What is the total wall selling area designated for these three vendors?

b. Determine the total amount of selling area allocated to vendor A, B, and C.

c. Calculate the average monthly sales each vendor generates.

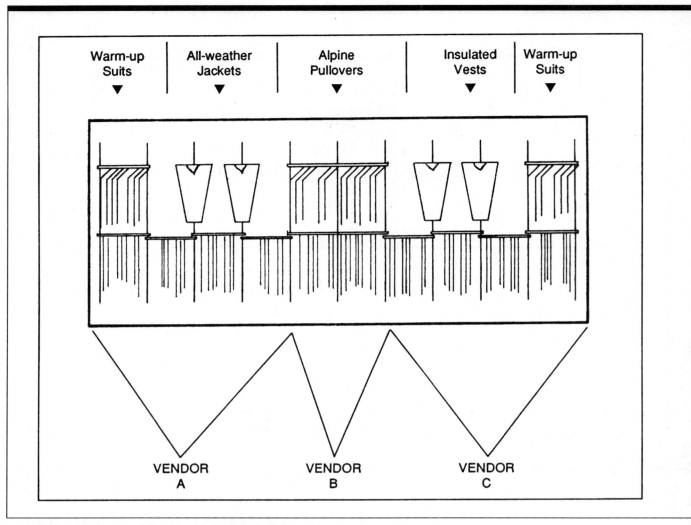

Figure 15.3. For All Seasons' Planogram for Men's Sports Apparel

d. Compute the sales per square foot for the total selling area and for each vendor.

e. Vendor C consistently contributes 33% of the total sales yet is allocated 40% of the space. The retailer advises the vendor that sales are not warranting the allotted space and requests immediate solutions to remedy this problem. Be specific in describing solutions for this vendor's problem.

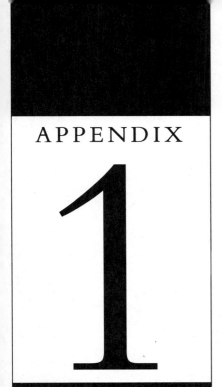

APPENDIX 1

Calculator Review

Calculators come in a variety of styles. However, this review will focus only on the operation of the minicalculator, which runs on solar or battery power and does not come equipped with a paper tape (see Figure A1.1).

Review the keys and their locations on your calculator because formats will vary. All calculators include basic arithmetic abilities, including addition, subtraction, multiplication, and division. Some will also include the automatic computation of percents and square roots and will have memory capabilities (keys lettered beginning with *M*). Each calculator will also have a clear key to erase a number entered in error. In Figure A1.1 the clear key is lettered *CE/C*.

To turn on your calculator, press the *ON* key. In Figure A1.1 this key is lettered *AC* with *on* noted above. The calculator will display a zero (0).

To perform a desired calculation, illustrations using the whole numbers twenty (20) and five (5) are as follows:

ADDITION

	20	5
	+ 5	+ 20
	25	25

Operation:

Enter	20	5
Press	+	+
Enter	5	20
Press	=	=

The calculator display shows 25 for both examples.

SUBTRACTION

	20
	− 5
	15

Operation:

Enter	20
Press	−
Enter	5
Press	=

The calculator display shows 15.

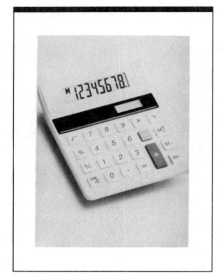

Figure A1.1. Standard Calculator

Operation:

Enter 5

Press −

Enter 20

Press =

The calculator display shows −15.

MULTIPLICATION

$$
\begin{array}{r} 20 \\ \times\ 5 \\ \hline 100 \end{array}
\qquad\qquad
\begin{array}{r} 5 \\ \times\ 20 \\ \hline 100 \end{array}
$$

Operation:

Enter	20	5
Press	×	×
Enter	5	20
Press	=	=

The calculator display shows 100 for both examples.

DIVISION

$$
\frac{20}{5} = 4 \qquad\qquad \frac{5}{20} = .25 = 25\%
$$

Operation:

Enter	20	5
Press	÷	÷
Enter	5	20
Press	=	=

The calculator display shows 4 for the example on the left and .25 for the right hand example.

PERCENTAGES

The percent key (%) is a valuable tool in calculating percentages, percentage ratios, percentage add-ons, and percentage discounts. The percent key (%) quickly calculates the percentage of a number. By using the percent key to complete a division problem, the calculator automatically multiplies the result by 100 to quickly determine a percentage ratio. When a percentage calculation is followed by the + or − key, the calculator automatically adds or subtracts the percentage from the principal amount to compute percentage add-ons and discounts.

PERCENTAGE OF A NUMBER

$$\begin{array}{r} 20 \\ \times\ 5\% \\ \hline 1 \end{array}$$

Operation:

Enter 20
Press ×
Enter 5
Press %

The calculator display shows 1.

PERCENTAGE RATIOS

$$\frac{5}{20}\ =\ 25\ =\ 25\%$$

Operation:

Enter 5
Press ÷
Enter 20
Press %

The calculator display shows 25.

PERCENTAGE ADD-ON

$$\begin{array}{r} 20 \\ \times\ 5\% \\ \hline 1 \end{array}$$

$$\begin{array}{r} 20 \\ +\ 1 \\ \hline 21 \end{array}$$

Operation:

Enter 20
Press ×
Enter 5
Press %
Press +
Press =

The calculator display shows 21.

PERCENTAGE DISCOUNT

$$\begin{array}{r} 20 \\ \times\ 5\% \\ \hline 1 \end{array}$$

$$\begin{array}{r} 20 \\ -\ 1 \\ \hline 19 \end{array}$$

Operation:

Enter	20
Press	×
Enter	5
Press	%
Press	−
Press	=

The calculator display shows 19.

PERCENTAGE CHANGE

Percentage change may be easily computed using a minicalculator. Some models may include a specific percentage change key that quickly calculates percentage change. However, the minicalculator in this appendix does not have this function key so percentage change will be outlined the long way.

EXAMPLE:

The retail price of ski gloves has increased from $19.00 a pair to $24.00 per pair. What is the percentage increase in the price?

$$\begin{array}{r} \$\ 24.00 \text{ New Retail} \\ -\ \underline{19.00 \text{ Old Retail}} \\ \$\ \ \textbf{5.00 \$ Change} \end{array}$$

$$\frac{\$\ 5.00 \text{ \$ Change}}{\$\ 19.00 \text{ Old Retail}} = \ \textbf{\$26.3\% Increase}$$

Operation:

Enter	24.00
Press	−
Enter	19.00
Press	=
Press	÷
Enter	19.00
Press	=

The calculator display shows .263. To convert the decimal to a percent, move the decimal point 2 places to the right and add the percent sign, 26.3%.

MEMORY OPERATIONS

The memory function within a calculator allows entered values to be stored for the solving of more complex problems. The minicalculator as shown in Figure A1.1 includes the following memory keys:

Key	Function
M+	Adds the value of the number on the display to the value stored in the calculator's memory.
M−	Subtracts the value of the number in the display stored in the calculator's memory.
MRC	Recalls the resultant value from a sequence of memory calculations within the memory and displays it.

Using these keys, the calculator stores the entered values. The *M* in the display appears when any value other than zero is stored in the memory of the calculator.

The calculator's memory keys enable the solving of more complex problems in a sequence.

$$(20 \times 5) - (20 \div 5) + (20 + 5) = 121$$

Operation:

Enter	20
Press	×
Enter	5
Press	M+
Enter	20
Press	÷
Enter	5
Press	M−
Enter	20
Press	+
Enter	5
Press	M+
Press	MRC (memory recall)

The calculator shows 121.

CLEAR KEY OPERATIONS

The calculator's clear key (CE/C) allows the erasure of a number entered in error. This key becomes particularly useful when a number is entered by mistake during calculations involving a long sequence of entries.

For example, the desired calculation is:

$$5 + 10 = 15$$

Now, assume that the number 6 is entered in error instead of 5:

$$6 + 10 =$$

Operation:

Enter	6
Press	CE/C
Enter	5
Press	+
Enter	10
Press	=

The calculator display shows 15.

The clear key may also be used during memory operations.

The desired calculation is:

$$(20 \times 5) - (20 \div 5) + (20 + 5) = 121$$

Again, assume that the number 6 is entered instead of 5:

$$(20 \times 6) - (20 \div 6) + (20 + 6) =$$

Operation:

Enter	20
Press	×
Enter	6
Press	CE/C
Enter	5
Press	M+
Enter	20
Press	÷
Enter	6
Press	CE/C
Enter	5
Press	M−
Enter	20
Press	+
Enter	6
Press	CE/C
Enter	5
Press	M+
Press	MRC

The calculator display shows 121.

APPENDIX 1 REVIEW

1. For All Seasons has just received a shipment of 45 pairs of ski boots from its supplier. With in-store stock of 9 pairs before receipt of the shipment, what is the total number of ski boots now on hand?

2. Fourteen pairs of silk long underwear had been returned after Christmas for various reasons. Two pairs of each size—S, M, L—were returned to stock and the others were returned to the vendor. How many pairs were sent back to the vendor?

3. Five hundred dollars was allocated for the purchase of beach towels. How many beach towels can be purchased if they cost $14.25 each?

4. The cost per pair of cross country skis is $126.00. The initial markup is 30%. Calculate the retail price.

5. For All Seasons' stock of ladies cashmere sweaters totals 40 pieces. If 85% of the total stock is sold, how many sweaters remain?

6. Sales increased 9% over last year's sales. Last year's department sales totaled $675,000.

 a. What was the dollar amount of this year's sales?

 b. If next year's department sales are planned at $792,000, what is the planned percentage increase over this year's sales?

7. For All Seasons' spring sale event offers savings between 30% and 50%. What is the average discount a customer will receive?

8. The total stock of down jackets was 100 pieces. Each jacket cost $75.00. Of the 100 jackets, 60 sold at the original retail price of $155.00, 15 were sold during a special sale for $105.40 each, and the remainder were sold at the clearance price of $89.99.

 a. Calculate the average markup percent.

 b. Compute the average sales price of the jackets.

 c. How many jackets would have to be sold at $155.00 to realize a total profit of $800.00?

9. For All Seasons plans to expand its line of swimwear by 25% and reduce its sunglasses assortment by 10%. The total number of swimsuits currently in stock is 68, and the total number of sunglasses currently in stock is 40 pairs.

 a. How many swimsuits will be on hand after the increase in stock occurs?

 b. How many pairs of sunglasses will be on hand after the assortment is reduced?

10. For All Seasons stocks thermal insulated ski gloves. Of the 40 pairs in stock, 10 are black, 5 are royal blue, 7 are white, 12 are red, and 6 are hunter green. What percentage of the total are each of these colors of ski gloves?

11. An annual summer promotion produced $115,000 in sales. This was a sales increase of $9,550.00 over last year's summer promotion. What percent did sales increase?

12. Total sales for the 4th of July sales event were $27,559.28. The average sale was $224.71. How many sales transactions occurred?

13. For All Seasons' sales staff experienced numerous requests for a particular brand of roller blades. Responding to the customer requests, the sports equipment buyer ordered 50 pairs at $73.00 each.

 a. What is the total cost of the order?

 b. What is the retail price of the roller blades if the initial markup percent of 49% is to be achieved?

14. An outerwear stock assortment totals 780 pieces. If patterned ski jackets represent 24% of the outerwear stock assortment, how many patterned ski jackets are stocked?

15. For All Seasons purchased 144 wool rag sweaters that cost $34.00 each and were initially priced at $75.00 each.

 a. Calculate the total cost and retail amounts of this order.

 b. What was the initial markup percent?

 c. If 108 wool rag sweaters sold for $75.00 each, calculate the percent sell-through.

 d. The remaining sweaters were marked down to $59.99. Compute the markdown percent.

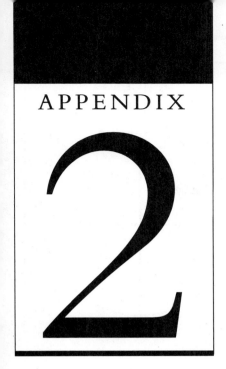

Fractions, Decimals, And Percents

Fractions, decimals, and percents are equivalents and represent parts of a whole, as illustrated in Figure A2.1.

How are these equivalents determined?

FRACTIONS

fractions–used to express a part of a whole; consist of numerator and denominator

numerator–the top number of a fraction; represents a portion of the whole

denominator–the bottom number of a fraction; represents the number of equal parts in the whole

Fractions are used to express a part of a whole quantity. They consist of two components, the numerator and the denominator. The **numerator** is the top number of the fraction and represents a portion of the whole. The **denominator** is the bottom number of the fraction and represents the number of equal parts that make up the whole. The line between the numerator and denominator means "divided by" and indicates that the top number (numerator) is to be divided by the bottom number (denominator).

EXAMPLE:

The circles in Figure A2.1 each represent 100. The circle on the left has been divided into quarters to illustrate that 1 of 4 parts equals the fraction expressed as 1/4.

There are three forms of fractions—*proper fractions*, *improper fractions*, and *mixed numbers*.

PROPER FRACTIONS

proper fractions–fractions with values less than 1; the numerator is less than the denominator

Fractions with values less than 1 where the numerator is less than the denominator are known as **proper fractions** and have the value of less than 1.

EXAMPLES:

$$\frac{1}{2} \qquad \frac{2}{3} \qquad \frac{3}{4} \qquad \frac{1}{4} \qquad \frac{7}{8}$$

IMPROPER FRACTIONS

improper fractions–fractions with values of 1 or more

Fractions with values of 1 or more where the numerator is equal to or greater than the denominator are known as **improper fractions** and have the value of 1 or more.

Figure A2.1. Fraction/Decimal/Percent Pie Chart

EXAMPLES:

$$\frac{9}{4} \qquad \frac{4}{3} \qquad \frac{10}{6} \qquad \frac{12}{5} \qquad \frac{6}{6}$$

MIXED NUMBERS

mixed numbers–fractions made up of a whole number and a fraction

Fractions made up of a whole number and a fraction are known as **mixed numbers**.

EXAMPLES:

1 3/4 2 1/2 5 2/3 7 7/8 10 1/4

CONVERTING IMPROPER FRACTIONS AND MIXED NUMBERS

To convert an improper fraction to a whole or mixed number :

Divide the numerator by the denominator and place the remainder, if any, over the denominator.

EXAMPLES:

$$9/4 = \quad 4\overline{)\,9\,} \begin{array}{r} 2 \\ \underline{-8} \\ 1 \end{array} = 2\tfrac{1}{4}$$

$$6/6 = \quad 6\overline{)\,6\,}^{\,1} = 1$$

$$12/5 = \quad 4\overline{)\,12\,} \begin{array}{r} 2 \\ \underline{-10} \\ 2 \end{array} = 2\tfrac{2}{5}$$

To convert a mixed number to an improper fraction:

The denominator is multiplied by the whole number, then added to the numerator. The sum is then placed over the denominator.

EXAMPLES:

$$2\ 3/4\ =\ \frac{(2 \times 4) + 3}{4}\ =\ \frac{11}{4}$$

$$6\ 7/8\ =\ \frac{(6 \times 8) + 7}{8}\ =\ \frac{55}{8}$$

DECIMALS

decimal fractions–express values less than 1; more commonly known as *decimals*

Decimal fractions, more commonly referred to as **decimals**, are merely another form of fractions. They express values less than 1. Referring to Figure A2.1 again, 1 of 4 parts may be expressed as the fraction 1/4 or as the middle circle illustrates, as .25 in decimal form.

To convert a fraction to a decimal:

First, find the multiplier to raise the denominator to 100.

$$\frac{1}{4}\ \times\ \frac{25}{25}\ =\ \frac{25}{100}$$

Next, divide the numerator by the denominator.

$$\frac{25}{100}\ =\ \mathbf{.25}$$

The number of places to the right of the decimal point designates the value of the denominator. In this example, .25 is the equivalent of 25 hundredths, or, simply expressed, 25/100.

Note: To quickly and easily write a fraction in decimal form, drop the denominator, when expressed as 100, and add the decimal point (.).

CONVERTING DECIMALS

Because decimals make mathematical computations easier, it is important to understand how to convert fractions to decimals. However, it is also important to be able to express them in fraction and percent form when necessary.

To convert a decimal to a fraction:

First, remove the decimal point. The decimal becomes the numerator and the denominator is 1 plus as many zeros as determined by the position of the decimal point.

$$\frac{.25}{100}\ =\ 25$$

Then, reduce the fraction to its lowest terms.

$$\frac{25}{100}\ \div\ \frac{25}{25}\ =\ \frac{1}{4}$$

EXAMPLE:

$$\underline{\text{Decimal}} \quad = \quad \underline{\text{Fraction}}$$
$$.25 \qquad\qquad\qquad 1/4$$

$$.25 \;=\; \frac{25}{100} \;\div\; \frac{25}{25} \;=\; \frac{1}{4}$$

To convert a decimal to a percent:

Move the decimal point two places to the right and add the percent sign or multiply by 100 to remove the decimal point.

EXAMPLE:

$$.25 \;=\; \mathbf{25\%} \qquad \text{or} \qquad .25 \;\times\; 100 \;=\; \mathbf{25.0\%}$$

PERCENTS

percents–fractions or decimals with the denominator of 100

Percents are fractions or decimals with the denominator of 100. The number of components that make up 100 is the percent; 100 is the whole, and the percent sign (%) replaces the denominator of 100. As shown in Figure A2.1, 1 of 4 parts is expressed as 25%.

EXAMPLE:

$$\text{Percent} \;=\; \text{Hundredths}$$

$$\frac{\text{Numerator}}{\text{Denominator}} \quad \text{thus,} \quad \frac{4}{100} \;=\; \frac{1}{25} \;=\; \mathbf{25\%}$$

CONVERTING PERCENTS

To convert a decimal to a percent:

Move the decimal point 2 spaces to the right and add the percent sign (%).

EXAMPLE:

$$.25 \;=\; 25\% \qquad\qquad .54 \;=\; 54\%$$

To convert a fraction to a percent:

Divide the numerator by the denominator to arrive at the decimal form. Then, move the decimal point 2 places to the right and add the percent sign (%).

EXAMPLE:

$$\frac{1}{4} \;=\; .25 \;=\; \mathbf{25\%}$$

To convert a percent to a fraction:

First, remove the percent sign. The percent becomes the numerator and add the denominator of 100.

$$25\% \;=\; \frac{25}{100}$$

Second, divide the numerator by the denominator and reduce to its lowest terms.

$$25\% = \frac{25}{100} \div \frac{25}{25} = \frac{1}{4}$$

To convert a percent to a decimal:

Drop the percent sign (%) and move the decimal point 2 places to the left.

EXAMPLE:

$$25\% = .25 \qquad\qquad 54\% = .54$$

If a percent contains a fraction (i.e., 25 1/2%), express the fraction as a decimal (.50) and then move the decimal point 2 places to the left.

EXAMPLE:

$$25\ 1/2\% = 25.50\% = .255$$

CALCULATING PERCENTAGE CHANGE

percentage change–increase or decrease expressed as a percent

Percentage change is an increase or decrease expressed as a percent. For our purposes, it will be used as an increase or decrease over last year's figures for comparison in the preparation of budgets and forecasts.

EXAMPLE:

Last year's Sales Volume (LY) = $100,000

This year's Sales Volume (TY) = $125,000

To calculate the percentage change over last year:

First, find the dollar amount difference between TY and LY.

$$
\begin{array}{r}
\$\ 125,000 \\
-\ 100,000 \\
\hline
\$\ \ 25,000
\end{array}
$$

Second, divide the difference by LY's sales volume.

$$\frac{\$\ 25,000}{\$100,000} = \mathbf{.25}$$

Third, convert the decimal to a percent.

$$
\begin{array}{r}
100 \\
\times\ .25 \\
\hline
\mathbf{25\%}
\end{array}
$$
or: Move the decimal point 2 spaces to the right and add the percent sign (%).

CALCULATING ON PERCENTAGE

On percentage is a short-cut method of calculating successive or chain discounts through the use of the product of complements. For instance, some vendors will offer *trade discounts*, which are a percentage or a series of percentage discounts that cannot be added together for one percentage calculation. Using the on percentage method makes easier the calculation of offered successive discounts.

EXAMPLE:

A vendor offers the retailer a trade discount of 30, 10 on a $1000 order. To determine the billed cost of this order, the long method of calculation is:

$1000	$1000	$ 700	$ 700
× .30	– 300	× .10	– 70
$ 300	$ 700	$ 70	$ 630

The billed cost of this order is $630.

Formula for Calculating On Percentage

First, find the complement of each offered discount percentage by subtracting the percent from 100.

100%	100%
– 30%	– 10%
70%	90%

Next, multiply the complements to find the product of complements.

$$.70$$
$$\times .90$$
$$.63$$

Finally, multiply the order amount by the product of complements or on percentage.

$$\$1000$$
$$\times \ \ .63$$
$$\$ \ 630$$

The billed cost of this order is $630.

CONVERSIONS MADE EASY

The following conversion table is an easy, at-a-glance tool that may be used to quickly convert fractions, decimals, and percent values. Although it does not contain every possible value, it does include the most common values used by retailers and vendors.

CONVERSION TABLE

Fractions	Decimals	Percents
1/10	.10	10.0%
1/5	.20	20.0%
1/4	.25	25.0%
3/10	.30	30.0%
1/3	.333	33.3%
2/5	.40	40.0%
1/2	.50	50.0%
2/3	.666	66.6%
3/4	.75	75.0%

1. Identify each of the fractions below as *proper, improper,* or *mixed numbers* by placing an X under the correct column.

Fraction	Proper	Improper	Mixed
a. 1/2			
b. 4/3			
c. 2 5/6			
d. 7/8			
e. 1/4			

2. Convert the improper fractions to whole or mixed numbers. Show your computations.

 a. 10/7

 b. 4/4

 c. 15/2

3. Convert the mixed numbers to improper fractions. Show your calculations.

 a. 7 2/3

 b. 4 1/2

 c. 9 3/8

4. For All Seasons stocks wool scarves in a variety of colors. The total in-store stock amounts to 24 pieces. Of the 24, 1/4 are navy plaid. Calculate the following:

 a. How many scarves are navy plaid?

 b. What fraction represents the remaining number of scarves?

5. One hundred pairs of ski poles were sold during the month of December. In January, 133 pairs were sold. Express as a fraction the increase in ski pole sales.

6. If For All Seasons held a special Labor Day sale in which 5/6 of its summer apparel was sold, how many garments would be left over if the total inventory included 120 pieces at the beginning of the sale?

7. During a promotional sale, a customer brought several pieces of merchandise to the check-out register. The items to be purchased included a swimsuit originally priced at $66.00, a beach towel orignally priced at $21.00, and sunscreen originally priced at $6.00. During the promotion, all of the items were 1/3 off. Use the provided information to answer the following questions.

 a. Calculate the promotional price of the swimsuit.

 b. What was the promotional price of the beach towel?

 c. Compute the price of the sunscreen at 1/3 off.

d. What was the customer's total savings realized on the total purchase?

8. A ski goggles display fixture holds 10 pairs of ski goggles. If 2/5 of the display is sold, how many goggles remain on display?

9. Inventory results were as follows:

 4/5 of the total inventory of tennis rackets (50 pieces) have been sold

 7/8 of the total inventory of tennis balls (64 pieces) have been sold

 3/4 of the total inventory of tennis bags (48 pieces) have been sold

 Express as a decimal:

 a. The portion of tennis rackets sold.

 b. The portion of tennis balls sold.

 c. The portion of tennis bags sold.

10. The rectangle in Figure A2.2 represents the actual space used by For All Seasons. Express as both a fraction and a decimal the space allocated for use as a stockroom.

Figure A2.2. Actual Space Utilized by For All Seasons

a. Fraction =

b. Decimal =

11. Given the projected sales per style, express as a fraction the planned portion of merchandise to be sold and the quantities in whole numbers.

Item	On Hand	Proj. Sales	Fraction Form	Whole Number
Boots	40	.50		
Hats	30	.30		
Sunblock	80	.80		

12. Use the information provided to complete the following exercises.

 a. The rectangle in Figure A2.3 represents For All Seasons' total annual sales. Divide and label the rectangle when apparel sales account for .50 of total annual sales, accessories account for .20 of total annual sales, and sports equipment sales account for .30 of total annual sales.

 b. Convert to a fraction:

 .50 =

 .20 =

 .30 =

13. Write the following fractions and decimals in percent form.

 a. 3/4

 b. 9/9

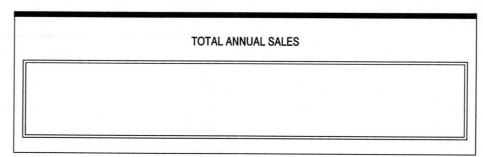

Figure A2.3. For All Seasons' Total Annual Sales

c. 1 1/2

d. .57

e. 1 5/6

f. .122

14. Convert the following percents to decimal form and then to fractions.

	Decimal	Fraction
a. 65%		
b. 82%		
c. 125%		
d. 33%		
e. 15%		
f. 4 3/4%		
g. 6 6/7%		

15. For All Season offers a premium brand of golf clubs at 25% less than the major competitor's. If the competitor's price is $350.00, at what price will For All Seasons sell them?

16. For All Seasons relies on tourism for 60% of its business. If annual sales are $2.5 million, what dollar amount may be attributed to tourism?

17. The inventory of tennis shoes includes four major brands. The total inventory of the four brands is 240 pairs. Of the 240 pairs, 45% are men's and 55% are ladies'. The ladies' shoe assortment size breakdown is 10% size 6, 25% size 7, 35% size 8, and 30% size 9. The men's shoe assortment size breakdown is 5% size 7, 10% size 8, 25% size 9, 20% size 10, 20% size 11, 10% size 12, and 10% size 13.

 a. How many ladies' tennis shoes are included in this inventory? Express as a whole number and in decimal form.

b. How many men's tennis shoes are included in this inventory? Express as a whole number and as a decimal.

c. Compute the number of ladies' tennis shoes per size.

Size 6 = _____

Size 7 = _____

Size 8 = _____

Size 9 = _____

d. Calculate the number of men's tennis shoes per size.

Size 7 =

Size 8 =

Size 9 =

Size 10 =

Size 11 =

Size 12 =

Size 13 =

18. If For All Seasons orders 10% of its merchandise from vendor A, 33% of its merchandise from vendor B, 7% of its merchandise from vendor C, 25% from vendor D, 20% from vendor E, and 5% from vendor F and the total amount of pieces currently stocked in the store is 4,892:

a. What portion does each vendor's merchandise assortment represent written in fraction and decimal form?

b. What is each vendor's total number of pieces of merchandise presently in stock?

Vendor A =

Vendor B =

Vendor C =

Vendor D =

Vendor E =

Vendor F =

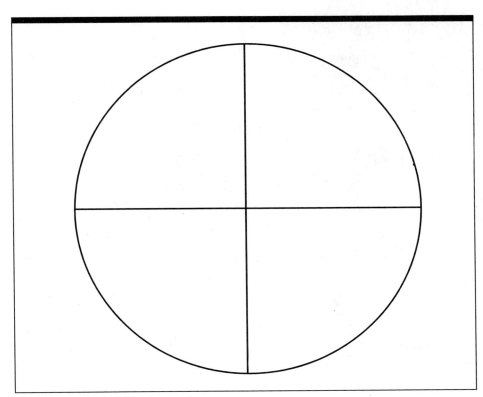

Figure A2.4. Pie Chart

19. Compute the net price for each problem.

List Price	Discounts	Net Price
$300	20, 10	$_____
$425	40, 10	$_____
$580	15, 15	$_____
$600	30, 20	$_____
$725	25, 10, 5	$_____

20. The pie chart in Figure A2.4 represents 100%. Shade in 75% and draw diagonal lines to represent 25%. Use the completed pie chart to answer the following questions.

 a. If an item costs $15.00 and the initial markup percent is 25%, what is the original retail price?

 b. Recalculate the original retail price using 75% as the IMU%.

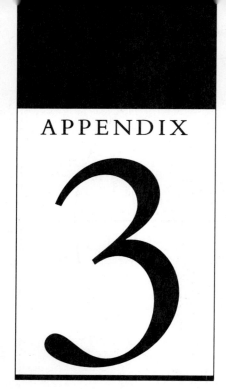

APPENDIX

3

Rounding Numbers and Financial Notation

In certain business situations it is better to simplify numbers to illustrate the facts—in budgets, for example. Rounding numbers and the use of financial notation provides an easy way to perform calculations and clearly present numeric findings when exact numbers are not necessary.

ROUNDING NUMBERS

To round a number, first determine the number to be rounded. Which position is it in? Ones, tens, hundreds or thousands? Or tenths, hundredths, or thousandths? (Refer to Figure A3.1).

The designated number will depend on how accurate the answer needs to be.

Second, examine the number to the right of the designated number. If the number is equal to (=) or greater than (>) 5, the designated number will be *rounded up*, which means increased by 1. If the number to the right of the designated number is less than (<) 5, the number(s) to the right of the designated number will be *rounded down*, which means replaced with zero(s).

ROUNDING UP

EXAMPLE: Rounding up 7,777.777

To the nearest one:

7,777.777 Underline the number designated to be rounded.

7,777.777 Look to the right of the designated (underlined) number. Is the number equal to (=) or greater than (>) 5? In this case, 7 > 5 so the designated number is rounded up.

7,778.000 To round up, increase the designated number by 1 (7 + 1 = 8). Replace the numbers to the right of the rounded up number with zeros.

To the nearest ten:

7,777.777 Underline the designated number.

7,777.777 7 is greater than (>) 5.

7,780.000 Increase the designated number by 1.

Replace numbers to the right of the rounded up number with zeros.

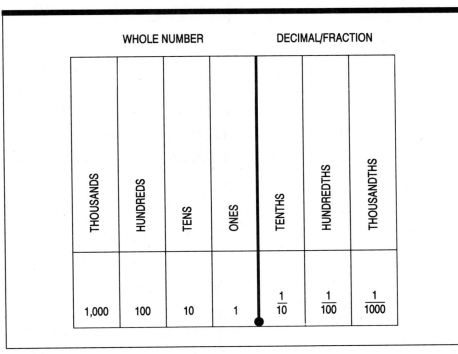

Figure A3.1. Place Value Chart

WHOLE NUMBER				DECIMAL/FRACTION		
THOUSANDS	HUNDREDS	TENS	ONES	TENTHS	HUNDREDTHS	THOUSANDTHS
1,000	100	10	1	$\frac{1}{10}$	$\frac{1}{100}$	$\frac{1}{1000}$

To the nearest hundred:

7,777.777 Underline the designated number.

7,777.777 7 is greater than (>) 5.

7,800.000 Increase the designated number by 1.

Replace the numbers to right of the rounded up number with zeros.

To the nearest thousand:

7,777.777 Underline the designated number.

7,777.777 7 is greater than (>) 5.

8,000.000 Increase the designated number by 1.

Replace the numbers to right of the rounded up number with zeros.

To the nearest tenth:

7,777.777 Underline the designated number.

7,777.777 7 > 5.

7,777.800 Increase the designated number by 1.

Replace the numbers to right of the rounded up number with zeros.

To the nearest hundredth:

7,777.777 Underline the designated number.

7,777.777 7 > 5.

7,777.780 Increase the designated number by 1.

Replace the numbers to right of the rounded up number with zeros.

To the nearest thousandth:

7,777.777 Underline the designated number.

7,777.777 Unless the value is carried out 4 places to the right of the decimal, rounding up to the nearest thousandth is not possible, and in most cases insignificant.

ROUNDING DOWN

EXAMPLE: Rounding down 4,444.444

To the nearest one:

4,444.444 Underline the designated number to be rounded.

4,444.444 Look to the right of the designated (underlined) number. Is the number less than (<) 5? In this case, 4 < 5 so the designated number, 4, remains the same.

4,444.000 Replace all numbers to the right of the designated number with zeros.

To the nearest ten:

4,444.444 Underline the designated number.

4,444.444 4 is less than (<) 5.

4,444.000 The designated number remains same.

Replace the numbers to the right of the designated number with zeros.

To the nearest hundred:

4,444.444 Underline the designated number.

4,444.444 4 is less than (<) 5.

4,400.000 The designated number remains same.

Replace the numbers to the right of the designated number with zeros.

To the nearest thousand:

4,444.444 Underline the designated number.

4,444.444 4 is less than (<) 5.

4,000.000 The designated number remains same.

Replace the numbers to the right of the designated number with zeros.

To the nearest tenth:

4,444.444 Underline the designated number.

4,444.444 4 < 5.

4,444.444 The designated number remains same.

Replace the numbers to the right of the designated number with zeros.

To the nearest hundredth:

4,444.444 Underline the designated number.

4,444.444 4 < 5.

4,444.440 The designated number remains same.

Replace the numbers to the right of the designated number with zeros.

FINANCIAL NOTATION

Financial notation is a way of abbreviating numbers when formulating planned financial reports (i.e., income statements, stock/sales plans). The decimal point acts as the holding point for thousands.

EXAMPLE: One thousand dollars

$$\$1,000 \quad = \quad 1.0$$

EXAMPLE: Five hundred dollars

$$\$500 \quad = \quad .5$$

EXAMPLE: One hundred thousand dollars

$$\$100,000 = \quad 100.0$$

	WHOLE NUMBERS				FRACTIONS			FINANCIAL NOTATION			
	THOUSANDS	HUNDREDS	TENS	ONES	TENTHS	HUNDREDTHS	THOUSANDTHS	HUNDRED THOUSANDS	TEN THOUSANDS	THOUSANDS	HUNDREDS
	1,000	100	10	1	$\frac{1}{10}$	$\frac{1}{100}$	$\frac{1}{1,000}$	100.0	10.0	1.0	.1
NUMBER TO BE ROUNDED UP (= OR > 5)	7,770	770	777	777.7	.17	.177	.1777	777.7	77.7	7.77	.777
ROUNDED VALUE	8,000	800	780	778.0	.20	.180	.1780	800.0	80.0	8.0	.8
NUMBER TO BE ROUNDED DOWN (< 5)	7,440	740	744	744.4	.74	.744	.7444	744.4	74.4	7.44	.744
ROUNDED VALUE	7,000	700	740	744.0	.70	.740	.7440	700.0	70.0	7.0	.7

Figure A3.2. Rounding Numbers and Financial Notation Reference Chart

Note: When using financial notation, round all numbers to the nearest hundred.

$$\$750.00 \ = \ .8$$
$$\$820.00 \ = \ .8$$
$$\$\ 75.00 \ = \ .1$$
$$\$\ 35.00 \ = \ \text{Omit}$$

THE ROUNDING NUMBERS AND FINANCIAL NOTATION REFERENCE CHART

The chart in Figure A3.2 clarifies the process in which one rounds numbers and uses financial notation for the simplification of presenting numbers when exact numbers are not necessary.

APPENDIX 3 REVIEW

1. Round up to the nearest one.

 a. 62.5

 b. 767.7

 c. 3.9

2. Round up to the nearest ten.

 a. 567

 b. 789

 c. 328

3. Round up to the nearest hundred.

 a. 5,462.25

 b. 1,290.18

 c. 9,076.42

4. Round up to the nearest thousand.

 a. 2,825.75

 b. 7,601.27

 c. 8,923.65

5. Round up to the nearest tenth.

 a. .899

 b. .4552

 c. .5731

6. Round up to the nearest hundredth.

 a. .3699

 b. .557

 c. .669

7. For All Seasons offers three brands of cross county skis. They retail for $167.00, $199.00, and $289.00. What are the new retail prices if they are rounded up to the nearest ten? The nearest hundred?

	Ten	Hundred
$167.00		
$199.00		
$289.99		

8. Sales for the first quarter of the year were:

January	$486,591.00
February	$422,970.00
March	$397,659.00

What would the sales figures be if they were rounded up to the nearest hundred? The nearest thousand?

	Hundred	Thousand
January		
February		
March		

9. Round down to the nearest one.

 a. 845.20

 b. 297.40

 c. 713.10

10. Round down to the nearest ten.

 a. 1,653.24

 b. 6,940.97

 c. 2,274.68

11. Round down to the nearest hundred.

 a. 107

 b. 6,426

 c. 7,431

12. Round down to the nearest thousand.

 a. 3,420

 b. 5,252

 c. 4,192

13. Round down to the nearest tenth.

 a. .54

 b. .122

 c. .84

14. Round down to the nearest hundredth.

 a. .321

 b. .684

 c. .992

15. During its recent Memorial Day Savings Spectacular, For All Seasons offered tennis rackets at $39.40, $46.40, $52.40, and $66.40. If these prices were rounded down to the nearest one, what would the new retail prices be?

$39.40 _____

$46.40 _____

$52.40 _____

$66.40 _____

16. Men's down parkas are priced at $124.00, $132.00, and $140.00. If the retail prices were rounded down to the nearest ten, what would the new prices be? To the nearest hundred?

	Ten	Hundred
$124.00		
$132.00		
$140.00		

17. The gift department's planned markdowns for the spring/summer season are:

Feb.	$ 620.00
March	$1,100.00
April	$ 842.00
May	$ 915.00
June	$ 641.00
July	$1,221.00

Round the markdown figures down to the nearest hundred for posting on the merchandise plan.

18. Use financial notation and abbreviate the following numbers.

 a. $235,000

 b. $ 14,700

 c. $ 1,100

 d. $ 800

 e. $999,999

19. Round the numbers while using financial notation. The designated number to be rounded is underlined.

 a. $238,<u>7</u>90

 b. $ 45,<u>2</u>80

 c. $ 6,<u>4</u>88

 d. $ <u>5</u>50

 e. $ <u>9</u>9

20. Convert the following values from financial notation back to their unabbreviated form.

 a. .9

 b. 4.0

 c. 15.6

 d. 67.9

 e. .2

Key Merchandising Math Formulas

The interaction of the three pricing formula elements enables profitable pricing calculations.

Cost	**Retail**	**Retail**
+ Markup	**– Cost**	**– Markup**
= Retail	**= Markup**	**= Cost**

COST	+	MARKUP	=	RETAIL
merchandise cost		desired net profit		net sales
shipping charges		reductions		reductions
trade and quantity discounts		operating expenses*		shortage

* Operating expenses include shortage as they are a result of poor operating controls of pilferage and paperwork errors in receiving and processing goods.

MARKUP ON COST VERSUS MARKUP ON RETAIL FORMULAS

MU% on Cost

Retail $
– Cost $
= Markup $

MU% = **Percent of Cost**

Cost = **100%**

$$\frac{\text{Markup \$}}{\text{Cost \$}} = \textbf{Markup \%}$$

$$\frac{\text{Retail \$}}{\text{Multiplier}} = \textbf{Cost \$}$$

100%
+ MU% on Cost
= Multiplier

MU% on Retail

Retail $
– Cost $
= Markup $

MU% = **Percent of Retail**

Retail = **100%**

$$\frac{\text{Markup \$}}{\text{Retail \$}} = \textbf{Markup \%}$$

Retail $
× Cost Complement %
= Cost $

100%
– MU% on Retail
= Cost Complement % (CC%)

$$\begin{array}{c} \text{Cost \$} \\ \underline{\times \text{ Multiplier}} \\ = \textbf{Retail \$} \end{array}$$

$$\frac{\text{Cost \$}}{\text{CC\%}} = \textbf{Retail \$}$$

$$\frac{\text{MU\% on Retail}}{\text{CC\%}} = \begin{array}{l} \textbf{MU\%} \\ \textbf{Cost} \end{array}$$

$$\frac{\text{MU\% on Cost}}{\text{Multiplier}} = \begin{array}{l} \textbf{MU\%} \\ \textbf{Retail} \end{array}$$

INITIAL MARKUP FORMULAS

Formula for Calculating Initial Markup

$$\frac{\begin{array}{c}\text{Gross Margin} \\ \text{Reductions} + [\text{Operating Expenses} + \text{Profit}]\end{array}}{\text{Reductions} + \text{Shortage} + \text{Net Sales Volume}} = \textbf{IMU}$$

Note: If the retailer always takes advantage of cash discounts, cash discounts would be deducted from the top line calculation.

Formula for Calculating Initial Markup Dollars

$$\begin{array}{ll} & \text{Original Retail Price} \\ \text{Less:} & \underline{\text{Cost Price}} \\ & \text{Initial Markup Dollars} \end{array}$$

Formula for Calculating Initial Markup Percent

$$\frac{\text{Initial Markup \$}}{\text{Original Retail Price \$}} = \textbf{IMU\%}$$

PROFIT FORMULAS

Formula for Calculating Net Sales Volume

$$\begin{array}{ll} & \text{Gross Sales} \\ \text{Less:} & \underline{\text{Customer Returns \& Allowances}} \\ & \textbf{Net Sales Volume} \end{array}$$

Formula for Calculating Gross Margin Dollars

$$\begin{array}{ll} & \text{Net Sales Volume} \\ \text{Less:} & \underline{\text{Cost of Goods Sold}} \\ & \textbf{Gross Margin Dollars} \end{array}$$

Formula for Calculating Gross Margin Percent

$$\frac{\text{\$ Gross Margin}}{\text{\$ Net Sales Volume}} = \textbf{GM\%}$$

Formula for Calculating Net Operating Profit

Gross Margin Dollars

Less: <u>Total Operating Expenses</u>

Net Operating Profit

Formula for Calculating Net Profit Before Income Taxes

Net Operating Profit

+ Other Income

- <u>Other Expense</u>

= **Net Profit Before Income Taxes**

Formula for Calculating Net Profit

Net Profit Before Income Taxes

- <u>Income Taxes</u>

= **Net Profit**

Formula for Calculating Net Profit Percent

$$\frac{\text{Net Profit \$}}{\text{Net Sales Volume \$}} = \textbf{Net Profit \%}$$

MARKDOWN FORMULAS

Formula for Calculating Markdown Percent (MD%)

$$\frac{\text{Original Retail Price} - \text{New Retail Price}}{\text{Original Retail Price}} = \textbf{MD\%}$$

Formula for Calculating Markdown Price

Current Retail Price

× <u>Markdown Cost Complement %</u>

= **Markdown Price**

100%

- <u>Desired Markdown Percent</u>

= **Markdown Cost Complement %**

STOCK AND SALES BUDGETING FORMULAS

Formula for Calculating Annual Average Inventory

$$\frac{\text{Initial Month B.O.M.} + 12 \text{ B.O.M. Inventories}}{\text{Number of Inventory Figures Used (13)}} = \textbf{Annual Average Inventory}$$

Note: An additional month is always included in retail averaging to reflect the last month's changes in stock value (i.e., actual sales, markdowns).

Formula for Calculating Seasonal Average Inventory

$$\frac{\text{Initial Month B.O.M.} + 6 \text{ B.O.M. Inventories}}{\text{Number of Inventory Figures Used (7)}} = \textbf{Seasonal Average Inventory}$$

Formula for Calculating Retail Stock Turn

$$\frac{\text{Total Sales for Planning Period}}{\text{Average Inventory \$ at Retail}} = \textbf{Stock Turn}$$

Formula for Calculating Cost Stock Turn

$$\frac{\text{Total Cost of Goods Sold}}{\text{Average Inventory \$ at Cost}} = \textbf{Stock Turn}$$

Formula for Calculating Stock to Sales Ratio

$$\frac{\text{B.O.M. Stock}}{\text{Sales for Month}} = \textbf{Stock:Sales (S:S) Ratio}$$

Formula for Calculating B.O.M. Plan

Sales Plan for Month

× Stock:Sales Ratio Plan

B.O.M. Plan

Formula for Calculating Planned Purchases

B.O.M. Plan

Less: Month's Planned Sales

Less: Month's Planned Markdown Dollars

Less: E.O.M. Plan (Following Month's B.O.M.)*

Month's Planned Purchases*

*Planned purchases appear as a negative number on the calculator's readout. The negative indicates the shortfall that will occur if the necessary planned purchases are not made and emphasizes the importance of maintaining proper S:S ratios.

Formula for Calculating Purchases

Planned E.O.M.

Plus: Planned Sales

Plus: Planned Markdowns

Total Month's Inventory Required

Less: Planned B.O.M.

Planned Month's Purchases

ORDERING FORMULAS

Formula for Calculating Weeks of Supply Ordering Method

Step 1:

$$\frac{\text{Number of Weeks in Planning Period}}{\text{Planned Stock Turn}} = \textbf{Planned Number of Weeks Supply}$$

Step 2:

$$\frac{\text{Total on Hand Pieces} + \text{On Order}}{\text{Average Weekly Sales}} = \textbf{Weeks of Supply}$$

Step 3:

Average Weekly Sales

\times Planned Number of Weeks Supply

$=$ **Order-up-to Level**

Step 4:

Order-up-to Level

$-$ Total Inventory

$=$ **Order Quantity**

Formula for Calculating the Unit Rate of Sale

$$\frac{\text{Unit Sales for Specific Time Period}}{\text{Number of Specific Time Periods}} = \textbf{Rate of Sale}$$

Formula for Calculating the Order-up-to Level

Rate of Sale

Plus: Rate of Sale \times Turnaround Time

Plus: Rate of Sale \times Reorder Period

Plus: Safety Cushion (educated judgment)

Stock Level

Formula for Calculating Order Quantity

Order-up-to Level

Less: On Hand Count

Less: On Order

Order Quantity

SALES ANALYSIS FORMULAS

Formula for Calculating Sales per Square Foot

$$\frac{\text{Sales for Specific Period}}{\text{Selling Area Square Feet}} = \textbf{Sales per Square Foot}$$

Formula for Calculating Sales per Linear Shelf Foot

$$\frac{\text{Sales for Specific Period}}{\text{Linear Shelf Feet}} = \textbf{Sales per Linear Shelf Foot}$$

Formula for Calculating Percentage Change

$$\frac{\begin{array}{c}\text{Dollar Amount of}\\\text{Most Recent Time}\\\text{Period}\end{array} - \begin{array}{c}\text{Dollar Amount of}\\\text{Comparison}\\\text{Period}\end{array}}{\text{Dollar Amount of Comparison Period}} = \begin{array}{c}\% \\ \textbf{Change}\end{array}$$

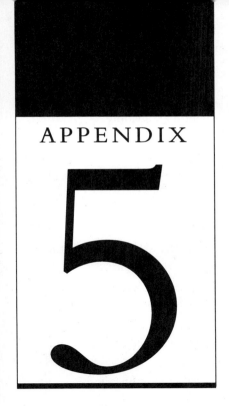

APPENDIX 5

Computerization Decisions

This book focuses on learning the basics of merchandizing and then building on this acquired knowledge to further increase sales and profits. Therefore, successful retailers must first have a thorough understanding and working application of merchandising principles and formulas before considering the conversion of their manual inventory management systems to computerized systems. Such knowledge is necessary to interpret each computer printout and understand how the results were computed, to analyze the data, and to set short- and long-term action steps to correct problems and maximize future sales and profits. The successful retailer also recognizes that computer systems are only as accurate as the person who enters the data; errors do happen. Therefore, retailers must be able to determine the integrity of the figures and be capable of analyzing their results to react effectively.

Just as the focus of this book is on the basics of profitable merchandising, this appendix focuses on merchandising computer systems, not accounting packages, although they may be purchased as an integral system at the onset.

COMPUTER SYSTEMS

computer system—an electronic component system that records, stores, and retrieves information and performs calculations

A **computer system** is an electronic component system that records, stores, and retrieves information and performs calculations.

Two components comprise a computer system: hardware and software. Computer **hardware** includes the computer, its data storage devices, terminals (monitors that show information as it is inputed or recalled from memory), and printers. Computer programs, called **software**, direct the operation of the computer and produce the desired results.

MERCHANDISING COMPUTER SYSTEMS

hardware—computer components that include the computer, its storage devices, terminals, and printers

software—computer programs that direct the operation of the computer

Merchandising computer systems permit the retailer to maintain a perpetual inventory via a computer. Basic systems require the input of merchandise activity to update the perpetual inventory records; more sophisticated systems will automatically record the daily addition and subtraction of all merchandise transactions at the time each sale is made. These systems will aid the retailer in effective inventory management by providing the information necessary to make the correct merchandising decisions.

Some of the features available in inventory management systems include:

1. The capability of handling numerous departments and classifications within each department

2. Purchase order management

3. Ease of cost, retail, gross margin, markup, and markdown calculation and tracking

4. Automated physical inventory processing

5. Printed receiving worksheets generated from purchase orders

6. Integration with point-of-sale (POS) terminals

7. Capability for entry of mass price changes and promotional sale prices

8. The printing of price tags

9. Cumulative storage of information for inventory valuation

10. Printed data analysis reports that record and report current inventory levels, stock turns, markdown dollars, purchases, open-to-buy status, inventory replenishment requirements, item and group rate of sale figures; provide gross margin per item, classification, and department

THE COMPUTERIZATION DECISION

The retailer should answer the following questions when investigating the purchase and installation of a computer system.

1. Is it becoming more difficult to control inventory levels in relation to sales as the existing manual systems are becoming too cumbersome and more time consuming?

2. Which computer system will best suit the merchandising needs required by my type of retail operation?

3. What are the recommendations from industry trade publications?

4. Which retailers are willing to discuss the capabilities and drawbacks of their computerized systems?

5. What training and computer support will be available, and what impact does the cost of implementing a computer system have on the cost of doing business?

6. What length of time is involved to start up the system, become proficient at using its capabilities, and be confident of its accuracy?

7. How often will the computer require maintenance, and what will the consequences be of not having access to the computer?

After considering these questions, the retailer must also understand that the manual inventory management procedures should be continued, in tandem with the new computer system, for a minimum of 3 months. This step is to verify data entry accuracy of the newly created computerized perpetual inventory and the resultant reports. Without this safety measure, the system may not provide effective inventory management and can become a costly mistake.

on-line–fully operational computerized system

In addition, several steps must be taken before going **on-line**:

1. A total physical inventory stock count must be taken by style, cost, retail, and size and color, if applicable.

SKU (stockkeeping unit number)–the identification number assigned to each product

2. Each item must be assigned a designated **SKU**, **stockkeeping unit number**, whose number of digits is specified by the computer system selected. (Some allow up to 5 digits, others 10, etc.)

3. All the compiled data are entered into the computer and checked for accuracy.

COMPUTER SYSTEM OPTIONS

electronic cash systems–cash systems that not only print receipts or calculate sales, taxes, and customer change, but also tabulate vital information that aids the retailer in determining what merchandise is selling, when reorders are necessary, and aids in inventory valuation

The first step toward creating a computerized inventory system focuses on the retailer's cash system. **Electronic cash systems** provide the essential link between inventory control and sales. They not only print receipts and total sales, but tabulate vital information that aids the retailer in determining what merchandise is selling and when reorders are necessary, as well as aiding in inventory valuation.

independent electronic cash register– calculates total sales, taxes, and customer change, and may be programmed to subtotal merchandise groupings to provide department or class sales and accumulate sales data for the compilation of storewide reports

electronic point-of-sale (POS) terminals– cash systems that act as cash registers and double as computer systems, automatically updating sales and inventory data as each individual sale is processed through the terminals

*scanning–*act of moving a wand or laser gun over a computer-coded merchandise ticket, which captures the accurate ticket data and updates the perpetual inventory

The most elementary electronic cash system is the **independent electronic cash register**, which works well for retailers with six or fewer cash registers. These registers do not share and compile information, but do calculate total sales, taxes, and customer change. They can also be programmed to subtotal merchandise groupings to provide department or class sales and accumulate sales data for the compilation of storewide reports.

Gaining in popularity are **electronic point-of-sale (P.O.S.) terminals**. These are cash systems that not only act as cash registers, but double as computer systems, automatically updating sales and inventory data as each individual sale is processed through the register. Such cash systems allow for the transmittal of sales data at the time of purchase to update merchandise information by item level and track inventory.

The benefits of P.O.S. cash systems include:

1. Price control

2. Labor efficiency through **scanning**, an alternative to data entry errors whereby computer-coded merchandise tickets are scanned by a wand or laser gun, which captures the accurate ticket data

3. Improved customer service. Customer checkouts are performed more quickly, thus eliminating long lines. "Walkouts" (customers who leave the store because they will not stand in long lines) are lessened

4. Reduced out-of-stock situations because item inventory levels are adjusted by each sale, each return, and each receipt of new merchandise to improve the replenishment cycle

5. Compiled sales results and promotional events analyses

6. Faster reorder cycles

7. Reduced inventory levels while maintaining the proper ratio between stock and sales

*price look-up (PLU)–*process by which a point-of-sale terminal automatically finds the corresponding price of an item at the time the merchandise ticket is scanned, thus eliminating the need for entering a price separately

Point-of-sale cash systems may also incorporate the function of **price look-up (PLU)**, the process by which a point-of-sale terminal automatically finds the corresponding price of an item at the time the merchandise ticket is scanned, thus eliminating the need for entering a price separately.

Some computerized systems may also incorporate **order point mechanisms**, which indicate when inventory levels are running low. Model stock levels/order-up-to levels are established as the order point mechanisms. Orders are then manually written or electronically generated depending on the sophistication of the selected system. In larger operations, the systems are often electronically linked together to identify the location of a particular style or size that may be obtained for customers when not available at the customer's location.

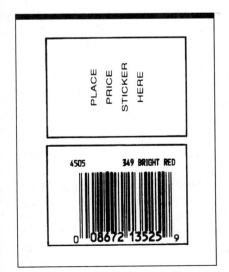

Figure A5.1. Bar-Coded Product Tag

POINT-OF-SALE REQUIREMENTS

For P.O.S. systems to work effectively, each item must be ticketed with a computerized code. This computerized system of identifying each item by style, size, color, etc. is called **bar coding**. Bar codes may be vendor or retailer produced. Increasingly, vendors are bar coding merchandise following the **uniform product code (UPC)**. Vendor-produced item codes are referred to as the **universal vendor marking (UVM)**, which may or may not include retail prices. If vendors do not provide UVMs, the retailer establishes an internal bar code SKU system.

Figure A5.1 illustrates the use of bar coding on a manufacturer's product tag.

AUTOMATED ORDERING SYSTEMS

order point mechanisms–model stock levels/order-up-to levels are established as the indicators incorporated within computerized systems, which indicate when inventory levels are running low, prompting manually written or electronically generated orders depending on the sophistication of the system

bar coding–computerized system of identifying each item by style, size, color, etc.

uniform product code (UPC)–price and item code identifying each product

universal vendor marking (UVM)–vendor-produced item codes, which may or may not include retail prices

automated ordering systems/automated replenishment systems–computerized order systems that generate orders via hand-held computers or point-of-sale cash systems

Basic stock merchandise (not fashion items or seasonal goods) may be ordered through **automated ordering systems** aside from initiating orders through the buying office. Automated ordering can occur on the store level based on order entry systems using hand-held computers or through the automatic tabulation of inventory figures from P.O.S. cash systems. Automated ordering systems, also referred to as **automated replenishment systems**, may be retailer- or vendor-generated, and are becoming widely used by retailers. In large retail operations and manufacturing concerns, manual ordering systems are quickly becoming outdated.

Before the retailer can use automated ordering systems, model stock levels/order-up-to levels must first be established for each item carried. These model stock levels are then entered into the computer system, and all reordering computations are based on these figures. As goods sell, basic programs flag reorder points, whereas more advanced programs automatically calculate reorder quantities in store or transmit the data electronically to vendors for orders to be shipped automatically according to established order-up-to levels.

When properly monitored, automated ordering systems will:

1. Reduce merchandise out-of-stock situations

2. Shorten ordering cycles

3. Reduce inventory carrying costs

4. Prevent starving basics (or out-of-stock basics) when overbought situations occur

Although the benefits of automated ordering systems far outweigh its one disadvantage, the retailer must still weigh the following factor when considering automated ordering systems. The disadvantage of automated ordering systems is overstock situations are created if order-up-to levels are not monitored closely or adjusted for declining sales

As long as the system is maintained and updated, the retailer should experience relatively few complications during the ordering process.

ELECTRONIC DATA INTERCHANGE

As headlined in a *Women's Wear Daily* ad, "Until now, the apparel industry replaced its stock about as fast as Mother Nature," meaning that before the advent of *electronic data interchange (EDI)*, the process by which computer-to-computer communication occurs between a business and its suppliers, most apparel stores restocked their merchandise about as quickly as a national forest replenishes itself. This also occurred throughout other merchandise industries—accessories, health and beauty aids, and hardware, to name a few—and resulted in dissatisfied customers. Customers who repeatedly visit a store only to find that it is out of the item(s) they came to buy will eventually cease shopping there. Replacing stock quickly in response to consumer demand is the basis of EDI.

The data captured at the P.O.S. are used as the basis of EDI. Sales data are fed electronically into automated ordering systems and then transmitted to the vendor automatically. These sales data are then compared to the agreed-on retailer/vendor order-up-to levels and, subsequently, a supplier's order is automatically generated and forwarded to the store. Through EDI the order cycle is shortened significantly. Typically the turnaround time on basic stock items averages 5 days, and many apparel suppliers have been able to reduce their average 90- to 120-day turnaround times to 10 to 35 days. EDI enables apparel suppliers to react quickly to the customer's buying response in styling and fashion through the analysis of the retailer's automatically transmitted sales data. Such electronic communication

makes the retailer and vendor extremely efficient in terms of managing the order cycle for replenishable goods and is vital to increasing customer satisfaction and improving customer relations.

The implementation of UPC and scanning, coupled with EDI, creates the key ingredients for success in the ordering cycle.

The advantages for retailers of this combination are:

1. Elimination of stock counts

2. Automatic restocking of basic stock items

3. Increased concentration on planning and buying new fashion goods

4. Reduced receiving costs

5. Minimum paper handling as purchase orders, shipping manifests, and invoices are sent and processed electronically

6. Reduced distribution center costs

7. Shortened order cycles

shipping container marking (SCM)— identifies contents of a carton of goods through use of a carton number embedded in a bar code printed on the carton label to expedite the movement of merchandise to the selling floor

The final link in the ordering cycle is the shipment of goods for arrival at their destination—the retailer's business. If the merchandise is marked, scanned, and reordered with UPC codes, the **shipping container marking (SCM)** system can further reduce the order cycle. The SCM identifies the contents of a carton of goods through the use of a carton number embedded in a bar code printed on the carton label. This carton number corresponds to an EDI notice, shipped in advance, which lists specific details of the carton contents. The SCM system allows retailers to eliminate time-consuming carton checks and permits deliveries direct to each branch store, thus reducing warehouse space requirements and expediting the movement of merchandise to the selling floor.

QUICK RESPONSE

Quick response originated as a strategy to enable American manufacturers to compete with the influx of imported products. Its primary aim today is improved customer service, which equals increased sales. Increased sales usually result when retailers can provide ample quantities of the merchandise most frequently demanded by customers. It is this basic merchandising theory that spurred the further development of the ordering system known as **quick response (QR)**.

quick response (QR)—a cooperative electronic strategy between a business and its suppliers using bar coding and electronic data interchange to increase the accuracy and reduce the response time between orders and shipments to better respond to customers' wants and needs

Quick response is the use of bar coding and EDI to increase the accuracy and reduce the response time between orders and shipments among businesses and suppliers. It is a cooperative effort among trading partners, the retailer and vendor, the vendor and manufacturer, the manufacturer and the textile resource, in which all trading partners set up mutual goals so that everyone in the chain is ready to respond to what the customer wants and needs, not what they "think" the customer will want. In this full circle of cooperation, the retailer electronically transmits its P.O.S. data to the vendor. The vendor analyzes the data and transmits the data to the manufacturer who shares the information with its textile resources to secure the necessary raw materials for production. This full circle of trading partners allows participants to recognize and respond to trends in a timely manner to better serve their direct customers.

The advantages of quick response include:

1. Reduced or eliminated excess inventory and overstocks

2. Increased stock turns through increased frequency of orders

3. Builds the *right* stock customers need and want

4. Reduces the ordering cycle

5. Lowered basic inventory levels, therefore, reduced inventory carrying costs

6. Meaningful sales histories for all trading partners

7. Stronger WIN/WIN partnerships

8. Ultimately, improved customer service and satisfaction

Quick response supports retailers, vendors, and manufacturers in having the *right* merchandise, at the *right* time, in the *right* place.

JUST-IN-TIME

just-in-time—strategy between trading partners to deliver goods "just as" the last product is being picked off a shelf or fixture; similar to quick response

Just-in-time is the most advanced goal of both the retailer and supplier. Similar to quick response, the just-in-time system works to deliver goods "just as" the last product is being picked off a shelf or a display fixture to further reduce inventory investment expenditures and to increase stock turns, sales, and profits while delivering the merchandise the customer wants.

COMPUTERIZATION DECISIONS

Retailers who have a thorough understanding and working application of merchandising principles and formulas can benefit from converting manual inventory merchandising systems to computerized systems after determining their merchandising needs and weighing the investment costs against their overall profit projections.

Certainly, computerized systems offer many advantages to knowledgeable retailers, which will enable them to make sound merchandising decisions more quickly. To recap a few, computerized systems will:

1. Reduce replenishment cycles to better meet the customers needs and wants

2. Increase stock turns through reduced inventory levels, yet minimize or eliminate out-of-stock situations

3. Reduce operating costs through automated ticketing, minimized paper handling, and reduced warehouse requirements

4. Increase the level of WIN/WIN partnerships

To further the computerization decision, the chart below illustrates the differences between manual versus computerized merchandising systems.

Manual	*Computerized*
Dept/class tickets	Bar-coded tickets
Longer check-out time	Reduced check-out with scanning at P.O.S.
Manual P.O.S. entry	Automatic perpetual inventory updates
Physical stock counts to compute reorders	Automatically replenished basic orders
Monthly reorders	Weekly fill-ins
Gathering of size, color information for trend determination	Merchandise summary recaps by size, color

1. What knowledge is necessary before retailers convert to computer systems? Explain the importance of this knowledge.

2. Name and define the two primary components of a computer system.

3. For All Seasons plans to convert the manual inventory management system to a computerized system.

 a. What information must be considered before For All Seasons selects a computer system?

 b. What initial steps must be taken before going on-line?

 c. What safety should be implemented and why?

4. Define electronic cash systems and explain how they are used in a retail operation.

5. What requirements must be met for P.O.S. systems to work effectively?

6. Write the correct letter by each abbreviation on the provided lines. Then define each term next to the correct letter below.

a.	Price Look-Up	QR	_____	
b.	Quick Response	SCM	_____	
c.	Electronic Data Interchange	UVM	_____	
d.	Shipping Container Marking	PLU	_____	
e.	Universal Product Code	EDI	_____	
f.	Universal Vendor Marking	UPC	_____	

a.

b.

c.

d.

e.

f.

7. List and describe the components and benefits of automated ordering systems.

8. Describe the components of the quick response system and explain how quick response improves customer service and satisfaction.

9. What are the advantages provided by quick response?

10. Explain the difference between quick response and just-in-time.

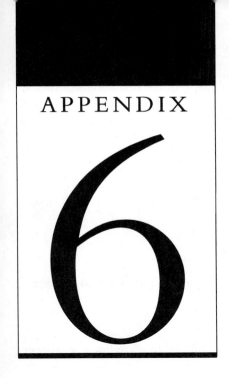

The Impact Of Federal Laws And Regulations On The Retailer

The buying and selling of merchandise is regulated by many governmental laws. The retailer must be aware of these laws to ensure compliance in day-to-day business activities. Such laws and government regulations have been passed to maintain free competition as well as to protect the consumer from unfair trade practices. The retailer should have enough basic knowledge to be aware of areas of potential violation and the hazards of noncompliance and to know when to ask legal counsel for advice. It is of utmost importance that retail organizations, whether large or small, provide the retailer with resources to stay abreast of legal obligations to avoid possible unlawful activities, because laws and regulations are always changing.

This appendix guides the retailer through the major federal laws that regulate free competition and are designed to protect consumers. Because state and local laws vary, it is suggested that retailers research the laws governed by their own municipality.

The major legislative laws were enacted to protect businesses, their employees, and consumers. The purpose of these laws is not to hinder competition, but to allow "fair" competition. When agreements are knowingly entered that favor one party more than another—through price discrimination, promotional allowances and discounts, and monopolizing product availability—then the parties involved are subject to civil and criminal laws. The major laws affecting retailers and vendors are outlined in Table A6.1.

Table A6.1 Anti-Trust and Trade Legislation

Sherman Act (1890)
 Written in general terms, the Sherman Act prohibits all agreements between retailers and vendors that may reduce or eliminate competition and restrain trade.

Clayton Act (1914)
 This act specifically details arrangements that have been found to reduce or eliminate competition. The Clayton Act clearly prohibits
 - Price and promotional discriminations
 - Exclusive dealing arrangements
 - Mergers and acquisitions

FTC Act (1914)
 The Federal Trade Commission (FTC) was established as an investigative body to prevent unfair competitive practices such as deceptive advertising and promotions, price discrimination, and unfair trading market controls.

Robinson Patman Act (1936)

This amendment to the Clayton Act is of importance to the retailer because it not only requires that vendors provide proportionally equal terms to all customers to prevent discrimination, but holds retailers responsible for unfair trade practices if they knowingly encourage and enter price, promotion, and market discrimination agreements. Therefore, retailers who knowingly accept disproportionate advertising monies, quantity discounts, payment terms, markdown allowances, etc. are open to being found guilty of unfair trade practices.

Wheeler Lea Act (1938)

This amendment to the FTC Act not only prohibits the use of deceptive advertising and promotions, price discrimination, and unfair trading market controls, but also misleading packaging and selling claims. With this act, food and drug products were included under the Federal Trade Commission's jurisdiction.

Anti-Merger Act (1950)

This act, also known as the Celler-Kefauver Act, prohibits the acquisition of stock or assets of another corporation, which will substantially reduce or eliminate the market's competition.

Consumer Goods Pricing Act (1975)

Under this act, price maintenance agreements between vendors and retailers are prohibited to allow for free market competition.

Magnuson Moss Act (1975)

This act further protects consumers by expanding the Federal Trade Commission's interpretive powers regarding deceptive practices. It also requires minimum standards for written consumer product warranties and defines the minimum content standards.

GLOSSARY

actual B.O.M. dollar amount on hand from a physical stock count or from perpetual inventory control records

additional markup used to raise original retail price of merchandise in stock

additional markup cancellations cancellation of additional markups

additional on order orders placed for delivery the same month and written after the first calculation of the specified month's open-to-buy

advertising checking bureau bureau that validates retailer's claims for specific advertising dollars within each trading market in the country

allowances partial or complete reimbursements for damaged merchandise, price competition, or in lieu of returning unsatisfactory merchandise

alteration and workroom costs total costs incurred in preparing merchandise for sale

automated ordering systems/automated replenishment systems computerized order systems that generate orders via hand-held computers or point-of-sale cash systems

average markup percent percentage difference between cost and retail totals for a group of merchandise

back order an order placed, yet unable to be shipped because supplier is out of stock. With the retailer's approval, the goods will be shipped as soon as the supplier has the goods to ship.

bar coding computerized system of identifying each item by style, size, color, etc.

basic market research orderly, objective way of learning about targeted customers

basic stock lists merchandise within each classification that has consistent customer demand and that customers expect to always find

beginning cost inventory dollar amount of all merchandise in stock at cost value

beginning-of-month inventory dollar amount on hand from a physical stock count or from perpetual inventory control records; abbreviated as B.O.M.

best sellers items producing the greatest sales volume

bill of lading document indicating transport company's (common carrier) receipt of delivery from supplier

billboard rule as billboards are viewed in split seconds, each advertising vehicle is quickly viewed to determine if the purpose of the ad is clearly expressed and if it will make the consumer want to read the entire ad

billed cost negotiated purchase price; invoice amount after quantity, trade, seasonal, or promotional discounts have been deducted, but before the cash discount is deducted

body copy informs customer of special qualities, design features, sizes, colors, materials, and prices of merchandise

Bonus E.O.M. 26th–31st rule for all invoices dated the 26th – 31st of month, payment terms begin the end of the following month

"bottom line" limits the minimum and maximum concessions that a party is willing to compromise on to continue building a mutually profitable relationship

"bottom-up" planning planning method in which assortment plans are built based on targeted customers' needs and wants; model stocks are formulated for each merchandise classification and the sum total creates the master merchandise plan

C.O.D. terms and dating Cash on Delivery; payment due at time of delivery or shipment is immediately returned to supplier

cancellations order cancellations initiated and issued by either retailer or vendor

cash discount stated discount percentage deductible from the billed cost on invoice if payment is made on or before a designated payment period

class buying plans related merchandise group plans by classification for unit and dollar control purposes

closing cost inventory under retail method of inventory, is computed by multiplying closing retail inventory figure by cumulative markup cost complement percent

computer ordering method orders written based on each computerized item's model stock level in conjunction with the daily activity of each item

computer system an electronic component system that records, stores, and retrieves information and performs calculations

consignment terms allows retailer to test new products or resources without paying for the merchandise until it sells; vendor retains ownership of the merchandise until it is sold or returned by the purchaser

cooperative advertising dollars vendor partial or 100% contribution of "co-op" dollars to support retailer's advertising efforts

correction markdowns price reductions to correct merchandise problems

cost complement percent percentage difference between total retail price, valued at 100%, and initial markup percent (CC%)

cost method of inventory valuation value of inventory determined in actual cost dollars or market cost value, whichever is lower

cost multiplier method percentage value of cost price when retail price is valued at 100%; indicates the average relationship of cost to retail value of goods handled in an accounting period

cost of all goods purchased all new merchandise received after beginning cost inventory figure is totaled

cost of goods sold the total merchandise costs for a specific period of time, which include billed invoice amounts of merchandise purchased, transportation charges incurred, and costs of preparing merchandise for sale

cost price actual cost of merchandise shown on invoice or purchase order, including trade, quantity, seasonal and promotional discounts, and transportation charges when applicable

coupons certificates with a stated monetary or merchandise value presented to customer to redeem at time of purchase or for future purchases

cumulative markup dollar or percent difference between total cost and total retail value of all merchandise handled for a specific period of time

cumulative markup percent cost complement percent percent difference between retail, valued at 100%, and the cumulative markup percent

customer returns and allowances 100% refunds to comply with retailer's customer service policy; partial refunds to comply with retailer's customer service policy

daily sales flash recaps daily sales and reconciles cash register readings

daily sales report form that records and provides all necessary information for the calculation of daily net sales volume

dating agreement agreement specifying time period for payment of an invoice to increase selling period before payment is due

decimal fractions express values less than 1; more commonly known as *decimals*

denominator the bottom number of a fraction; represents the number of equal parts in the whole

discount reduction from original price of goods

E.O.M. payment terms the abbreviation E.O.M. stands for end-of-month, in which an invoice is dated, when the cash discount period and credit terms begin

electronic cash systems cash systems that not only print receipts or calculate sales, taxes, and customer change, but also tabulate vital information that aids the retailer in determining what merchandise is selling, when reorders are necessary, and aids in inventory valuation

electronic data interchange (EDI) process by which computer-to-computer communication occurs between a business and its suppliers to increase order accuracy and shorten order cycles to increase customer service levels

electronic point-of-sale (P.O.S.) terminals cash systems that act as cash registers and double as computer systems, automatically updating sales and inventory data as each individual sale is processed through the terminals

end of month inventory equal to the beginning of the following month inventory figure, the B.O.M.; abbreviated as E.O.M.

ending book inventory opening book inventory plus purchases, transfers in, customer returns, vendor allowances, price increases minus gross sales, transfers out, returns to vendors, markdowns, and additional markup cancellations; in other words, opening book inventory plus increases to inventory minus decreases to inventory for a specific period of time

ending cost inventory total dollar cost value of merchandise in stock at end of specified period of time

F.O.B. Free on Board or Freight on Board; the abbreviated transportation, which is always followed by point of destination and specifies who pays transportation charges and assumes risk of loss while goods are in transit

F.O.B. Origin/Factory agreement whereby purchaser assumes risk of loss and pays all shipping charges from the time the goods leave the designated origin

F.O.B. Store/Destination agreement whereby vendor assumes all risk of loss and pays all transportation charges until goods arrive at store or designated location

F.O.B. Store/Destination, Freight Collect and Allowed agreement whereby vendor assumes risk of

loss until goods arrive at store or specified location, and purchaser, on receipt of goods, pays shipping charges, which are deducted from the vendor's invoice when payment is made

facing each item displayed on the front line of a shelf or in a display case

financial notation way of abbreviating numbers which provides an easy way to perform calculations and clearly present numeric findings when exact numbers are not necessary

five golden rules of merchandising having the *right* merchandise, at the *right* time, at the *right* price, in the *right* quantity, in the *right* place

five key pricing considerations determination of retail price based on what customer would be willing to pay, pricing strategy, pricing terms, gross margin percent plan, and initial markup/markon

fixed expenses costs incurred regardless of sales volume

fractions used to express a part of a whole; consist of numerator and denominator

frequent buyer awards discount or special gift received when specific dollar amount is reached

games attention-grabbing devices to further stimulate immediate sales

gross cost of goods sold inventory value before alteration and workroom costs

gross margin dollar or percentage difference between net sales volume and cost of goods sold

gross margin of profit difference between net sales volume and cost of goods sold; also known as gross profit or gross margin

gross margin percent percent of net sales volume dollars remaining after costs related to purchasing and preparing merchandise for sale are subtracted; calculated by dividing gross margin dollars by net sales volume dollars

gross margin percent plan margin percent necessary to cover overhead and produce a profit

gross sales total amount of dollars received from sale of merchandise over specified period of time

gross wholesale price gross cost price

hardware computer components that include the computer, its storage devices, terminals, and printers

headline attracts customer's attention and sells positive benefits of merchandise

improper fractions fractions with values of 1 or more

income statement reveals net sales volume, cost of goods sold, gross margin of profit, all related expenses,

and resulting net profit or loss; also known as profit and loss statement (P&L) and operating statement

independent electronic cash register calculates total sales, taxes, and customer change, and may be programmed to subtotal merchandise groupings to provide department or class sales and accumulate sales data for the compilation of storewide reports

initial markup/markon difference between original retail price and cost price; when expressed as a percent, it is a percentage of the retail price

institutional promotions events aimed at building the store's image over a continuing period of time by promoting the advantages of a store in relation to its competition

interstore transfer form records inward and outward movement of merchandise between departments or other branch stores

intuitive ordering method ordering by intuition

inventory overage discrepancy between dollar value of book stock and actual stock value when physical inventory is greater figure

inventory shortage discrepancy between dollar value of book stock and actual stock value when book inventory is greater figure; also referred to as *shrinkage*

inventory valuation placing a cost or retail dollar value on stock

jobber resource of goods purchased from manufacturers, which are sold to wholesalers or direct to retailers

just-in-time strategy between trading partners to deliver goods "just as" the last product is being picked off a shelf or fixture; similar to quick response

keystone method doubling cost of an item to arrive at the retail price

layout tells typesetter the size and position of body copy and indicates location of each component

leader pricing when one or more items are selected and priced below normal gross margin potential with goal of increasing traffic and conveying idea that merchandise is priced low

linear shelf foot number of consecutive feet, or inches, of front shelf space allocated to an individual item

liquidation the mass selling of merchandise, usually at reduced prices, to produce sales dollars quickly

list prices prices listed in supplier's catalogues or on their product offering sheets

loss leader item that is knowingly priced below cost

maintained markup dollars the difference between net sales volume and gross cost of goods sold

maintained markup percent difference of net sales volume and gross cost of goods sold divided by net sales volume

markdown cancellation cancellation of a temporary markdown to bring merchandise back to its original price or previous markdown price

markdown dollars the dollar difference between the original retail price and the new retail price of an item

markdown percent as a percent of net sales—net markdown dollars divided by net sales volume

markdown percent cost complement difference between 100% and the desired markdown percent

markdown price reduced retail price

markup amount added to the cost, which covers the "overhead" burden (operating expenses) and which will yield the desired net profit

markup cancellations cancellation of original markup errors

markup dollars the dollar difference between retail and cost price; the markup on cost percent multiplied by the cost price; the markup on retail percent multiplied by retail price

markup on cost cash or percentage difference between retail price and cost price; when expressed as a percent, it is a percentage of the cost price

markup on retail cash or percentage difference between retail price and cost price; when expressed as a percent, it is a percent of the retail price

markup percent multiplier cost, valued at 100% plus markup percent

markup percent on cost found by dividing the initial markup percent by the cost complement percent

markup percent on cost method used by retailer to arrive at selling price by taking cost price and marking it up or by adding a percentage

markup percent on retail method difference between cost and retail expressed as a percentage of the retail price, which is valued at 100%

markup tracking log form to post all purchases and monitor progress toward achieving initial markup percent (IMU%) plan

master budget sum total of each department's stock/sales plans

memorandum terms similar to consignment terms except that purchaser holds title and risk of loss, ordinarily when goods are shipped from the point of origin

merchandise assortment ideal combination of merchandise that meets needs of targeted customer group at right time

merchandise classifications specific merchandise assortment groups; also known as *categories*

merchandise life span identifiable sales timetable of merchandise

merchandise plan a 6- or 12-month financial plan that forecasts and controls purchase and sale of merchandise; also referred to as *merchandise budget* or *stock/sales plan*

merchandise promotions events designed to immediately build store traffic and increase sales

merchandising all activities involved in the buying and selling of merchandise

mirroring the act of adopting another's behavior for the purposes of negotiations

mixed numbers fractions made up of a whole number and a fraction

model stock an outline of the necessary inventory items, with similar assortment and financial characteristics, which create an ideal assortment to meet the customers' needs and wants

model stock levels ideal stock quantity for each item stocked that should be on hand to meet everyday sales demands, plus a "cushion" amount for unanticipated additional sales and unforeseen delivery problems; also known as *par levels* and *order-up-to levels*

monthly promotion calendar detailed blueprint of a month's preplanned sales promotion

negotiations mutual discussions and arrangements of terms of an agreement with satisfactory solutions arrived at for each party

net operating profit difference between gross margin and total operating expenses

net profit total of net operating profit and other income, less other expense and income taxes

net profit percent calculated by dividing net profit dollars by net sales volume dollars

net sales volume gross sales less discounts, customer returns, and allowances

net terms and dating payment in full is due within the specified net period, from the date of invoice, which is understood to be 30 days unless otherwise stated

numerator the top number of a fraction; represents a portion of the whole

odd and/or even pricing specifies use of odd and/or even pricing digits as price point endings

off-price merchandise merchandise sold at discounts from originally quoted cost prices

on hand total number of pieces on selling floor and in stock room

on-line fully operational computerized system

on order orders placed but not yet received

on percentage short-cut method of calculating successive or chain discounts, such as trade discounts, through the use of the product of complements

open-to-buy (OTB) money available to retailer to spend on purchases to be received during a specific period

open-to-buy at cost dollars computed by multiplying OTB retail dollars by the cost complement of the initial markup percent (100% - IMU% = CC%)

opening book inventory total retail value of complete physical inventory at the beginning of a specified period

order point mechanisms model stock levels/order-up-to levels are established as the indicators incorporated within computerized systems, which indicate when inventory levels are running low, prompting manually written or electronically generated orders depending on the sophistication of the system

order-up-to level quantity of stock necessary to be on hand at a specific time to meet customers' needs and maintain profitable balance between stock and sales

ordering systems methods used by retailer to purchase goods and maintain profitable balance between stock and sales

original retail price first price set on goods for sale

other expenses costs not directly related to merchandising operations, i.e., interest paid on loans

other income monies received from nonoperating sources, i.e., interest on investments

out-of-stock ordering method stock ordered when previous stock has been totally sold

overhead expenses of operating a business that are not specifically chargeable to a selling, workroom, or manufacturing department

P.O.P. display Point of Purchase; display used for new product introduction and as impulse sale generator

Pareto rule states that of each line carried by a retailer, approximately 20% of the assortment will represent 80% of the sales

percent of markdown difference between original retail price and new retail price divided by original retail price

percentage change increase or decrease expressed as a percent

percentage increase analysis reflects the successful performance of vendor's line

percents fractions or decimals with the denominator of 100

performance to departmental plans figure difference between a department's actual gross margin plan and the vendor's actual gross margin, which highlights a vendor's performance for a designated period of time

perpetual ordering method orders placed based on daily addition of receipts and transfers in and subtractions of sales and returns and transfers out

physical inventory manual counting of all stock on hand

planogram item-by-item fixture presentation guidelines

point of purchase/point of sales displays P.O.P/P.O.S. displays positioned at or near check-out registers for new product introductions and as impulse sale generators

premiums free gifts or specially priced gifts offered at the time of specific item purchases; also referred to as *gift-with-purchase (GWP)* or *purchase-with-purchase (PWP)*

price change form records all increases and decreases of retail prices

price lines specific price points

price lining sets forth specific pricing guidelines for merchandise within a category, department, or total store

price look-up (PLU) process by which a point-of-sale terminal automatically finds the corresponding price of an item at the time the merchandise ticket is scanned, thus eliminating the need for entering a price separately

price zone a series of price lines that produce the strongest sale of units within an assortment of merchandise; where purchases are concentrated to maximize sales and profits

pricing fixing or establishing a price for goods

pricing strategy plan outlining a store's pricing policy based on the consideration of pricing above, equal to, or below competition; leader pricing; price lining; and odd and/or even pricing

projected sales planned sales that may be adjusted upward or downward depending on the current sales trend

promotional discount discount offered to retailer to help promote merchandise

promotional markdowns price reductions created by need to project store image and build traffic

promotional merchandise select products purchased to promote values to customers to increase store traffic and generate additional sales volume

promotional order merchandise ordered to specifically cover the needs of a planned promotion

proof tearsheet of the ad presented prior to authorizing printing

proper fractions fractions with values less than 1; the numerator is less than the denominator

purchase journal records inward movement of goods received from suppliers

purchase on order log form that provides a running record of all purchase information

purchase order written contract between retailer and vendor; includes specifics of an order

purchase order controls guidelines to prevent vendor order discrepancies

purchase order number specific number for each purchase order to provide both internal and external controls

quantity discount discount to retailer based on size of individual order or total sum of purchases over a specific period of time

quick response (QR) a cooperative electronic strategy between a business and its suppliers using bar coding and electronic data interchange to increase the accuracy and reduce the response time between orders and shipments to better respond to customers' wants and needs

R.O.G. terms and dating Receipt of Goods; payment begins on date retailer receives shipment from vendor, rather than the date on invoice

rack jobber jobber who typically provides an opening order on consignment or a guaranteed sales basis; periodically checks stock and refills it

rate of sale number of average unit sales for specific period of time

receipts, sales, and markdowns summary form form that summarizes all activity, by style, for a specific period of time

received quantity received

reorder period how often orders are placed

retail calendar unlike the conventional calendar year, the retail calendar year is divided into four quarters, each comprised of 13 weeks, thereby eliminating split conventional calendar weeks and allowing for the comparison of each day of a year to the same day from the previous year; also referred to as the 4-5-4 calendar

retail method of inventory valuation value of inventory determined in retail dollars and converted to cost

retailer the party who resells the goods obtained from a vendor

return privileges arrangement whereby vendors allow retailers to return merchandise

returns merchandise returns to vendor

rotating ordering method orders written based on rate of sale and established model stock levels after regularly scheduled physical inventory counts are taken

routemen jobbers whose inventory is carried on trucks; routemen come to retailer's location, see what merchandise is needed, and leave the desired amount of merchandise

"running book" inventory method a running dollar summary based on every item's value

safety cushion reserve stock units to cover uncertainties in sales and deliveries

sales forecasting projecting future sales volume for specific period of time based on past sales records, current sales trend, management's direction, and local economic and market factors

sales per linear shelf foot calculated by dividing sales for a specific time period by linear shelf feet

sales per square foot calculated by dividing sales for specific time period by selling area or total store square footage

sales promotion all events and devices designed to please customers while increasing market share, sales, and profits

satisfaction markdowns price reductions to correct the customer service policy of the store

scanning act of moving a wand or laser gun over a computer-coded merchandise ticket, which captures the accurate ticket data and updates the perpetual inventory

"Seasonal," "Advanced," or "Post" terms and dating payment made some time after receipt of shipment

seasonal discount discount offered to retailer who places orders before normal buying season, allowing manufacturer to preplan production schedules

seasonal merchandise broad assortment of merchandise purchased for a specific season or holiday

sell-through act of selling invoiced merchandise to produce the necessary monies for invoice payment prior or equal to final payment date

selling retail price actual dollar amount received for goods sold

shelf inventory sum total of product line's height and depth units when fully stocked

ship/cancel date specific start shipment date and specific last date shipment may leave the vendor's, or arrive at the retailer's, specified destination point

shipping container marking (SCM) identifies contents of a carton of goods through use of a carton number embedded in a bar code printed on the carton label to expedite the movement of merchandise to the selling floor

shopping goods merchandise that customers want to inspect and compare in relatively broad assortments of different styles, colors, and sizes, before selection

shortage difference between two physical inventory counts not accounted for in sales

six-month sales and promotional plan a summary of the previous 2 year's seasons sales, competitive activities, and an outline of the new season's initial planned sales and promotional events to aid in the achievement of the season's merchandise plan

SKU (stockkeeping unit number) the identification number assigned to each product

software computer programs that direct the operation of the computer

sourcing continual search for the next emerging trend, the next best seller to predict and meet the customers' changing needs

special events in-store devices to attract customers to specific merchandise areas to further build sales (i.e., personal appearances, demonstrations, register-to-win)

spiff vendor-provided merchandise or monetary award for achieving specific sales quota(s) mutually set by the retailer and vendor

stock-to-sales ratio (S:S) relationship between stock on hand at beginning of month and sales for month expressed as a ratio

stock turnover mathematical calculation that measures how fast merchandise is being sold and replaced for specific period of time; also referred to as *stock turn*

store intercept market research questionnaire

targeted customer profile developed from demographic descriptions of customer buying habits in a retailer's trading area, and includes information such as the targeted customer group's age, income levels, lifestyle and similar parameters

terms of sale terms specifying agreements negotiated between suppliers and purchasers

"top-down" planning top management specifies sales goals and dollar or unit budgets

total markdown dollars markdown dollars times the number of marked down pieces

total merchandise handled beginning cost inventory plus cost of goods purchased and transportation charges incurred

total operating expenses fixed and variable costs incurred in operating the store, not including merchandise expense

total stock on hand sum of all stock on hand plus incoming receipts for the specified month

total stock reductions sum of all stock reductions, which may include sales, markdowns, order cancellations, etc.

trade discount discount or series of discounts deducted from supplier's list price to arrive at the billed cost price

trading stamps stamps received per specified dollar purchase to fill the provided trading stamp booklet, which may be redeemed for merchandise

traditional customers conservative individuals who accept fashion change gradually, are quality minded, brand loyal, and purchase tailored looks with an emphasis on fashion

transportation costs incurred all shipping costs paid by retailer and not chargeable to vendor

turnaround time time between placing an order and receipt of it

"umbrella" theme unified sales promotion program tailored to the specific needs of a store and its merchandising situation

uniform product code (UPC) price and item code identifying each product

unit stock control book book in which item activity is recorded by style, size, color, etc.

universal vendor marking (UVM) vendor-produced item codes, which may or may not include retail prices

updated customers individuals who look to color and fashion in all purchases, understand fashion, and have the confidence to make their own fashion statements

value additives purchase enhancers to stimulate merchandise demand and spur customer response to buy now

variable expenses costs that fluctuate monthly as net sales volume increases and decreases

vendor the source from whom goods are obtained; also known as *manufacturer, supplier, wholesaler,* and *resource*

vendor allowances partial or complete reimbursements for damaged merchandise, price competition, or in lieu of returning unsatisfactory goods

vendor chargeback return to vendor form to document outward movement of merchandise

vendor log detailed outline of each supplier, including pertinent purchasing and negotiating information

vendor ordering method reorder on visit or phone call of vendor

vendor performance evaluation form simplified income statement that reflects vendor's performance in comparison to departmental or class plans for a specific period of time

vendor returns shipments of merchandise returned due to errors in filling store's purchase order(s) or due

to late delivery, defective materials or workmanship, or other breaches of contract

visual ordering method orders placed after visual inspection of item stock levels in stock room and on selling floor

volume price points prices that produce strongest sales volume

weeks of supply analysis per item summary reflecting current sales trends and allowing comparison to planned stock turn rates

weeks of supply ordering method orders written based on recent weekly sales rates and number of weeks of inventory on hand and on order

wholesaler resource of goods purchased from manufacturers or jobbers and then resold to retailers

WIN/WIN partnerships situation whereby the retailer and the vendor work together to mutually arrive at the satisfactory solutions for each party, while anticipating and meeting the consumer's needs and wants

INDEX